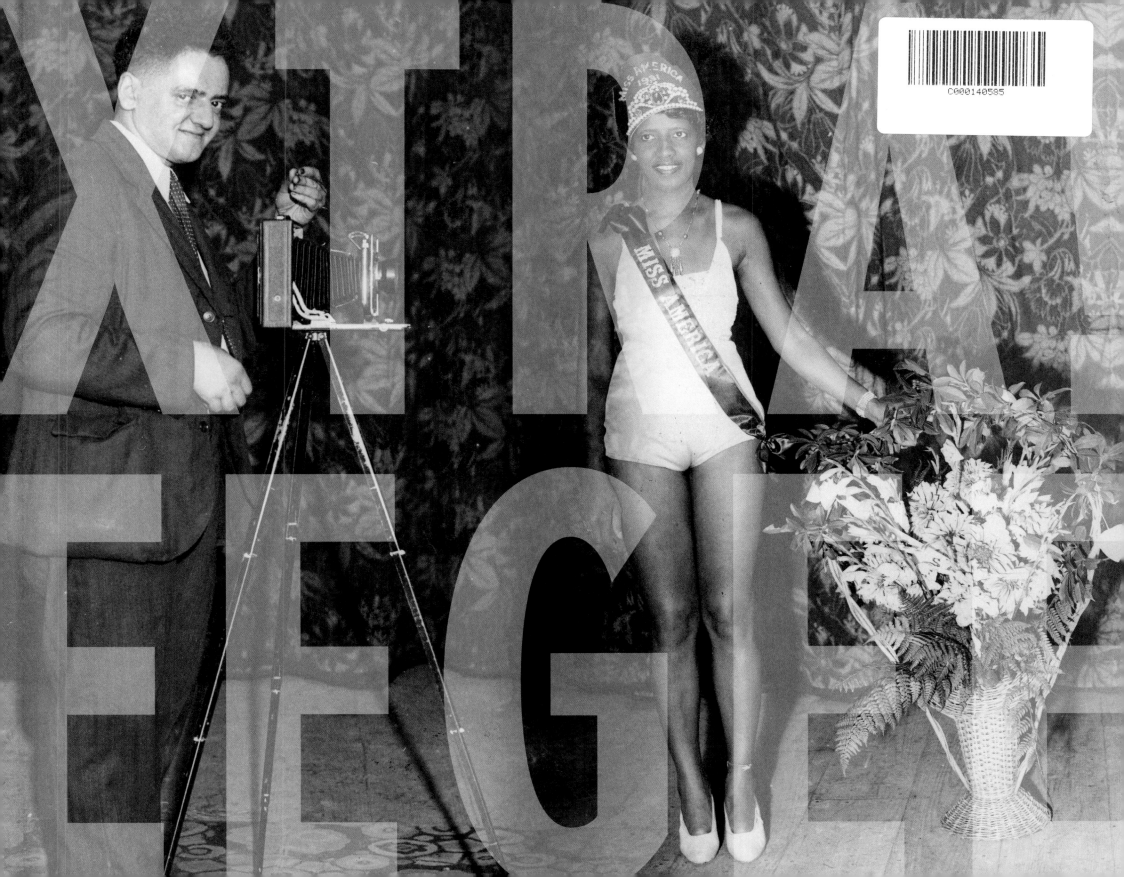

To Anton in NYC

EXTRA! WEEGEE

A COLLECTION OF
359 VINTAGE PHOTOGRAPHS
FROM 1929–1946

Edited by Daniel Blau

DANIEL BLAU

HIRMER

CREDIT PHOTO BY WEEGEE THE FAMOUS

ABOUT NEW YORK'S DAYS AND NIGHTS:
SO WELGEE (WEEGEE) TOOK HIS CAMERA TO A GABFEST

by Herbert Corey
Published January 9, 1929

New York—Weegee's night out could never have happened in any other city. I'm sure of that. St Louis, Kansas City, Cincinnati might have offered pitfalls for Weegee's wandering feet, but they would have been different pitfalls. Only New York could give him that kind of time.

"She was," said he, "the most charming woman I have ever met. Her philosophy precisely agreed with mine. She is a Thinker." Upper case T.

Weegee is a newspaper photographer. It might be urged that newspaper photographers must be slightly cracked or they would not follow such a furious occupation, but that might only be the venom of one who is associated with a rival line. In any case, the things that happened might have been experienced by any one else. Most of them anyhow.

Weegee took his camera and rambled down to the recent gabfest. He was standing in front of the long-distance talker who was writhing under the infliction of his neighbor's fifty-fifth hour of "Dangerous Dan McGrew" when he got into conversation with a slender, blonde, pretty woman. After a time Weegee said:
"My throat aches, I'm so thirsty."
"Me, too," said the pretty woman.

They went on a round of speakeasies. This, however, was no low drinking tour, but an enjoyable course in higher philosophy in which drink figured only as a motor forcer. The pretty woman knew more speakeasies than Weegee did. Now and then the doors did not open, or a suspicious eye told them through a peephole to go away, but as a rule they were admitted and furnished with restoratives.

"She had been talking for two hours about philosophy," said Weegee, "without drawing a breath. Then she just dived under the table."

This must not be taken as indicating a critical attitude on Weegee's part. He was enthralled with her philosophy, which so completely agreed with his own. His two hours of listening were hours of sheer delight. When she dived under the table he took the obvious course.

"I threw a glass of water in her face," said he. "So she came to and began talking again."

* * *

The inquiry turned on life after death. It appeared that the pretty lady's husband died recently and had agreed to communicate with her if possible in a manner known only to the pair. But he had never been heard from.

"Maybe he was once," said she. "I'm not quite sure."

In the day of, when Ruth Snyder was waiting for execution at Sing Sing, the pretty woman visited her at intervals. Ruth Snyder was interested in the mysteries of beyond the grave, as well as in many

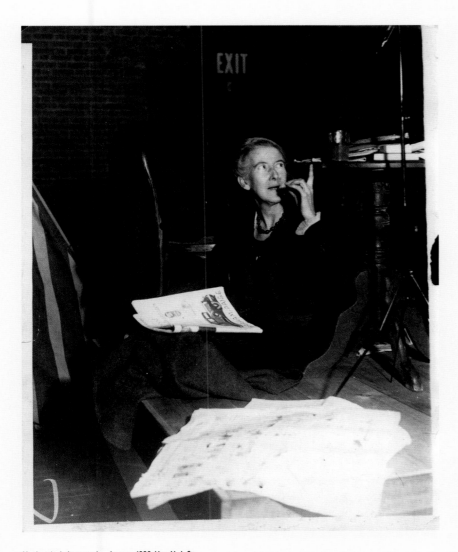

Unidentified photographer, January 1929, New York City

other things. She promised to come back to the pretty woman if she could and help her establish the longed-for connection with her husband.

"The first three nights after I go to the chair," said Ruth Snyder, "you go into your bedroom and turn out all the lights and just as the clock strikes twelve you wave a white handkerchief around your head three times."

Not on the night on which Mrs Snyder was to go to the chair, of course. This was made definite. Mrs. Snyder thought that on that night she might not be able to communicate.

* * *

On the first two nights, said the pretty woman, she turned out the lights in her bedroom and waved the white handkerchief around her head three times and nothing happened. But on the third—

"I'm not quite sure," said she, "Perhaps my husband did try to get in communication."

On the third night, standing in her darkened bedroom, waving her handkerchief around her head, something did happen. On the third wave there came a most terrific crash. The pretty woman fainted, she said and her maid came running in, yooping (Sic), and turned on the light, and found her mistress lying unconscious on the floor with a handkerchief clutched in her hand.

* * *

The crash had been occasioned by the fall of a huge wall mirror in the room occupied by her late husband. It has seemed firmly attached to the wall and the pretty woman thinks it possible that it might have become detached through super-normal agencies.

"But if that were the case," said she, "I do not know what to think."

Weegee asked why.

"I do not know what to think of the breaking of a mirror, said she. "Maybe it was merely an effort to communicate on the part of my late husband. Maybe he wished to warn me to let Ruth Snyder alone."

In the next speakeasy, as they discussed philosophy, a horrid cry was heard. A young girl had attempted suicide by drinking iodine. Weegee who is familiar with casualty through his occupation,

called the nearest hospital, and in his capacity as a newspaper photographer rode in the ambulance, and the pretty woman pursued in a taxicab. In the receiving ward of the hospital first aid was being given the girl when Weegee waked to a recognition of his duty. "She might have been somebody important," he explained, "and so I took a flashlight."

Nothing annoys hospital authorities more than to have a flashlight go bang just as they are resuscitating a dying woman. They seized Weegee by the neck.

* * *

They had to let him go, however, because his flashlight had set fire to the receiving ward. Weegee explains that flashlights are unreliable that way. You never can tell just what they're going to do. While the interns and the policeman were extinguishing the flames he slipped the plate-holder out of his camera and slipped another in. The Fire Demon—Upper case F and D—having been baffled, the officials returned to Weegee's neck.

"Listen," said he, "I know now I done wrong. I should not have banged away with that flash in a hospital. Just to show you my heart is right, I'll smash that plate."

So he smashed a plate. The other plate, when developed at the office, showed a lovely dying girl, and infuriated intern, some nurses and a policeman who seemed mostly eyeballs.

* * *

It was now daylight and the pretty lady took Weegee to his office in her taxicab and went on home. Not even philosophically.

I ask you. Could a nutty sequence like that happen anywhere except in New York?

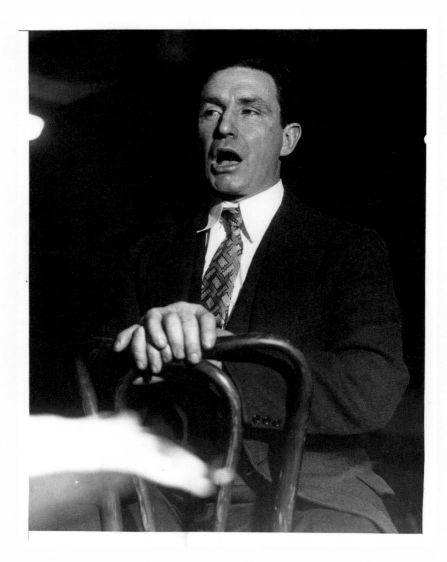

Unidentified photographer, January 1929, New York City

AND HIS JAWS NEVER GOT TIRED
Claude Yeomans, one of the leaders in the world's
Championship Gab Fest, keeping right on talking
in the marathon being held at the 71st Regiment
Armory, New York City.
YOUR CREDIT LINE MUST READ (..CME)

WEEGEE

by Ryan Adams, 2015

Rarely have photographers' careers been as celebrated and honoured as Weegee's.
Equally illustrious and renowned as his pictures was Weegee's persona, which heralded him as the world's most famous photographer. For most of his early career Weegee was unrelenting in capturing New York's seemingly endless affairs. From the grandiose halls of the Metropolitan Opera House to the unsophisticated sanctuary of *Sammy's Bar*, the congregation of inquisitive spectators to the abrupt silence of a gangland murder, Weegee navigated the labyrinth of New York's streets, documenting its untold life.

Ascher (anglicized to Usher) Fellig was born in 1899 in Złoczów near Lemberg, now part of the Ukraine. In 1909, his family immigrated to New York City, where he changed his name to Arthur. Growing up in New York proved to be crucial for Weegee as this is where he first fell in love with photography. Early in his career, Weegee worked for several photographers and later, in the darkrooms, assisted at the New York Times and Acme Newspictures. Weegee's speed, accuracy, talent, and skill in the darkroom made him an unrivalled technician. So much so, that in 1932 he travelled to California to work with Acme's LA-based photographer George Watson. Weegee continued to work for Acme in the darkroom and as a photographer, covering late night and early morning stories, until he left Acme in 1935, frustrated for never having received credit for his published work. Weegee then worked as a freelance photographer, covering anything he deemed newsworthy. He became known for his ability to be at the scene before anyone else, maybe as his name suggests but more likely due to the fact that in 1938 he was given permission to install a police radio in his car. Weegee remained in New York until 1947, when he moved to Hollywood to pursue an acting career.

Weegee dominated the New York landscape. In his own mind, he was the only individual, a cigar-wielding visual narrator, who could tell the story of his restless city. His inquiring eye found the sensational, the scandalous, the melodramatic, the newsworthy sides of New York life. From the hard-boiled detective to the meddlesome bandit, the late-night boozehounds to the dancing hepcats, the four-alarm blaze or the mangled remains of a car crash: Weegee covered it all.

The photographs illustrated in this book originate from the Newspaper Enterprise Association (N.E.A.) archive. N.E.A. was founded 1902 by Edward Willis Scripps and was the first of its kind. As a syndicate, it focused on national events, feature stories, cartoons, and illustrations. In the 1920s, wanting to include photography, N.E.A. created Acme Newspictures to serve as its primary news photo service. While Acme operated separately from N.E.A.'s syndication service, N.E.A. actively maintained a central photographic archive for all of Acme's bureaus, thus creating one of the largest archives in the country, housing photographs from New York, Chicago, Cleveland, Detroit, and Los Angeles.

In the early 1950s, N.E.A. sold Acme to the United Press Association. United Press, founded in 1907, had also been started by Edward W. Scripps to better solidify newspapers' unity. United Press is a predecessor to United Press International (UPI), which was formed after it merged with International News Service in May of 1958.

The physical N.E.A. photo archive never left Cleveland after UPI's founding in 1958. The archive was left undisturbed for more than 20 years until Don Kirschnick found the archive. Kirschnick was urged by his father, an employee of N.E.A., to take possession of N.E.A.'s photo archive. Kirschnick held onto the archive for six years until financial troubles consumed him, forcing him to sell the remaining archive in 1994 after a minor part had already been sold earlier.

In late 2012, Ryan Adams, a photojournalist expert, discovered the archive in a Midwest storage facility where it had been housed since its purchase in 1994. The following collaboration with Daniel Blau has resulted not only in the current presentation of vintage Weegee prints but also in the 2015 exhibition of early works by Margaret Bourke-White and the recent museum exhibition: *Robert Capa—Kriegsfotografien 1943-1945* at the Kupferstich-Kabinett Dresden.
Many of the photographs were exhibited for the first time, or first recognized as works by these famous photographers.

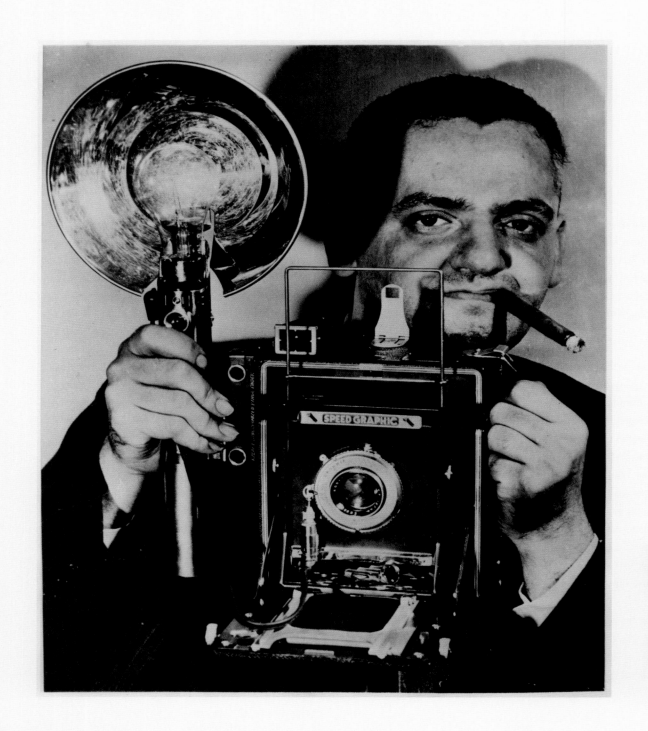

WEEGEE, THE NOTED PHOTOGRAPHER, HAS COMPLETED
A NEW BOOK, "WEEGEE'S PEOPLE," THAT WILL BE
PUBLISHED BY ESSENTIAL BOOKS OF DUELL, SLOAN
AND PEARCE ON NOVEMBER 12TH. "WEEGEE'S PEOPLE,"
UNLIKE HIS LAST BOOK, "NAKED CITY," WILL
EMPHASIZE THE HAPPY SIDE OF MANHATTAN.

FROM: DUELL, SLOAN AND PEARCE
 270 MADISON AVENUE
 NEW YORK 16, N.Y. (MU-52510)
PUBLICATION DATE: NOVEMBER 12TH
PRICE: $4.00.

WEEGEE
ONE OF THE GREAT MASTER WIZARDS OF PHOTOGRAPHY

by Daniel Blau, 2016

I never really liked Weegee.
Yet at some point in the 1980s I must have bought a book on his photographs; my first encounter with his work.

Somehow in my mind he merged with the bad 80s design of the book which seemed to show no greys—too much stark black-and-white and too much contrast for my taste, back then.
I didn't much enjoy the 80s and therefore didn't like Weegee.

But in fact, Weegee's best work was done in the 30s and 40s.

I understood from looking at his vintage prints that they have nothing in common with the illustrations in the book, as Géricault's *Raft of the Medusa* has nothing in common with its catalogue illustration. One is alive and the other is a mere specter.

When Weegee worked nights in Lower Manhattan, Ellis Island had been the entry point of most of its inhabitants. Most had come from Europe. Manhattan was Little Europe or a sort of Europe Town. Here they are united as proud Americans waving the American flag.

Guided by intuition, the police radio or the sirens' howl of the fire engines and ambulances, Weegee was there to record it in his picture diary of this great city.

He fixed it all onto film: the fear, the fun, grief and happiness and sometimes, a cat or dog.

From today, the time of the instant screen picture, when taking a photo has lost all its mystery, we look at these pictures witnessing another era.

Weegee was one of the great master wizards of photography.
The camera was his seeing eye, his wand to pull a single lasting image out of the city's fabric. He mastered the alchemy of creating a permanent image—fixing it. He brewed his potion in the cauldron that was his camera.

Our reference points to those mysterious worlds can be found in Hollywood entertainment such as *The Sopranos* or *Boardwalk Empire*. Weegee made these possible. He was a game changer— breaking new ground in both photography and photojournalism. Using the camera to tell a story as others used their pen or speech.
When he later turned to the movies, it was as an actor and not a director. By then he had already made all the films he wanted. All films made of a single frame. All telling a story in one take.
Today I love these short films.

WEEGEE LE MAGNIFIQUE

by Sydney Picasso

Photography, threading its way through the industrial revolution, has traversed multiple episodes of redefinition. And the photographer, as its primary manipulator, has been touted at once as "objective", an infallible observer, a recorder. The polar pendant to this is the notion of photographer as "conjurer", illusionist, or even magician. In early twentieth-century photography these two purviews are in constant interaction: on the one hand Man Ray actually interfered with "objects" and "bodies" and set them into a surreal fabrication; and on the other, Brassai, who recorded a unique tranche of Parisian life and later in his career responded with personal investigations into matter and surface, re-enforcing the notion that he was indeed an "objective" observer. The work of Weegee seems a priori to fit into the latter category, i.e. an unscrupulous and cold viewer of the human landscape. Not only has he roamed the terrain of night owls and police calls; he has depicted the actors of "high society" with the same indifferent gaze.

The present compendium of images predicated by its self-affirmed label: EXTRA! is deployed as an all-star program which includes the senses: sound and feeling, as well as the emotions: laughter and tears. Weegee's work has described a series of players: viewers, corpses, decoys, or dummies. His own persona evolved from the cold and objective observer to actor and impresario.

Accordingly, in the later part of his career, his travels to Hollywood and abroad seem to have concocted a more playful, mischievous character. In the film made in Paris: "The Real Weegee"[1] he portrays an impish, contriving character doing several slapstick charades. In one scene in a barber shop, he presumes to add a mustache, but using shaving cream, and with the impromptu troupe of the barber and his assistant sets a stage resembling more the Marx Brothers or the Three Stooges than an European caricature of "slapstick". Any preconceived notion of Weegee as a calculating pre-emptive striker of headline news is quickly dispersed by this film. In a later photo-essay he appears with a Rolleiflex around his neck in an improvised scenario of police procedure as if to insist on his transformation into "actor"—where he knowingly becomes part of the spectacle he wishes to create. It is in a way a step away or out of his lair in order to view life as a spectator and

not as a night crawler. His obsession with dressmaker dummies reiterates this displacement: we witness facsimile, the illusion and substitution of the real rather than the gritty portrayal of the city's viscera. Photos showing the shattered storefront window prefigure this empathy or misdirected need for the window dressed figurine—a clear allusion to the idea of substitution and the "crime scene".[2] In another such spoof, Weegee simulates a headline: "Police seize dummy lover!" In this attribution Weegee seems to fall into P. T. Barnum's description of the humbugs of the world in his "account of humbugs, delusions, impositions, quackeries, deceits, and deceivers".[3]

Daniel Blau, in describing this recovered treasure chest has stated:

"Weegee was one of the great master wizards of photography.
The camera was his seeing eye, his wand to pull a single lasting image out of the city's fabric. He mastered the alchemy of creating a permanent image, fixing it. He brewed his potion in the cauldron that was his camera."[4]

He thus equated Weegee's photography as a potent mix of fact and illusion.

Early photography using a powder-fuelled flash; the accessory to country fairs, rodeos and circus sideshows did have this component. The photographer was in some cases the "magician of the illusion". At the same time, abroad, there are countless stories of early ethnographers recording natives, having them pose, and their subjects being totally shocked at seeing the real representation of their countenances: shamans upstaged by witch doctors.

From sideshow to terrain pounding, the "news" photographer has enjoyed a particular reputation. Before the creation of photo agencies, the photographer worked primarily in a studio: such studios exist even presently in Africa, as seen in the work of Seydou Keita, and Malick Sidibé, whose studios used as primary model the nineteenth-century studios of Nadar and Atget. Whereas the

artist in his studio became a boiler-plate construct for the "photographer as artist", photographers such as Lewis Hine and later the terrain photographers of the WPA such as Walker Evans and even Margaret Bourke-White, walked the tightrope between art and observation, between studio portraits and the land.

The terrain of Weegee was and endured as a landscape of "Hell, heartbreak and revenge ..." His work depicted sideshows of shazam and schmaltz and the mini-dramas of city living.

On the side streets or backstage the innards were exposed, on display; porn raids, and murder scenes were there to be discovered: at one point Weegee in his own words described the work of "Murder, Inc.":

"Crime was my oyster and I liked it ... my post-graduate course in life and photography."[5]

As hucksters, snake-oil sellers and other masters of illusion resonated P.T. Barnum's purported but unattributed edict "there's a sucker born every minute", so the down-and-out, and the upward moving obeyed the street cries of "Extra, Extra, Read all about it!". Headlines sold newspapers, as the cover photo became their beacon, and Weegee's shots, each one full of what Proust described as the "theatre and drama of bedtime", stirred the streetwalkers into life, and in a moment pulled each and every reader out of the mundane, and out of the drudgery and despair of the streets. As magazine covers began to move away from pretty scenes to Cover Girls,[6] so newspaper tabloids, sold in the streets by vendors, machines, and in kiosks, hawking and the cry of a headline, thus became part and parcel of the urban experience.

Film, unchallenged and affirmed dominated the twentieth century, now whole and relegated to history. Defined by LIFE and TIME, from Eisenstein to Kubrick: from DU to WIRED in spite of the presence of art as a constant, it is possible to "remember" the twentieth century by flashing its major "clichés", and as television came to dominate the latter part of the century, the split screen, the trailer, crawler, and finally screens which are now categorically in the Leica frame format, (i.e. 35mm./ 24 x 36 format) have become a blackboard whose layout includes "pull quotes", "photo ids", statistics, and other widgets. And where no single screen is full frame (except probably commercials) one has become used to viewing a multi-imaged game-board, which mimics the "tabloid" format so deftly put into print by E. W. Scripps and others—where no matter the somewhat blurred quality or skewed form of the insets conveys "meaning" in the philosophical sense.

Weegee's choice of the night beat comes from his own analysis of opportunity. He saw that the staff photographers of most newspapers were not on call at night, so his work began around 7pm. He would go in to the police station, check the wires, and if all was calm would go out for a meal, only to return to be on call for any eventuality.

He calculated that there was one murder per night. His obsession with statistics was very strong: a dollar or five cents—everything was accounted for; if he hadn't enough to make ends meet, he went out on the streets until he could bring in a suitable number. The click of the shutter echoed the "kerchunk" of the cash register: the sound of profit registering in his mind.

FACES: FACTS AND FIGURES

Weegee wrote several autobiographical essays: recounting fact and figures, retelling his family's departure from Austria. His father had sent money: he relates in great precision the amount of money, the class of travel, and upon arrival, the sum his father had to present at Ellis Island to show he had enough cash (twenty dollars) to support his family. They arrived at a 12-dollar a month flat, and the adventure began. In his own words:

"My typewriter is broken, I own no dictionary, and I never claimed that I could spell, and if Shakespeare, Balzac, and Dostoevsky could do it in longhand, so can I. Everything I write about is true, and I have the checks, the memories and the scars to prove it."[7]

In one of his jobs: "A check from Life: Two murders, thirty-five dollars. Life pays $5 dollars a bullet. One stiff had 5 bullets in him and the other had two."[8]

His descriptions of his work reveled in fact:

"For over ten years I made a lush living covering murders from Manhattan Police Headquarters. I was on the job twenty-four hours a day seven days a week, including Sundays and legal and bank holidays. No eight-hour day for Murder,Inc., no punching time clocks, no two-week vacation!"[9]

His memories "the cold-water flat, the greatest blessing of modern civilization. Boy meets girl in the Village, they shack up, marriage optional, in a flat, rent seventeen dollars a month, which leaves them money for gin, groceries, etc."[10]

This meticulous calculation pervades his work: a profound knowledge of which sums are needed as rewards for work; and how much equipment was necessary.

"Looking back on the years of Murder, Inc. I find I used up ten press cameras, five cars, and every night twenty cigars and twenty cups of coffee."[11]

In the self-construction phase of his career, Weegee seems to have understood how to manipulate his use of his real name, and his moniker. Usher/Arthur Fellig was the bearer of the police line pass: however, "Weegee" measured the pulse of the beat.

By his own testimony:

"I remember one night I was walking in the heart of Chinatown. When I came to the corner of Pell and Mott Streets, something, I don't know what, made me stop and photograph the intersection. One minute after I took the photo, the street blew up, the water pipe broke, there was a terrific explosion ... hundreds of tenement dwellers were driven from their homes."[12]

His use of a credit stamp which imprinted "Weegee: The Famous" was also a harbinger of his future fame. Whatever possessed him to rubber-stamp himself as "The Famous" before he became indeed famous, performs as a circus-sideshow epithet: in other words to decree is to embody, so that the incredible elastic man, becomes, by its very invention, an approximate but hoped-for truth. As Weegee sought to self-create, so we the public also wish him to be created, to exist as a constant. Thus, his presence on the crime scene: his job as a validator of the event, his impassible demeanor as he calmly checks his apparatus whilst the police view the body "on the spot". And where Weegee's field notes complete the police report:

"Photos of body and scene where David Beadle was shot and killed at the SW cor(ner) of 46th Street and 10th Ave. Processes ... no prints of value found."[13]

When his work attracted attention in a town which had at least 12 daily newspapers, a story which was originally targeted to depict police work was transformed into a photo-essay where Weegee becomes the surrogate in the police station, as he steps in and becomes the main player in the "Police Procedural 1937".[14] At this point he becomes part of the action, often appearing in the police lineups, inhabiting the players, adding a new dimension to his work where he had been previously observer and spectator to the seething matter of the urban scenario.

In sum, his fractious and often precipitated shots become consecrated into a single figure, which is symbolized by his affection for the dressmaker dummy. This half life, characterized by his "mise en scène" in his studio, with his wall of fame, a series of changing news clips evolving from shot to shot: his presence witnessed by his own self-portrait, more than self-invented, his private life public,

and his love life taking place in a series of random pick ups, whorehouses, and not surprisingly, frequenting misfits. Whether this comes from his early distancing from his family, or his pure obsession with his work, it seems clear that even at the end of his life, faced with the constraints of diabetes, he ends up living with a social worker who can attend to his needs, seemingly never having loved more than the night he spent as a teenager on the roof of his tenement, lying with a girl, never identified, who had brought her mattress there to escape the heat.

"I could make out a young girl pacing back and forth ... God how I wanted her;[15] our bodies were on fire; no power on earth could separate us! The moon seemed to look down approvingly ... Our ecstasy lasted until dawn, I went back to my own mattress ... Then I became restless ... I felt I just had to leave home. Two weeks later, making sure the coast was clear and that everyone was asleep, I left for good. This time, my only baggage was my curiosity."[16]

This is the only element in Weegee's *The Autobiography*, where one feels he has interacted significantly with another human being. The mystery of his relationship with his parents will perhaps remain unsolved. Be it the rupture created by his father who preceded them abroad, or his seeming rigidity once the family was reunited, when Usher Arthur Fellig leaves home it is for good. His transition into the "Famous", the person who was to exist as "Weegee", is absolute: no looking back, no regrets. He becomes part and parcel of the "beat" of life,—and finally when the call comes, he goes to Hollywood:

"All sorts of things were going on around me, but my life seemed to be going stale. I was tired of gangsters lying dead with their guts spewed in the gutter, of women crying at tenement house fires..."[17]

He leaves his life and his studio across from the police station with seemingly no regrets. When he returns to New York (after crossing the country back and forth) in 1951, he describes it as "back to civilization". But he was no longer an ambulance chaser, working for advertising agencies, and trying out new techniques, his life as a first responder:

"I felt I had gone as far as I could with my old type of photography. My photo-caricatures would show not only how people looked, but what they were like inside. I would be giving the camera a new dimension. Photography had been invented to record scenes of nature, like a stencil. With my new lenses and new techniques I had gone beyond that. I felt that I had made my camera human. Anything the mind could think of, I could put on film."[18] So true to the magician he was and had become, as he dedicated his autobiography: "To My Modern Aladdin's Lamp, my Camera."

SOUND AS LIGHT

In the streets, sound reigns: the calm of night broken by the wail of fire trucks, the pop of the flash and the click of the shutter. A prelude to the final image, the "scene" which took front stage and where the tabloid was to develop and rule as it does today. As sound begets noise, noise begets "news". Sound predicates meaning, and the "slug" with all of its compressed meaning, becomes the message.[19]

The city's din, hawking, criers all added their voices to sound encrypted in each shot.

Plain speak emerges from pounding the streets: flatfoots on the "beat". And the beat is prefaced by a sound, the crackle of the police radio, the staccato of the teletype: the airwaves astir with the "wire". Photography is a validation of sound anticipating meaning. As Weegee said of his fiddle playing: "I suppose that my fiddle playing was a kind of subconscious training for my future photography."[20]

In this exceptional group of pictures, the image envelops and incarcerates its own sound. The sounds are encrypted in a potential digital production wherein the "pop" the "sizzle" and the scream of sirens are not just muffled they are reboxed, and sent back to the source.

Sound has become light, and the viewer doesn't need all his senses to experience the effect. But the individual symphony of sound depicted by imagery, compacted in to a landscape assimilates into semiosis, evolves into meaning.

Imagine the time frame of some of these photos: the compositions of Edgar Varese, the experiments of Eric Satie, where the *objet sonore* came into play. When the sound of human voices or street sounds were incorporated into de Falla's compositions and Dvorak's "New World Symphony" became concrete. This iconographic whole will carry through the twentieth century, through the deafening sounds of hard rock and heavy metal, into the twenty-first century where sound is remitted to a muffle: as ear buds and phones shut a greater part of the population into a void—single and separate worlds shuttering one field from the other. And, add the proliferation of triple crawler screens with no sound, omnipresent—at bars, in lounges, the relative reduction of the soundtrack being replaced either by the general din of the city, as bikers and walkers are in isolation, or sound is replaced by the cries and roars of the crowd. In either scenario, although the image predominates— an event is predicated by its reproduction. In selfies and other clichés, and their noise, their chatter is compressed back into a single space. This differentiation creates a new space to be explored: that of the non-simultaneous sound-track. In the example of William Kentridge's meaningful sound, where he takes meaning to another dimension, using for example in his last masterpiece, the tiny sound of a local fanfare band, to "illuminate" his shadowbox of parading figures. Meaning is thus swallowed and spit out by the images.

Contemporary art video has become the terrain par excellence of this disposition: either the images cry out for sound, or they incorporate a second "idea" into the work, which takes it to another level of interpretation.

In the twenties and thirties, where jazz was growing and refining itself, sound was becoming image. One needs only to shut one's eyes to "see" the sounds which were produced not only as linear score, but in juxtapositions and cuts which make jazz so unique, where it pretty much "defines" modernism, and sets the twentieth century into motion, sets it to music. Weegee's photos fall right into this schema: one "hears" the screams of the engines, the cries of the crowd. And one hears, whilst seeing, the unyielding "flash" of the camera, the click of the shutter, transforming life into an event, into a soundless memory.

Clang, clang, clang went the strolley
Ding, ding, ding went the bell
Zing, zing, zing went my heart strings
For the moment I saw her I fell.[21]

This unique body of Weegee's images seemingly comes to us as a rush of memory, of proof and of meaning: each unique shot, made by the click of the shutter regurgitates the sound of its own creation. It is the roaring brook of its own particular period of history: witness to the passage of civil life from the silence of darkness, through the era of gas and electric lights, to the general eruption of street lights, car headlights, neon signs, and "noise"; these bore the twentieth century foreward. The twenty-first, as yet undefined, as yet still compressing, seems prepared to enter space via warp speed, and back to a silence of sound and meaning.

Weegee was a perpetrator of "noise," the predecessor of "chatter". The translator and the interpreter of the walkie-talkie, the radio and the wire transmission, walked right into the ring, a heavyweight whose force is still resounding.

1 1965–1987 Sherman Price: *The Real Weegee.* | 2 fig. p. 39 (r) and fig. p. 112 | 3 P. T. Barnum: *The Humbugs of the world: an account of humbugs, delusions, impositions, quackeries, deceits and deceivers, in all ages.* London, John Camden Hotten, Piccadilly. 1866. | 4 Daniel Blau: Personal communication, May 2016 | 5 Weegee: The Autobiography, annotated. 2013. Memphis. Devault-Graves. p. 49. | 6 (to the extreme: *Vanity Fair* cover of Demi Moore half nude and pregnant) | 7 Autobiography, op. cit. p. 19 | 8 Autobiography, p. 76 | 9 ibid. p. 83 | 10 ibid. p. 83 | 11 ibid. p. 87 | 12 Weegee, cited by Alan Trachtenberg, "Weegee's City Secrets", in: Brian Wallis *Weegee, Murder is my Business,* ICP. New York. Delmonico. 2013. p. 229 | 13 Dossier 2 in Wallis, op. cit. p. 77 | 14 Dossier 1 in Wallis, op. cit. pp. 35–49 | 15 Autobiography. op cit. p. 31 | 16 Autobiography. op cit. pp. 31–32 | 17 ibid., p. 109 | 18 ibid., p. 139 | 19 This idea was formulated by Jasmin Blasco, MFA, Media Design Practice. www.Jasminblasco.com, and The Noise Index. | 20 Weegee, the Autobiography, op. cit. p. 39 | 21 Hugh Martin and Ralph Blane, 1944 "The Trolley Song"

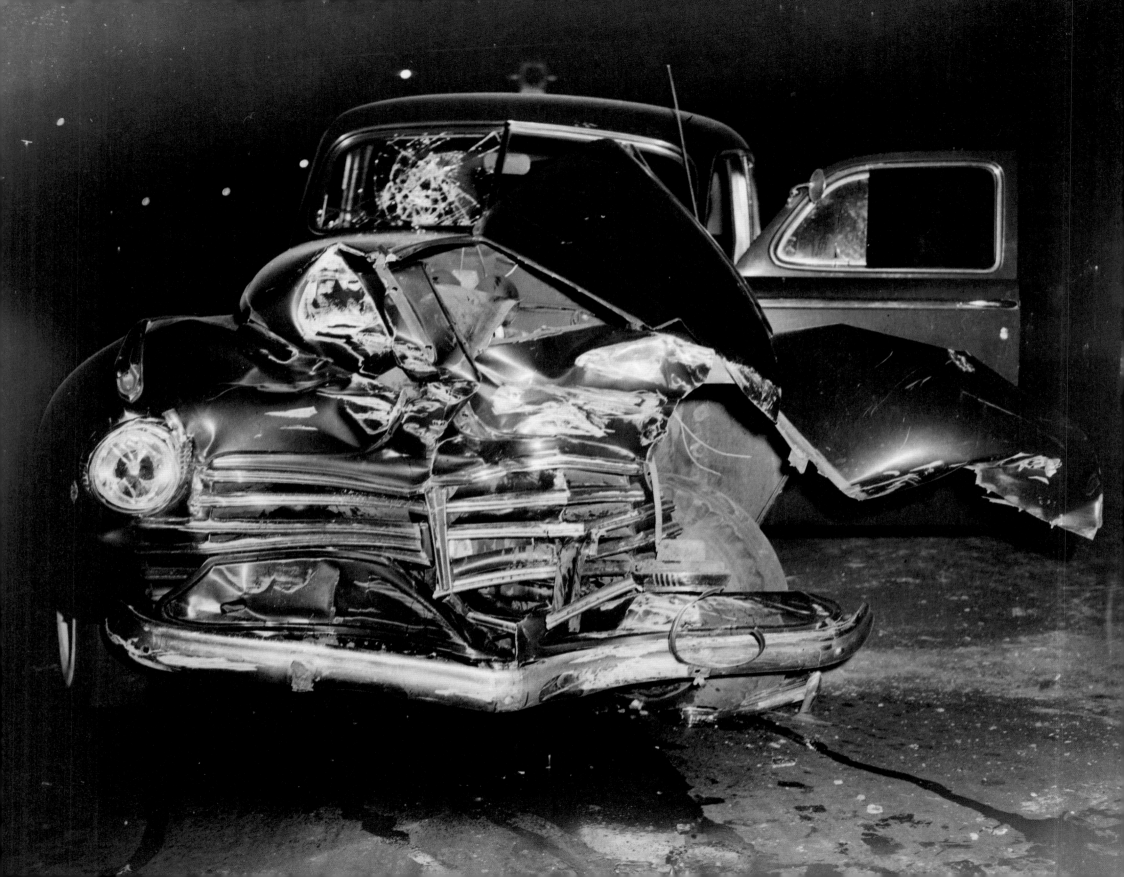

EXTRA!
CRASH

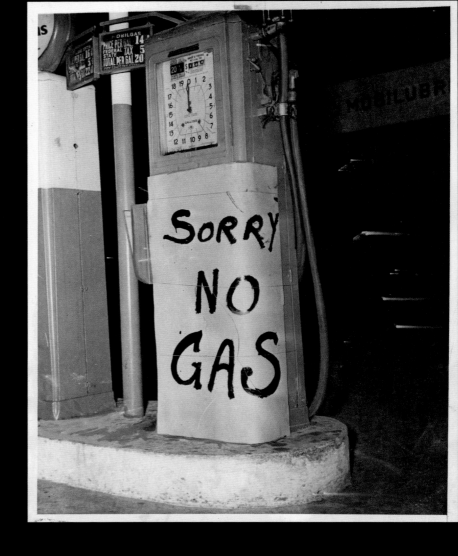

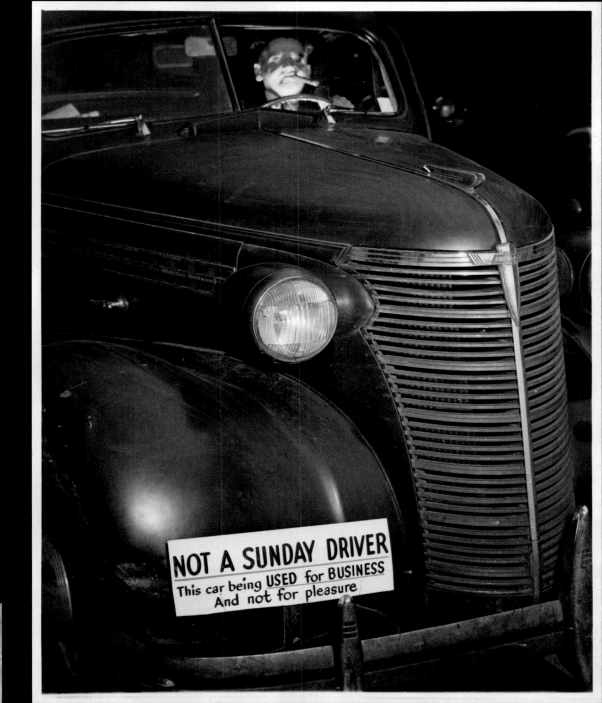

NOT A SUNDAY DRIVER
This car being USED for BUSINESS
And not for pleasure

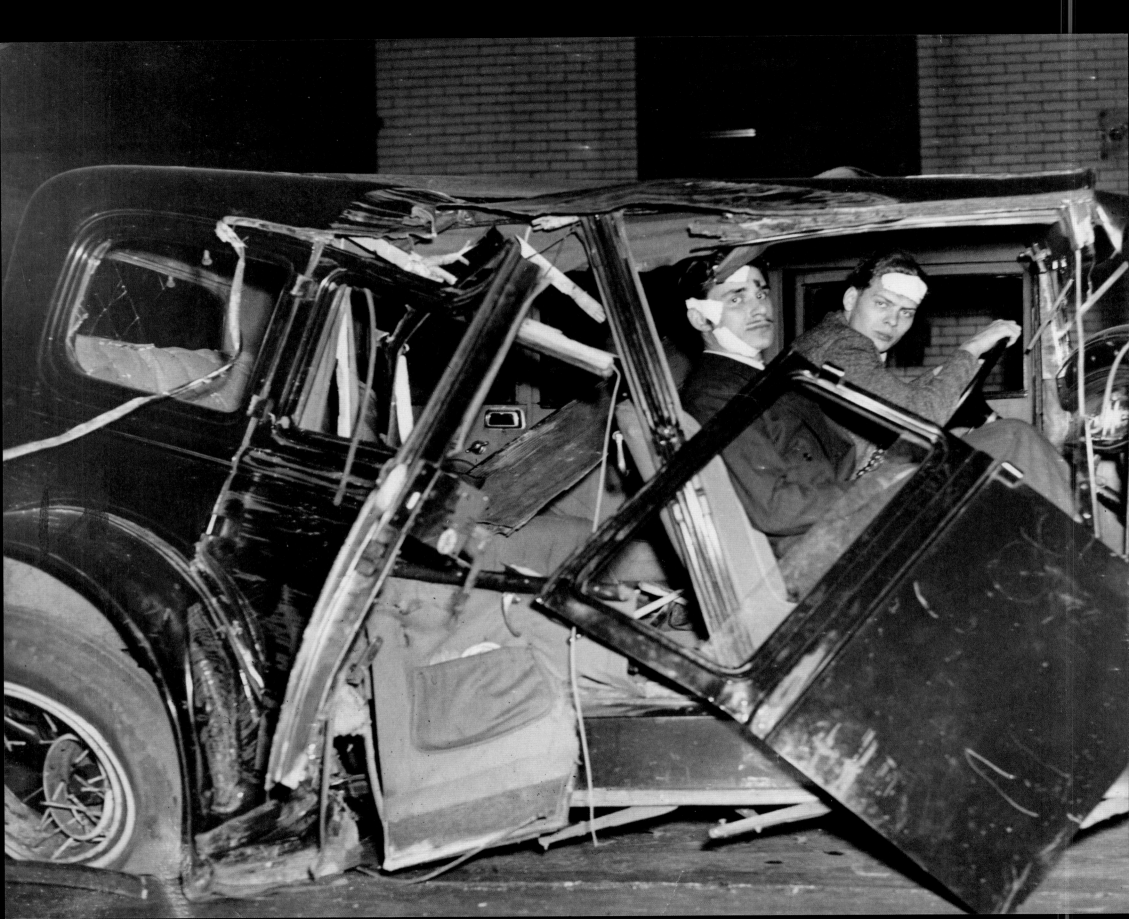

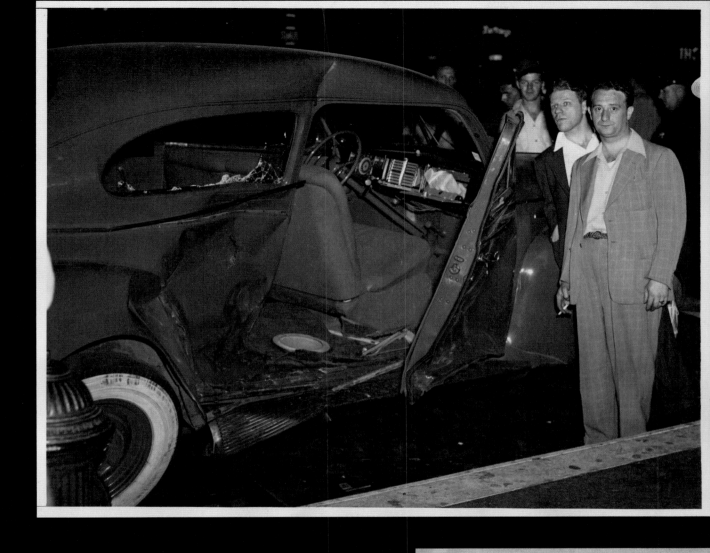

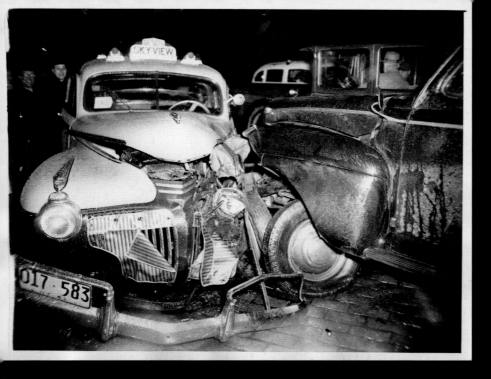

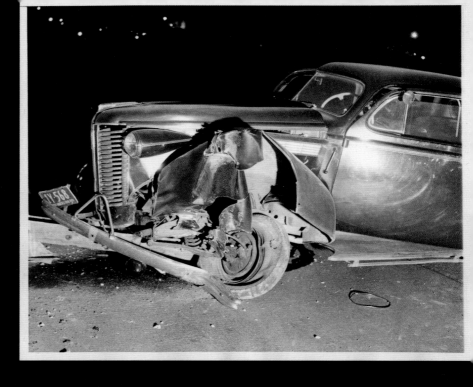

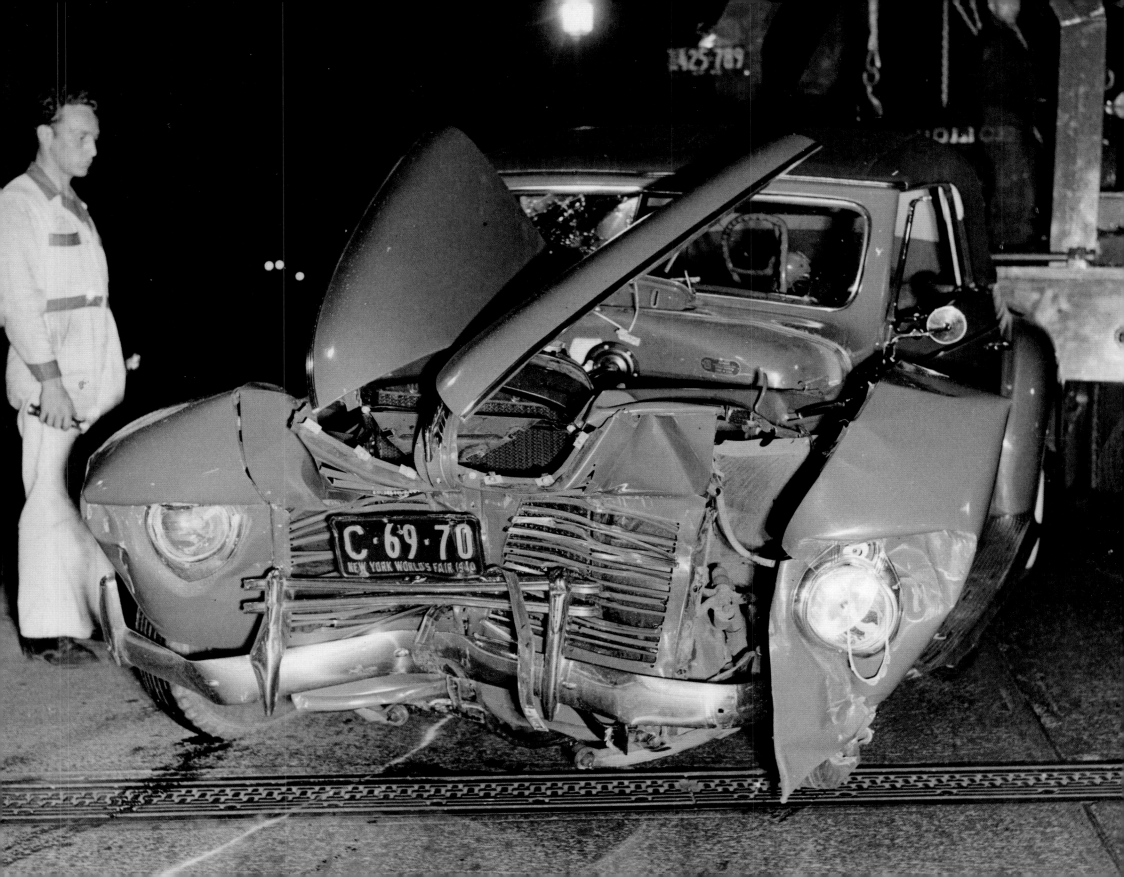

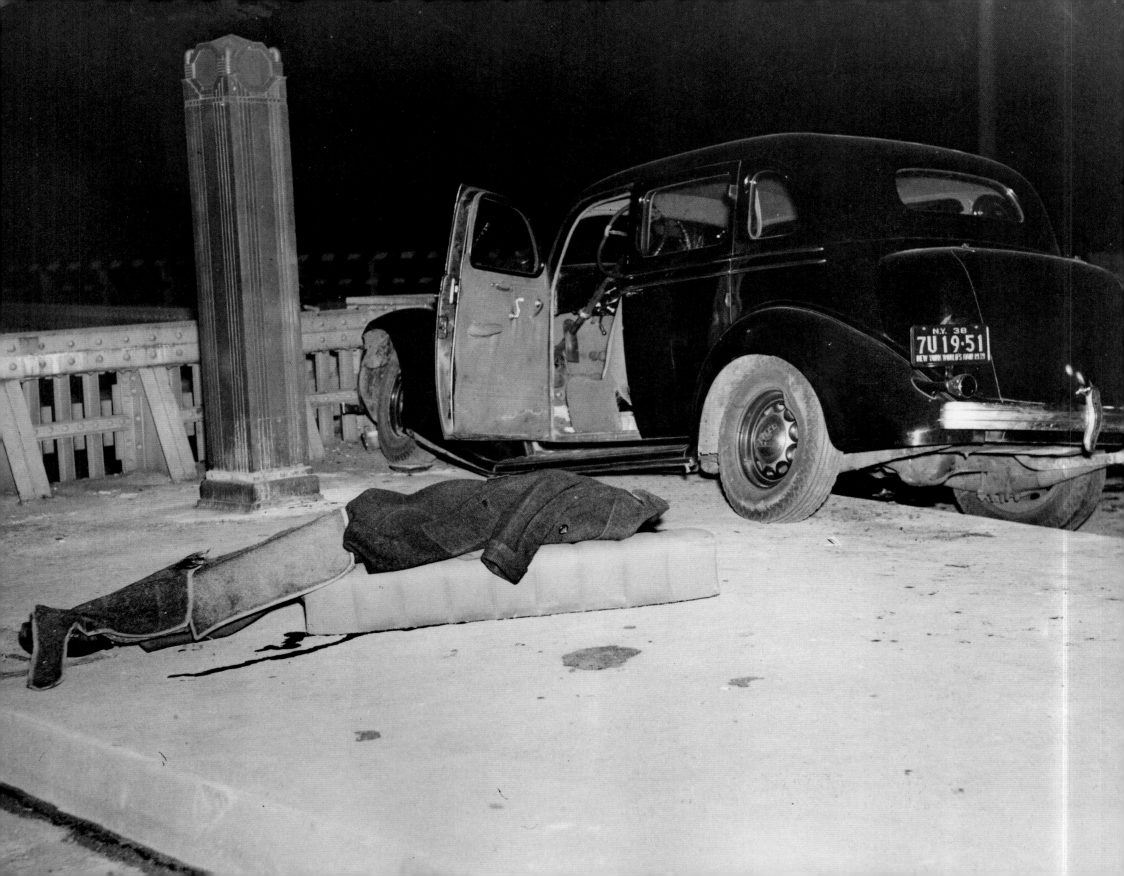

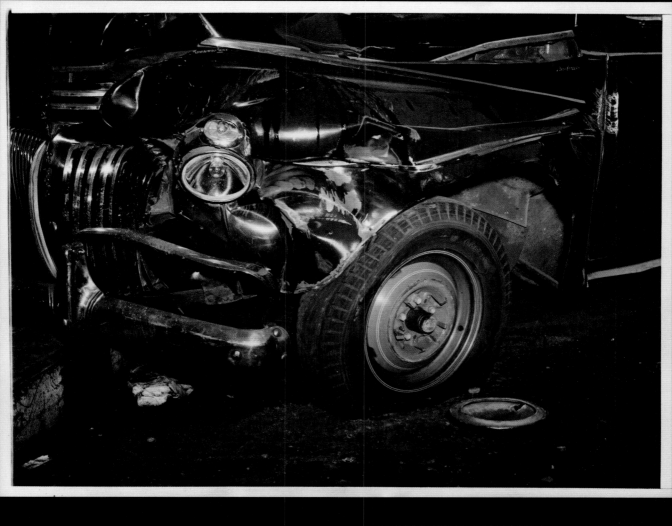

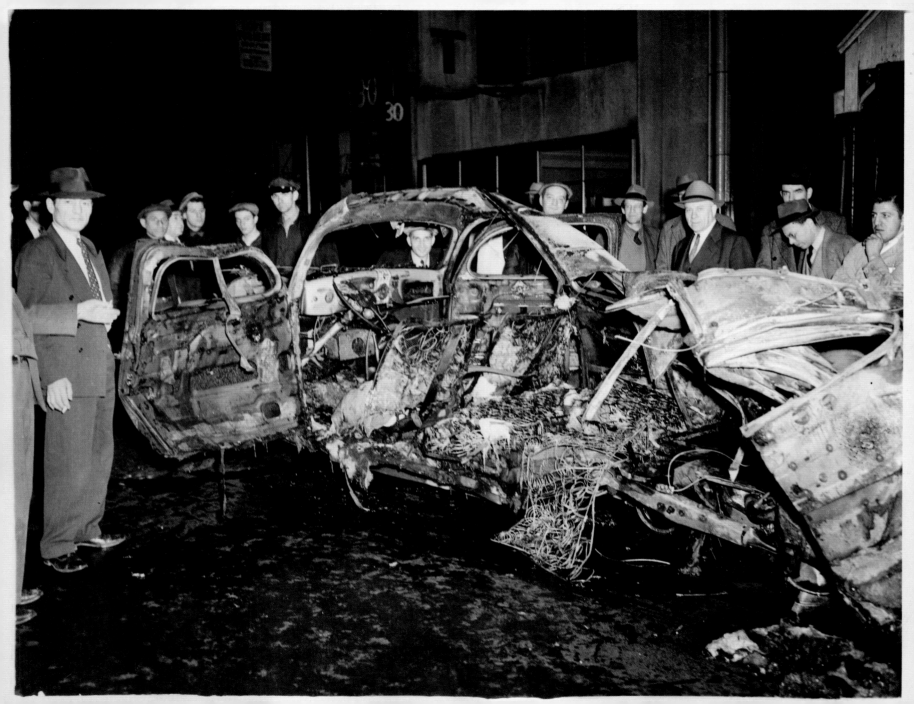

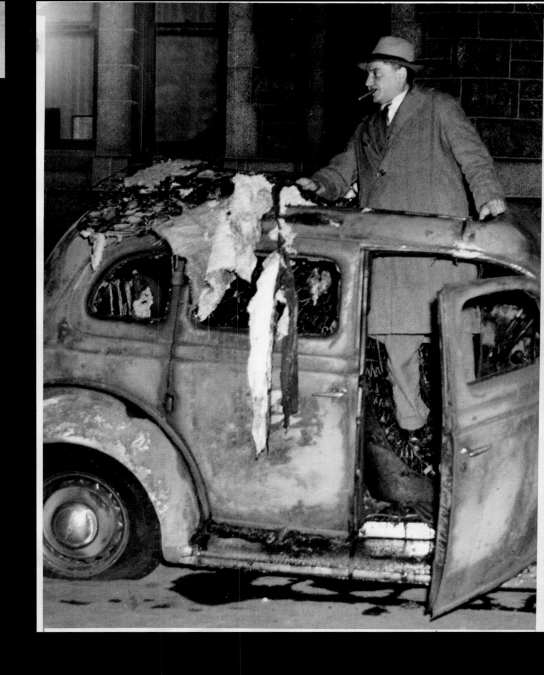

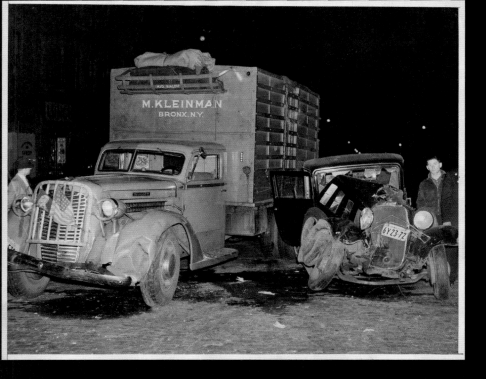

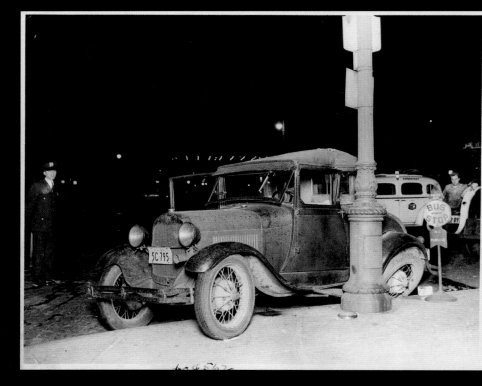

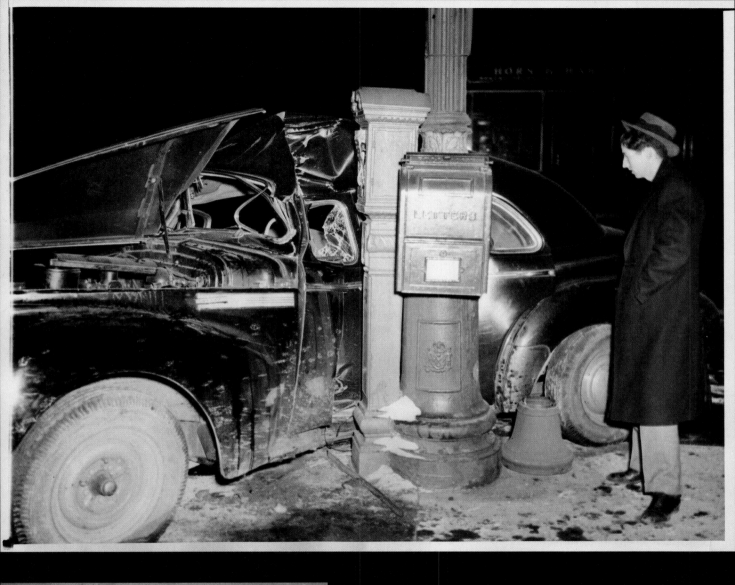

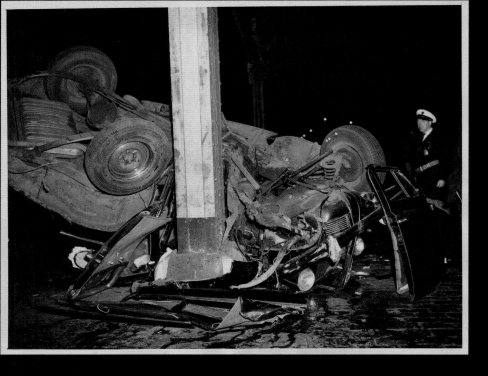

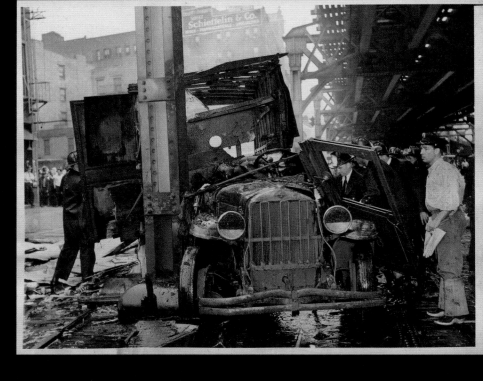

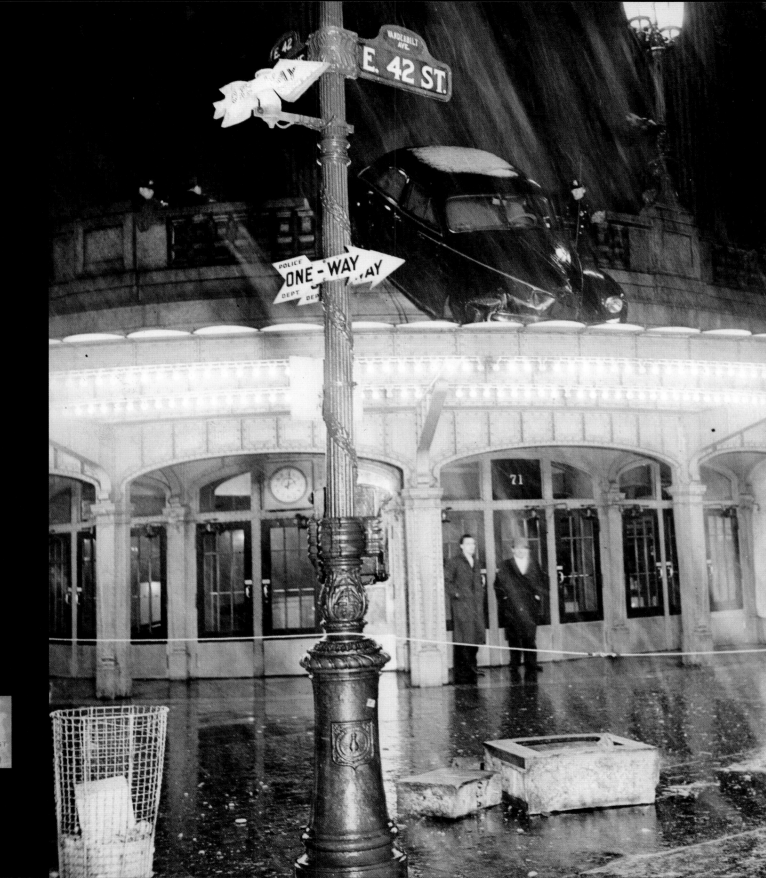

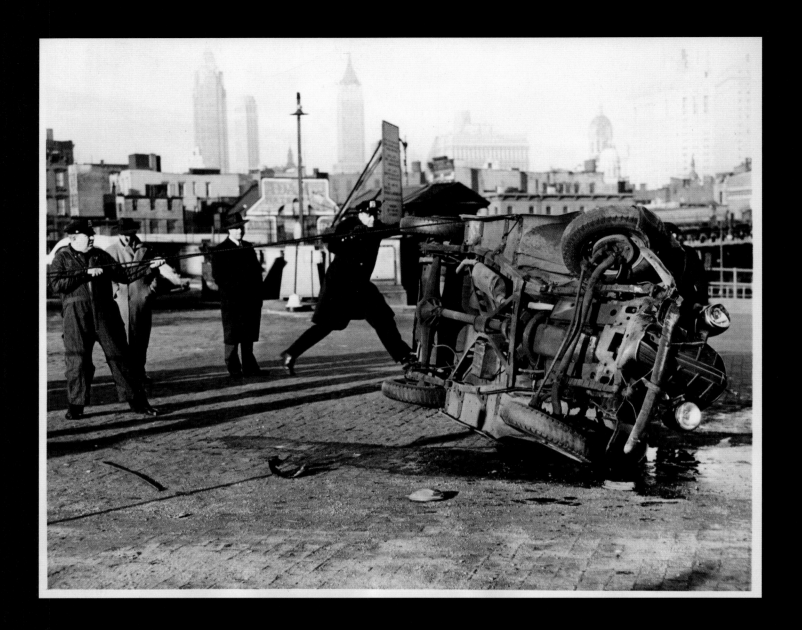

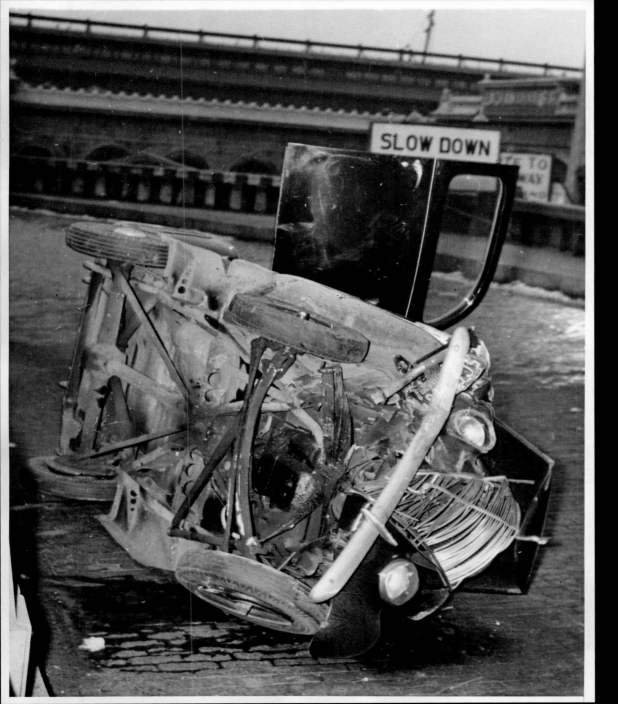

INJURIES: ONE LACERATED LIP

New York--Northbound on West Side Miller Highway at 23rd Street, Frank Woods's car missed a turn, leaped the center island and landed on its back in the other lane. Rushing him to a hospital, doctors found his injuries consisted of one lacerated lip.

CREDIT LINE (ACME) 40 NY CHI

SLOW DOWN

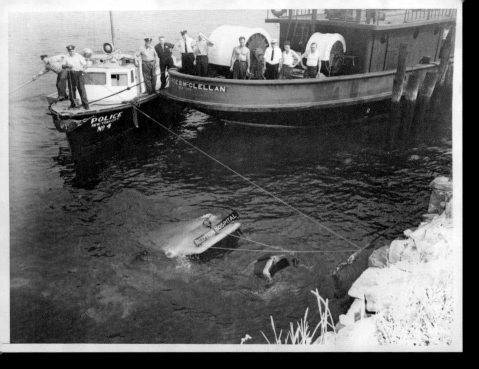

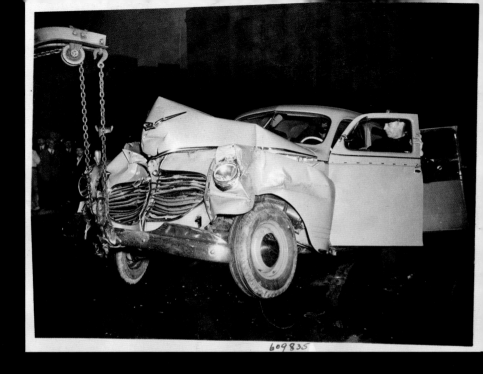

609835

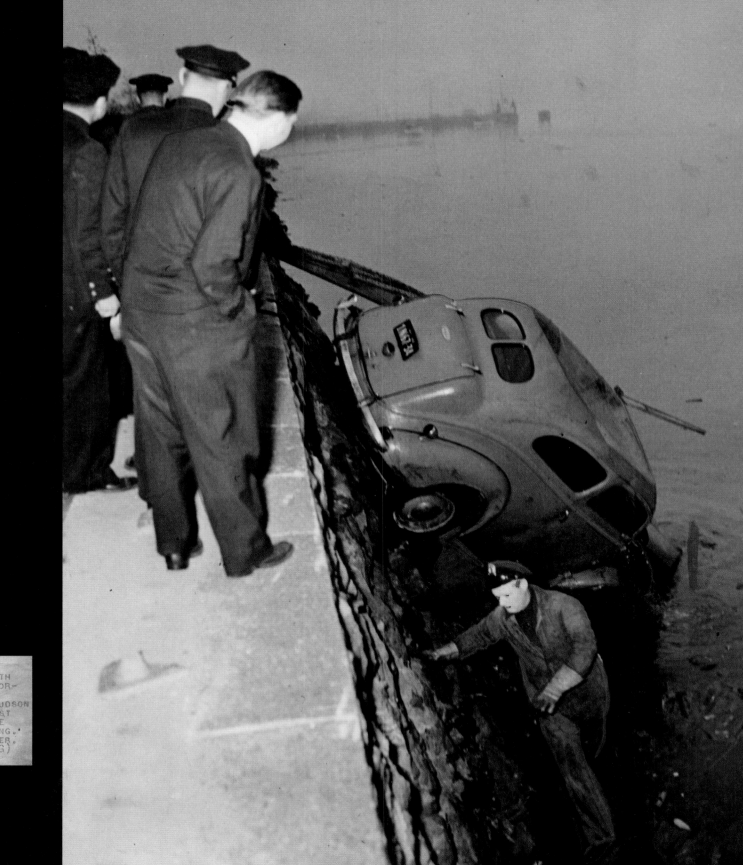

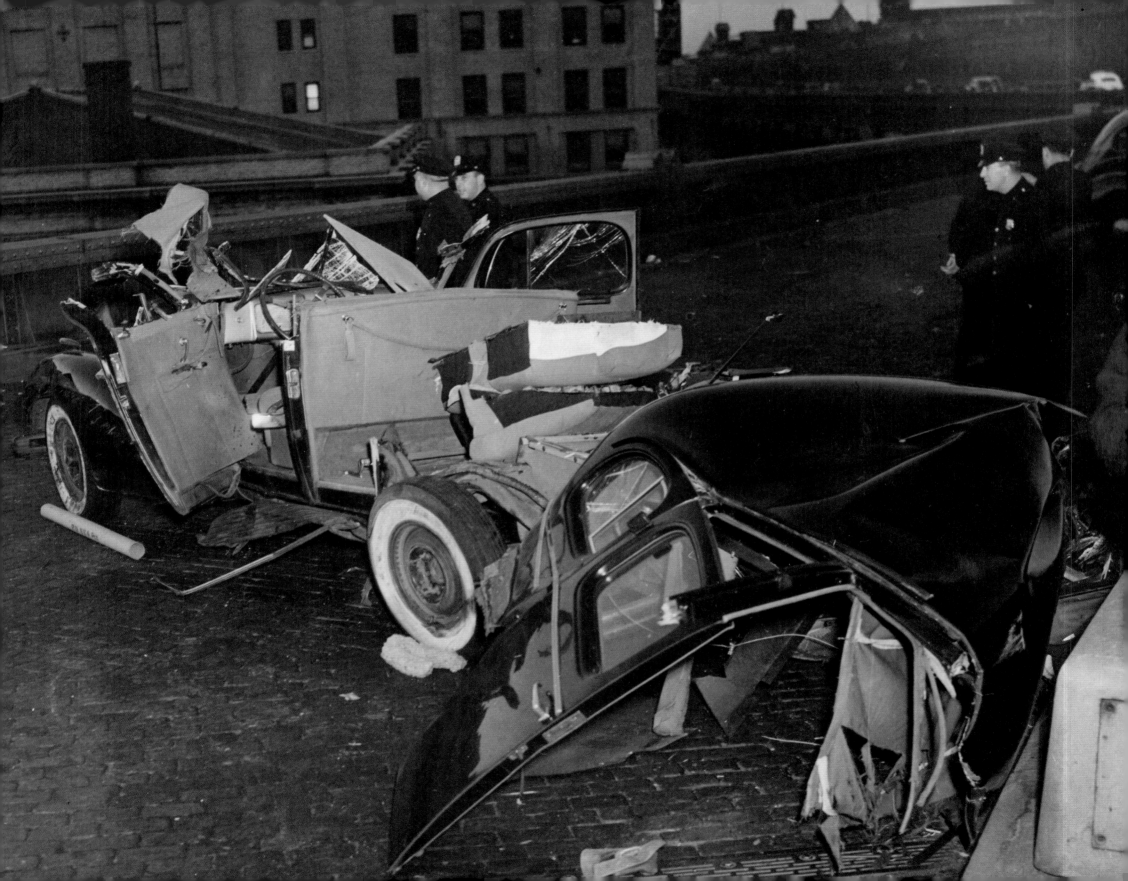

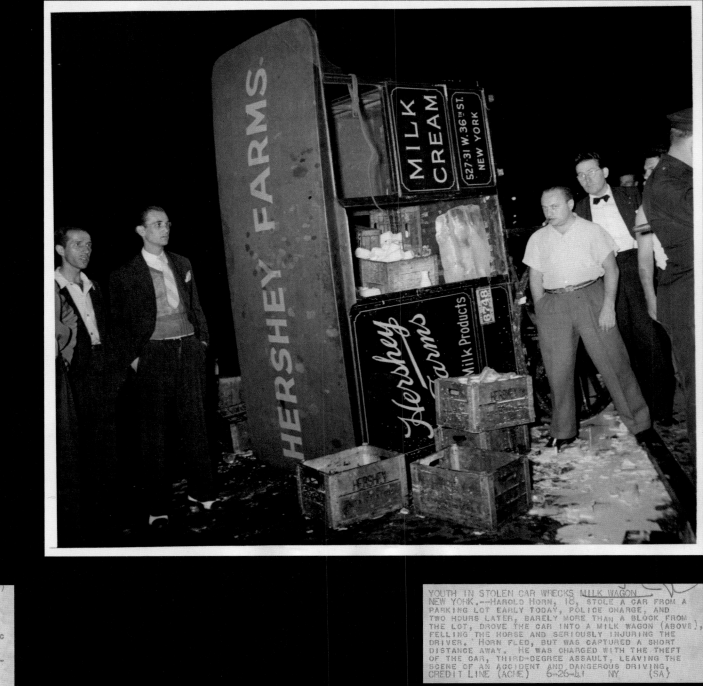

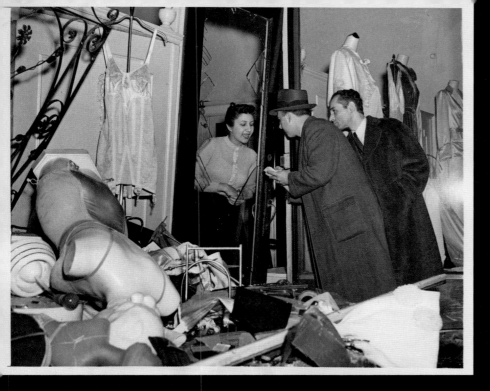

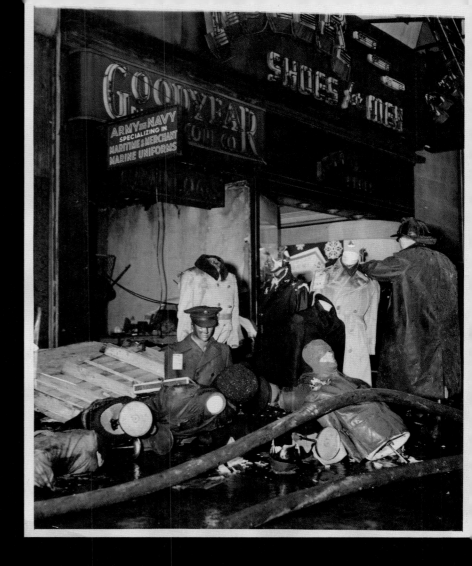

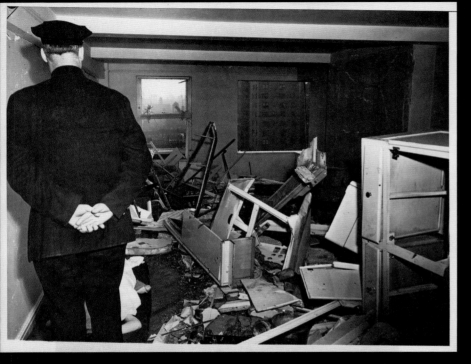

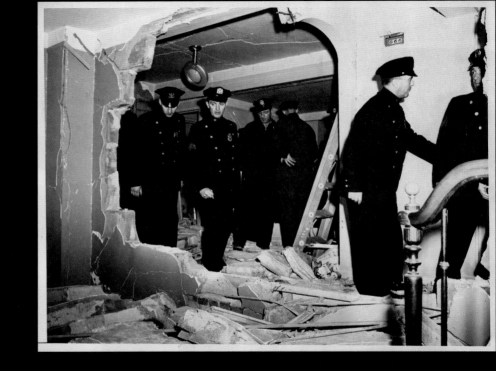

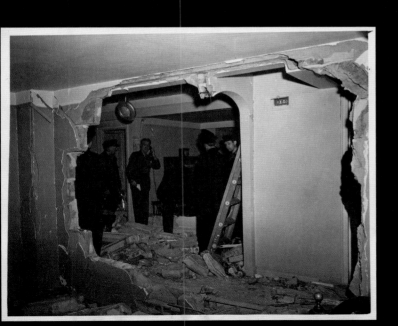

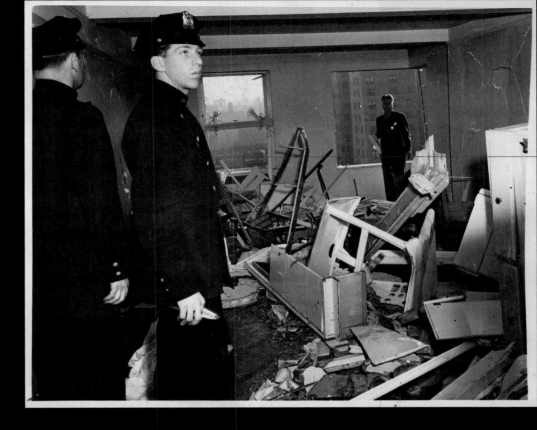

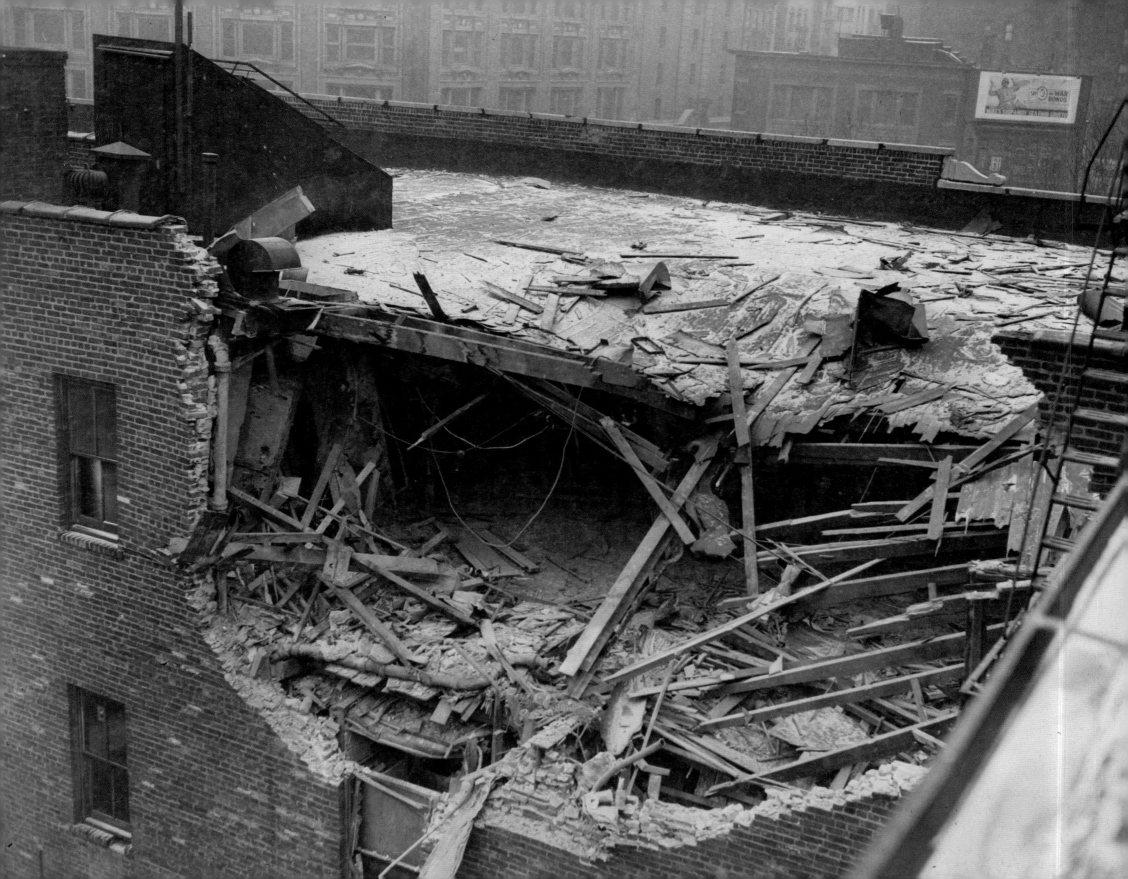

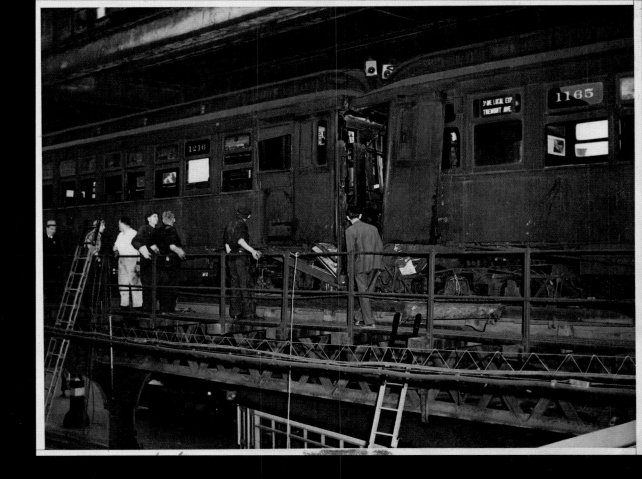

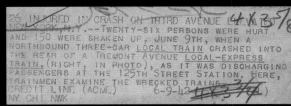

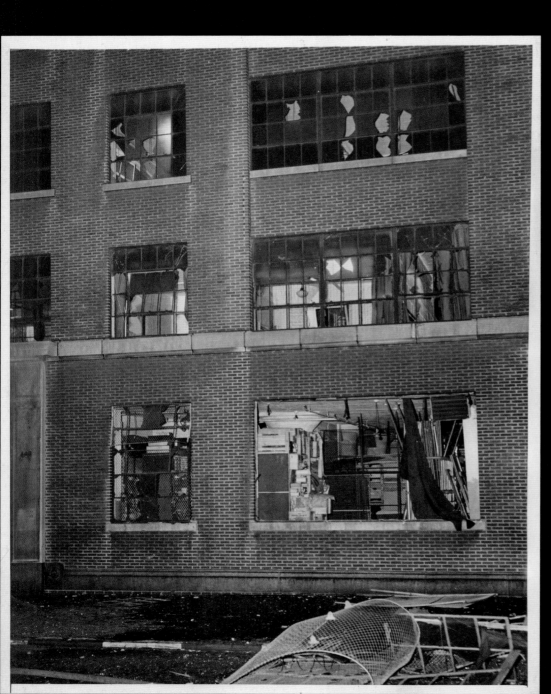

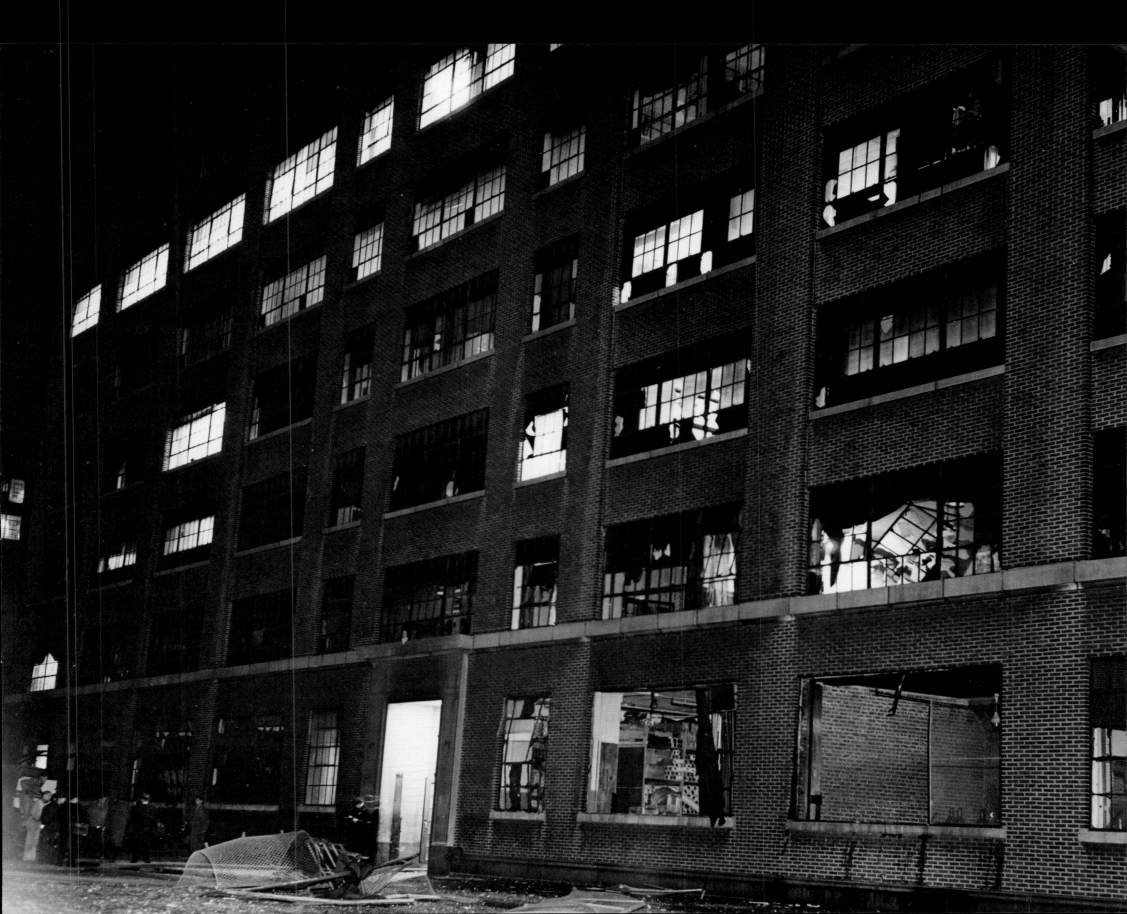

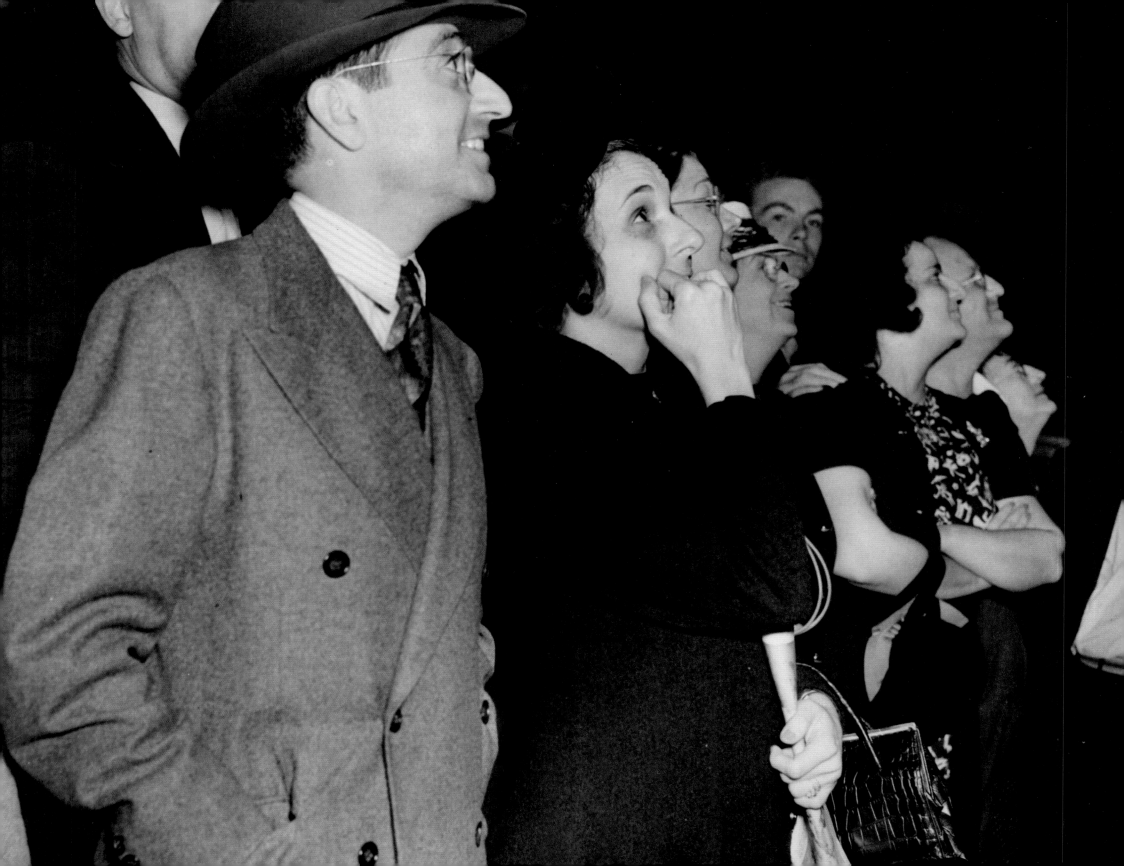

EXTRA!
CROWDS

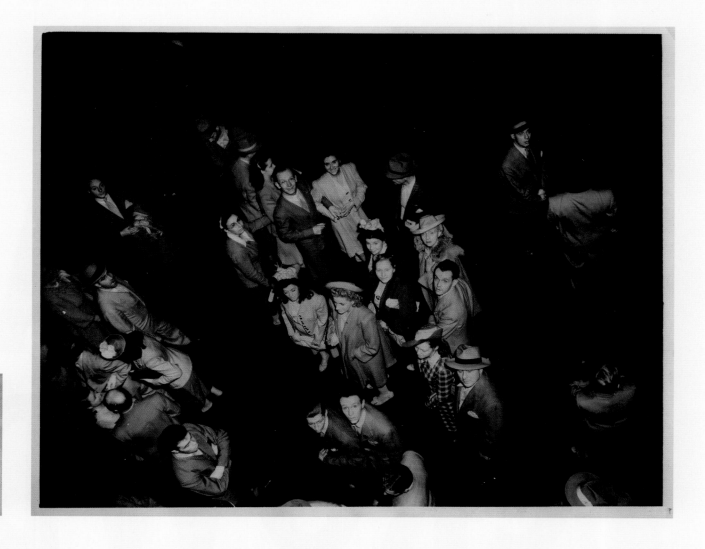

← page 46

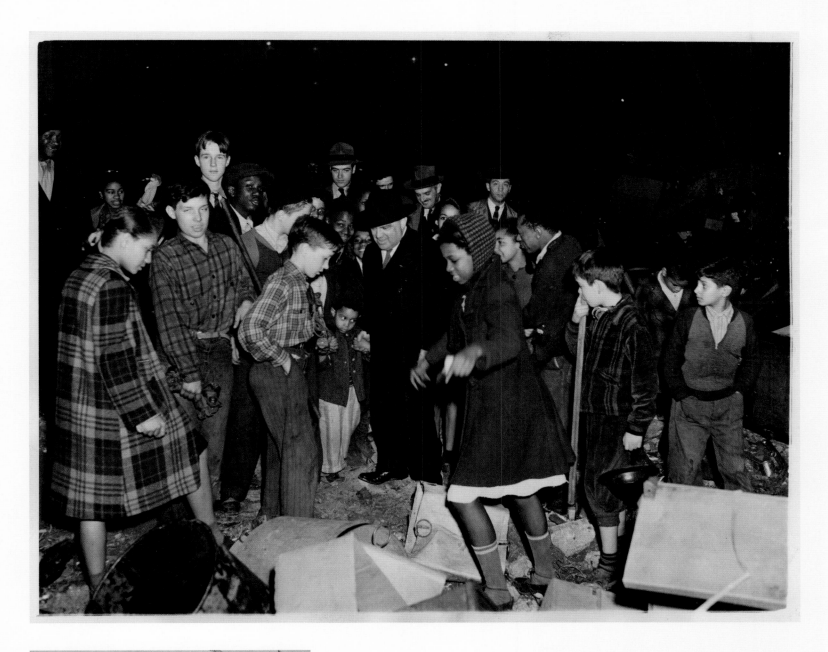

WHEE -- IT'S THE MAYOR
NEW YORK-- KIDS AROUND THE WEST END AND
AMSTERDAM AVENUE SECTION OF THE CITY CROWD
CLOSE TO MAYOR LA GUARDIA WHO IS INSPECTING
A HUGE PILE OF SCRAP. TODAY, MANHATTAN
BOROUGH RESIDENTS TURNED OUT WITH THEIR
SCRAP METAL, STRIVING TO BEAT THE IMPRESSIVE
TONNAGE DONATED BY OTHER NEW YORK BOROUGHS.

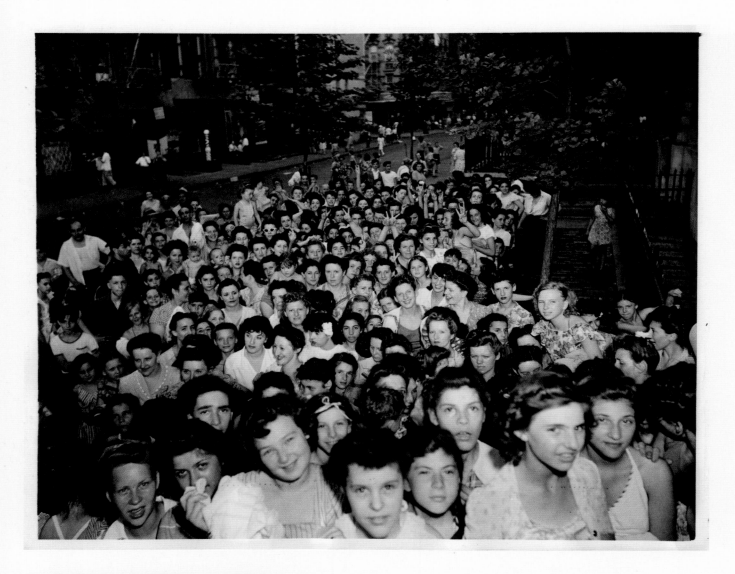

50

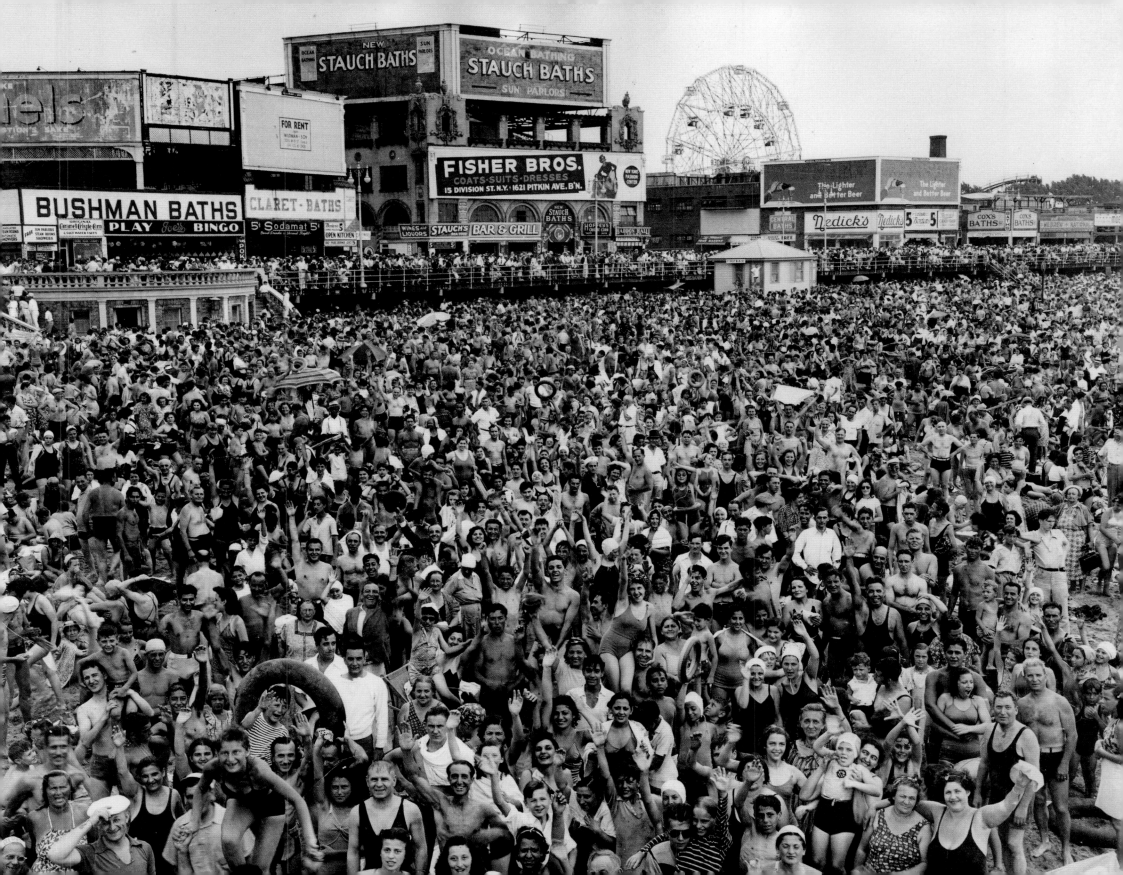

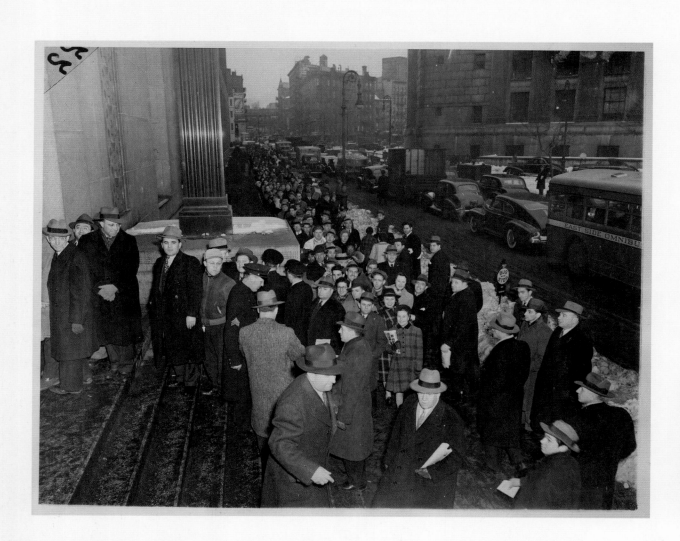

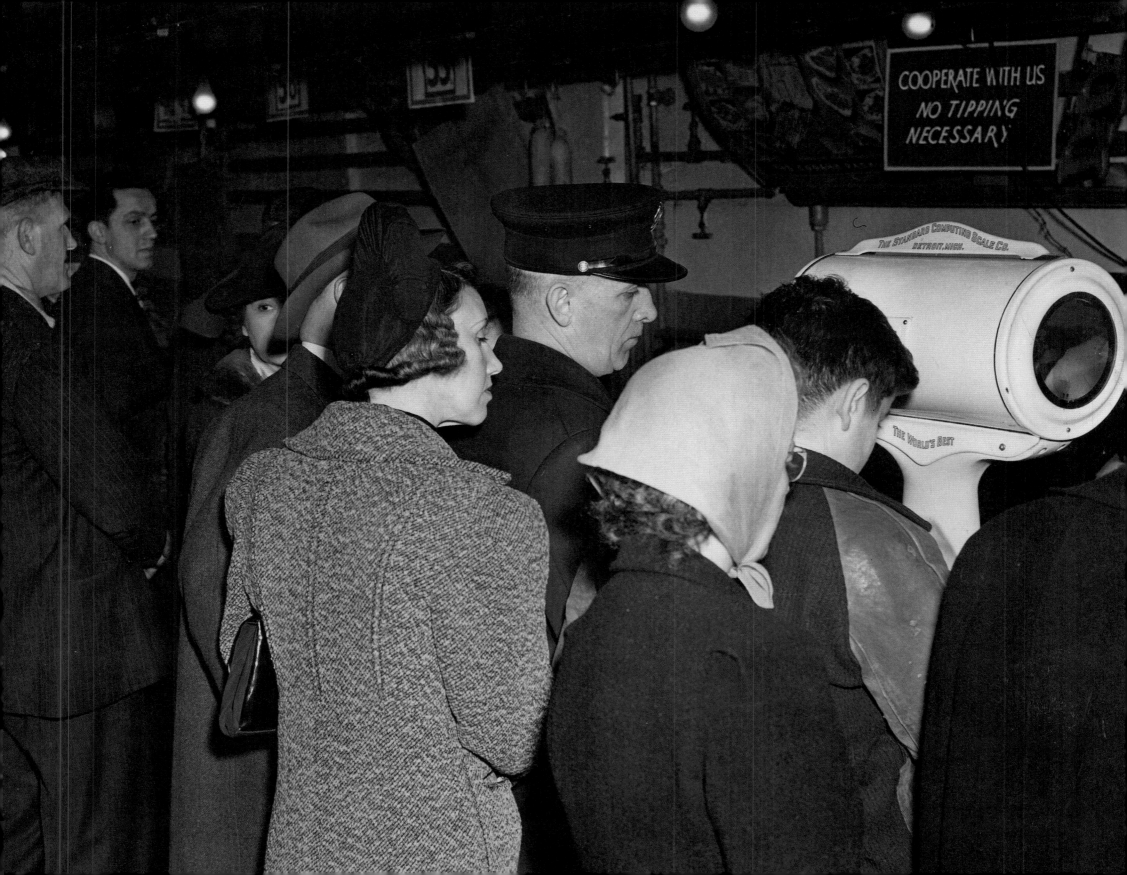

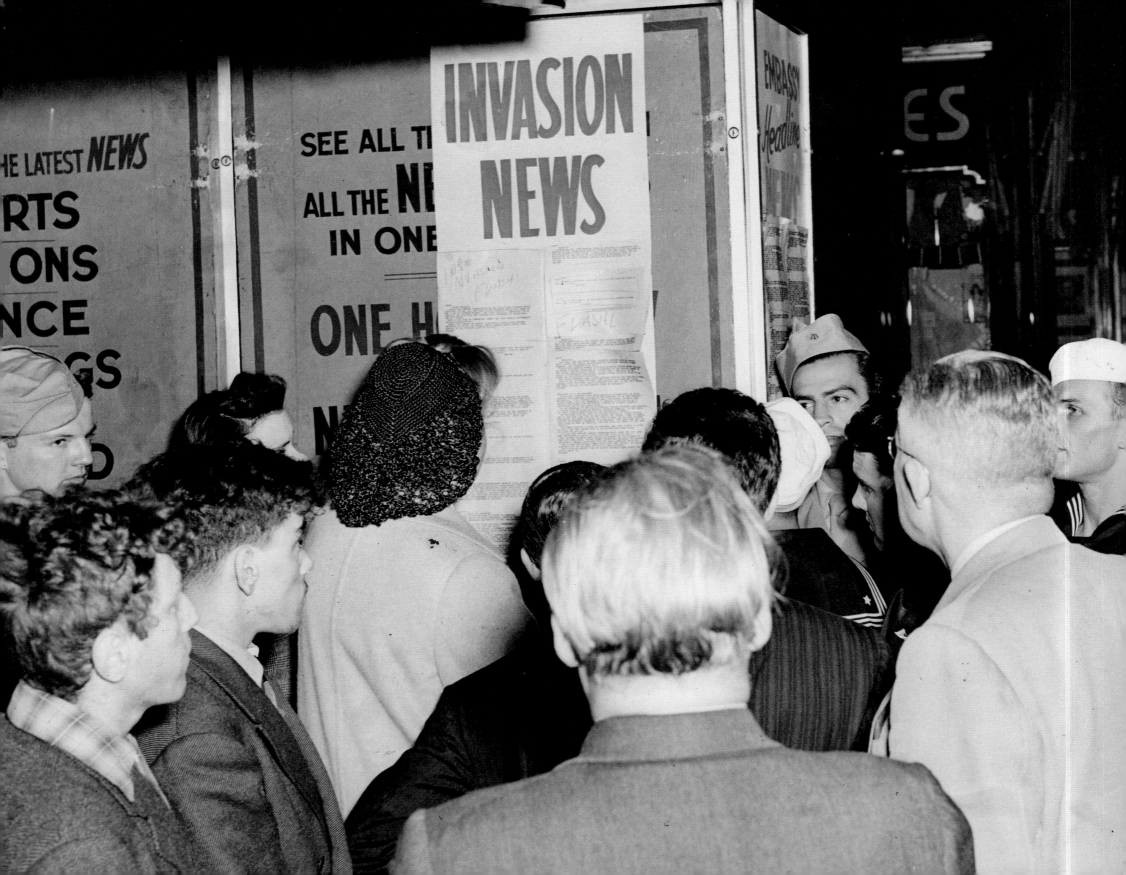

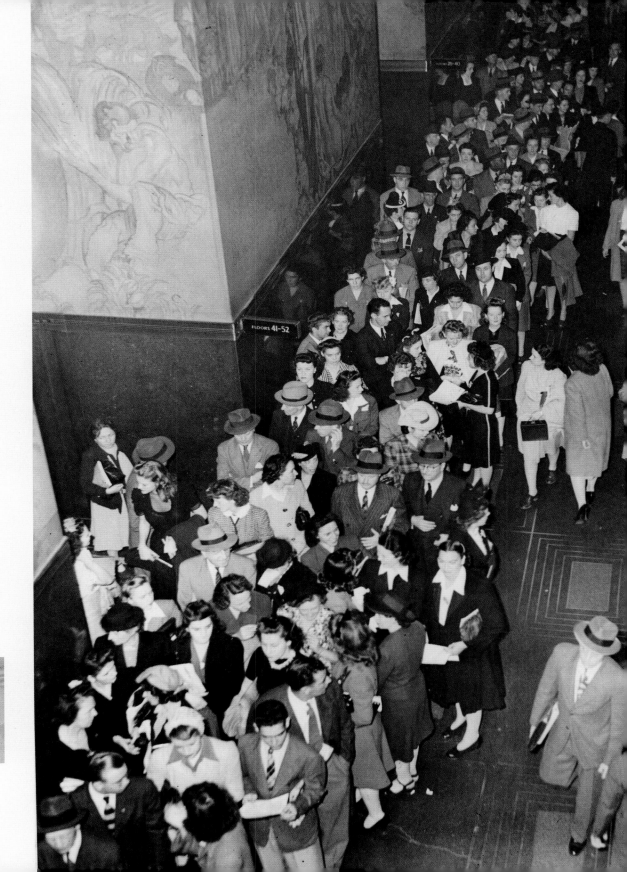

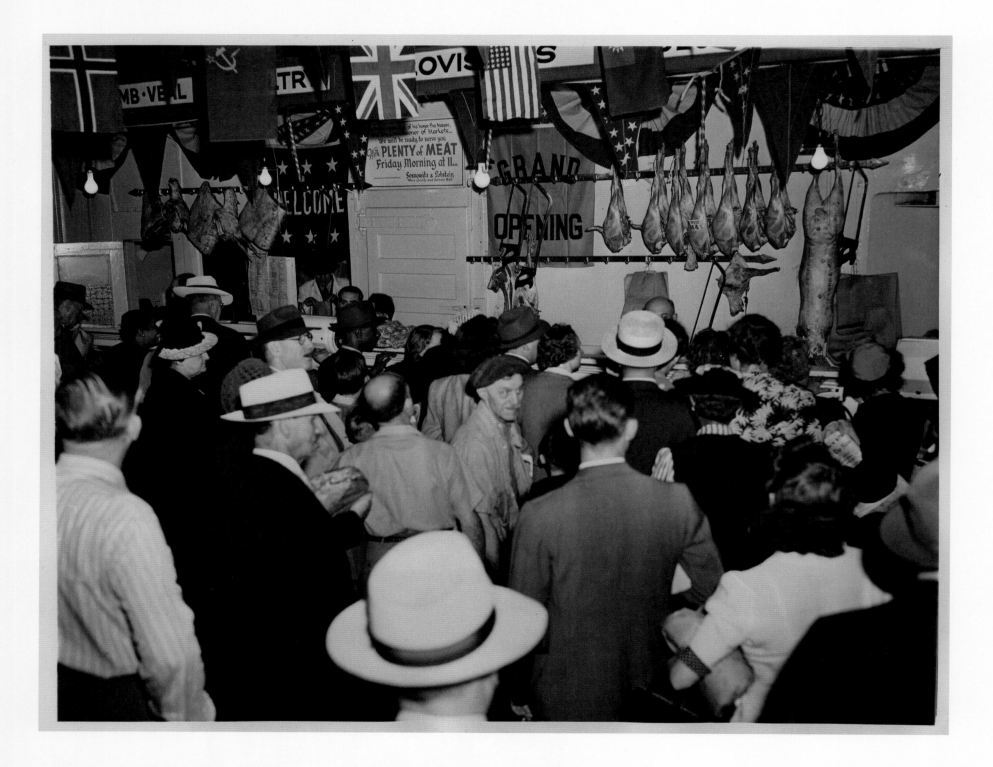

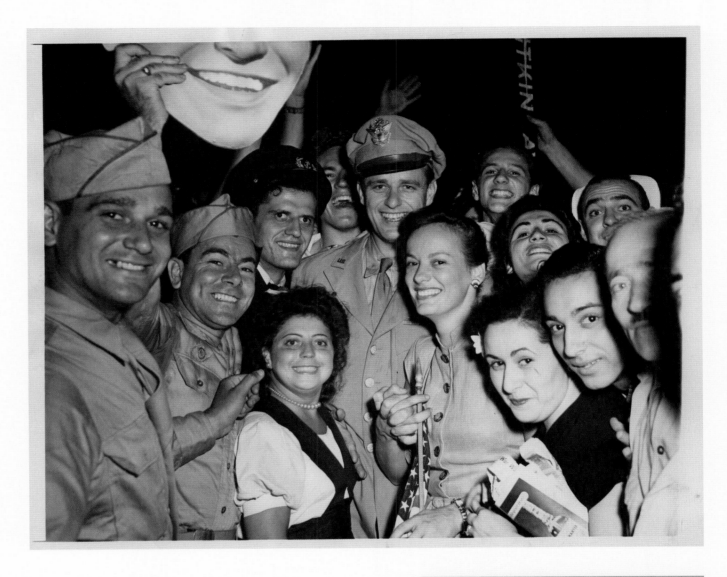

ELLIOTT AND FAYE MOBBED IN TIMES SQUARE
NEW YORK--WALKING IN THE TIMES SQUARE AREA
AFTER HEARING REPORT THAT JAPS HAD ACCEPTED
ALLIED SURRENDER TERMS, ELLIOTT AND FAYE
EMERSON ROOSEVELT BECAME MOBBED BY HAPPY
CELEBRANTS WHO RECOGNIZED THE COUPLE.
THE ROOSEVELTS WERE OUT TO WELCOME IN THE
JOYOUS DAY--AS WAS EVERYONE ELSE.

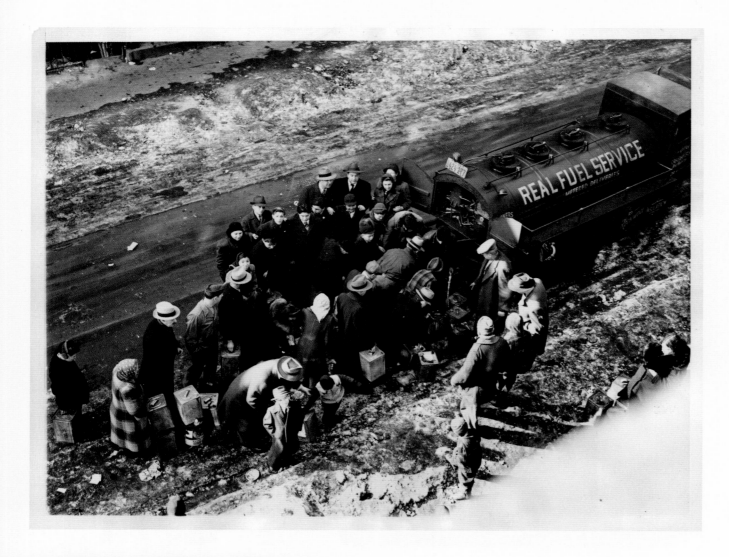

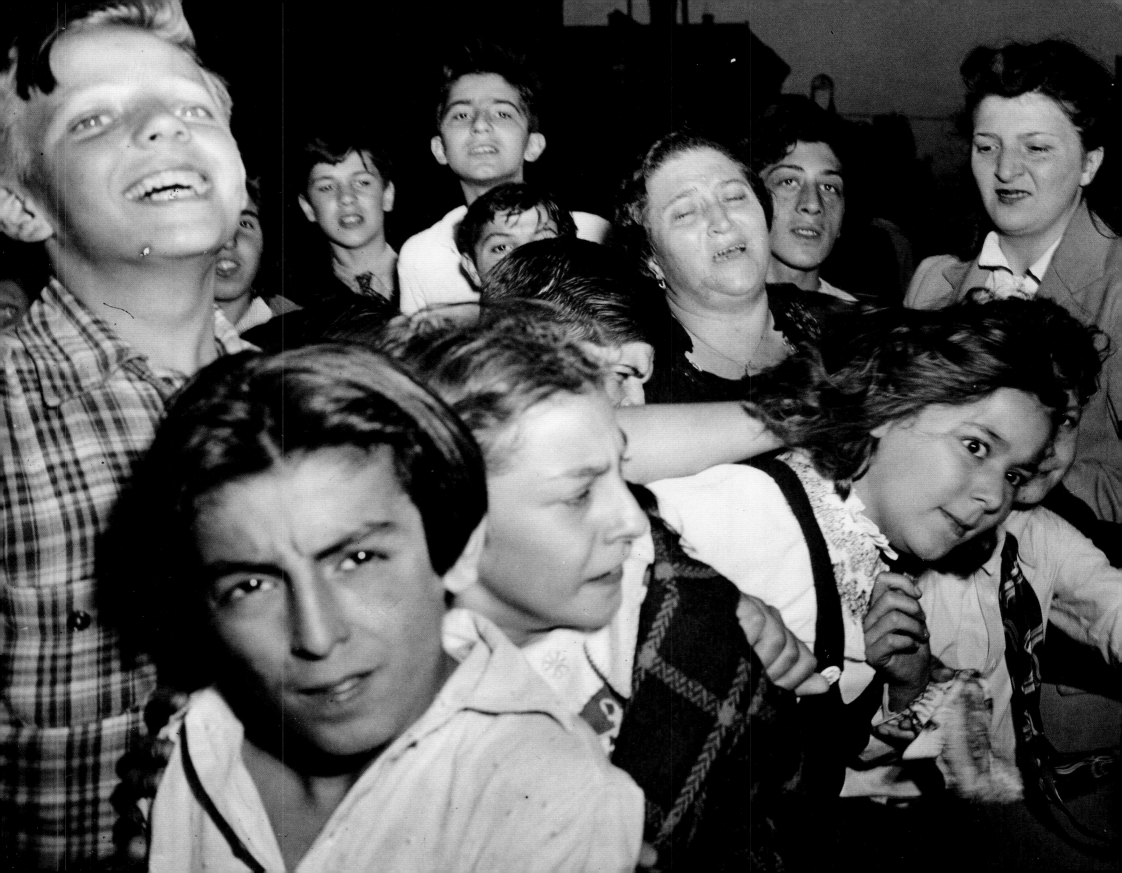

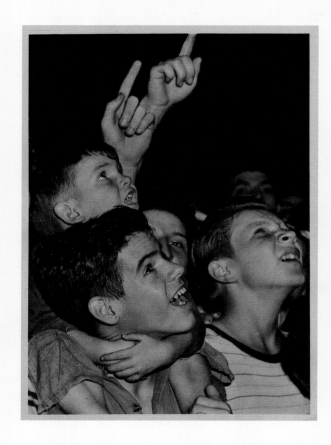

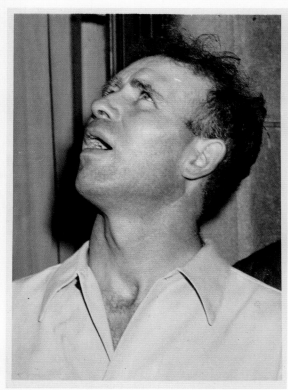

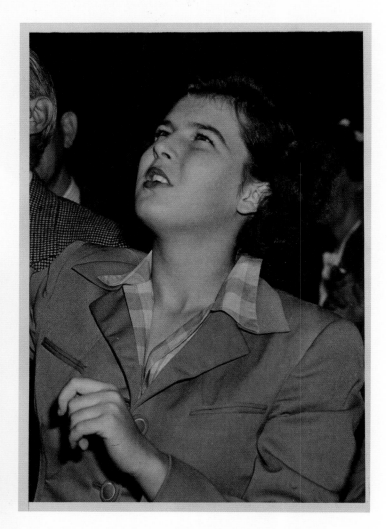

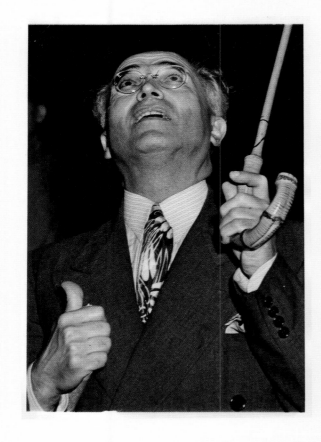

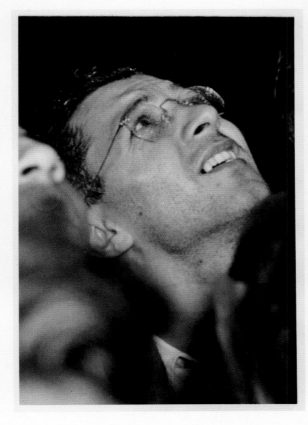

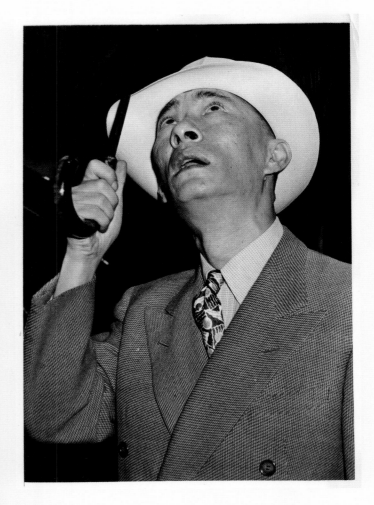

A SCHOLARLY-LOOKING GENTLEMAN, UMBERELLA
IN HAND, STOPS TO LOOK AT THE CATASTROPHE.
HE SEEMS TO BE GIVING AN UNCONSCIOUS THUMBS-
UP SIGN TO FIREMEN AND RESCUE WORKERS.
(8/3/45) CREDIT LINE (ACME)
ACME ROTO SERVICE FOR IMMEDIATE RELEASE

A CHINAMAN, WEARING A WHITE PANAMA IN
SPITE OF THE RAIN, GAPES SKYWARD AND REVEALS
HIS EMOTIONS, THOUGH HIS RACE USUALLY MAIN-
TAINS AN IMPASSIVE EXPRESSION.
(8/3/45) CREDIT LINE (ACME)
ACME ROTO SERVICE FOR IMMEDIATE RELEASE

A YOUNG MAN WITH GLASSES CONTINUES TO
STARE UPWARD EVEN THOUGH THE DRIZZLING
RAIN IS CLOUDING OVER HIS LENSES.
(8/3/45) CREDIT LINE (ACME)
ACME ROTO SERVICE FOR IMMEDIATE RELEASE

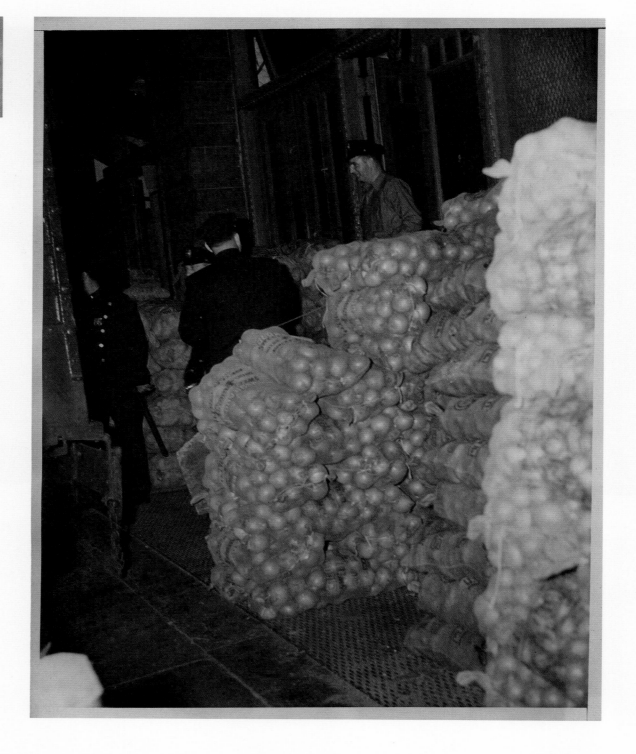

TONSORIAL SPUDS
NEW YORK CITY — No, Genevieve, potatoes don't grow in barber shops — that's why barber Charles Falcone had a lot of explaining to do when authorities discovered 16,100 pounds of the precious spuds in the back of his shop at 1221 Sixth Ave. As this load of potatoes was wheeled out of the shop, Falcone was busy telling the OPA and the Food Distribution Administration and the Commissioner of Markets and the Commissioner of Housing and Buildings and Mayor LaGuardia just how the potatoes got there. Seems he was holding them for a friend.

CREDIT LINE (ACME) 5/19/43 (HK)

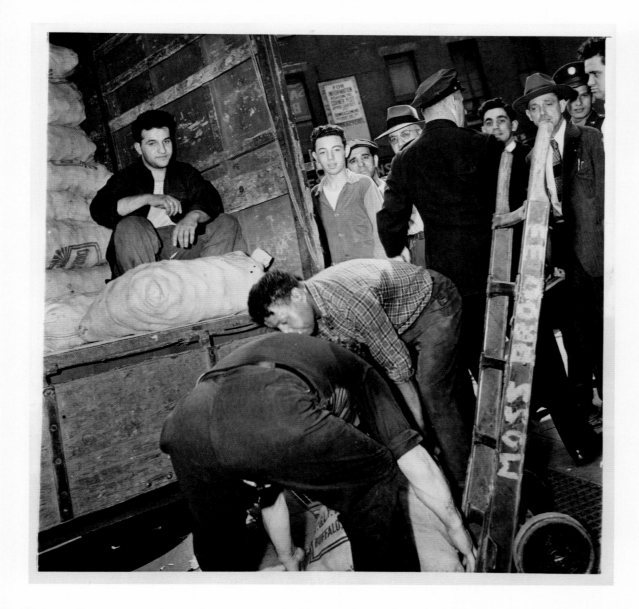

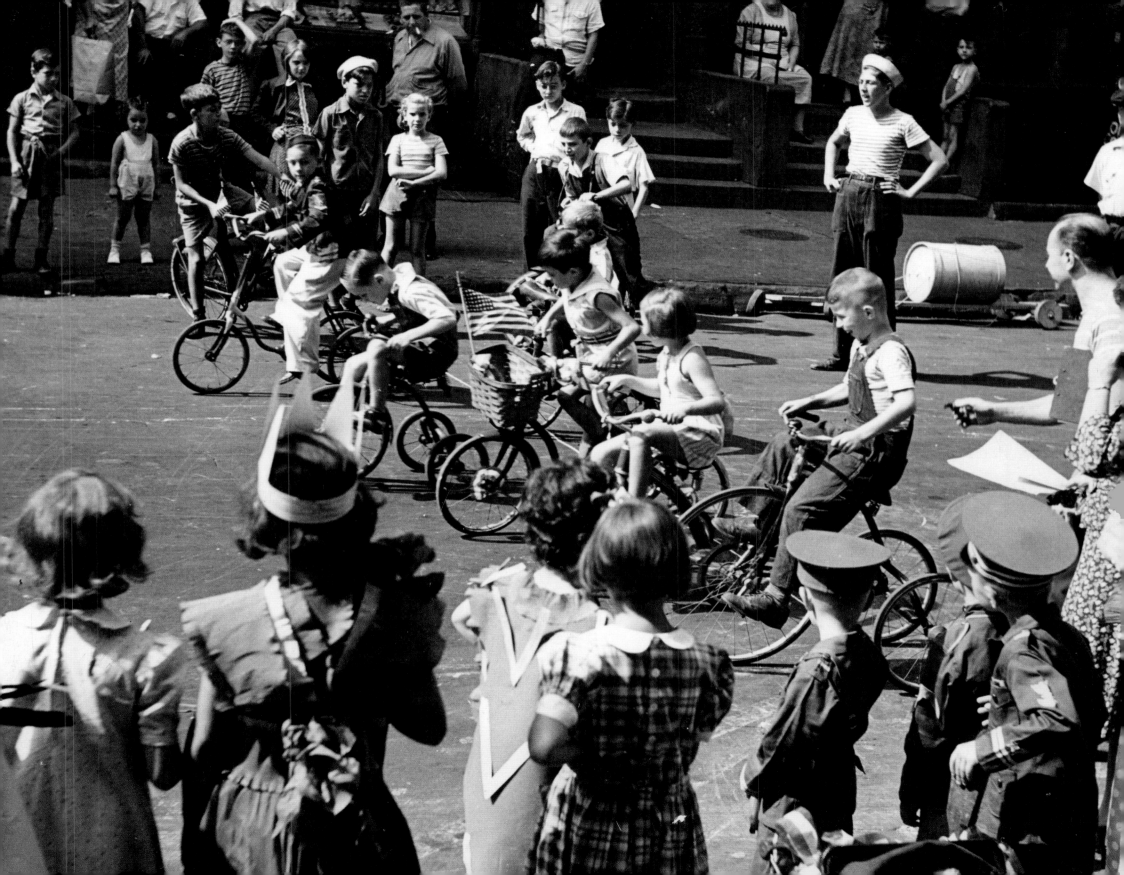

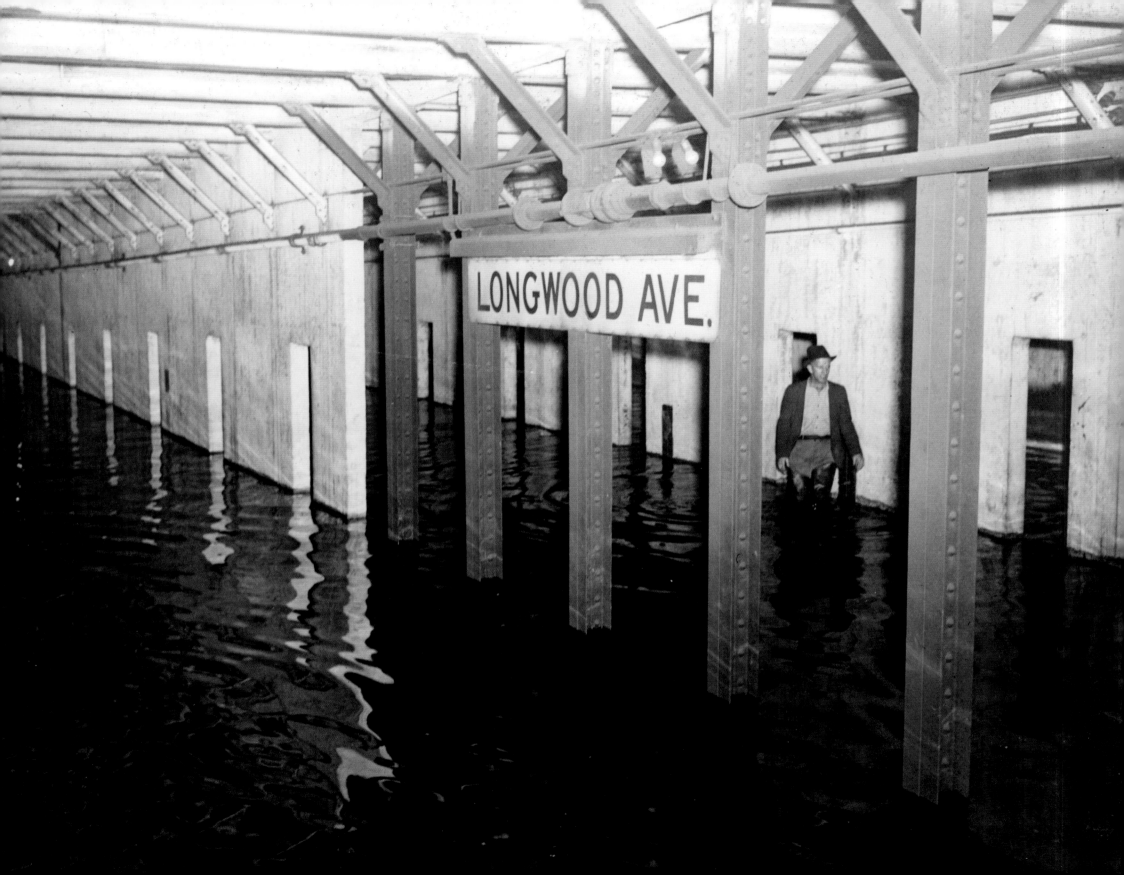

EXTRA!
WET

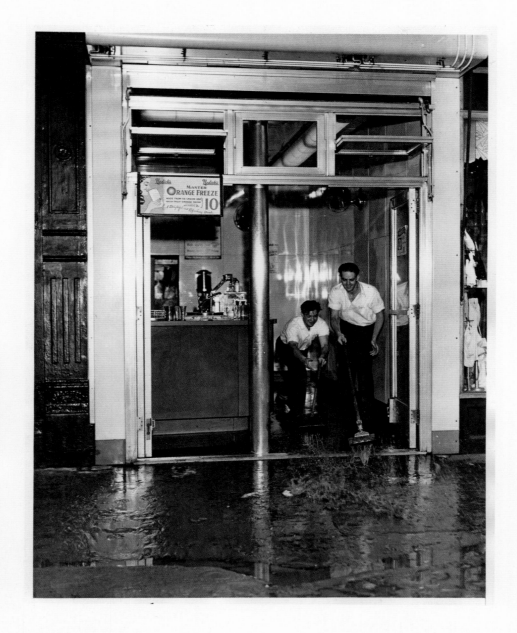

← page 66

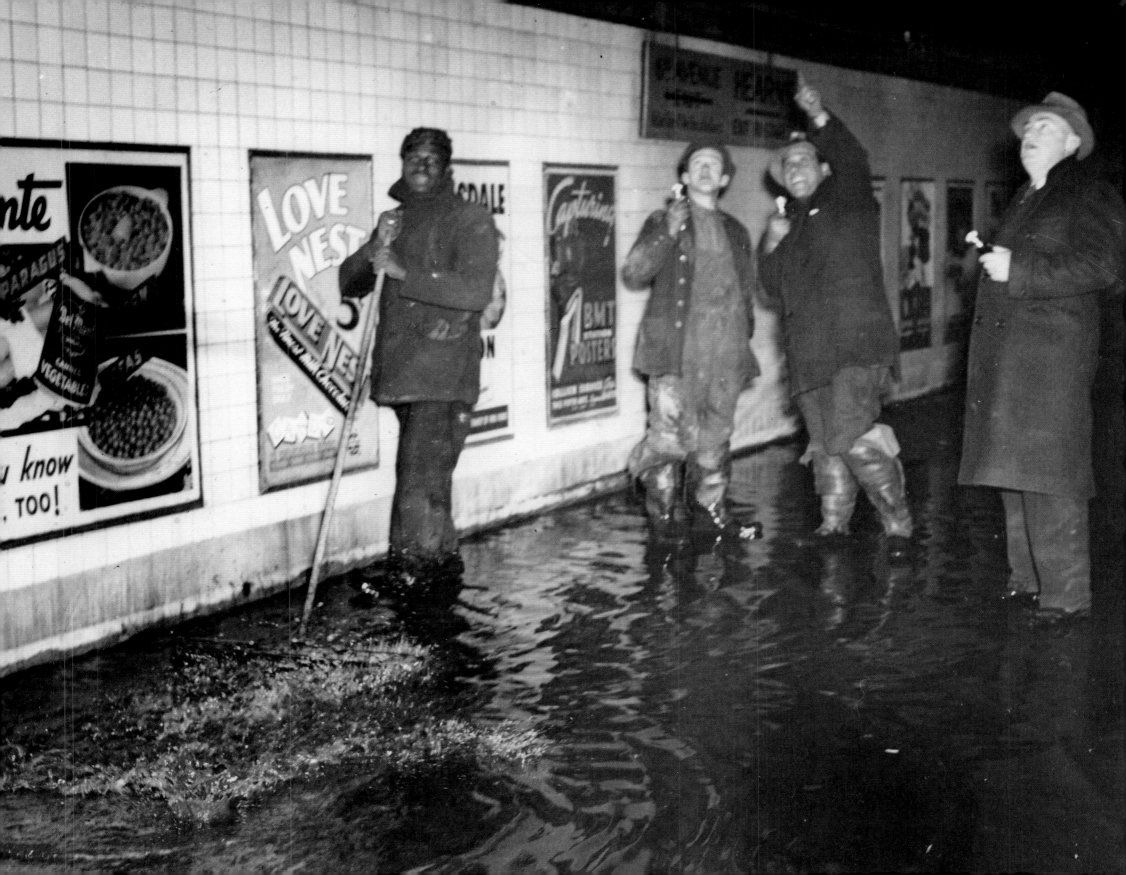

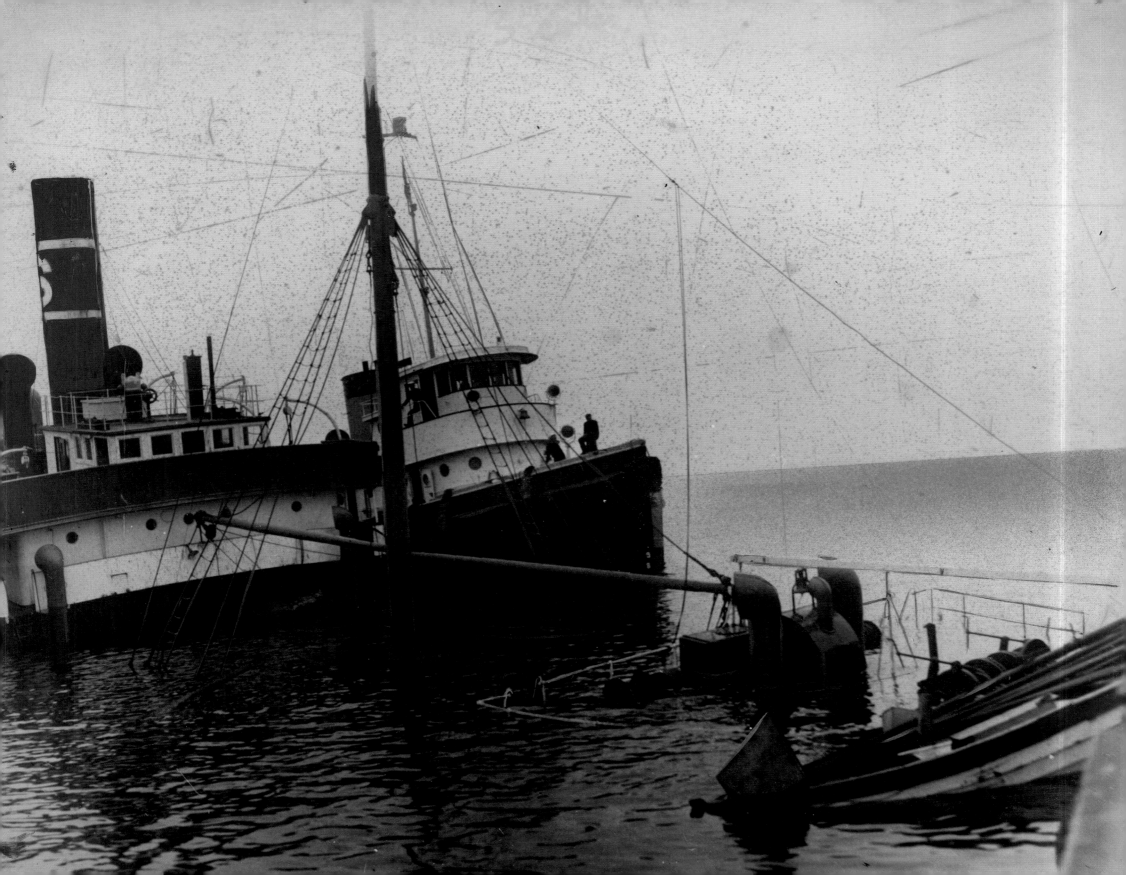

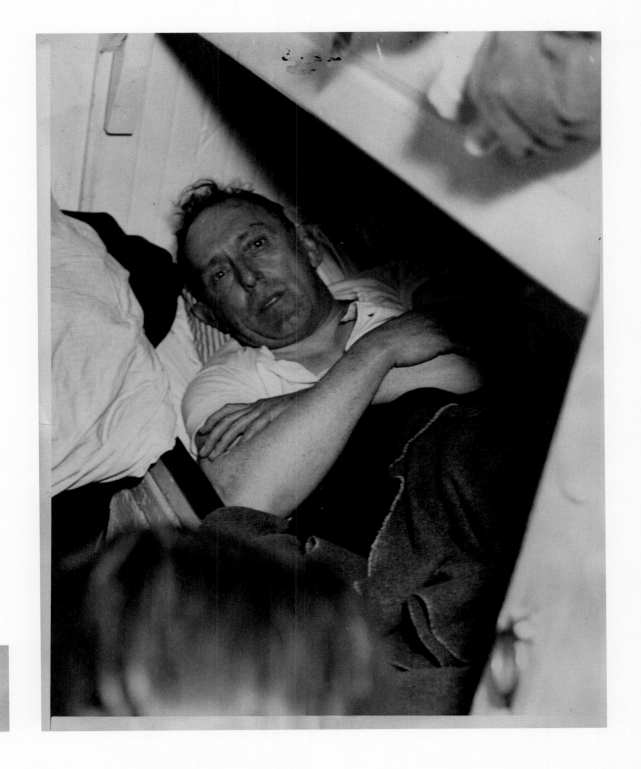

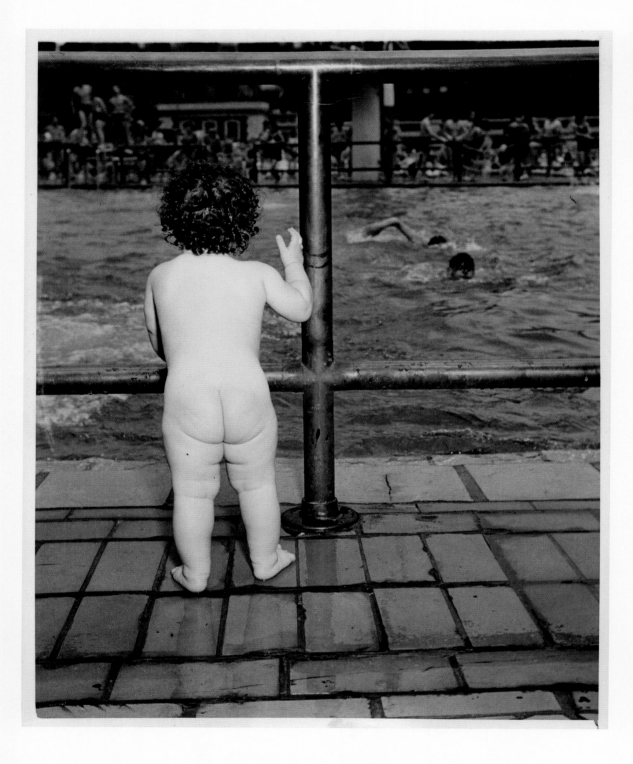

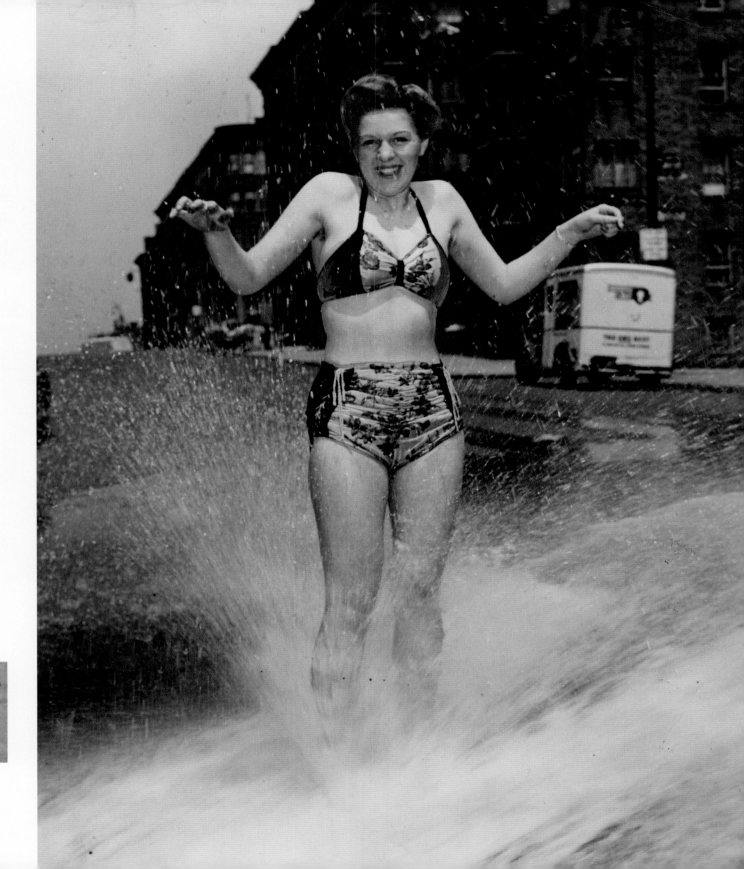

72.6

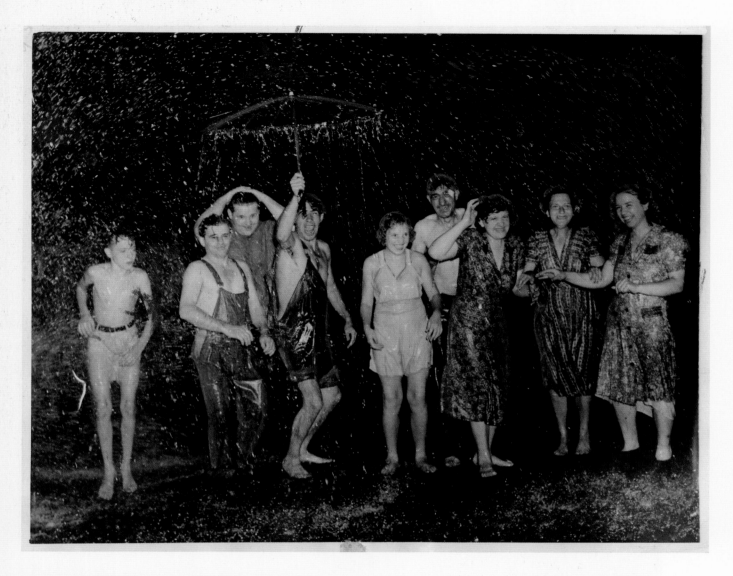

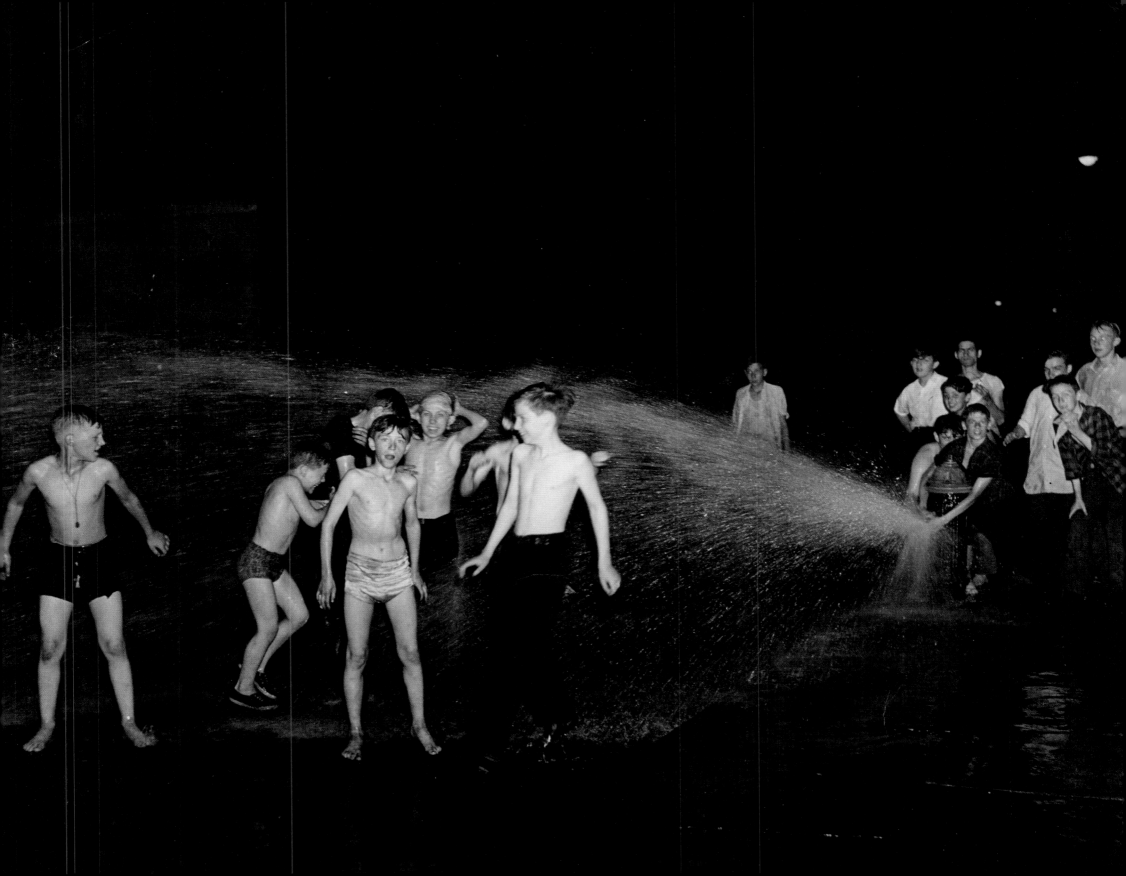

PIER BURNED TO WATER'S EDGE
NEW YORK.--DAYLIGHT VIEW OF THE MUNICIPALLY
OWNED PIER 83 ON THE HUDSON RIVER WHICH FIRE
BURNED TO THE WATER'S EDGE TODAY, DAMAGING
A FREIGHTER. IT TOOK FIREMEN, USING ALMOST
EVERY PIECE OF LAND EQUIPMENT IN MANHATTAN
BOROUGH AND THREE FIREBOATS, 2½-HOURS IN THE
BITTER COLD TO BRING THE FLAMES UNDER CONTROL.
FOUR FIREMEN WERE TREATED FOR BURNS AND SMOKE
INHALATION. FBI AGENTS WERE SEEKING EVIDENCE
OF SABOTAGE.
CREDIT LINE (ACME) 1-8-42 (SA)

CONEY ISLAND HAS NEW YEAR'S EVE THREE ALARM FIRE
NEW YORK CITY- THREE ALARMS WERE SOUNDED FOR THE
FIRE THAT SWEPT THE AMUSEMENT CONCESSIONS AT SURF
AVENUE AND WEST 5TH STREET CONEY ISLAND ON NEW YEAR'S
EVE. THE FIREMEN FOUGHT THE BLAZE IN SUB FREEZING
TEMPERATURE AND HIGH WIND ADDED TO THEIR DIFFICULTIES.
CREDIT LINE (ACME) 1/1/40. BURC WCR

← page 76

GARAGE FIRE DESTROYS 200 TRUCKS
NEW YORK CITY---WEST 55TH STREET IS A TANGLE OF HOSE
AS FIREMEN BATTLE FLAMES GUTTING THE WEST SIDE GARAGE.
FIRE, WHICH STARTED WHEN A SPARK IGNITED A POOL OF
GASOLINE, DESTROYED 200 TRUCKS AND MORE THAN 25 PRI-
VATE CARS.
NY CHI
CREDIT LINE (ACME) 42 (FK)

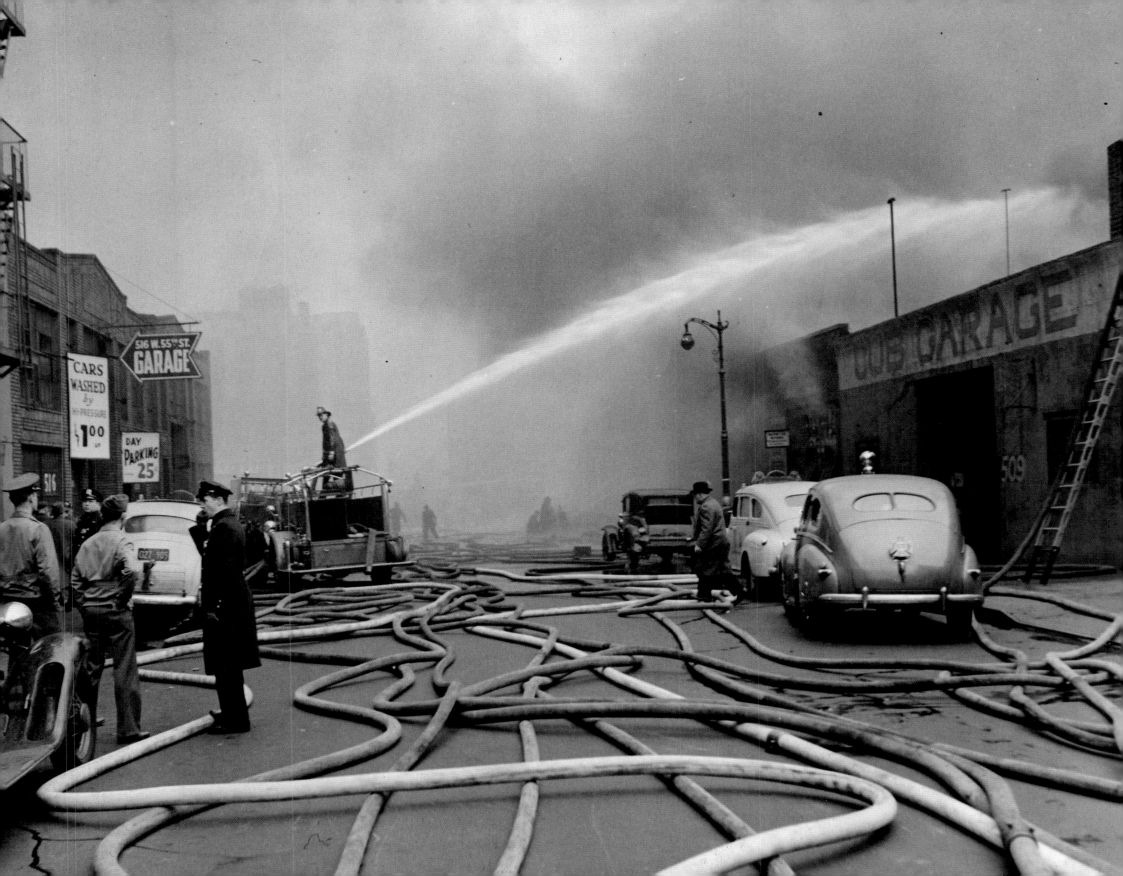

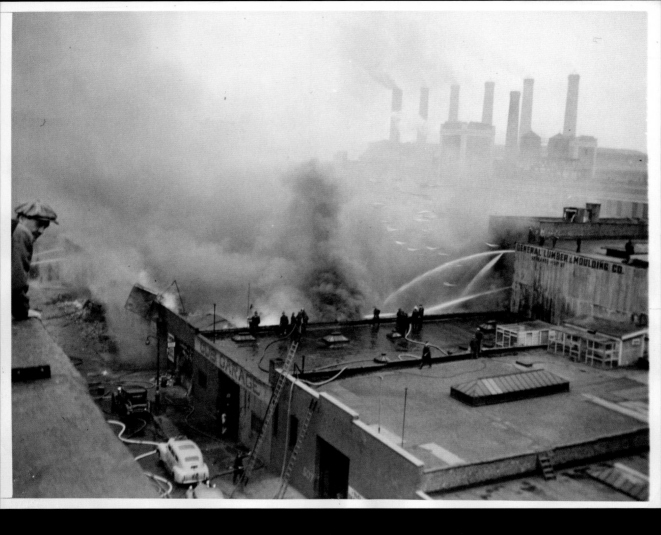

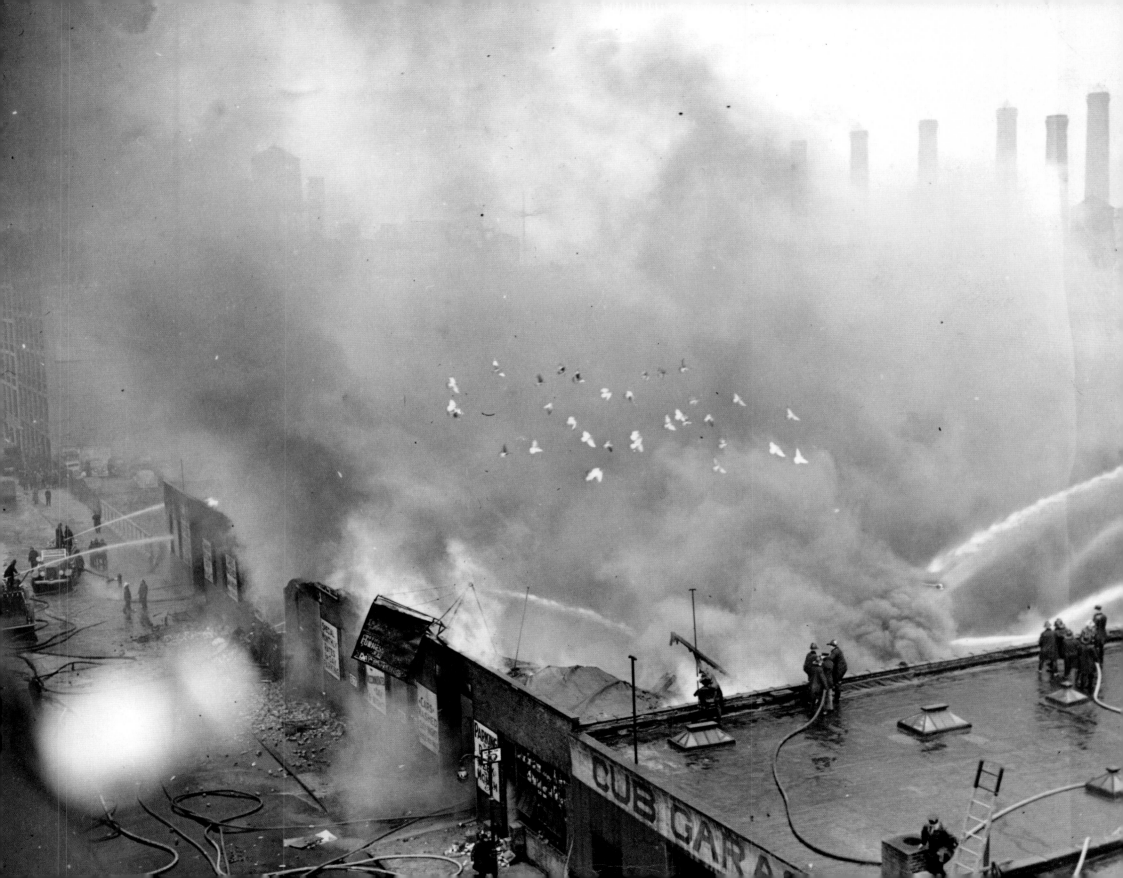

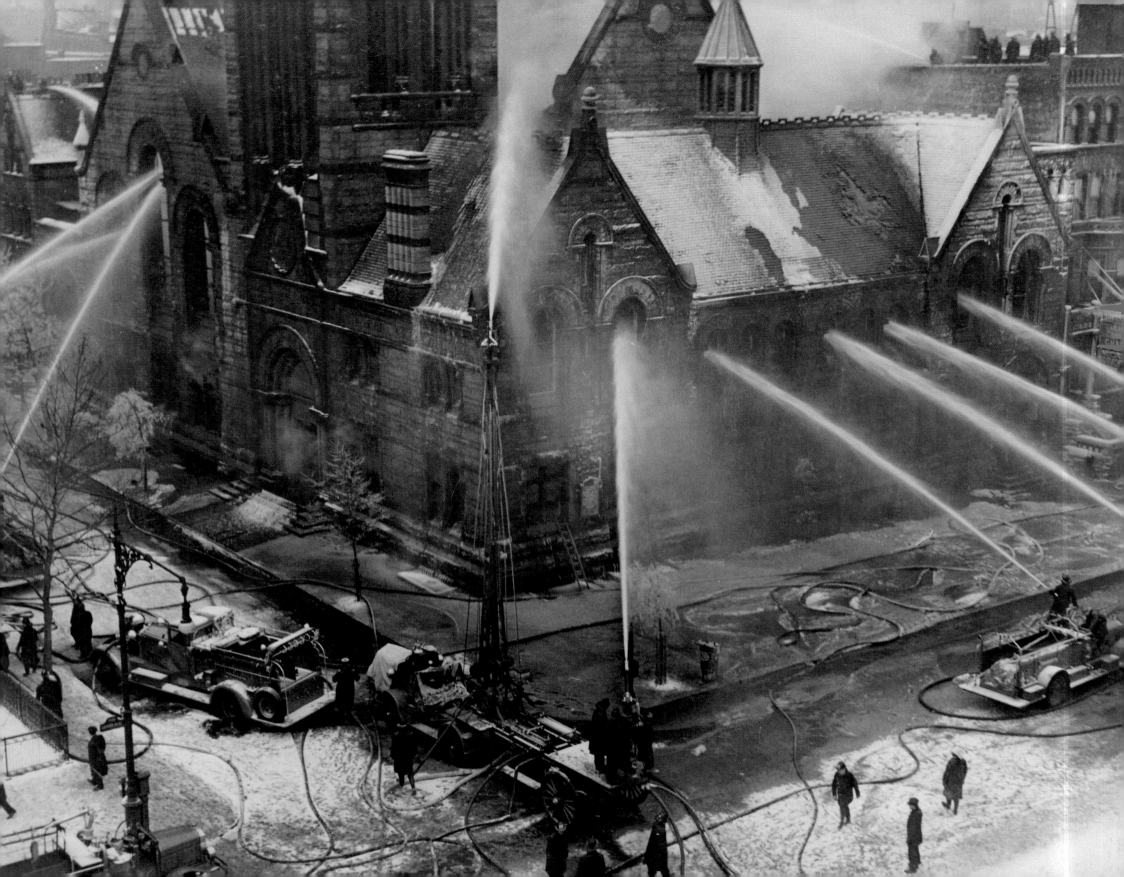

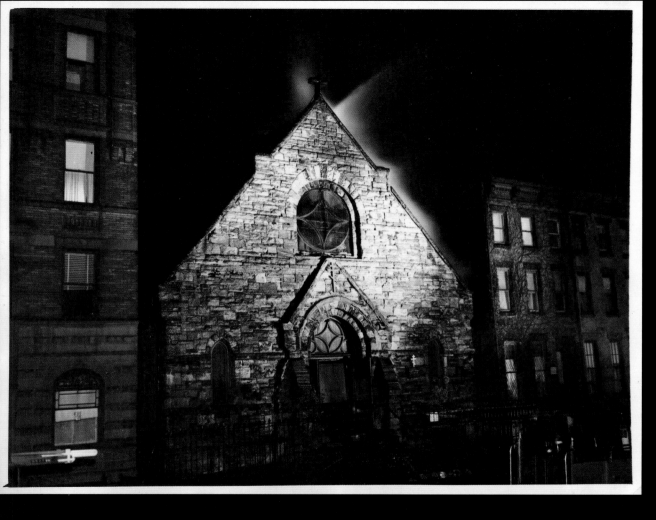

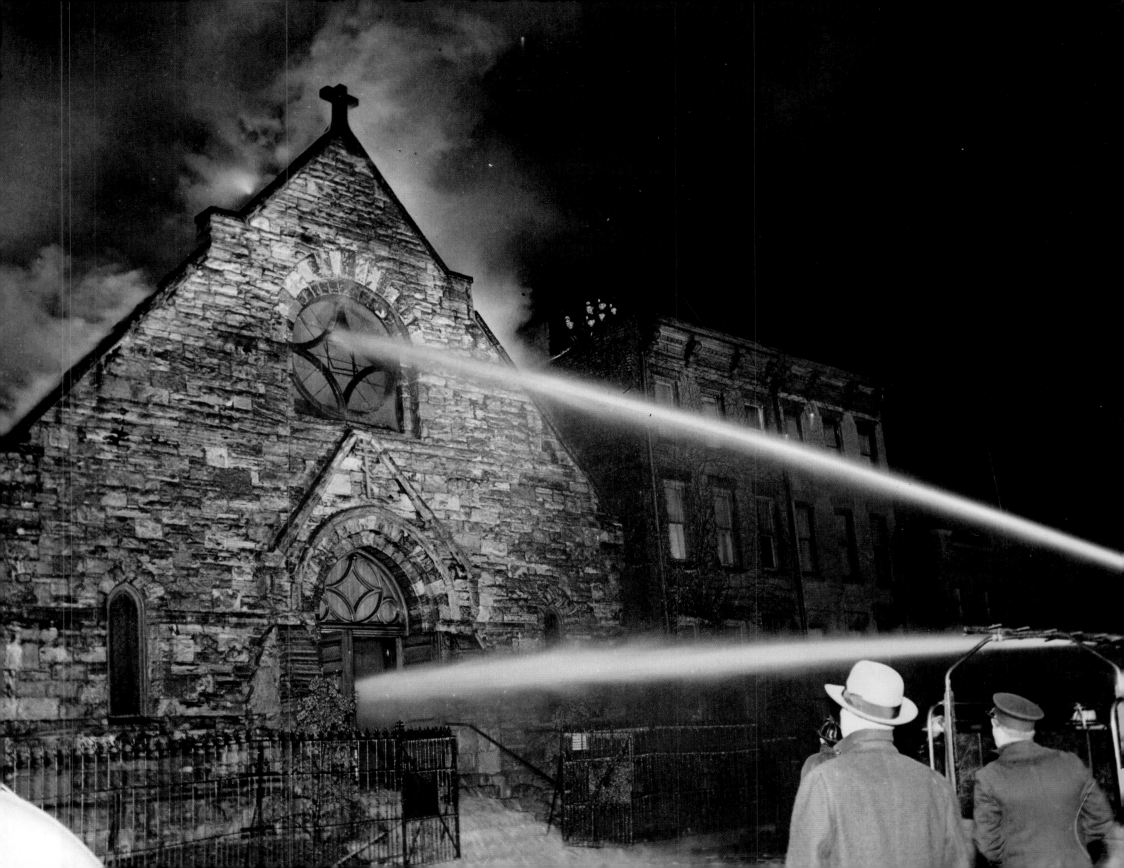

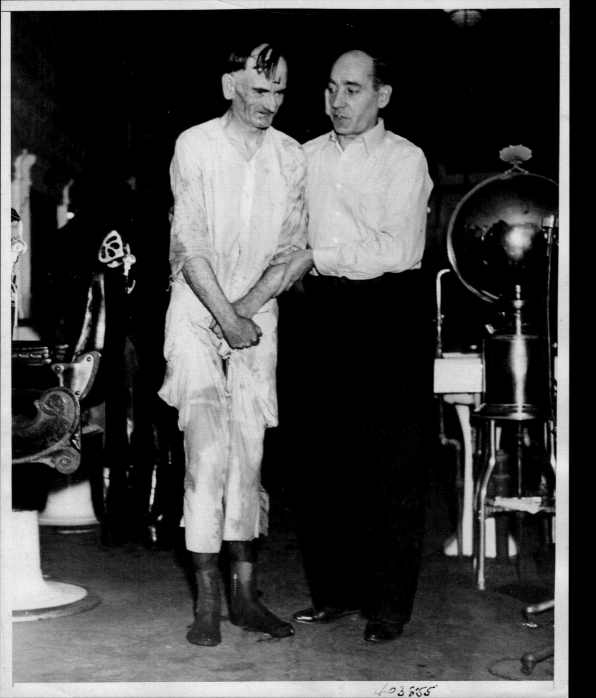

403655

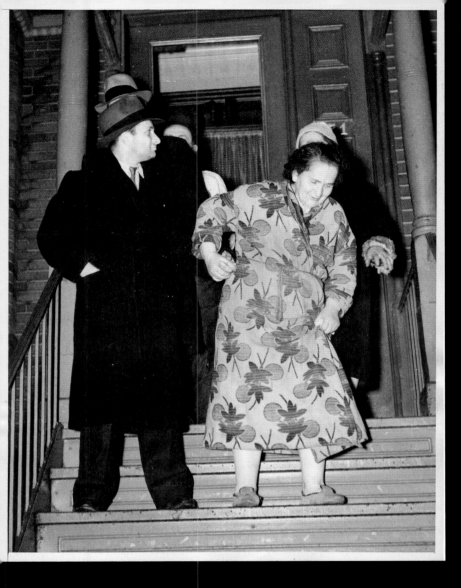

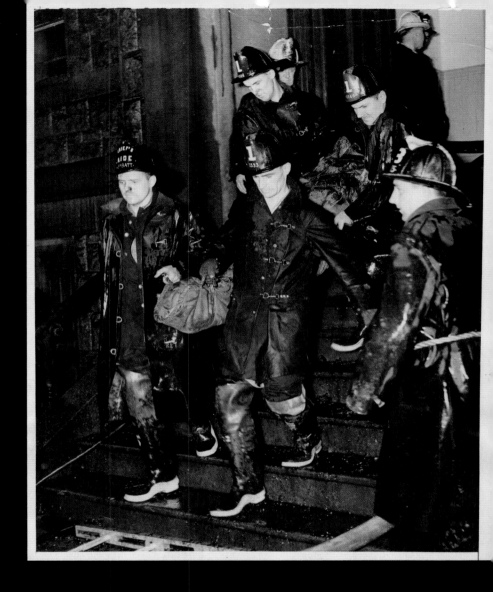

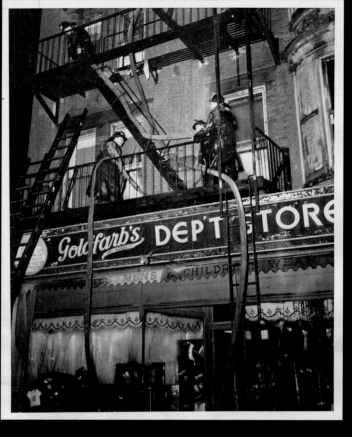

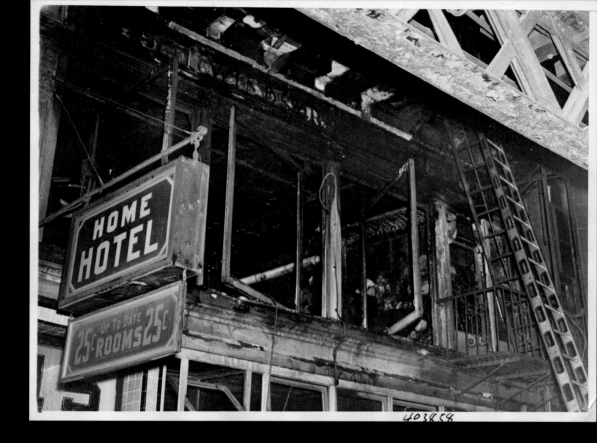

403858

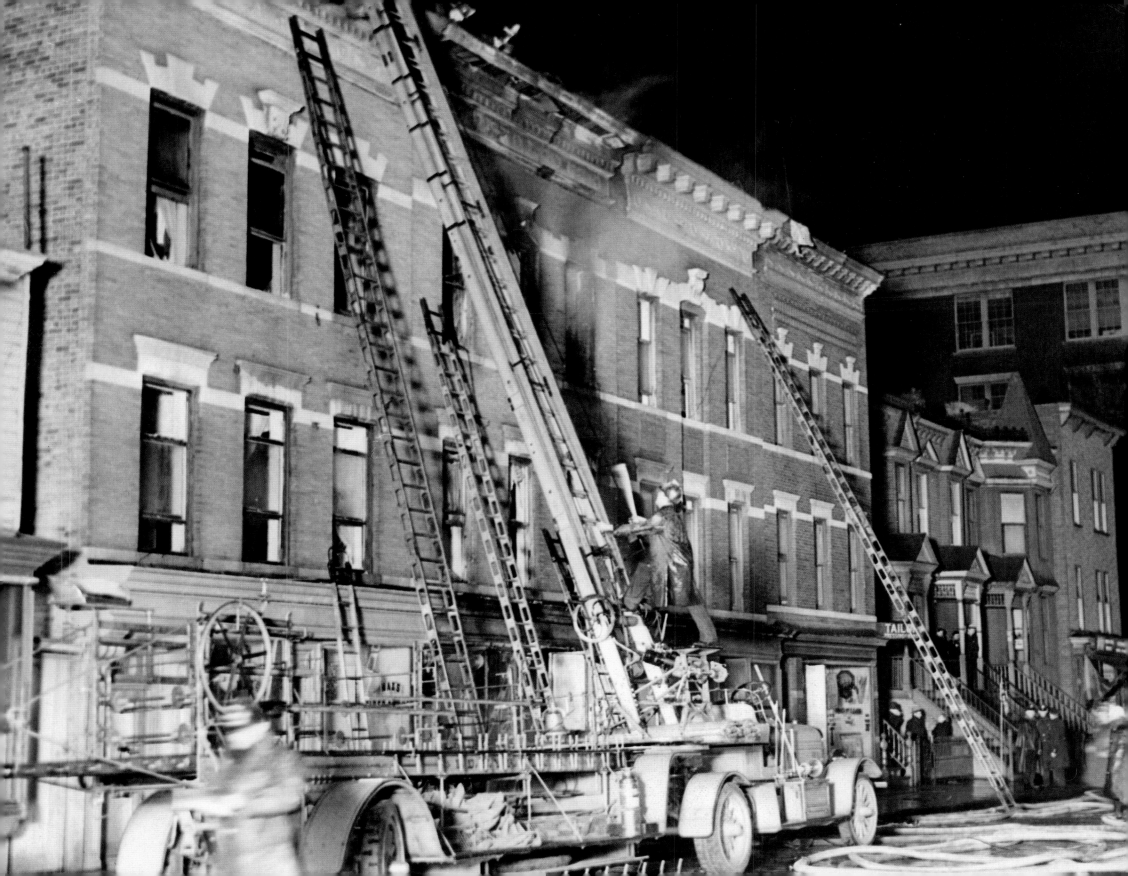

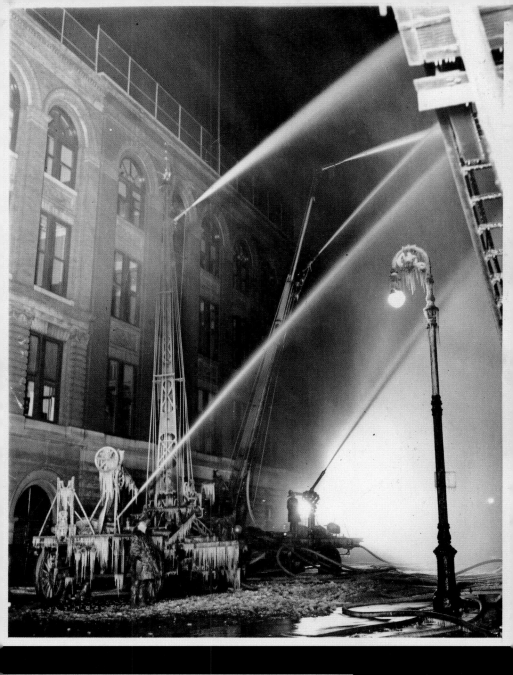

#2—FIREMEN DIRECTING WATER ON THE FIRE AS ICE FORMS
IN THE STREET AND ON THE APPARATUS.

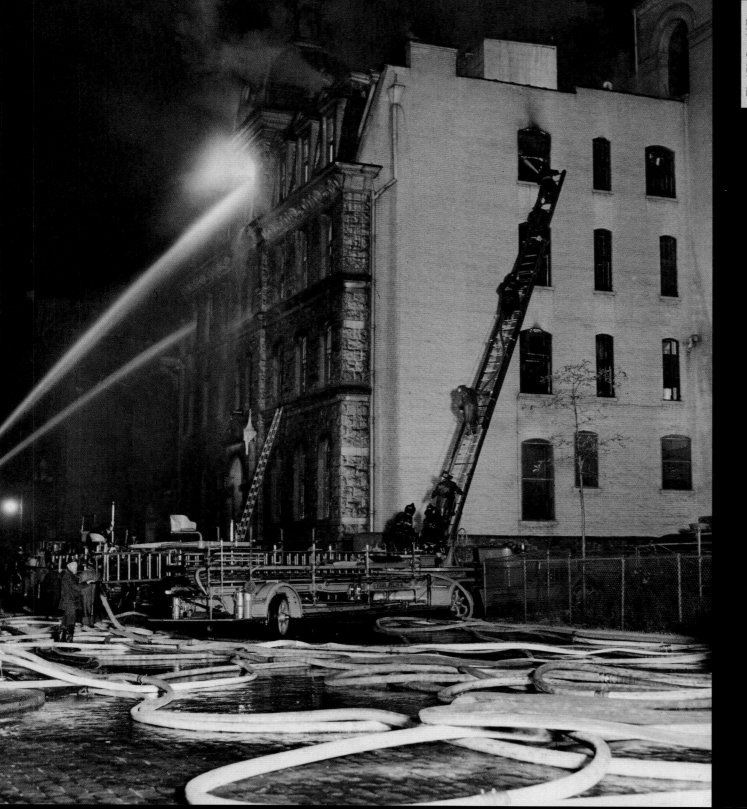

TWO DIE IN RECTORY FIRE

NEW YORK:- A FRANCISCAN LAY BROTHER AND A COOK OF
THE PARISH CHURCH OF ST. ANTHONY OF PADUA, 151
THOMPSON STREET, WERE SUFFOCATED EARLY NOV. 4,
IN A FIRE WHICH BROKE OUT IN THE RECTORY OF THE
CHURCH. EIGHT OTHERS ESCAPED FROM THE FLAMES
AMID SPECTACULAR SCENES WHICH STIRRED THE ENTIRE
NEIGHBORHOOD. TWO ALARMS WERE TURNED IN BEFORE
THE FIRE WAS BROUGHT UNDER CONTROL. PHOTO SHOWS:-
A GENERAL VIEW OF THE FIRE.
BU CL NK
CREDIT LINE (ACME) 38

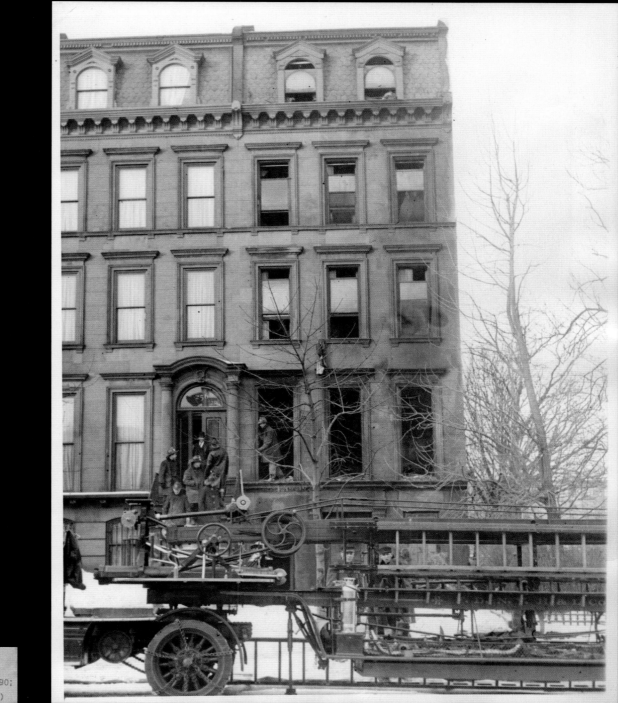

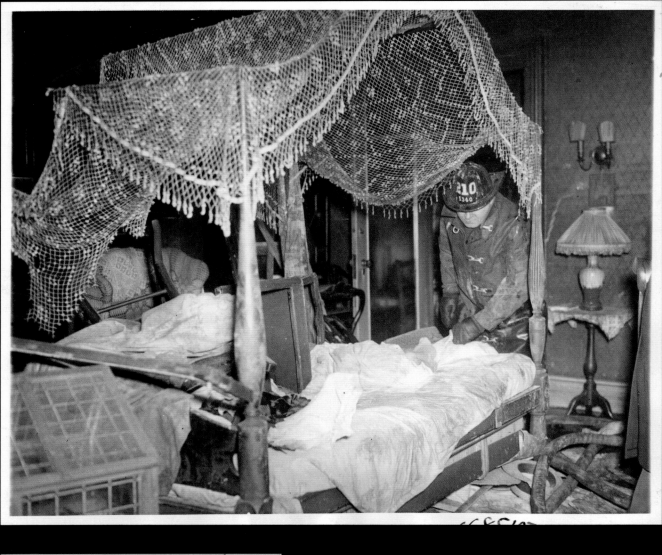

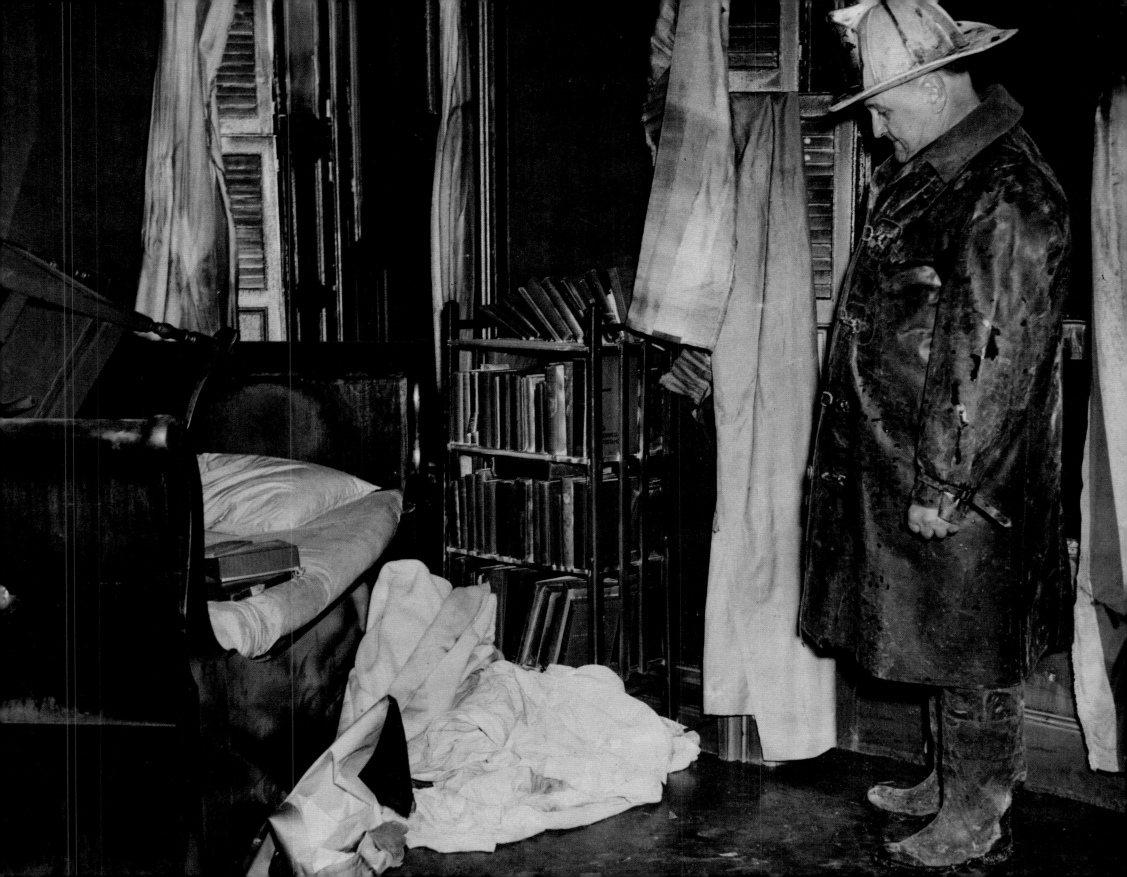

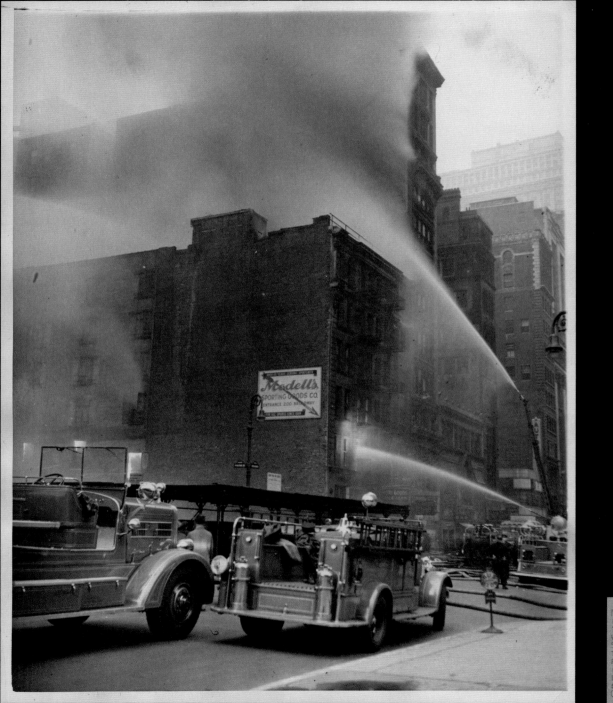

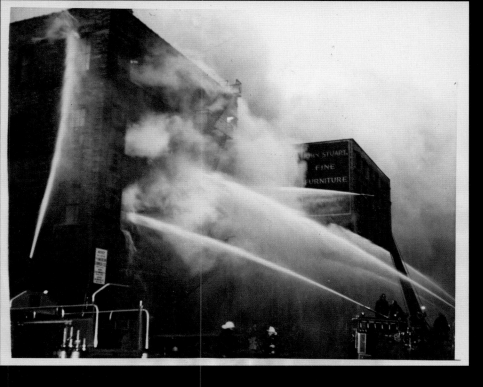

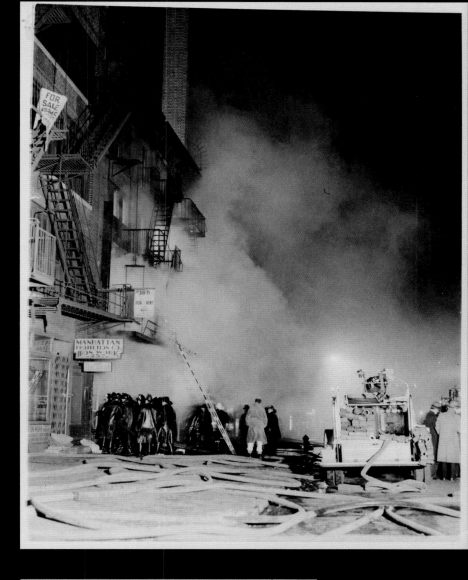

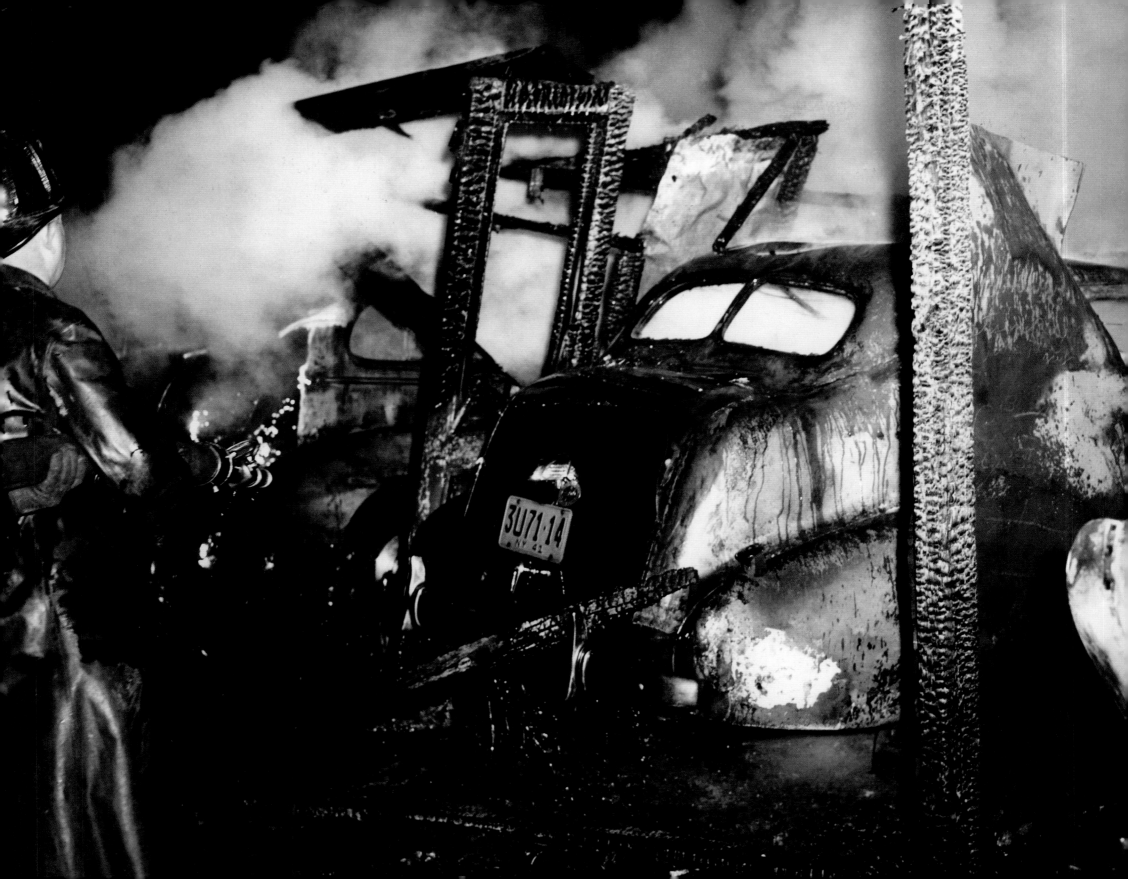

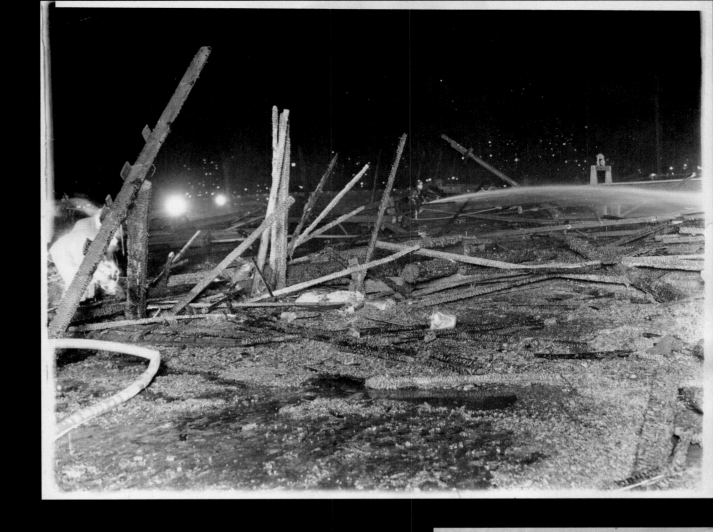

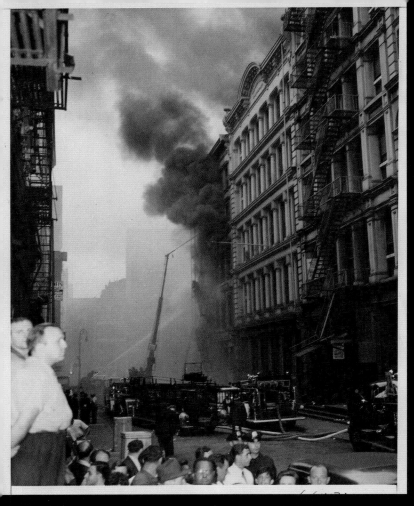

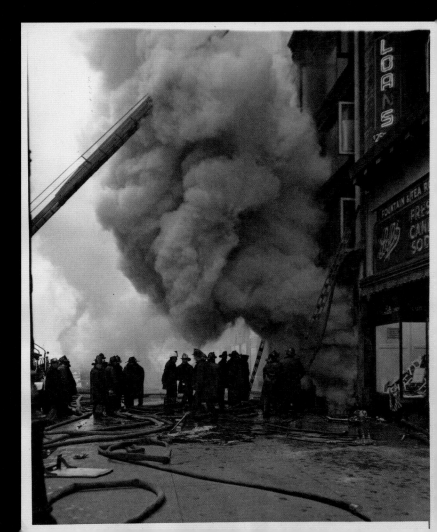

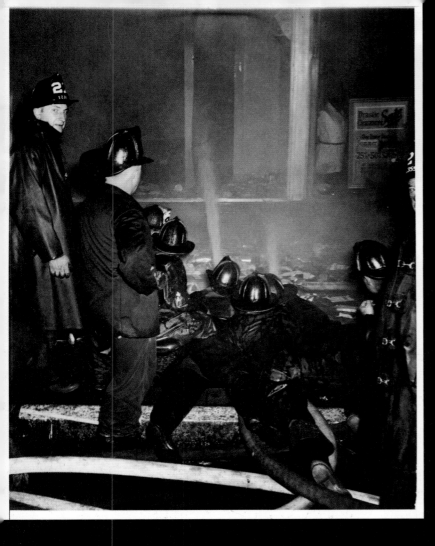

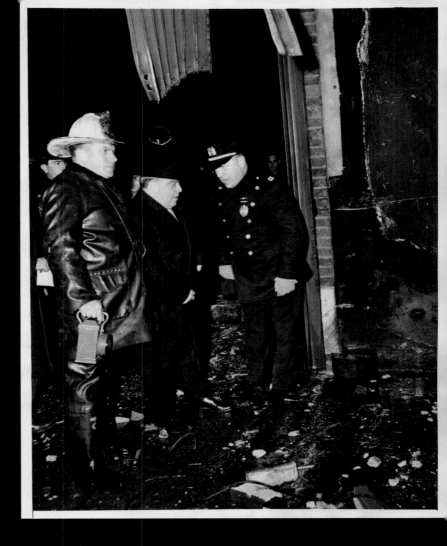

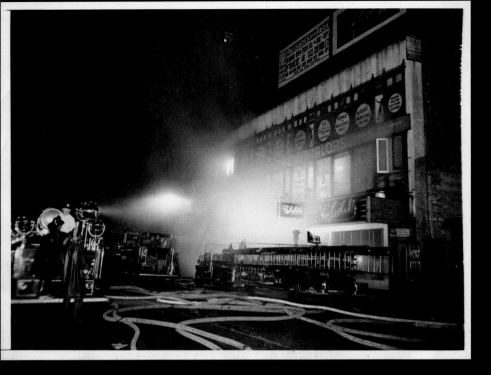

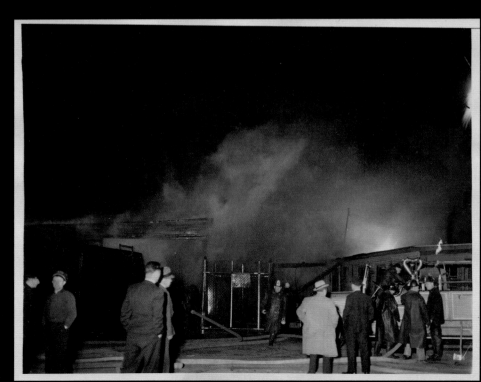

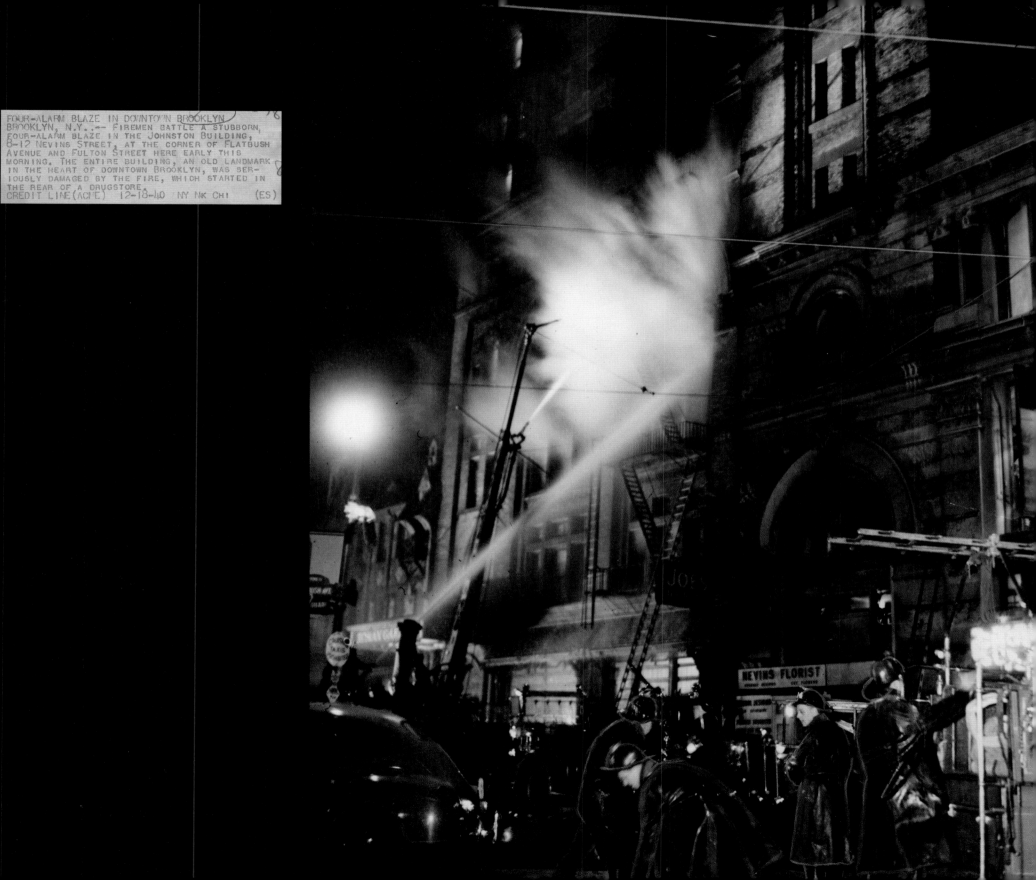

FOUR-ALARM BLAZE IN DOWNTOWN BROOKLYN
BROOKLYN, N.Y.—FIREMEN BATTLE A STUBBORN,
FOUR-ALARM BLAZE IN THE JOHNSTON BUILDING,
8-12 NEVINS STREET, AT THE CORNER OF FLATBUSH
AVENUE AND FULTON STREET HERE EARLY THIS
MORNING. THE ENTIRE BUILDING, AN OLD LANDMARK
IN THE HEART OF DOWNTOWN BROOKLYN, WAS SER-
IOUSLY DAMAGED BY THE FIRE, WHICH STARTED IN
THE REAR OF A DRUGSTORE.
CREDIT LINE (ACME) 12-18-40 NY NK CHI (ES)

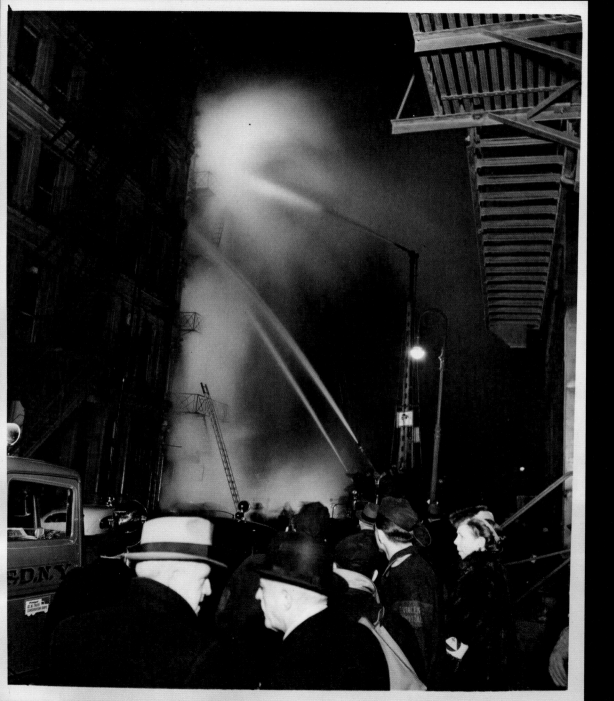

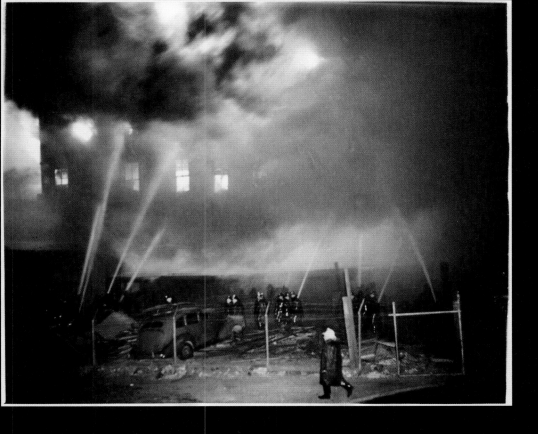

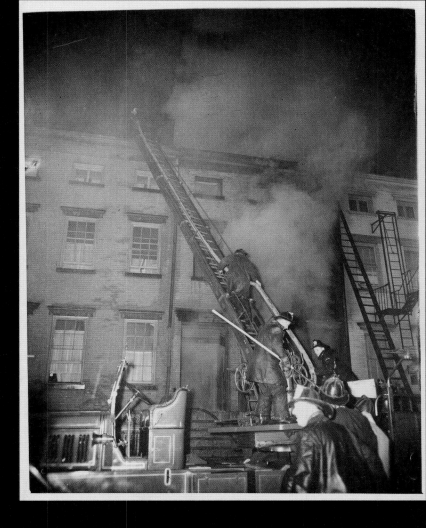

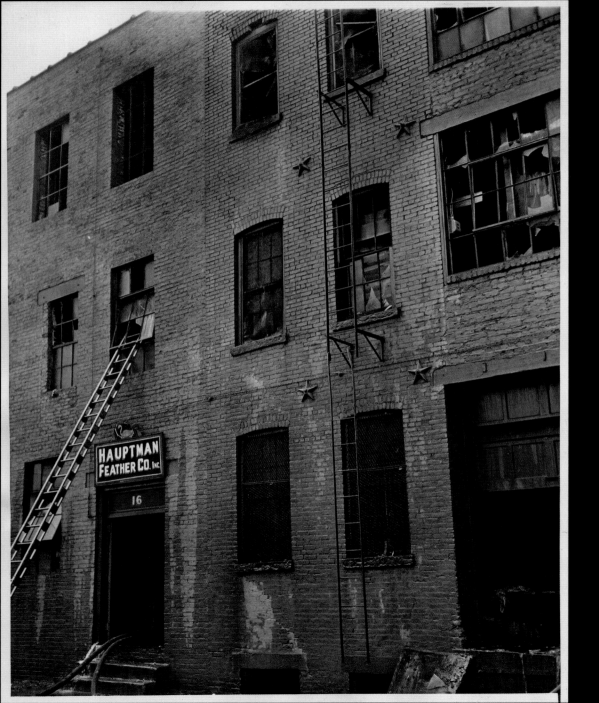

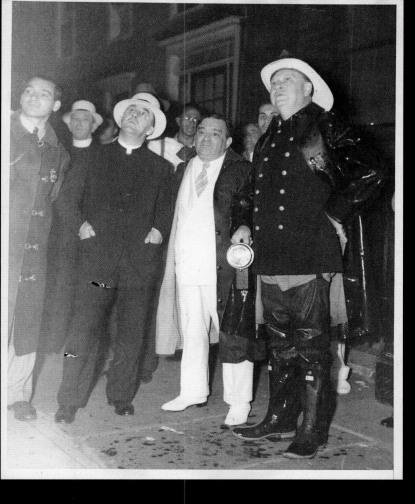

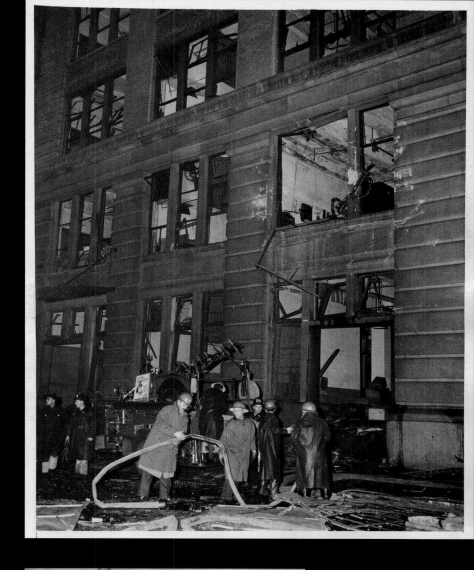

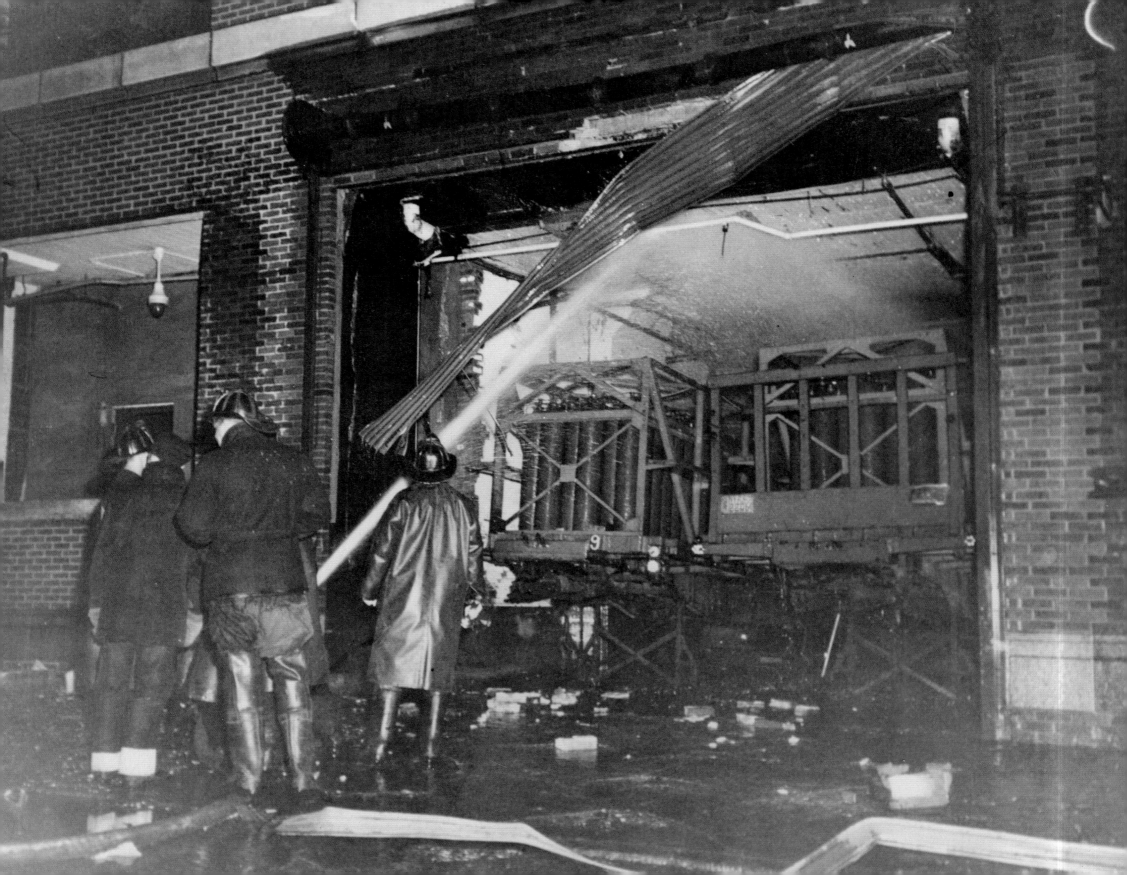

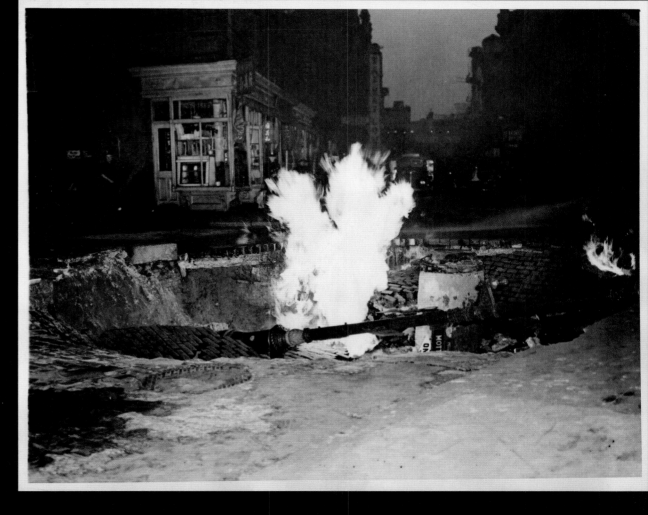

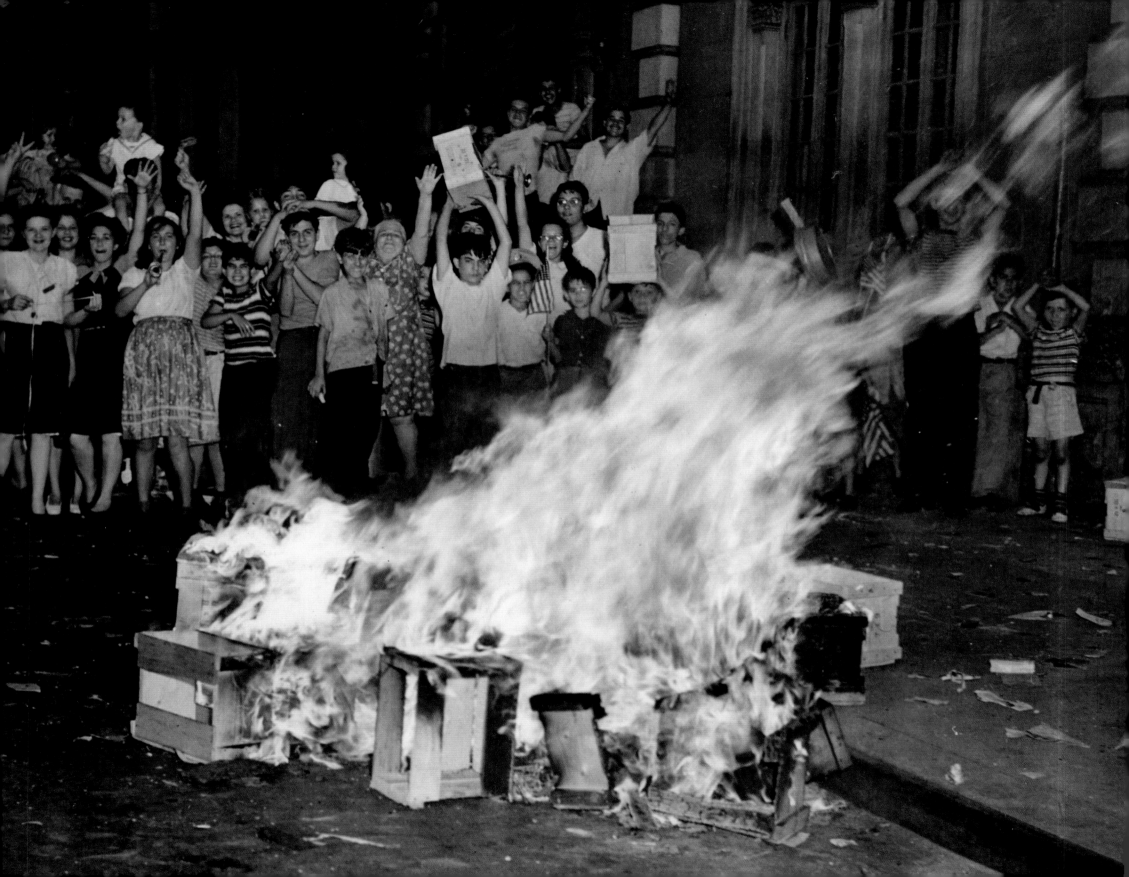

EXTRA!
FEST

THOSE THREE DUMMIES LAND ON THE SCRAP HEAP
NEW YORK CITY — OF COURSE THEY'RE ONLY DRESS
MODEL DUMMIES, BUT DON'T THEY LOOK REAL
ON THE SCRAP PILE AT THE GARMENT WORKERS CENTER
AT 520 8TH AVE. IN NEW YORK. GARMENT
WORKERS ALL OVER THE CITY HELPED THEIR FIRMS
COLLECT SALVAGE MATERIALS TODAY.
CREDIT LINE (ACME) 10/19/42 (EO)

 VICTORY FIRE

NEW YORK,N.Y.—BLAZING MERRILY, THIS BONFIRE
STARTED BY CELEBRANTS, MARKS AN EVENT FOR
PEOPLE ON E. 5TH STREET NEAR FIFTH AVENUE AS
NEWS OF THE END OF THE WAR WITH JAPAN
ANNOUNCED.
CREDIT LINE (ACME) 45 (ML)
BUR SPC MGS #80 BUFF NWK TREN DCN

← page 110

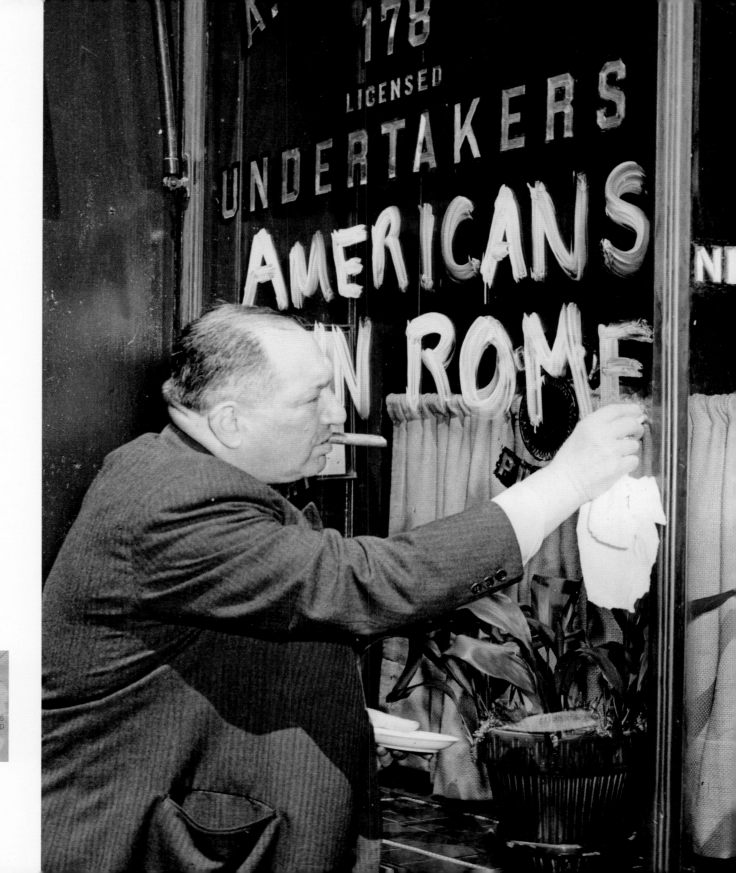

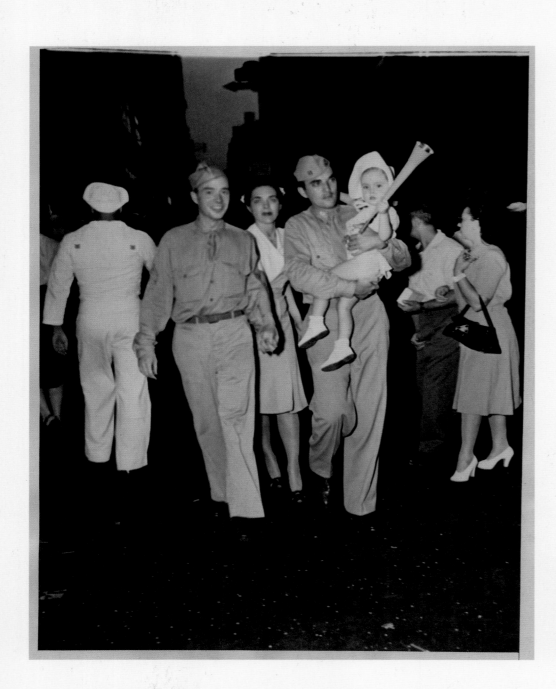

114

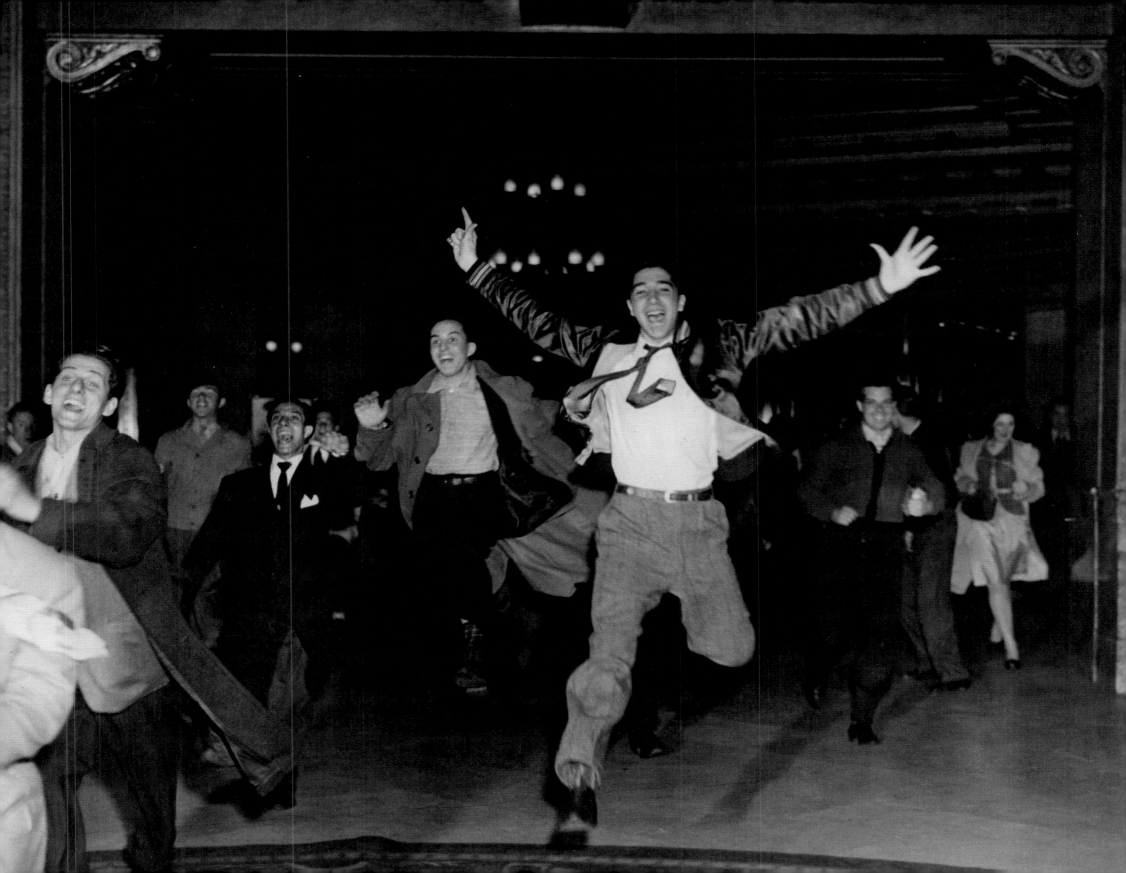

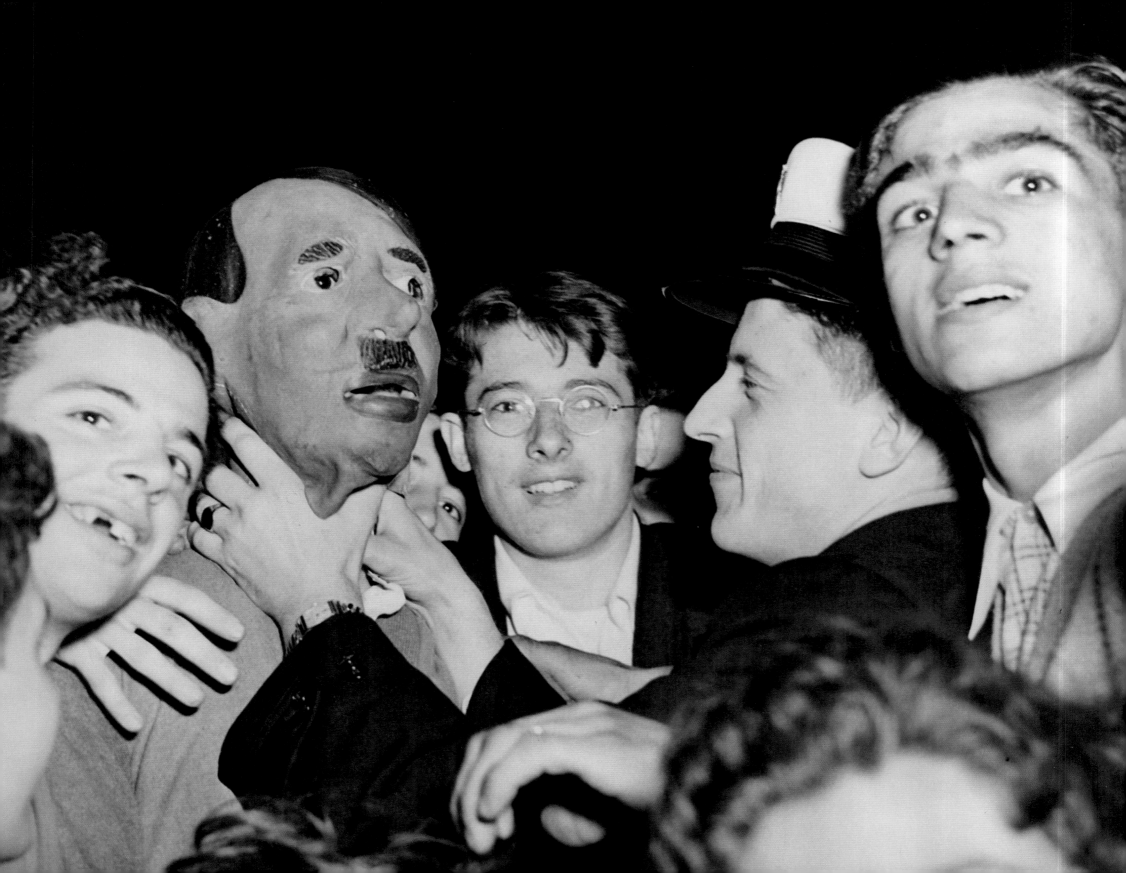

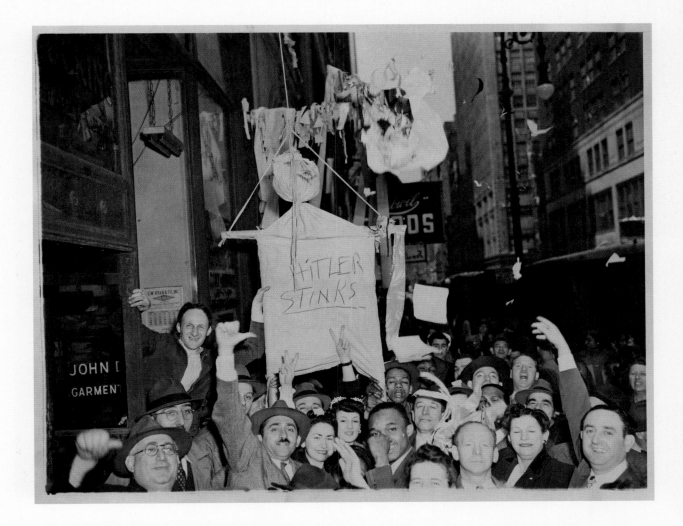

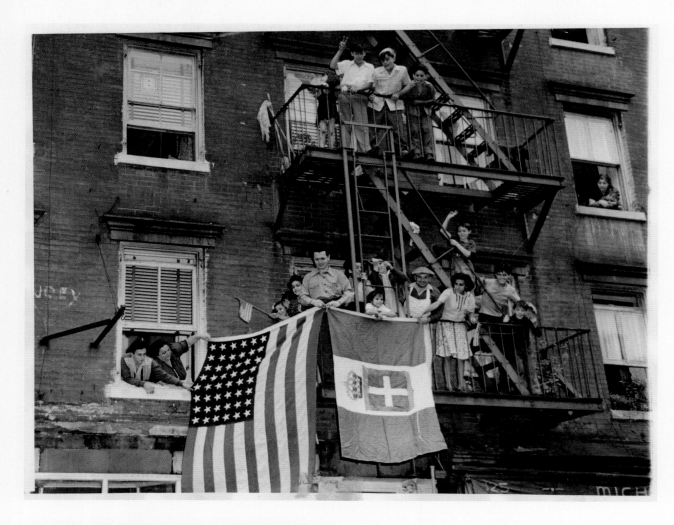

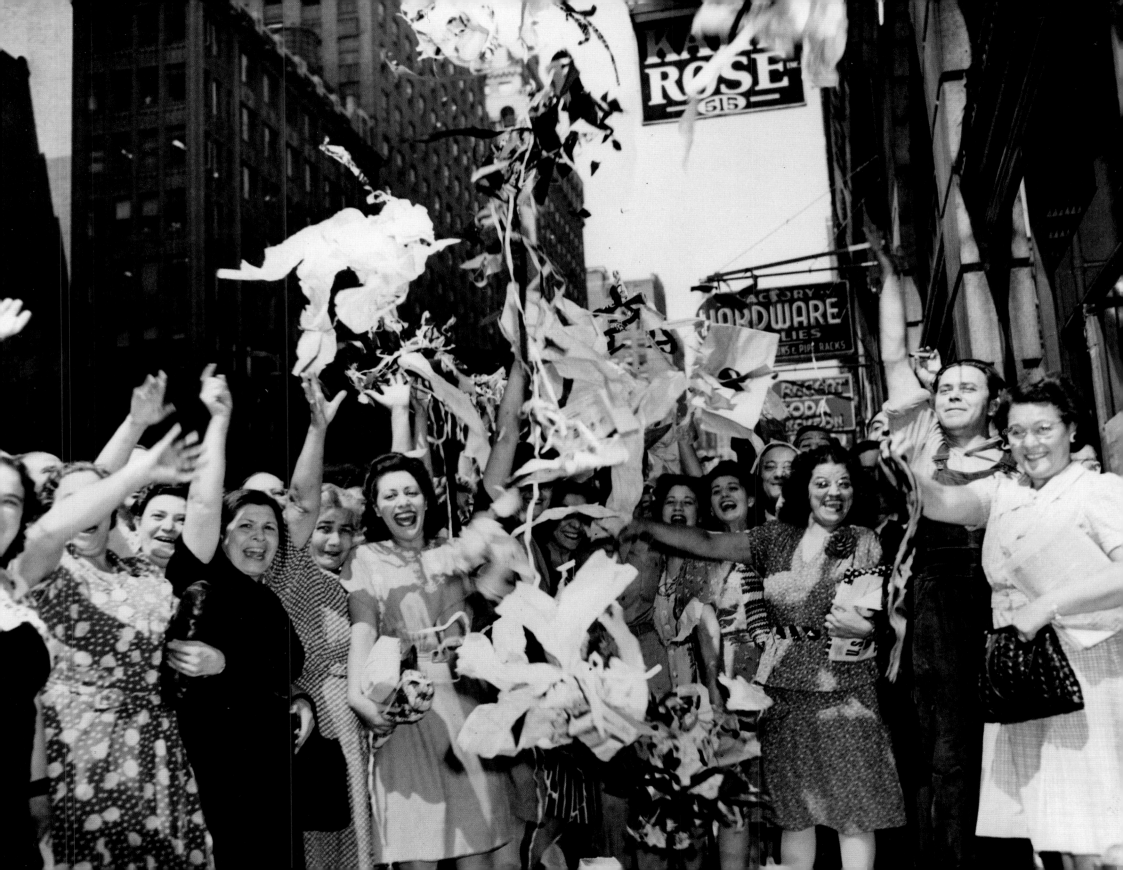

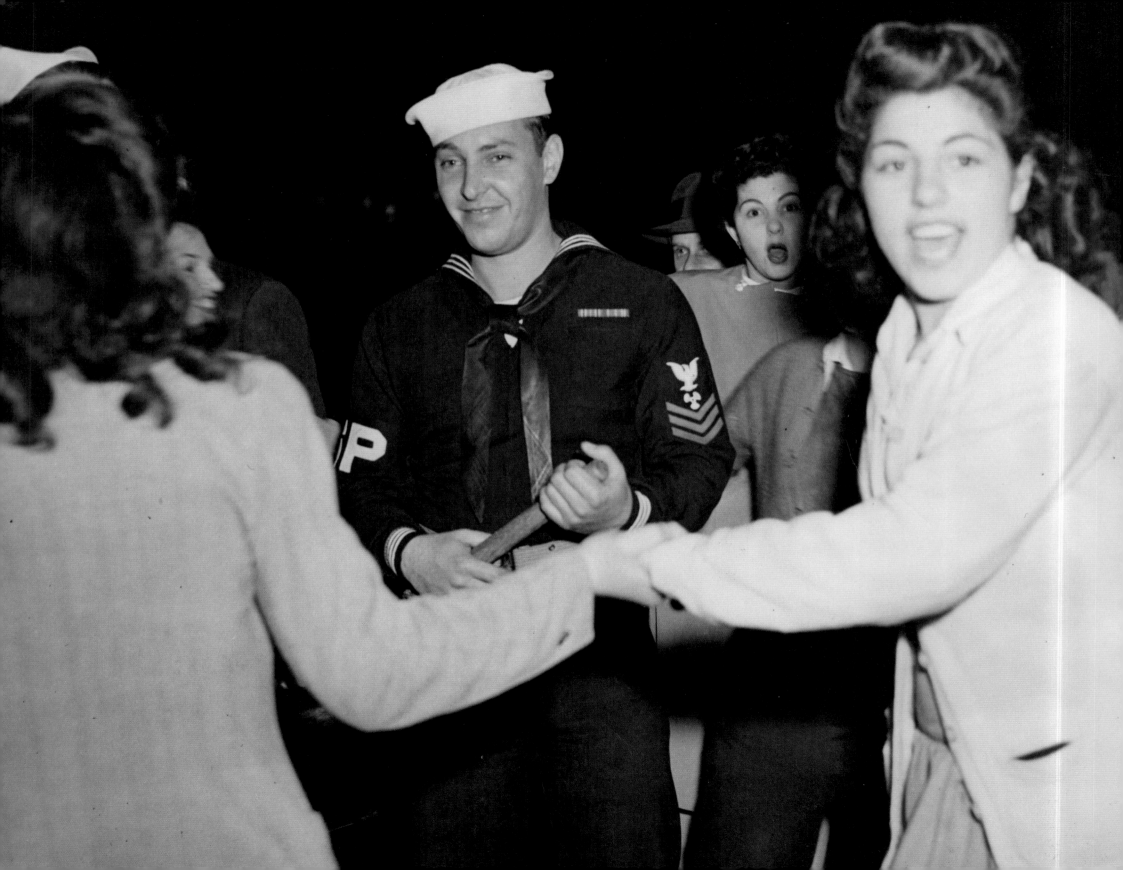

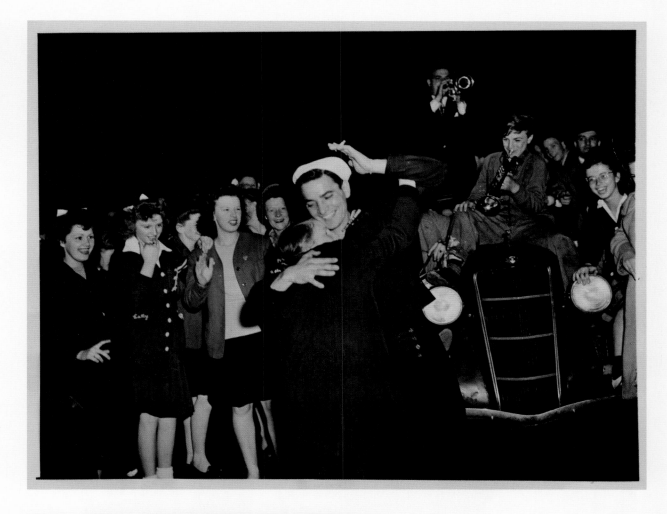

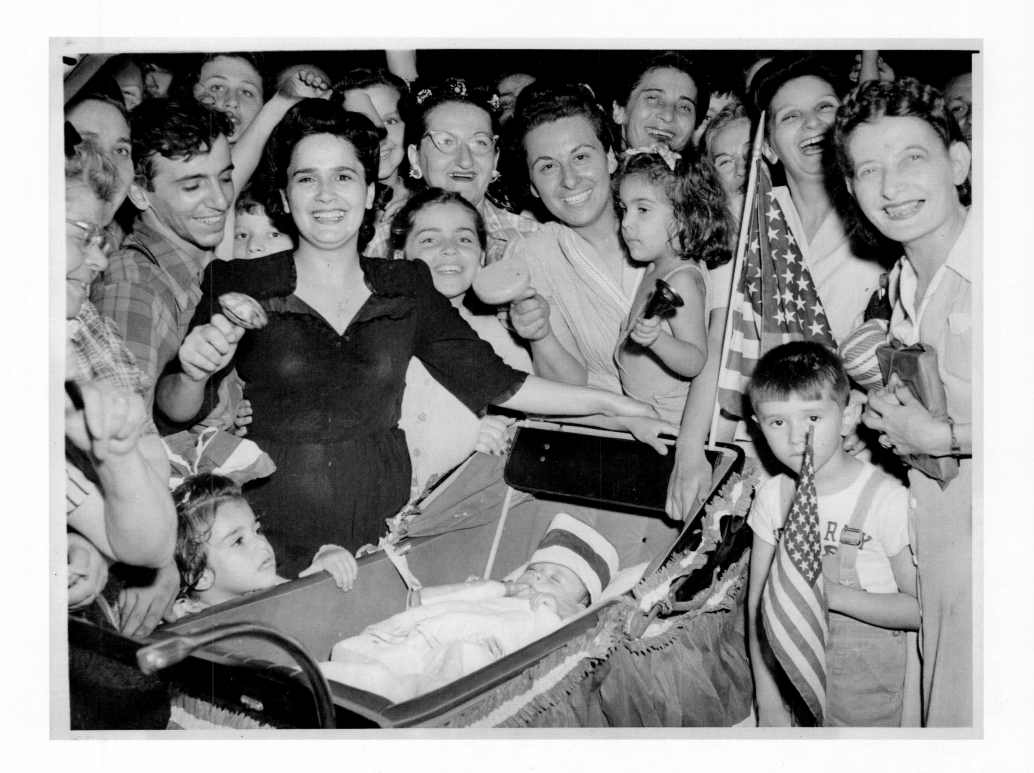

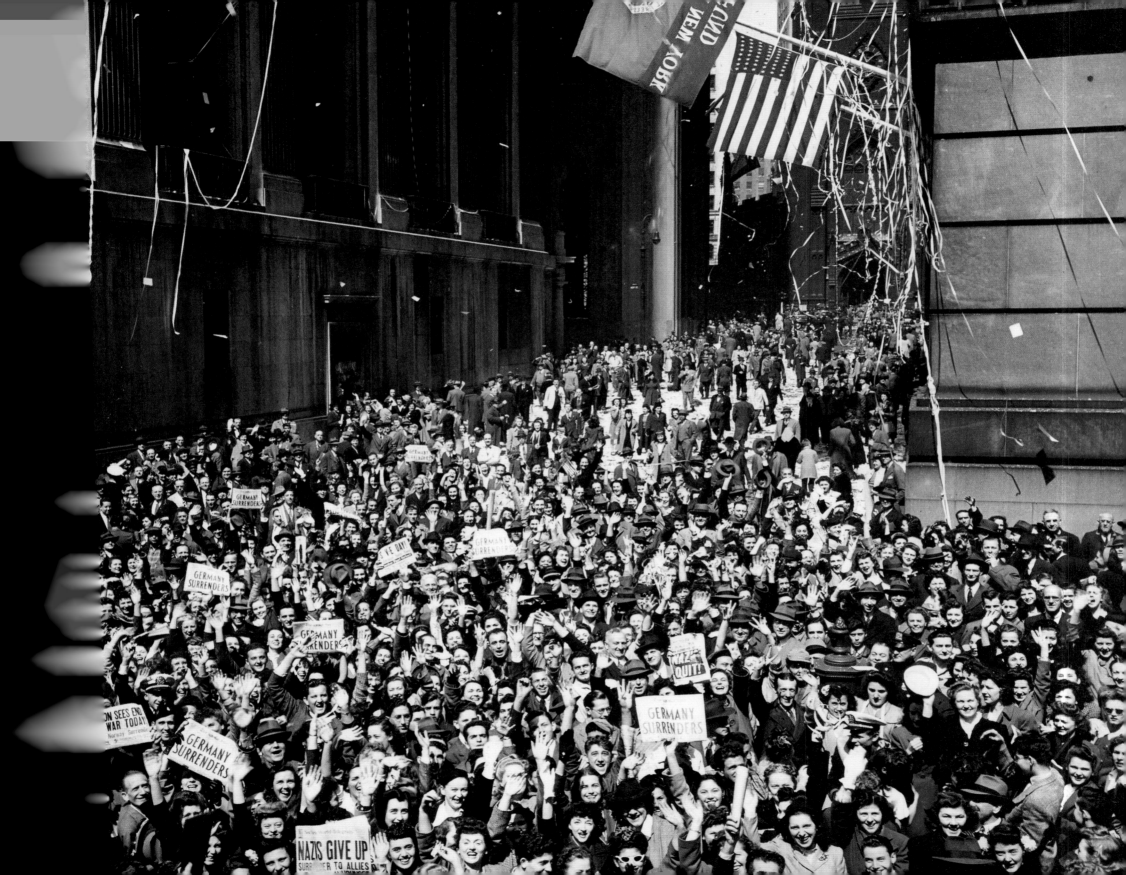

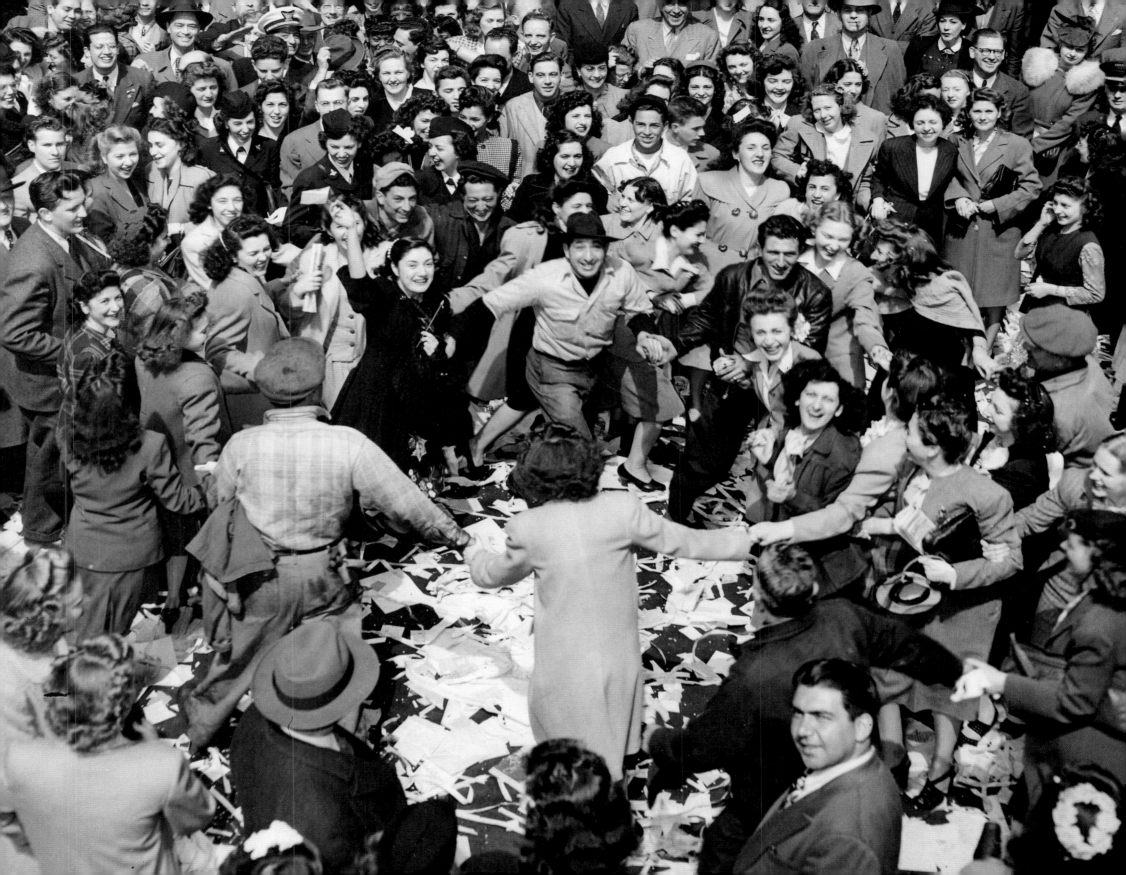

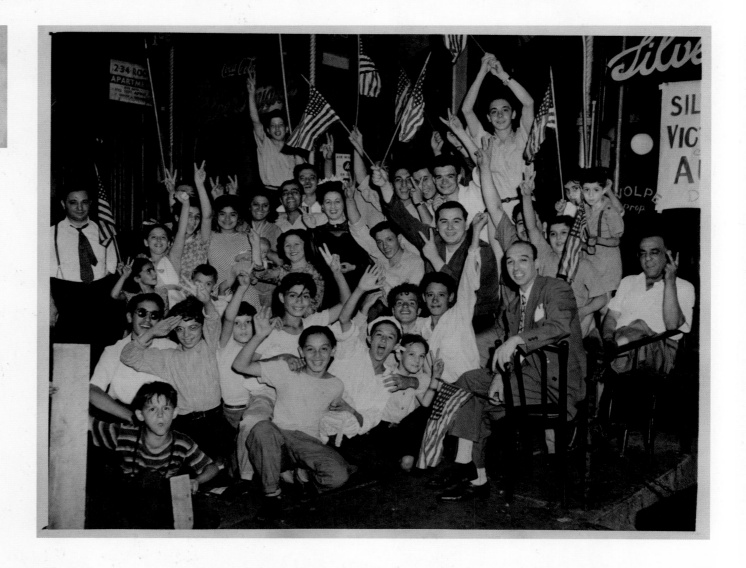

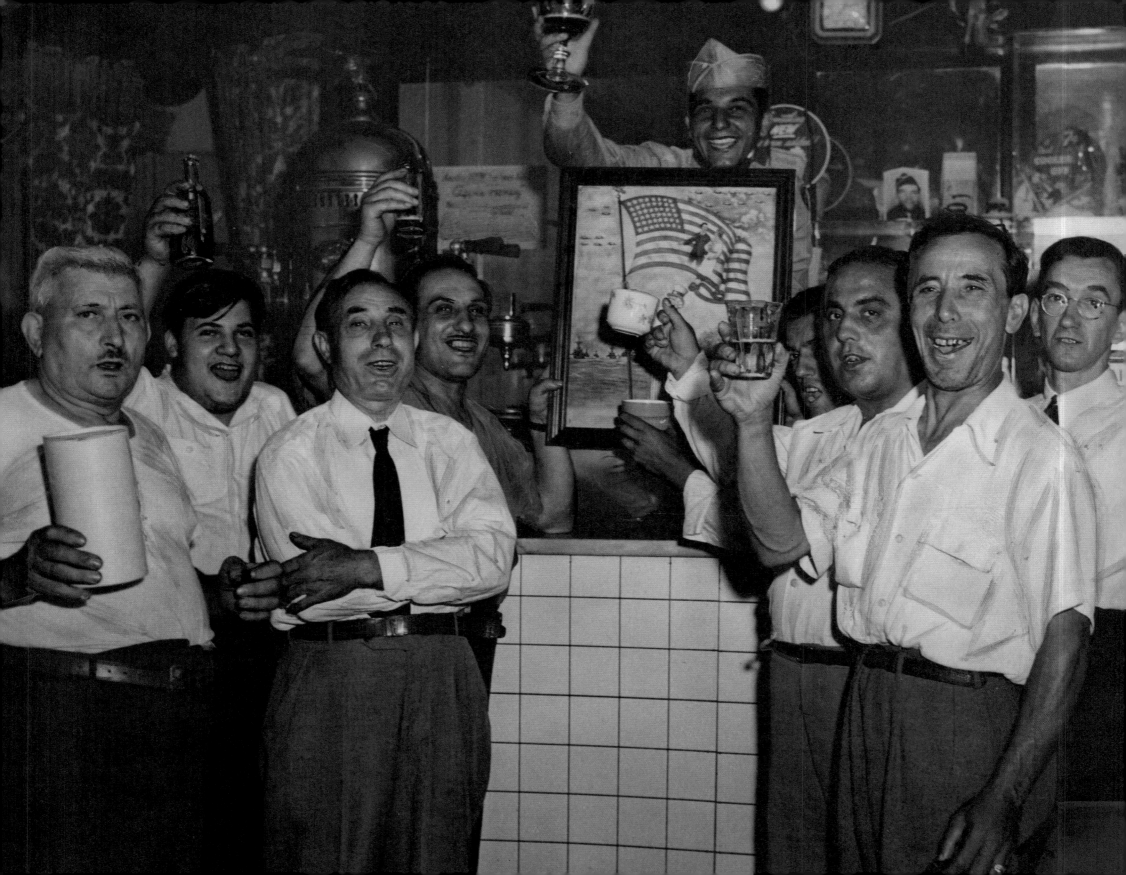

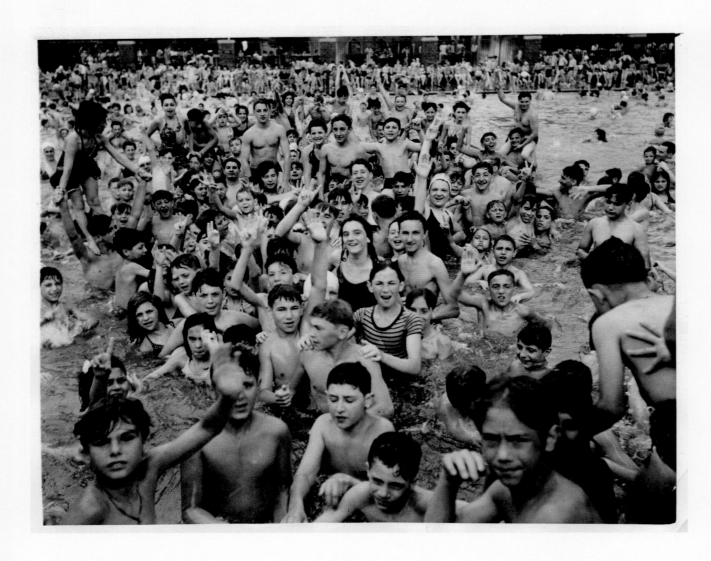

ANYWAY, IT FEELS COOL
NEW YORK CITY--More fortunate than hundreds of
others who couldn't find room in the crowded
pool in Hamilton Fish Park on New York's lower
East Side, these seekers of relief from the
mounting mercury haven't much room to move
around but even a little share of the water
feels great to them.
CREDIT LINE(ACME) 43 Burs New Buff 80 (GM)

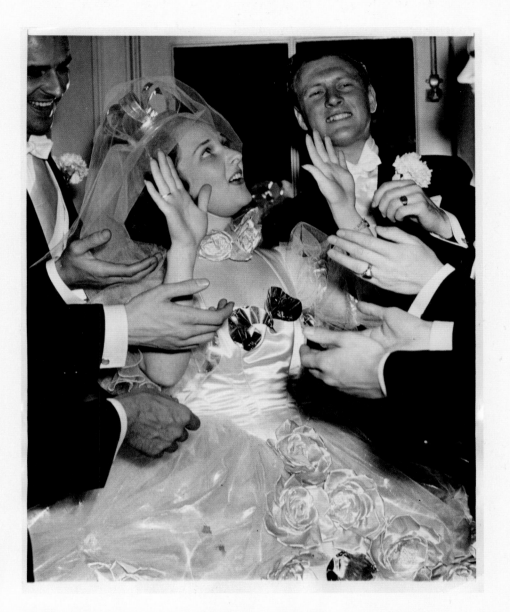

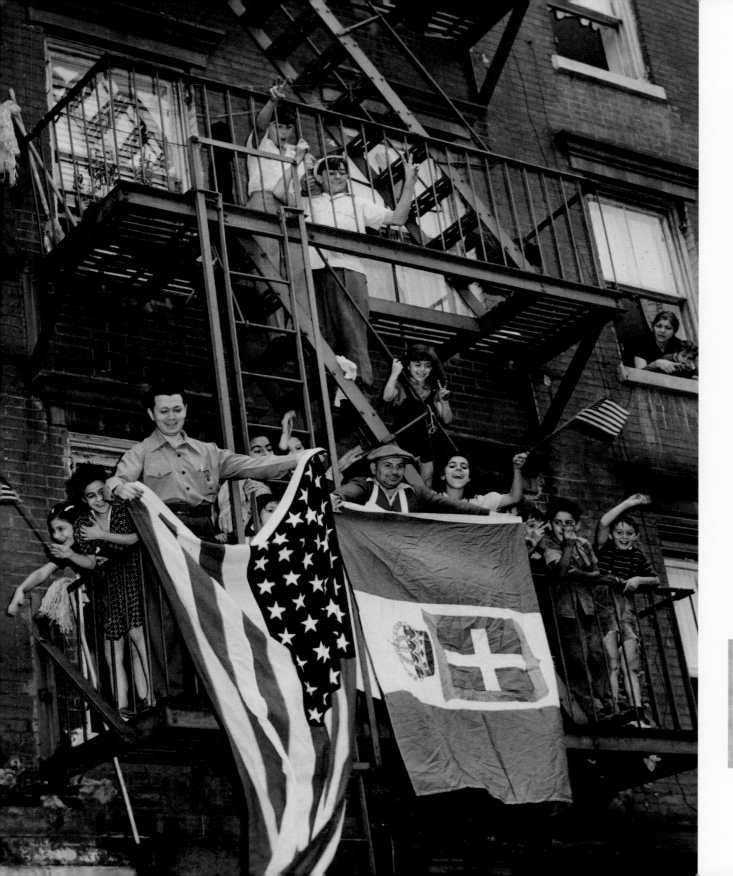

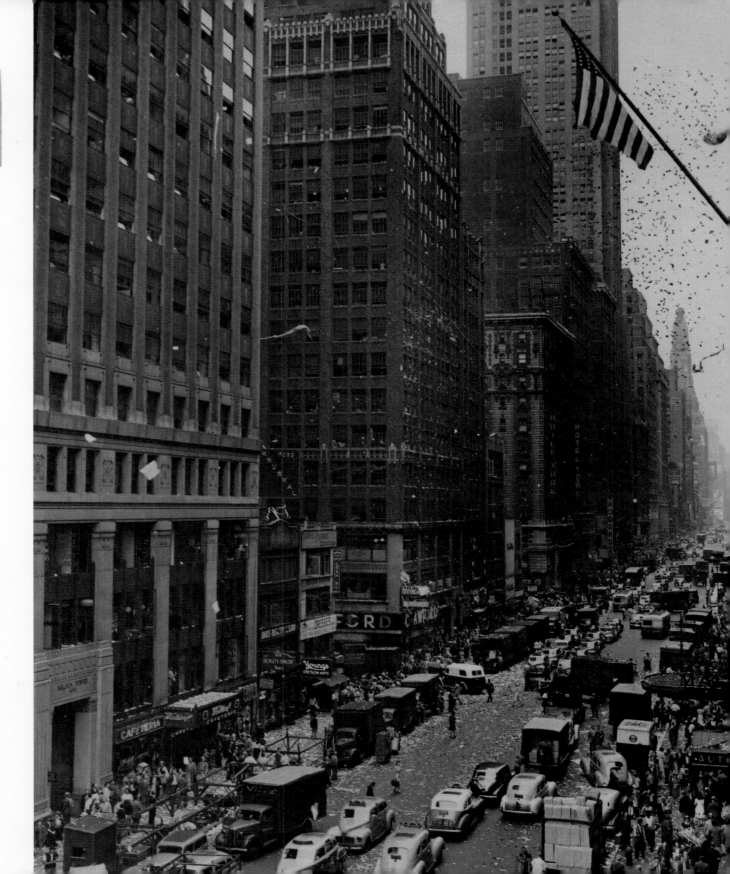

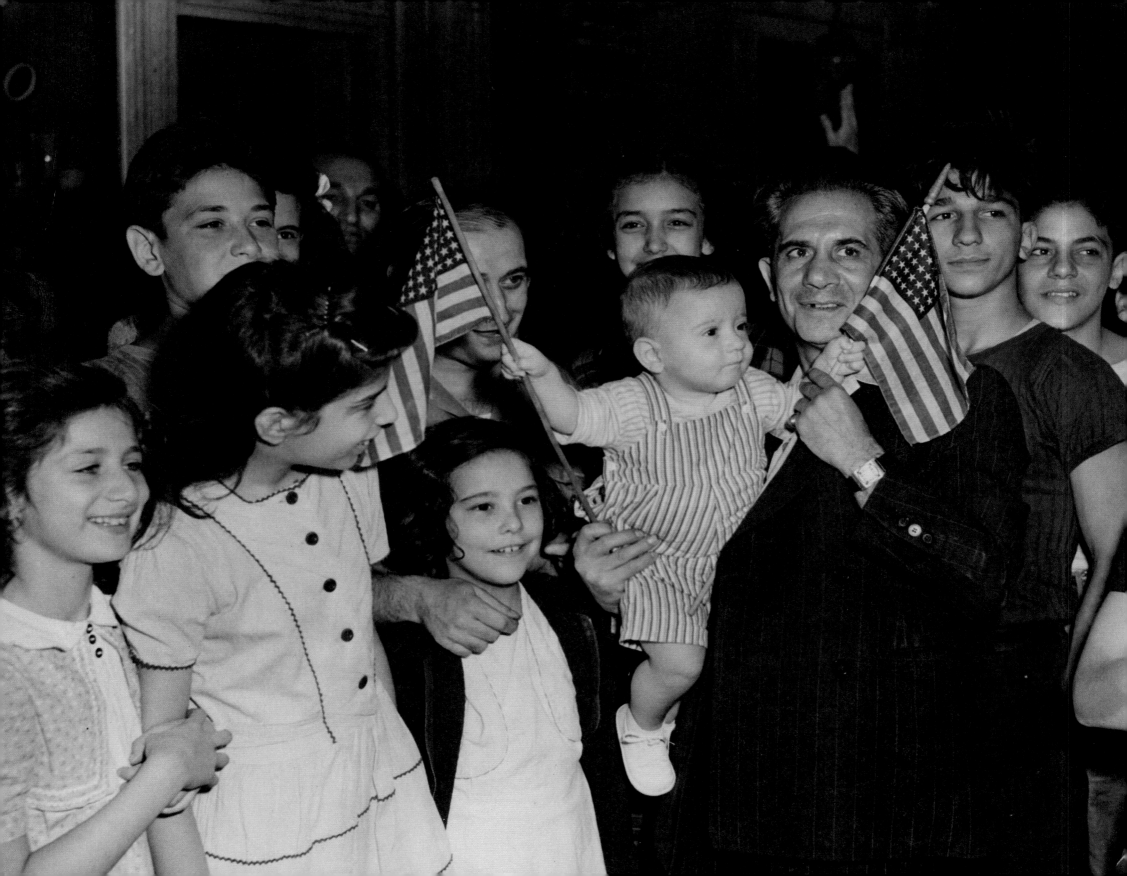

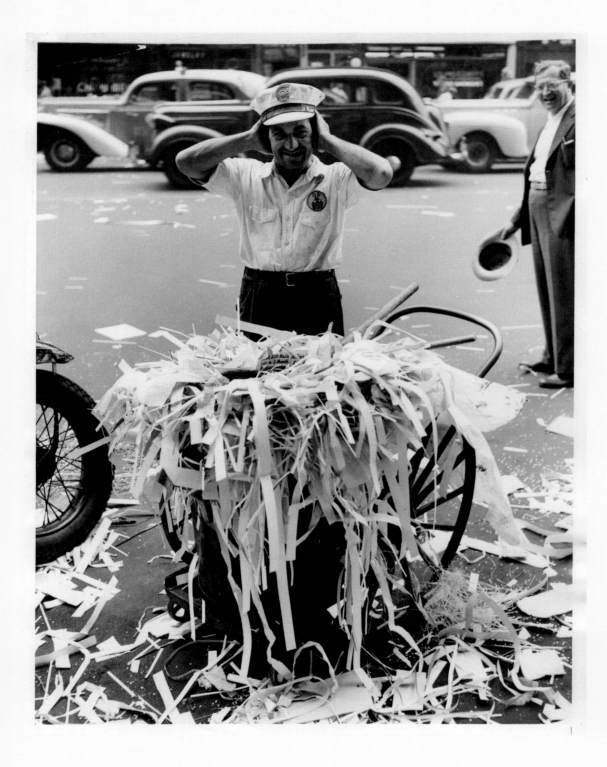

136

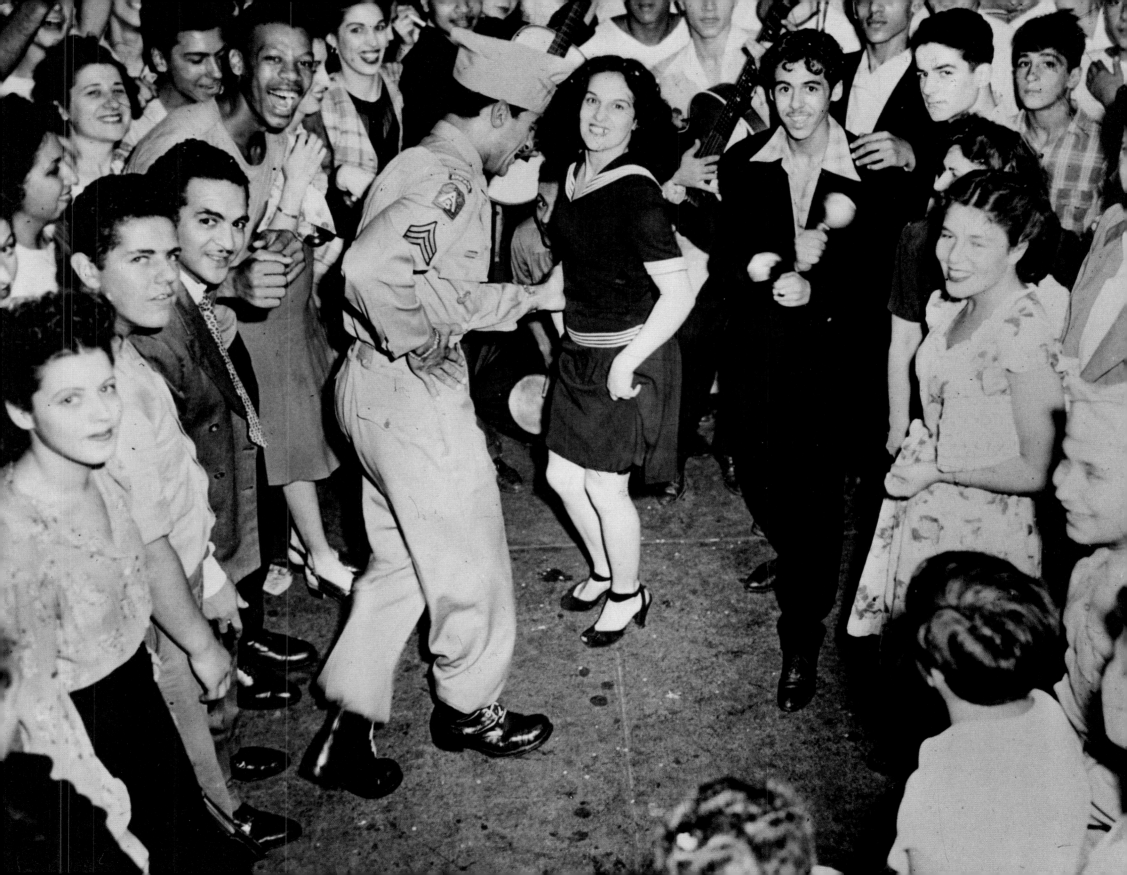

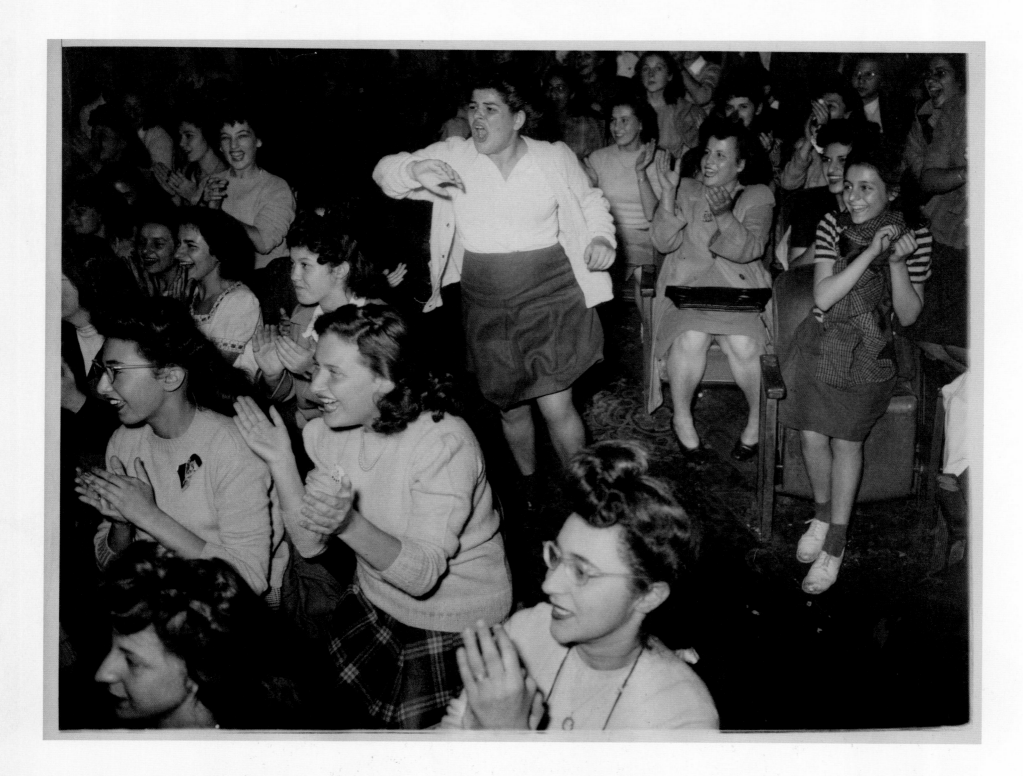

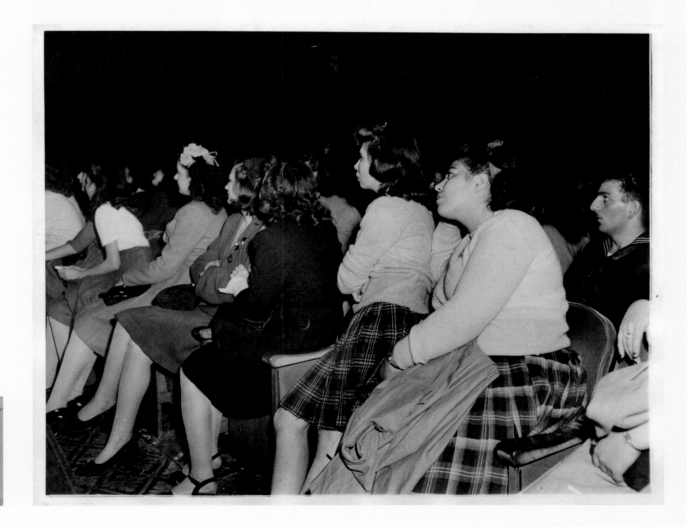

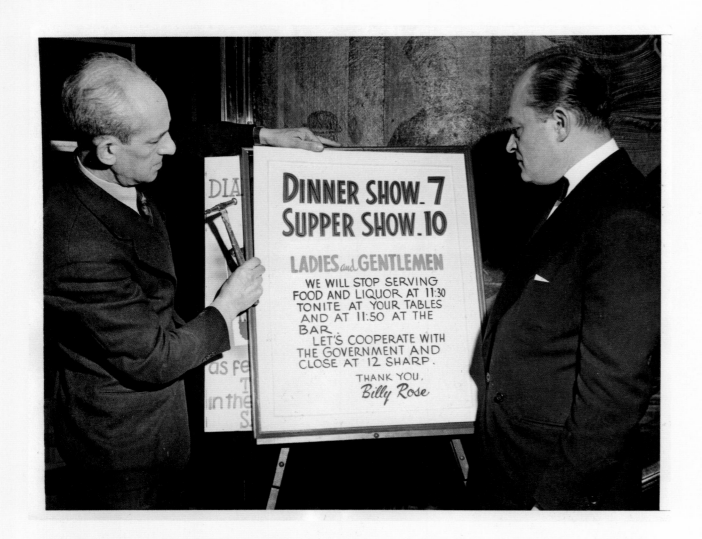

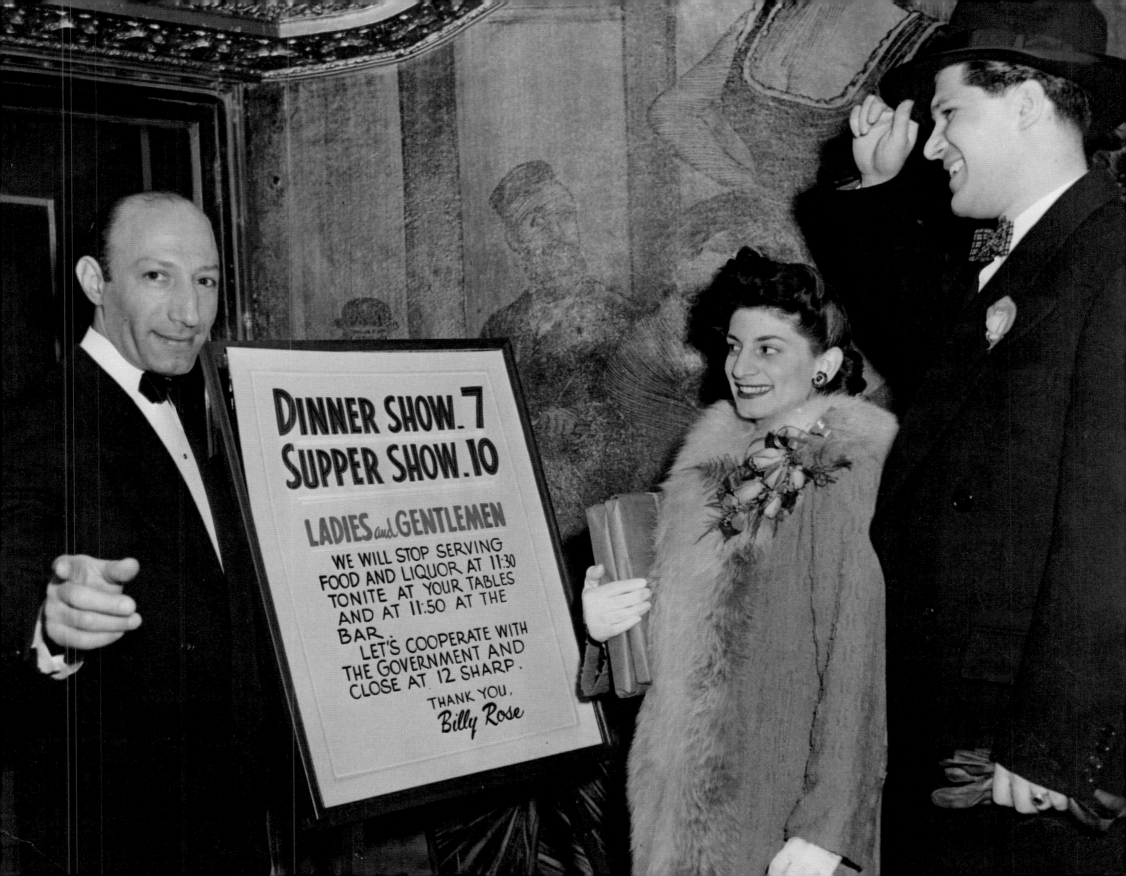

DINNER SHOW.7
SUPPER SHOW.10

LADIES and GENTLEMEN

WE WILL STOP SERVING
FOOD AND LIQUOR AT 11:30
TONITE AT YOUR TABLES
AND AT 11:50 AT THE
BAR.
LET'S COOPERATE WITH
THE GOVERNMENT AND
CLOSE AT 12 SHARP.

THANK YOU,
Billy Rose

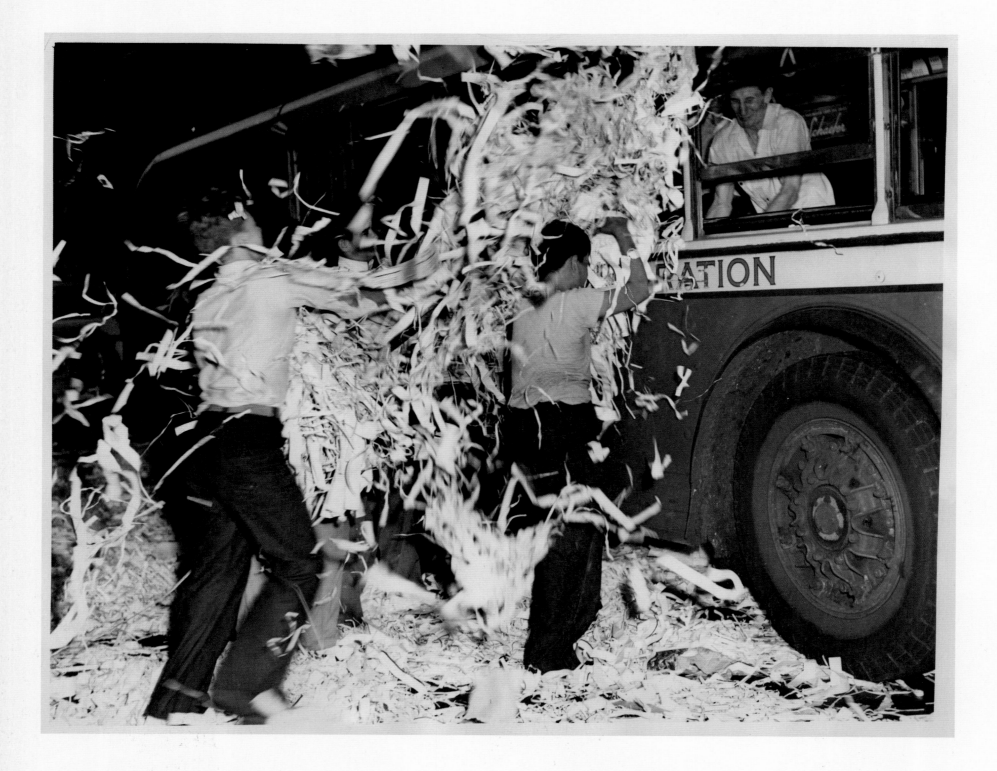

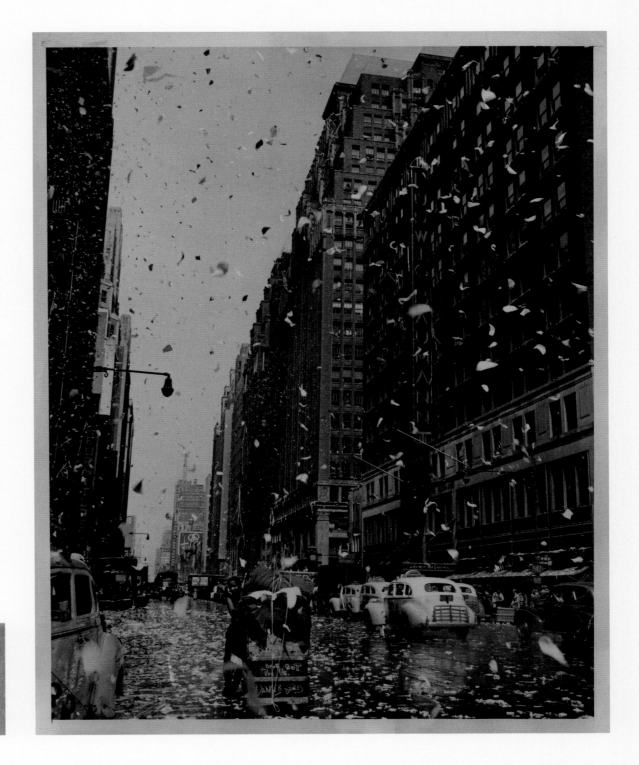

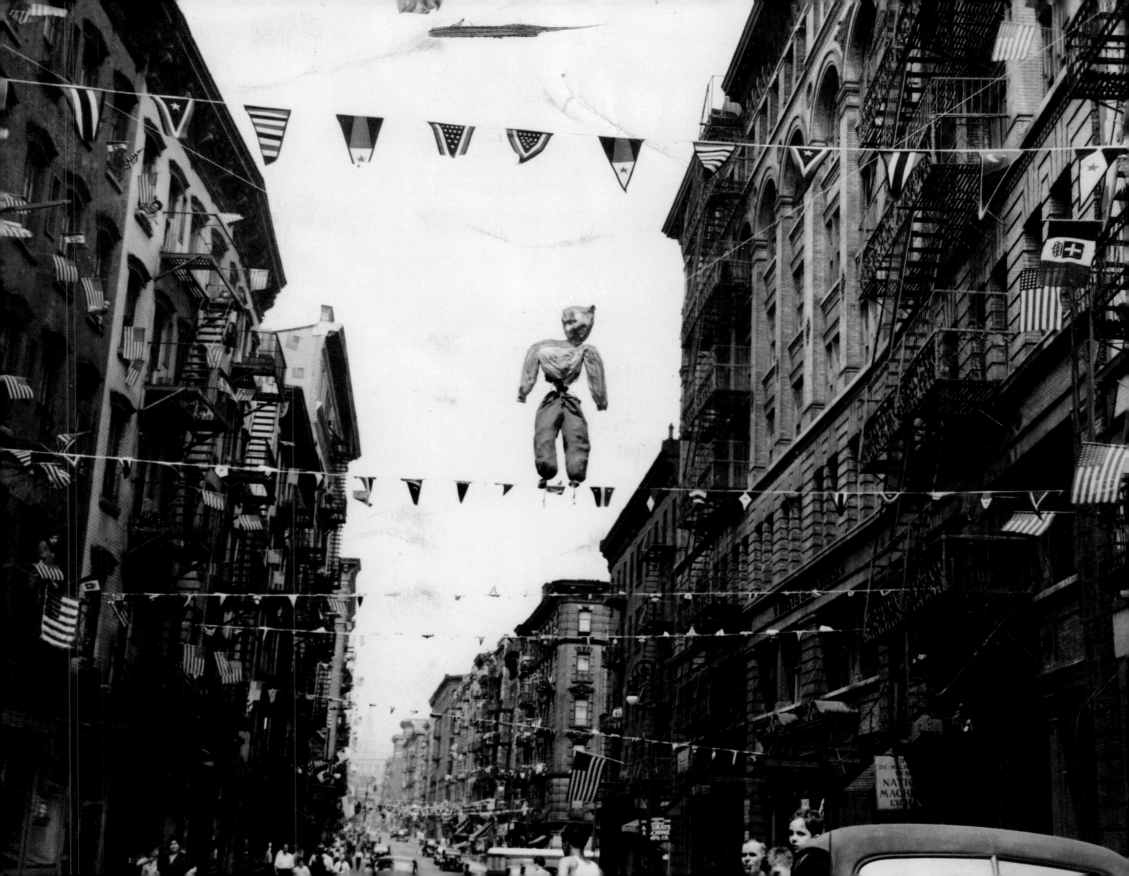

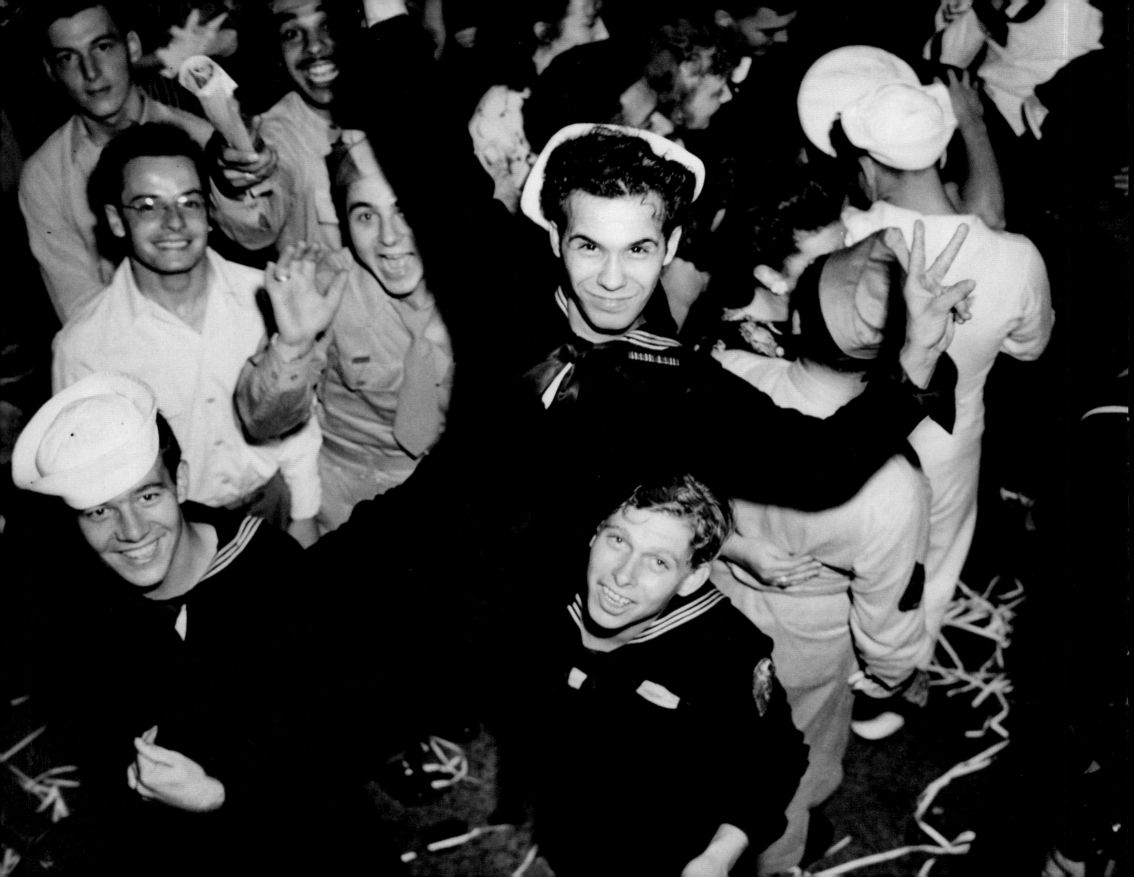

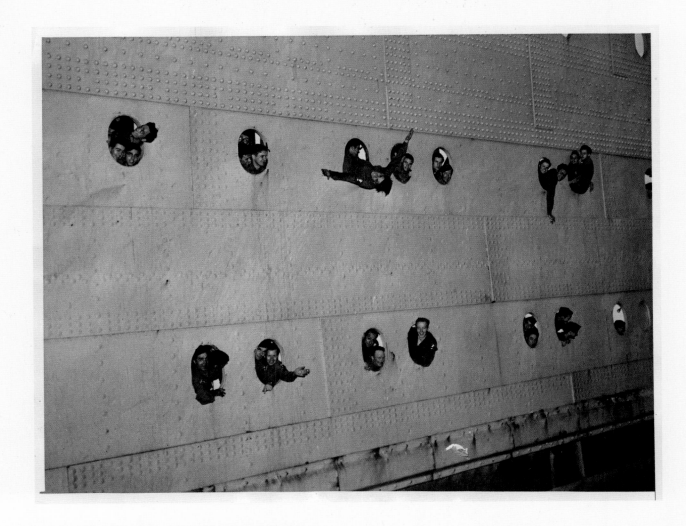

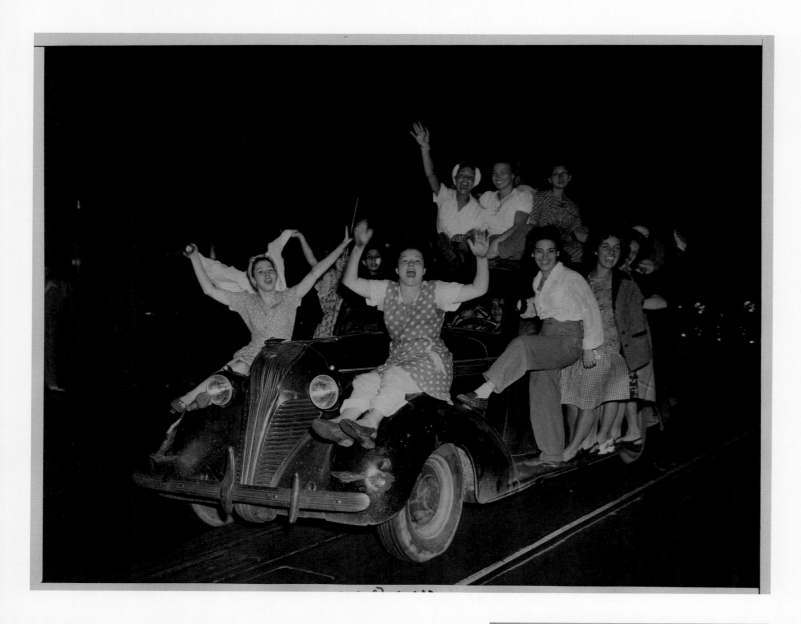

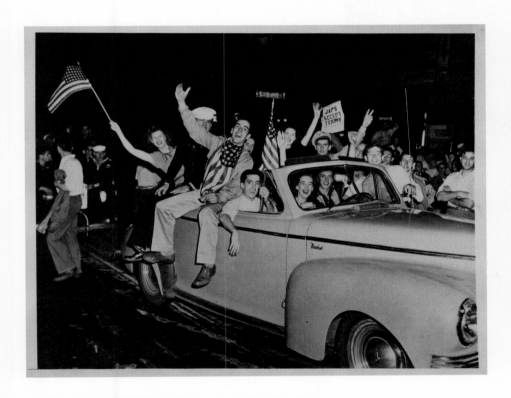

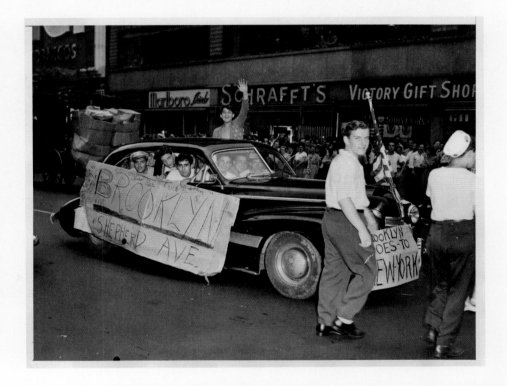

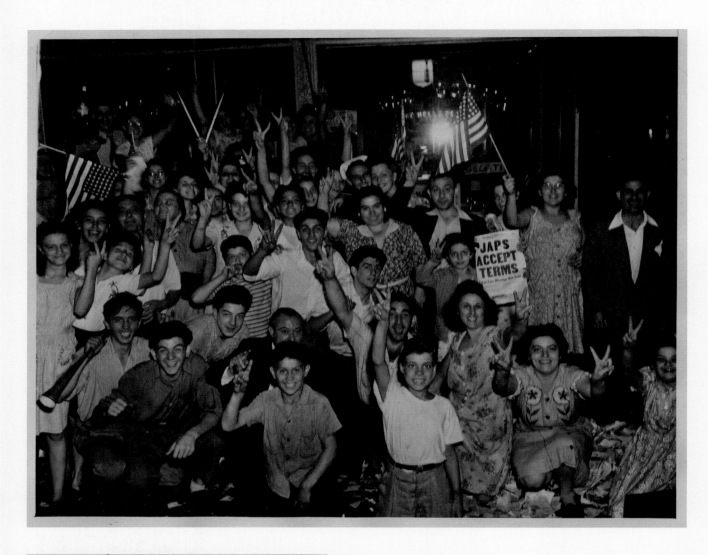

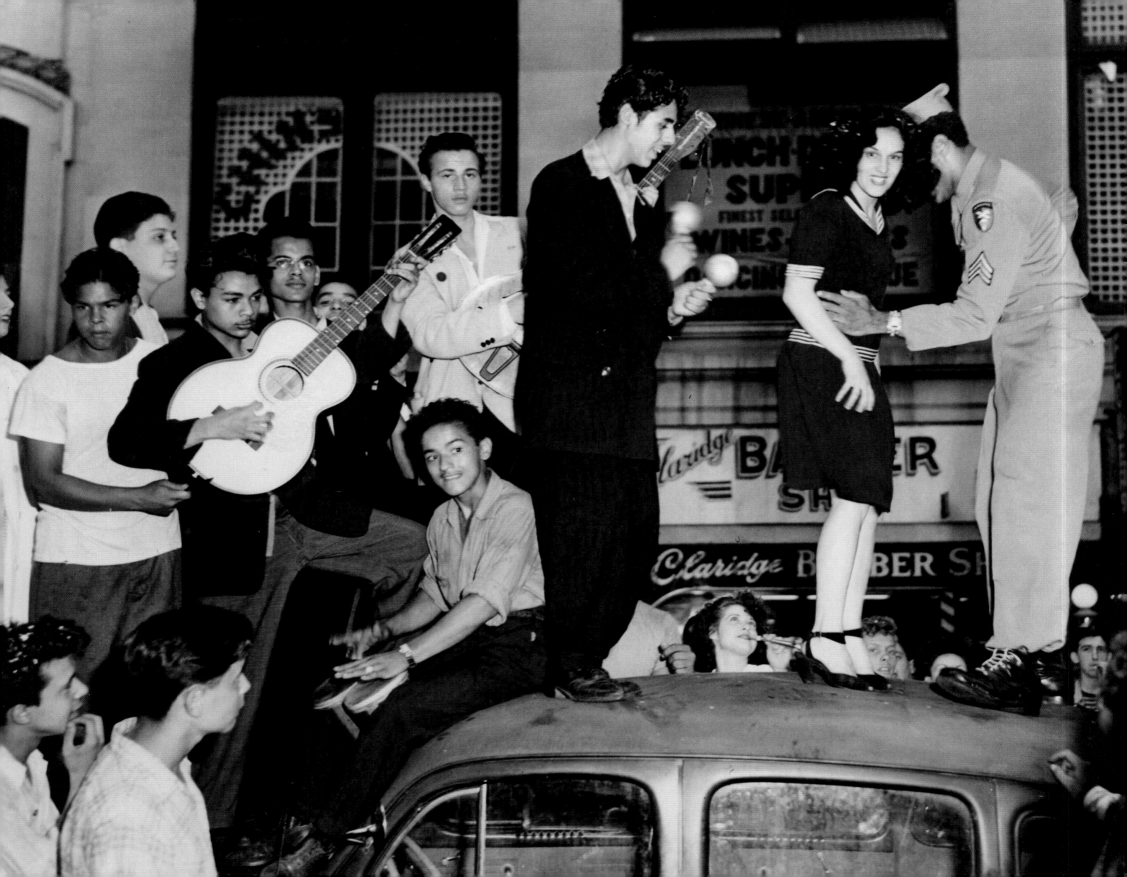

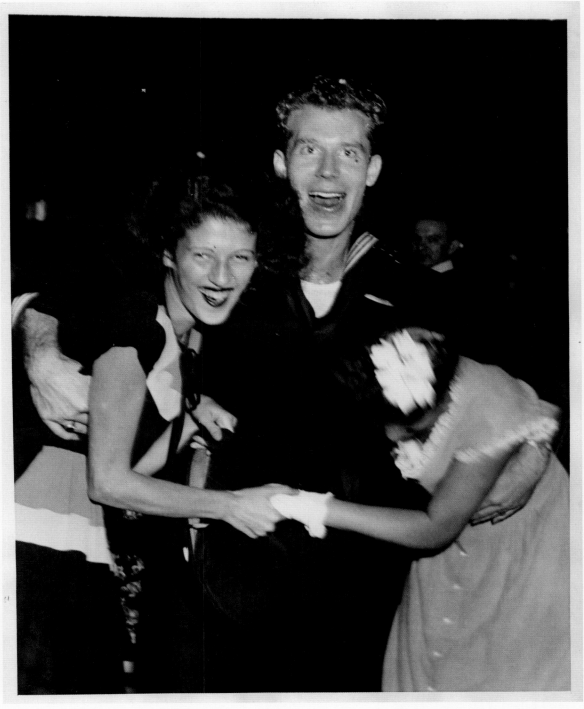

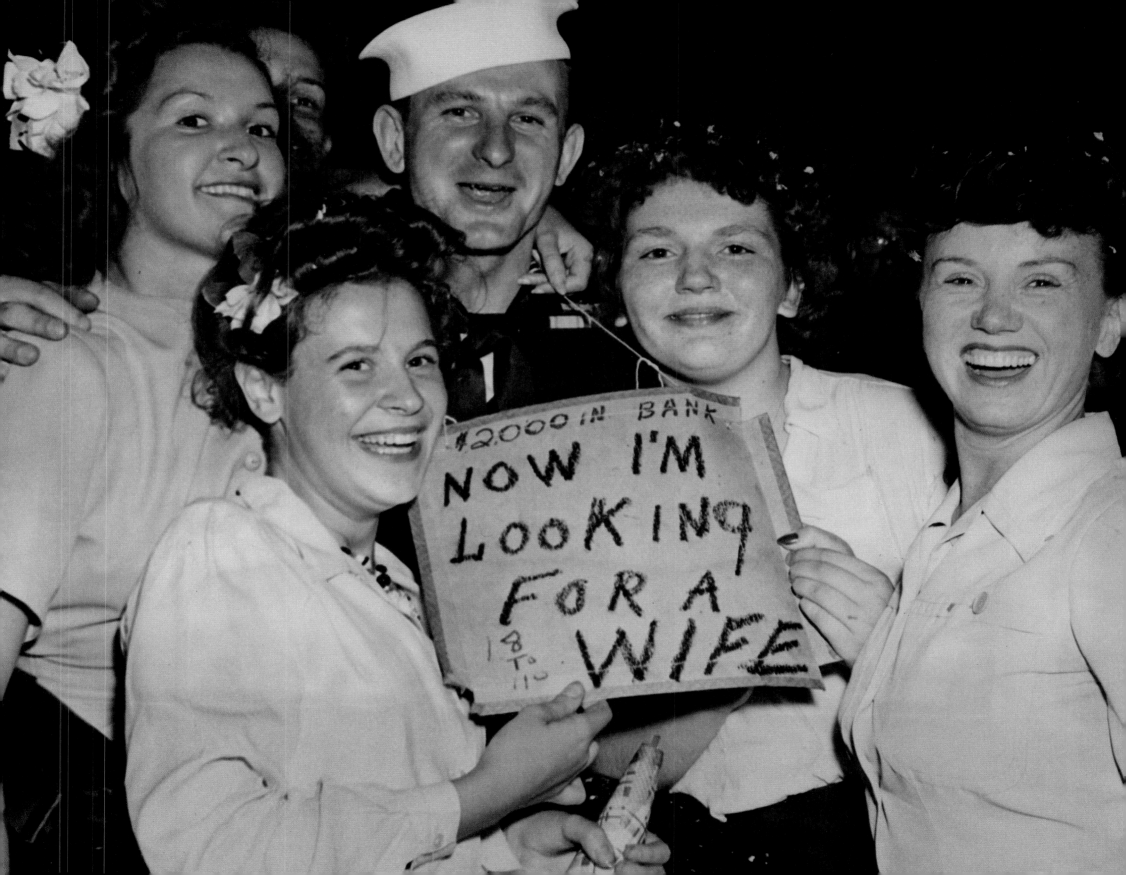

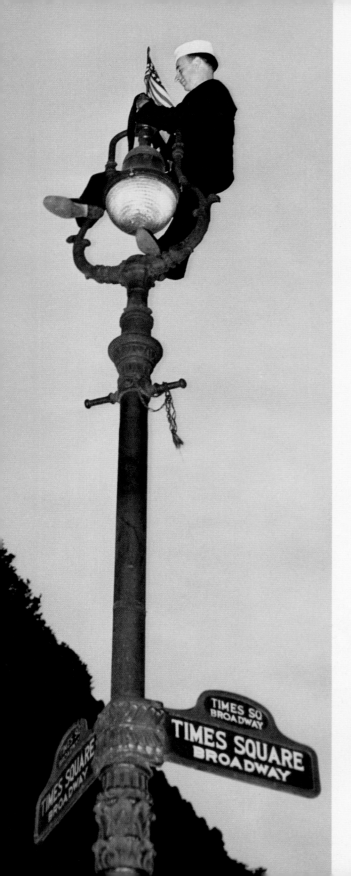

TIMES SQ
BROADWAY

TIMES SQUARE
BROADWAY

TIMES SQUARE
BROADWAY

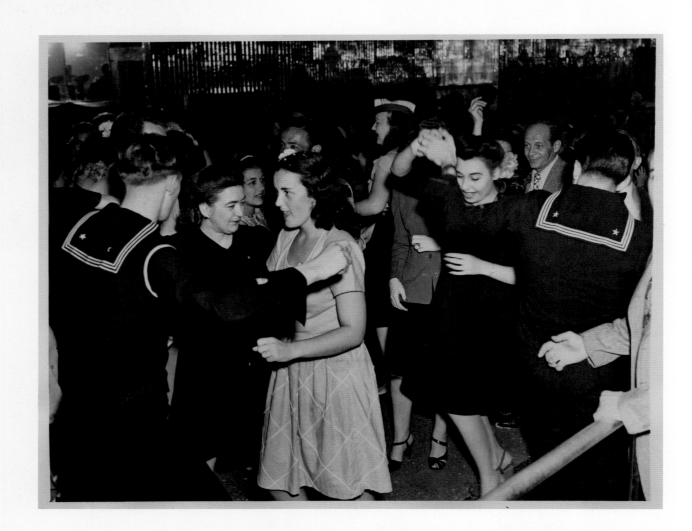

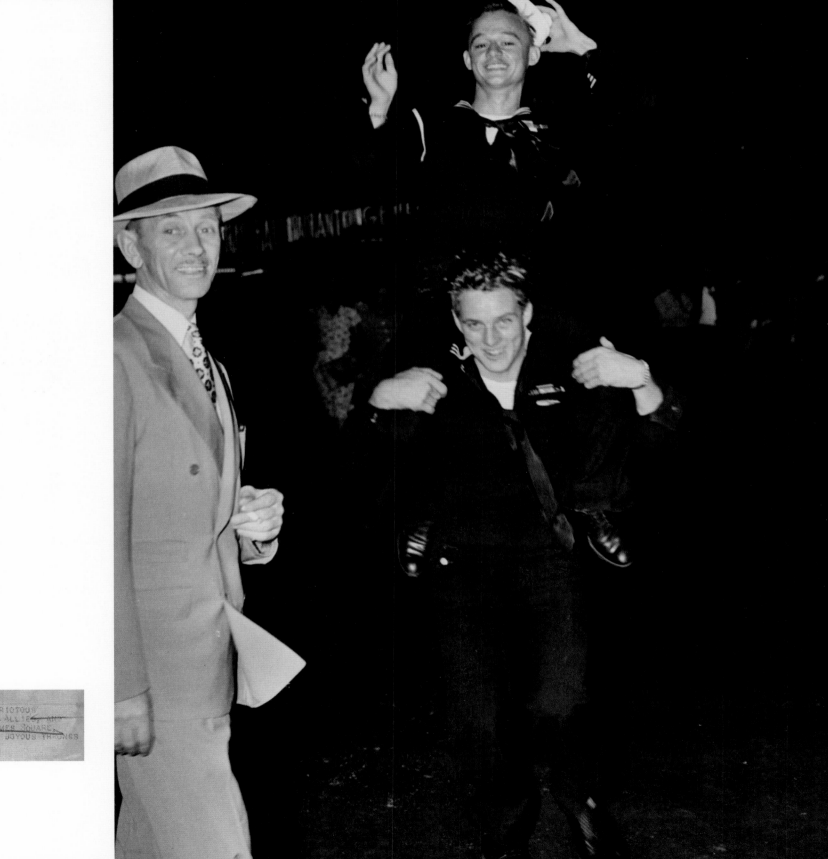

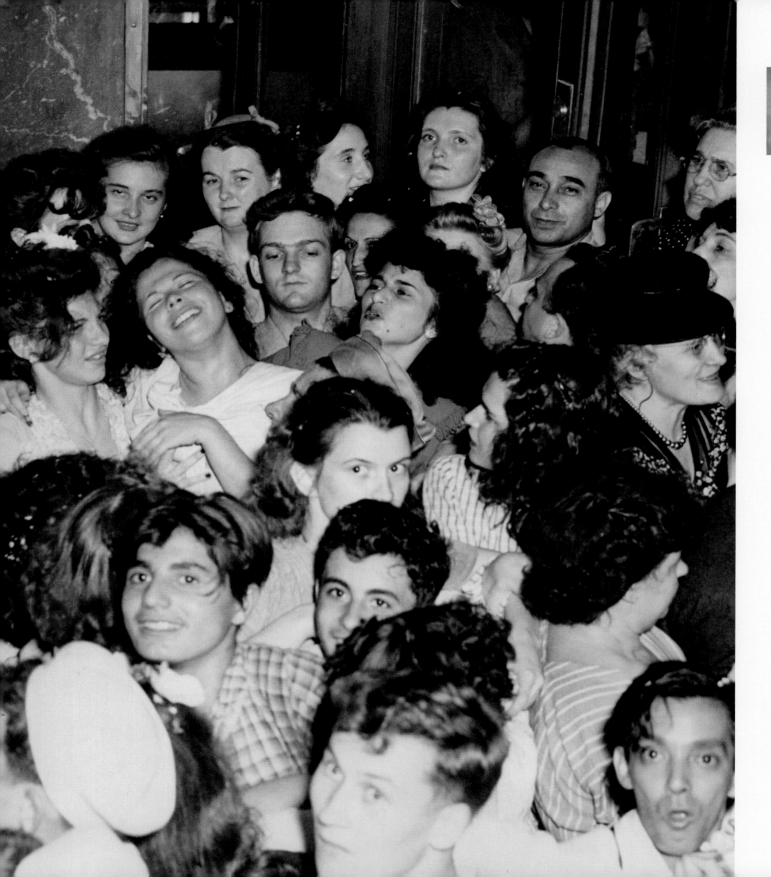

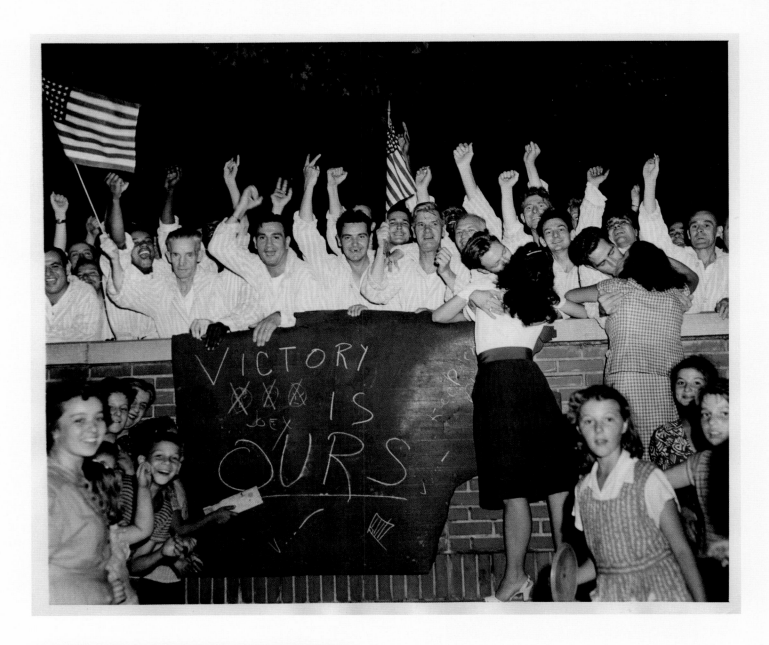

"PAJAMA PARTY"
NEW YORK --- VICTORY IS SWEET FOR THESE VETERANS AT
THE VETERANS' HOSPITAL, KINGSBRIDGE ROAD AND
SEDGEWICK AVE., THE BRONX, AND THE OBLIGING YOUNG
LADIES GIVE THE PAJAMA-CLAD LADS THEIR JUST DUES,
AS EVEN THE HOSPITAL WALLS FAIL TO SQUELCH THE
JOYOUS CELEBRATIONS OF JAPAN'S SURRENDER TO THE ALLIES
ALL OF NEW YORK ECHOED WITH THE TUMULTOUS CELEBRATION
CREDIT (ACME) 8/14/45 (AC)

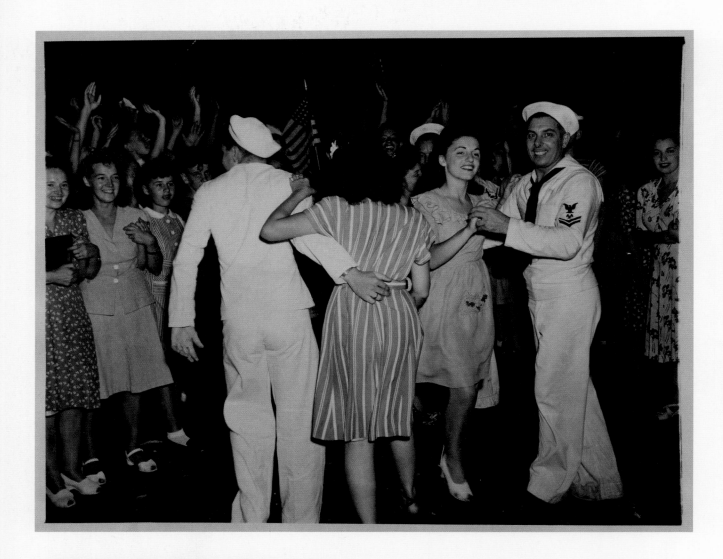

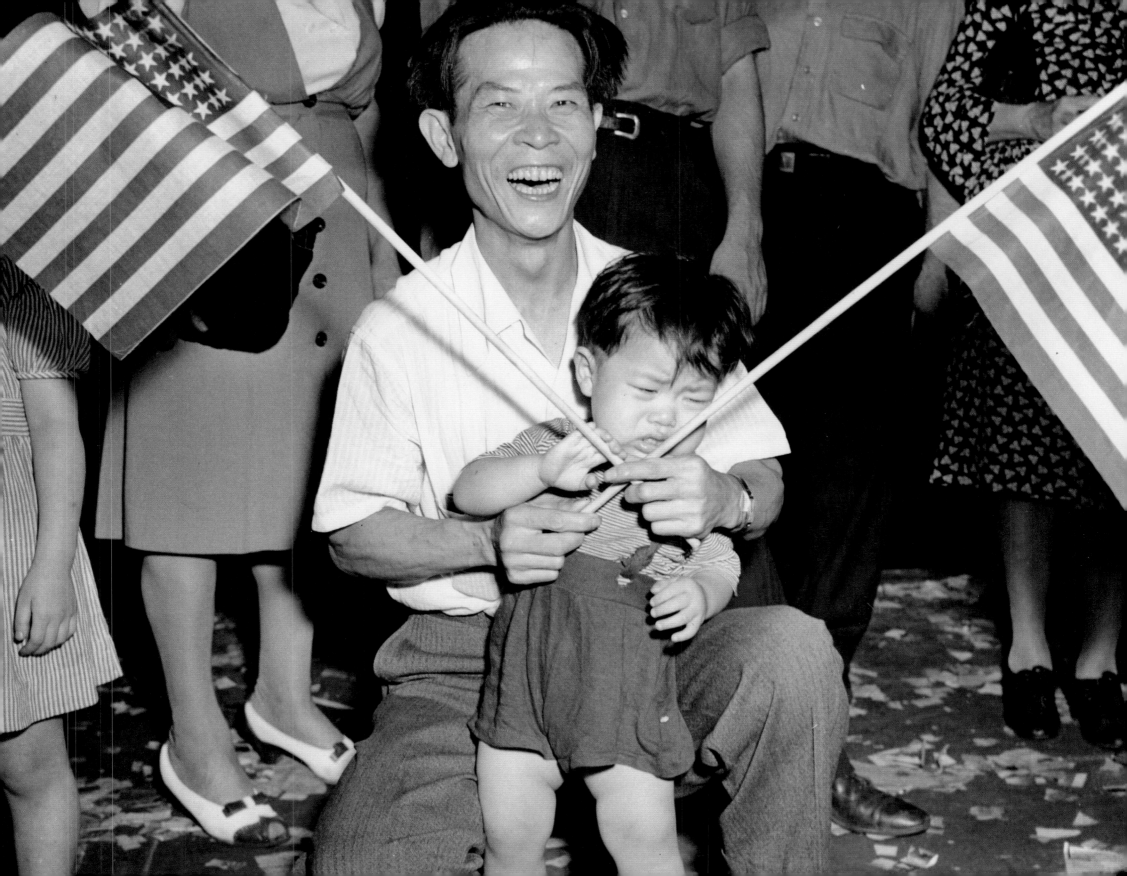

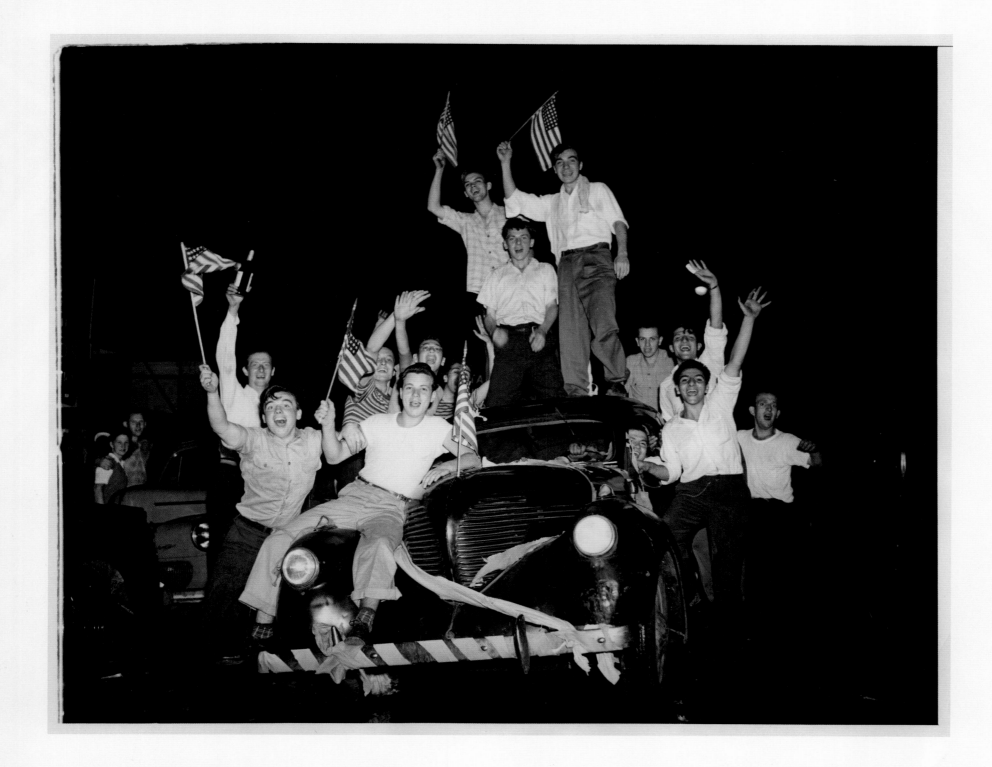

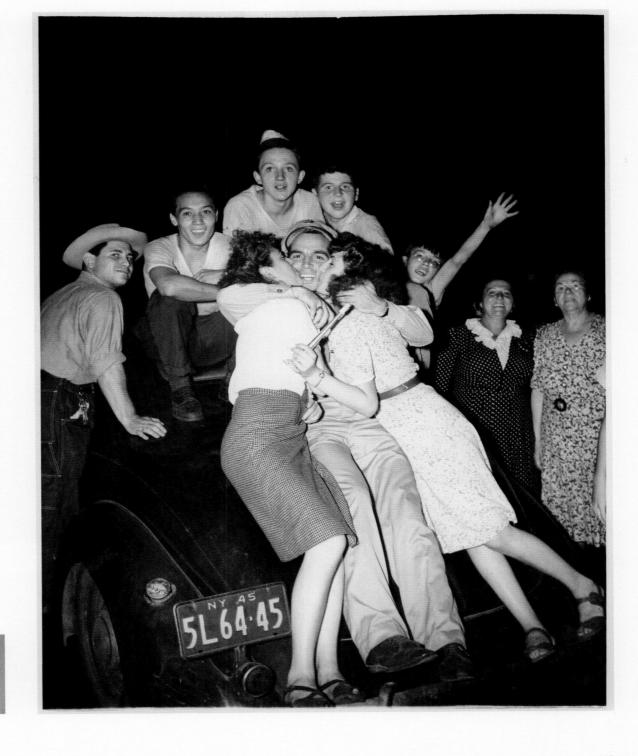

164

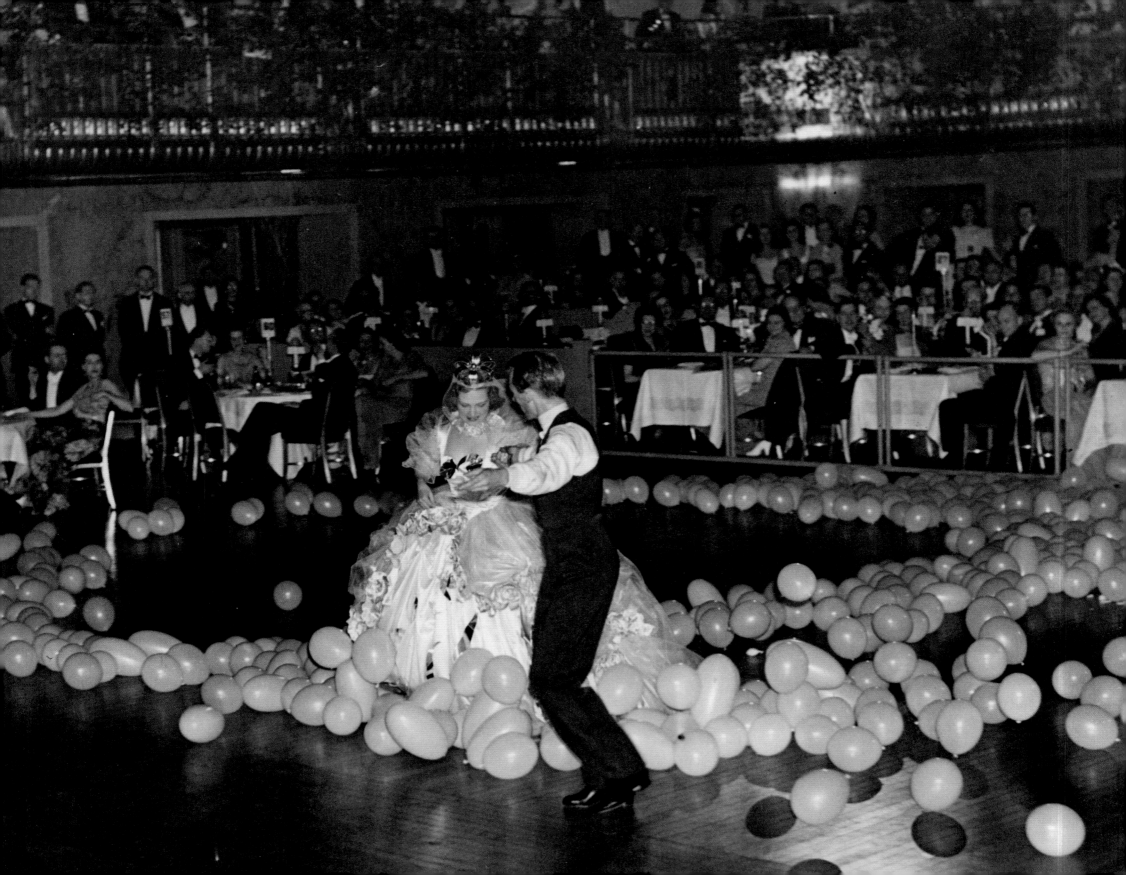

EXTRA!
FINE

"PRINCE CHARMING" TO THE RESCUE
NEW YORK. Miss POLLY HARVEY, APPEARING AS
"CINDERELLA" AT THE CINDERELLA BALL HELD
AT THE WALDORF-ASTORIA FOR THE BENEFIT OF
THE NATIONAL ASSOCIATION OF DAY NURSERIES,
INC., IS RUSHED OFF THE FLOOR BY "PRINCE
CHARMING," PLAYED BY DANCER PAUL DRAPER, AT
THE CONCLUSION OF THEIR DANCE DURING THE
CINDERELLA WALTZ.
CREDIT LINE (ACME) 41 NY (SA)

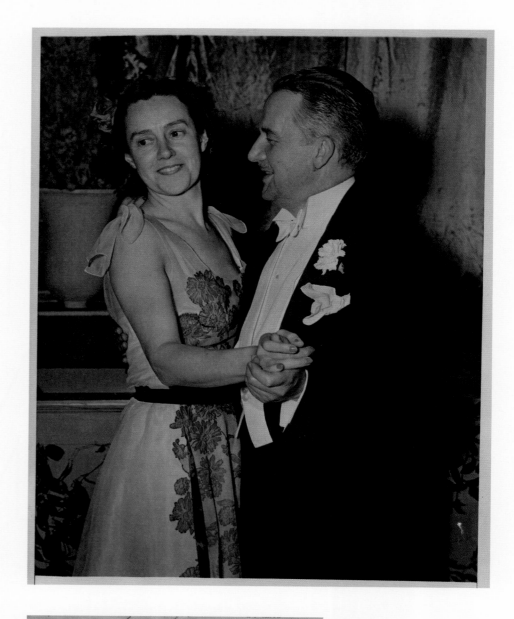

WIN WALTZ CONTEST AT CINDERELLA BALL (SOC. REG.)
NEW YORK.--MR. AND MRS. FRANCIS T. BOYD,
WALTZED OFF WITH THE CINDERELLA WALTZ CONTEST
AT THE CINDERELLA BALL. THE BALL, HELD AT
THE WALDORF-ASTORIA, WAS FOR THE BENEFIT OF
THE NATIONAL ASSOCIATION OF DAY NURSERIES, INC.
CREDIT LINE (ACME) 4-17-41 NY (SA)

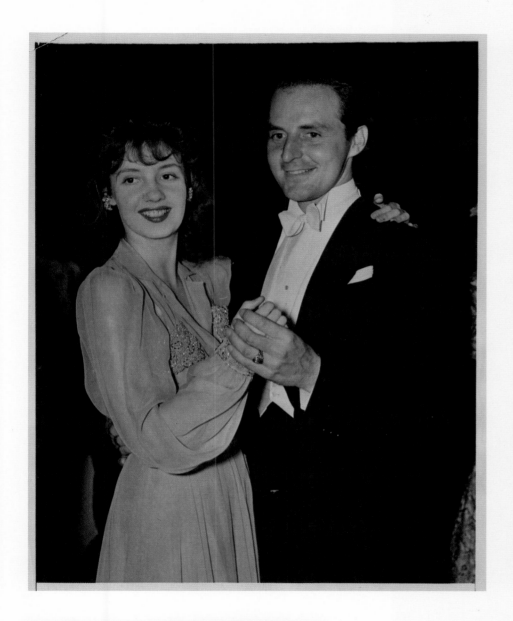

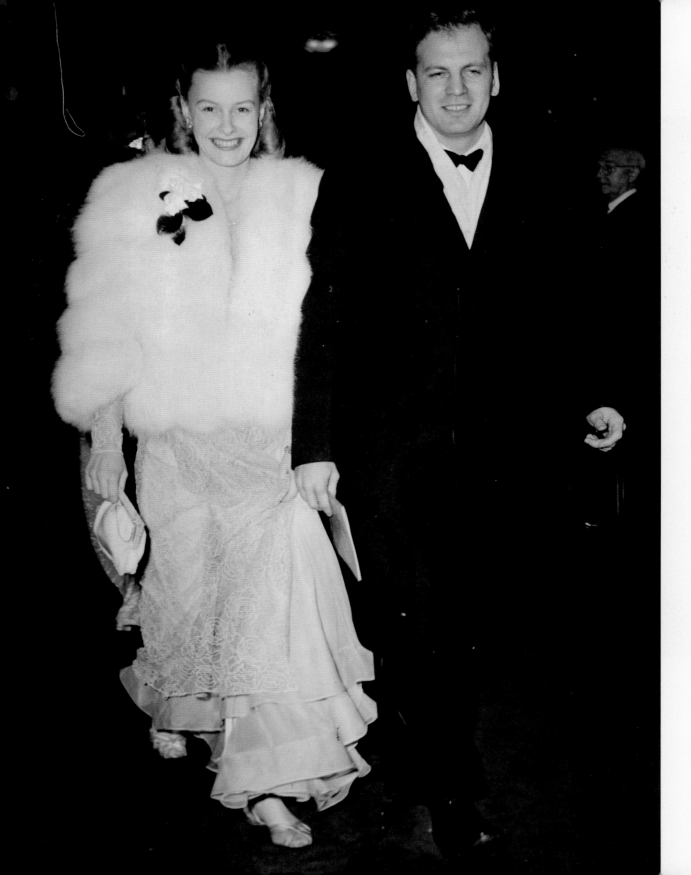

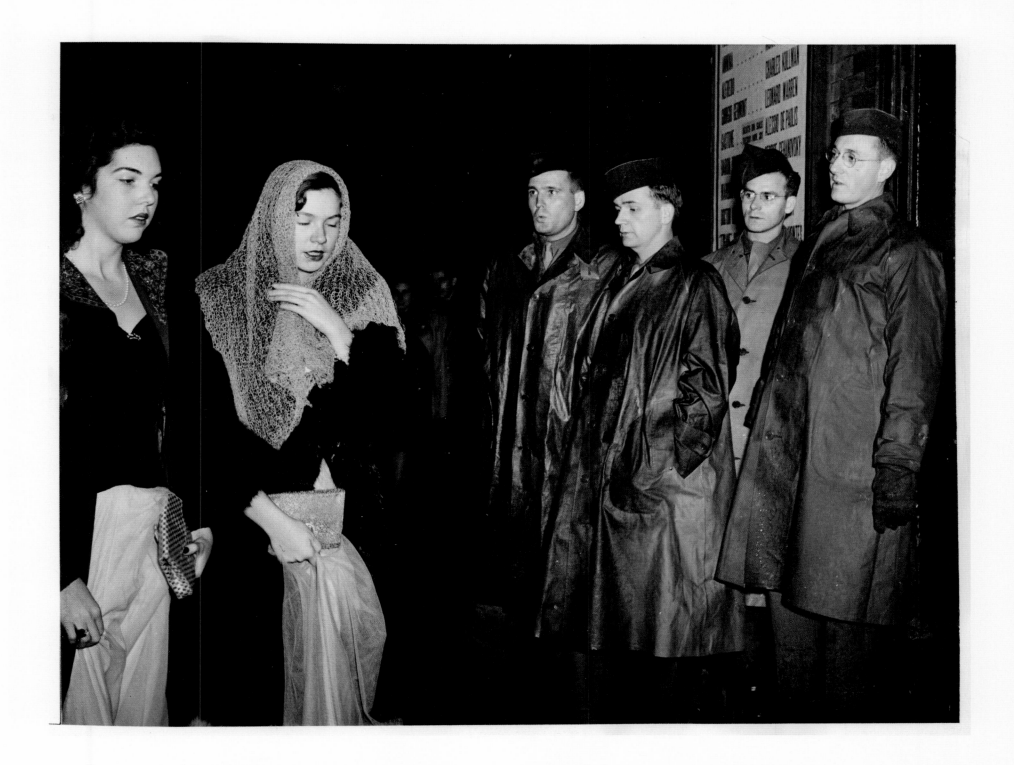

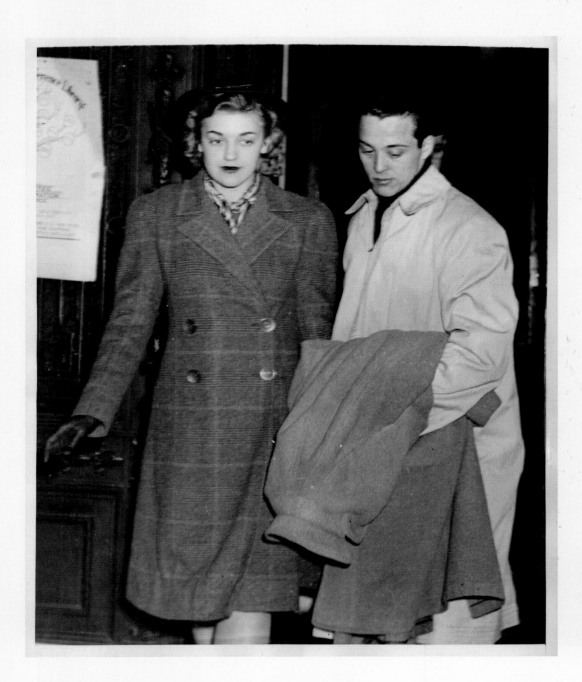

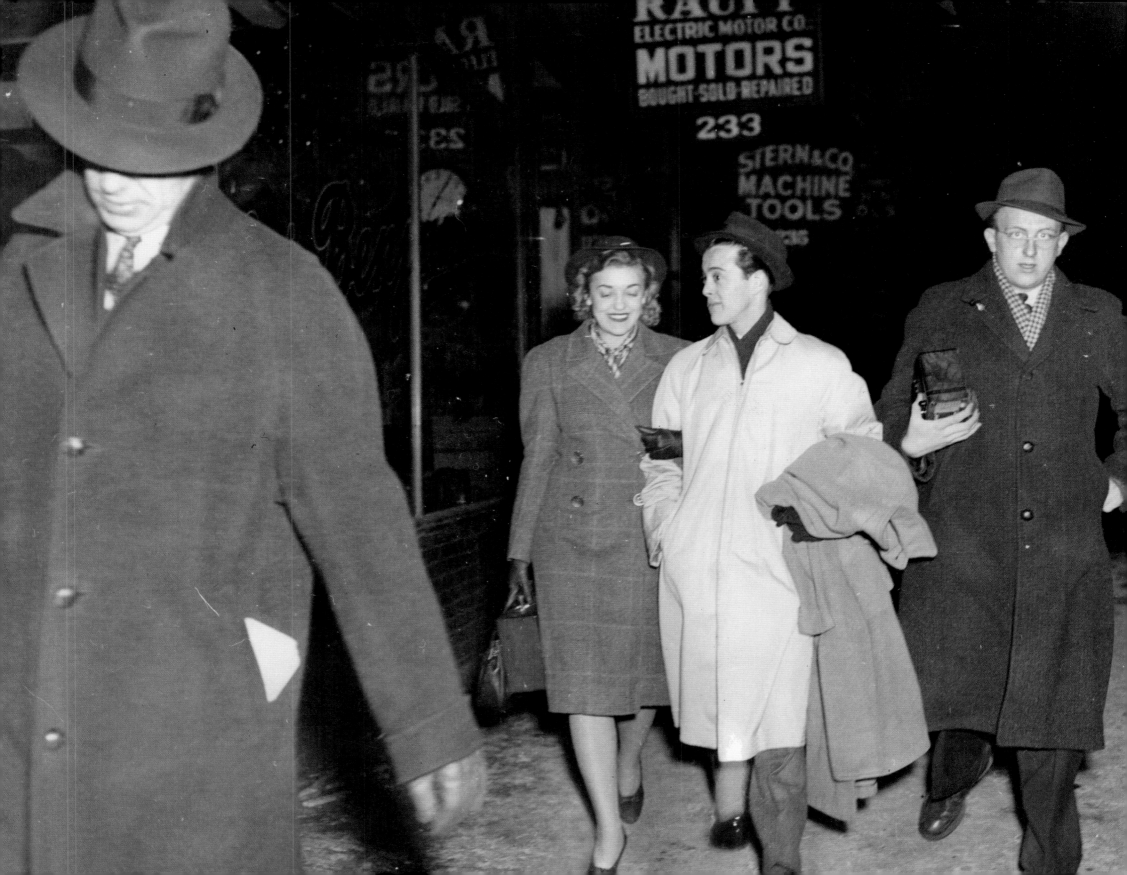

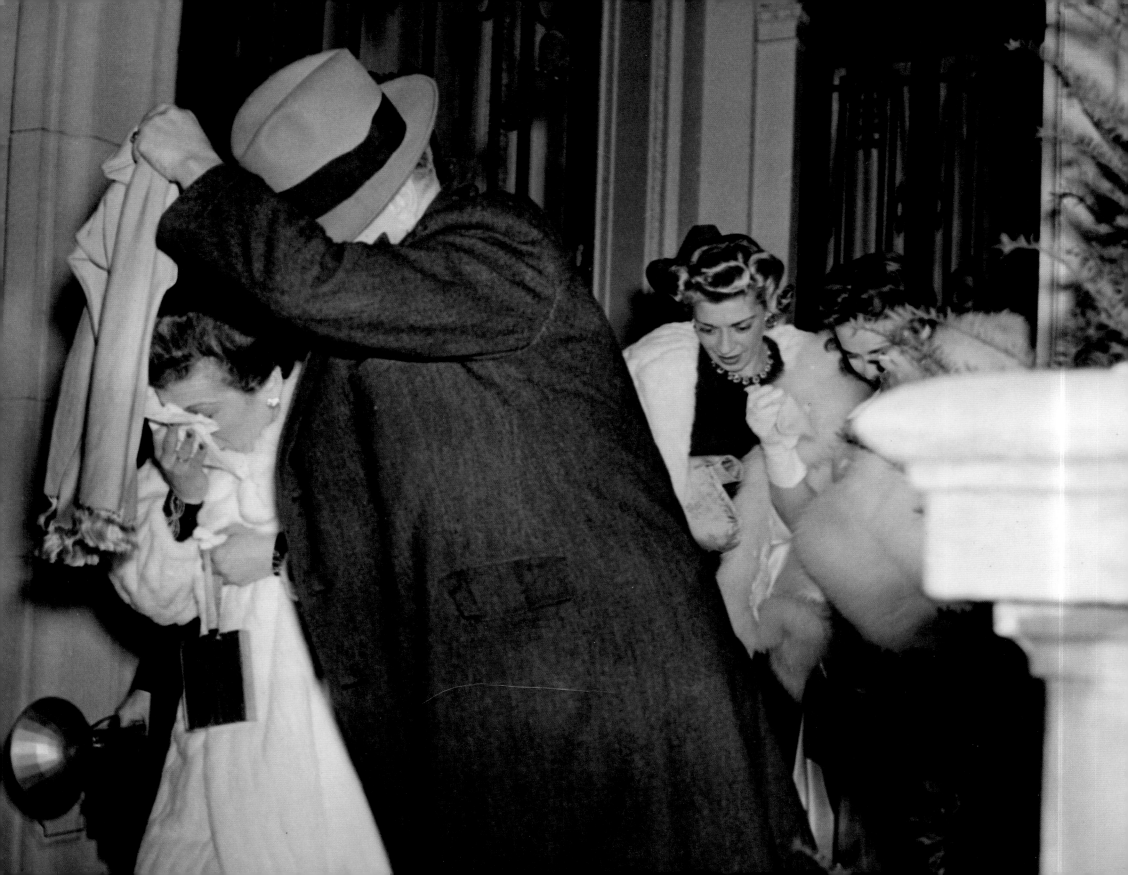

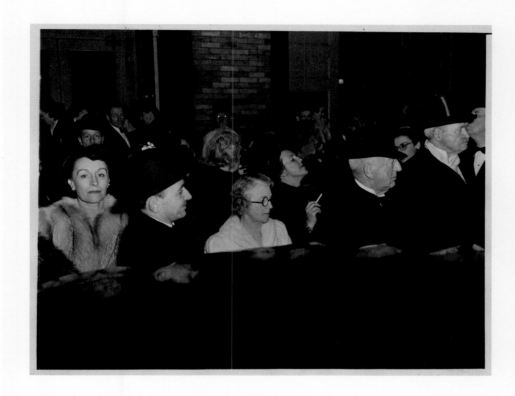

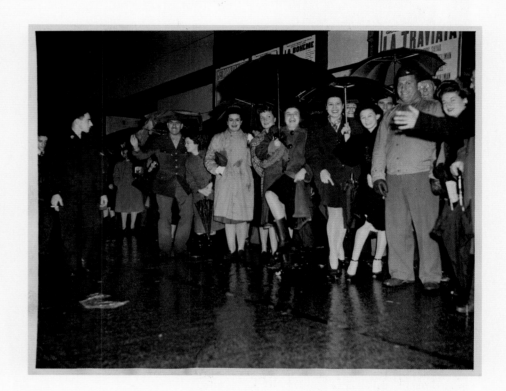

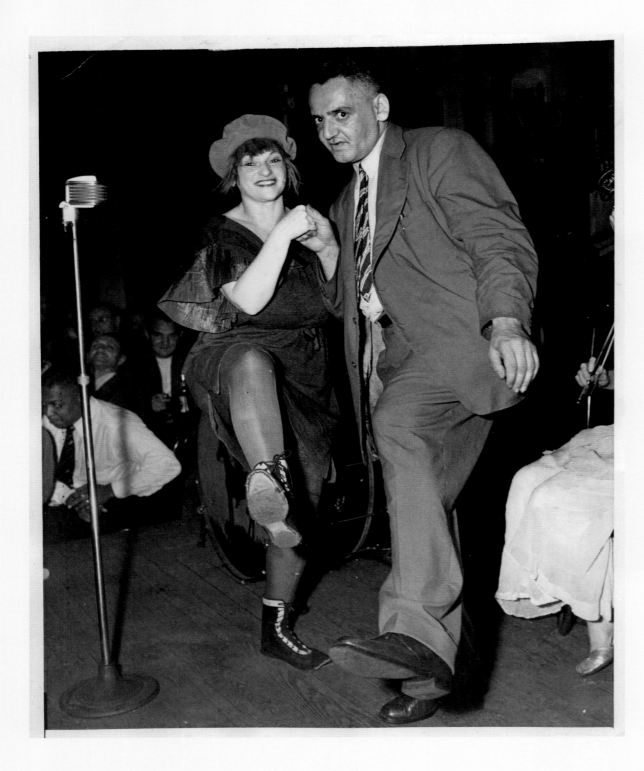

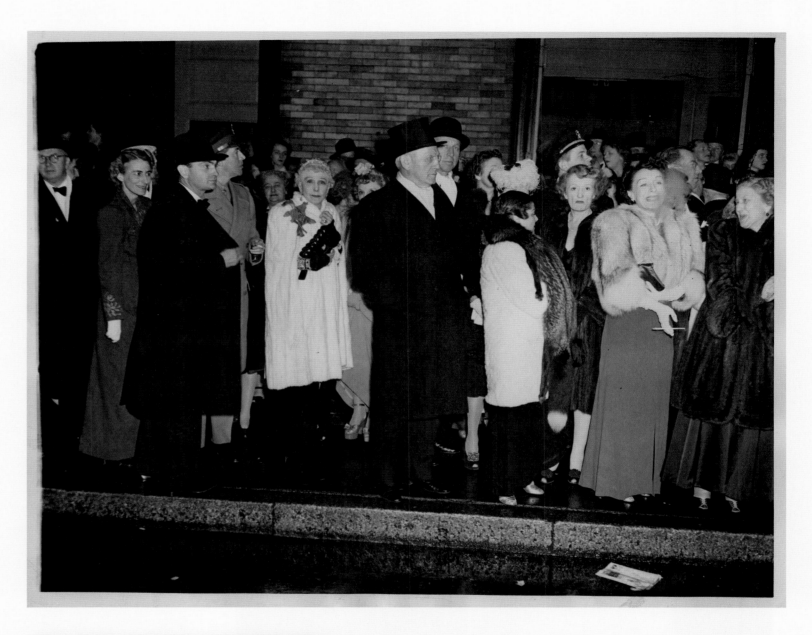

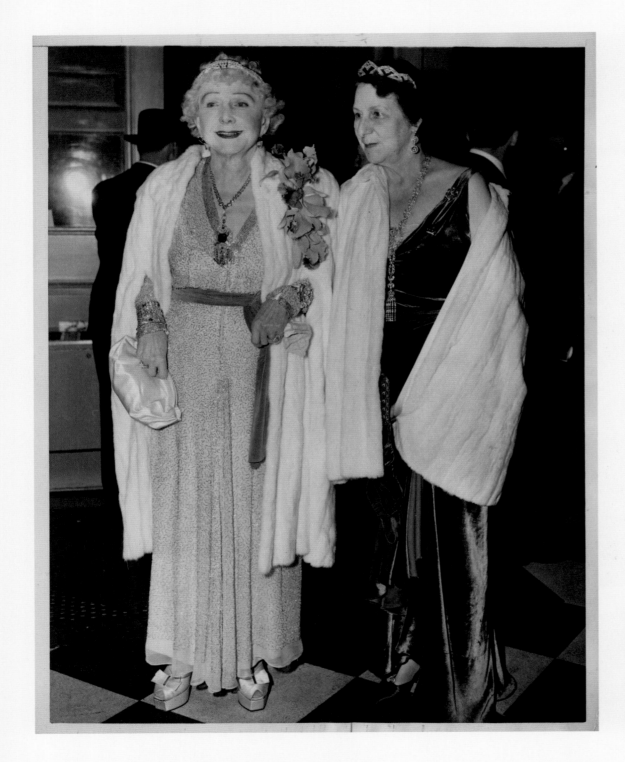

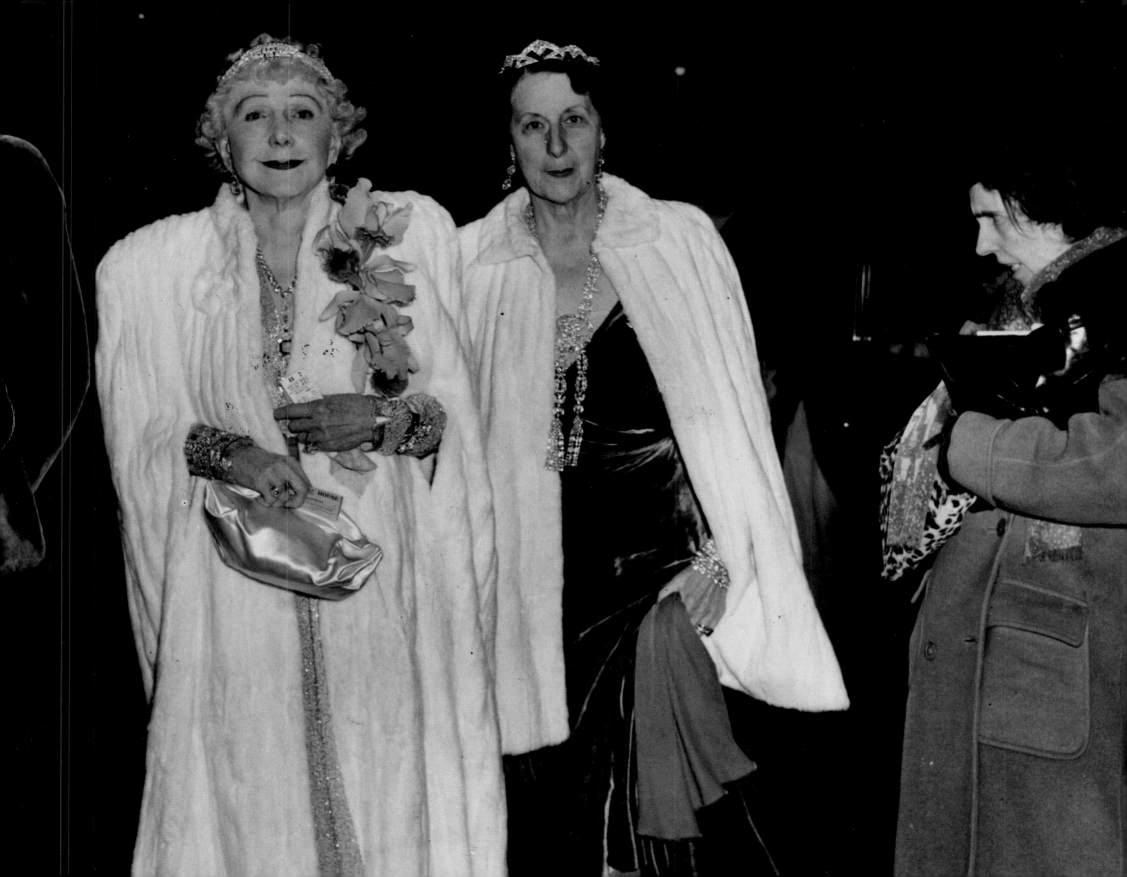

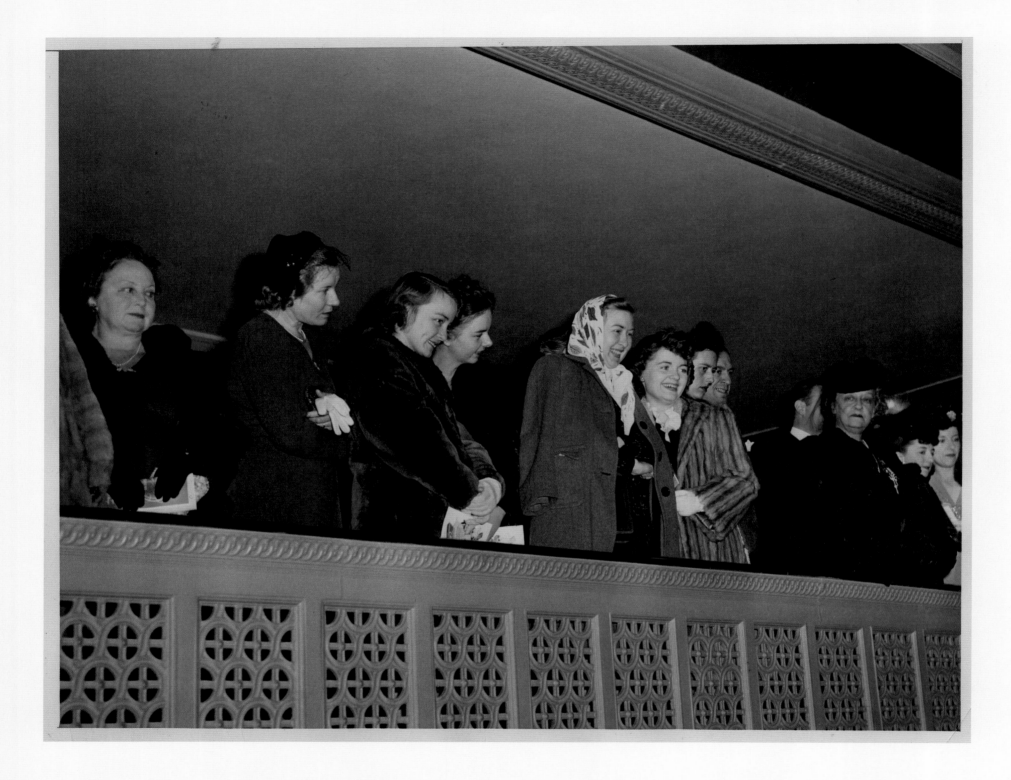

page 182 →

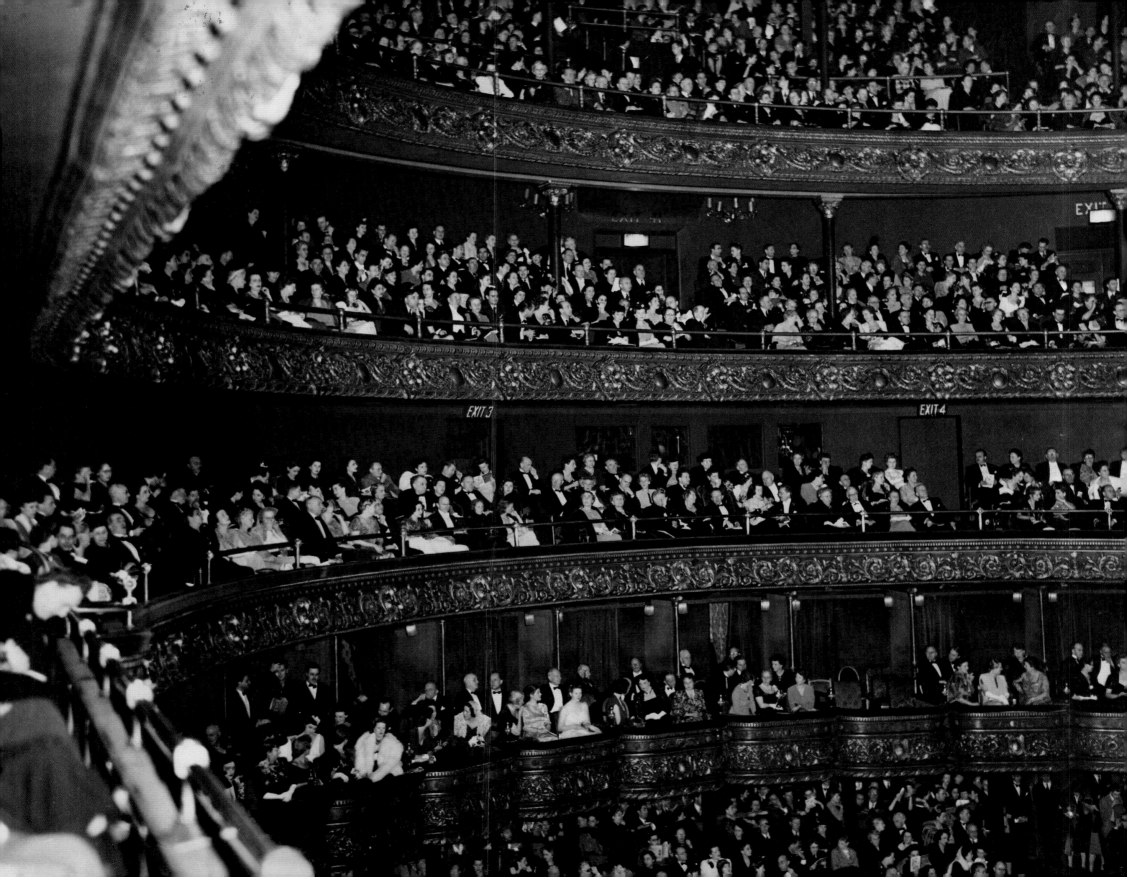

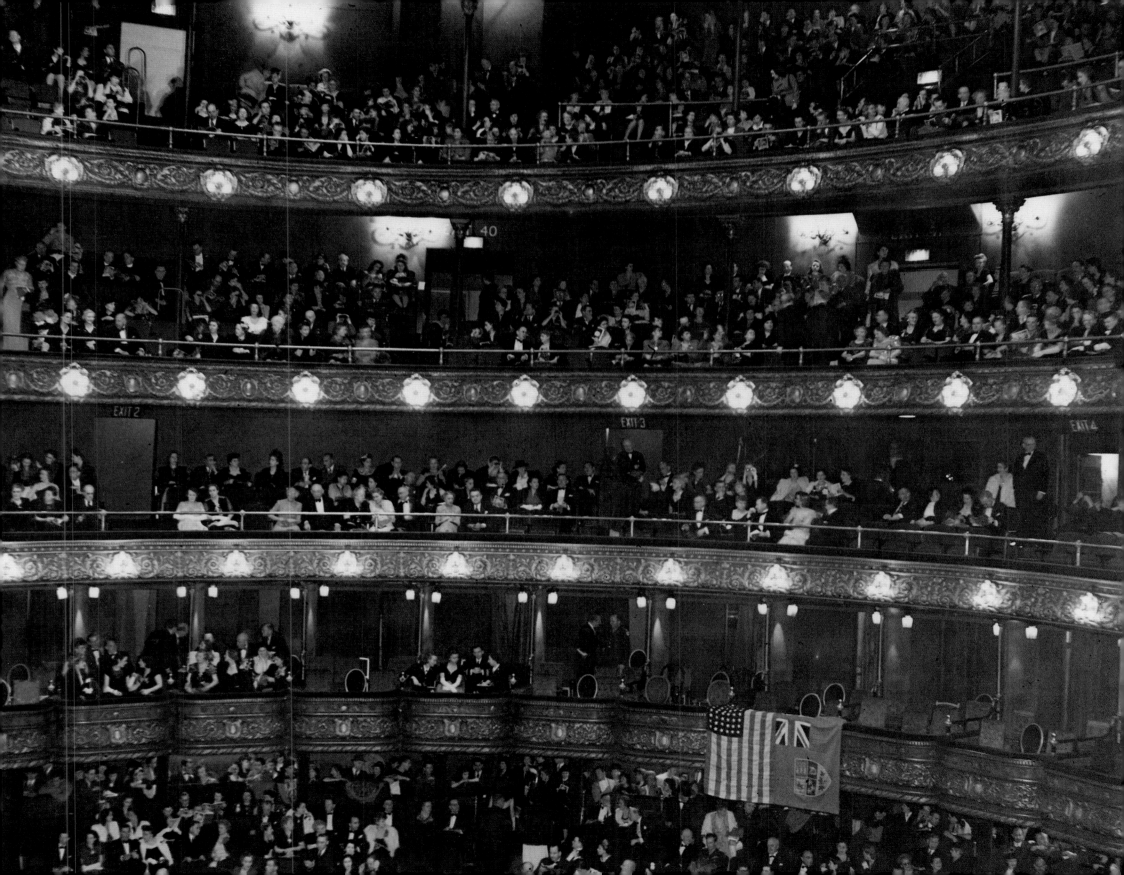

← page 183

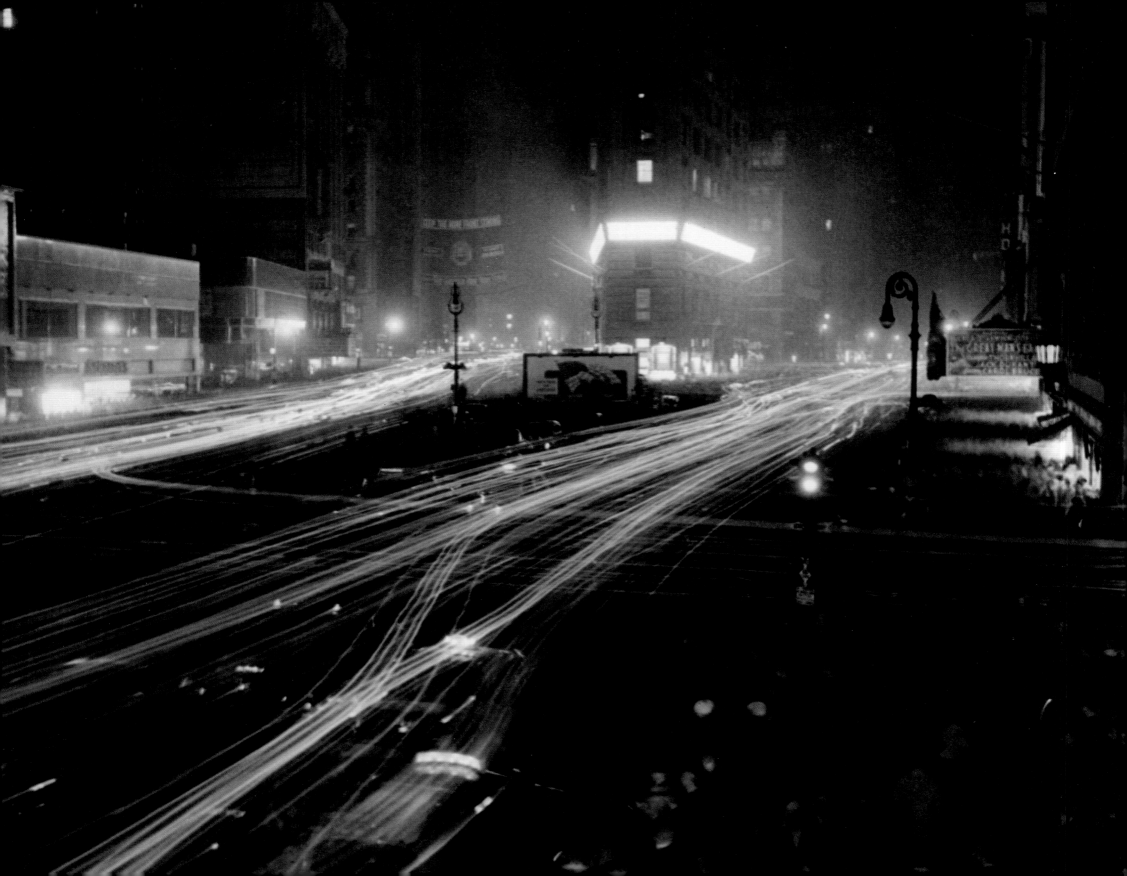

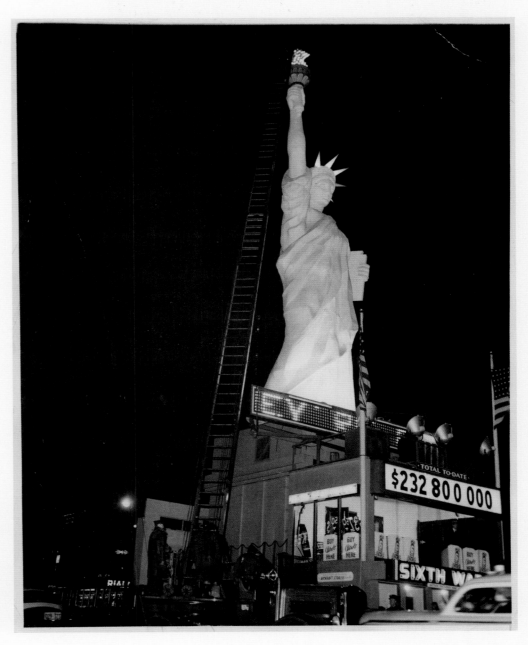

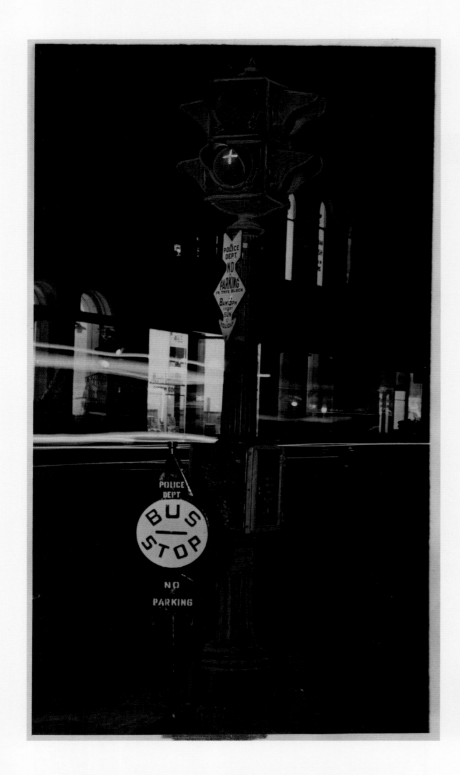

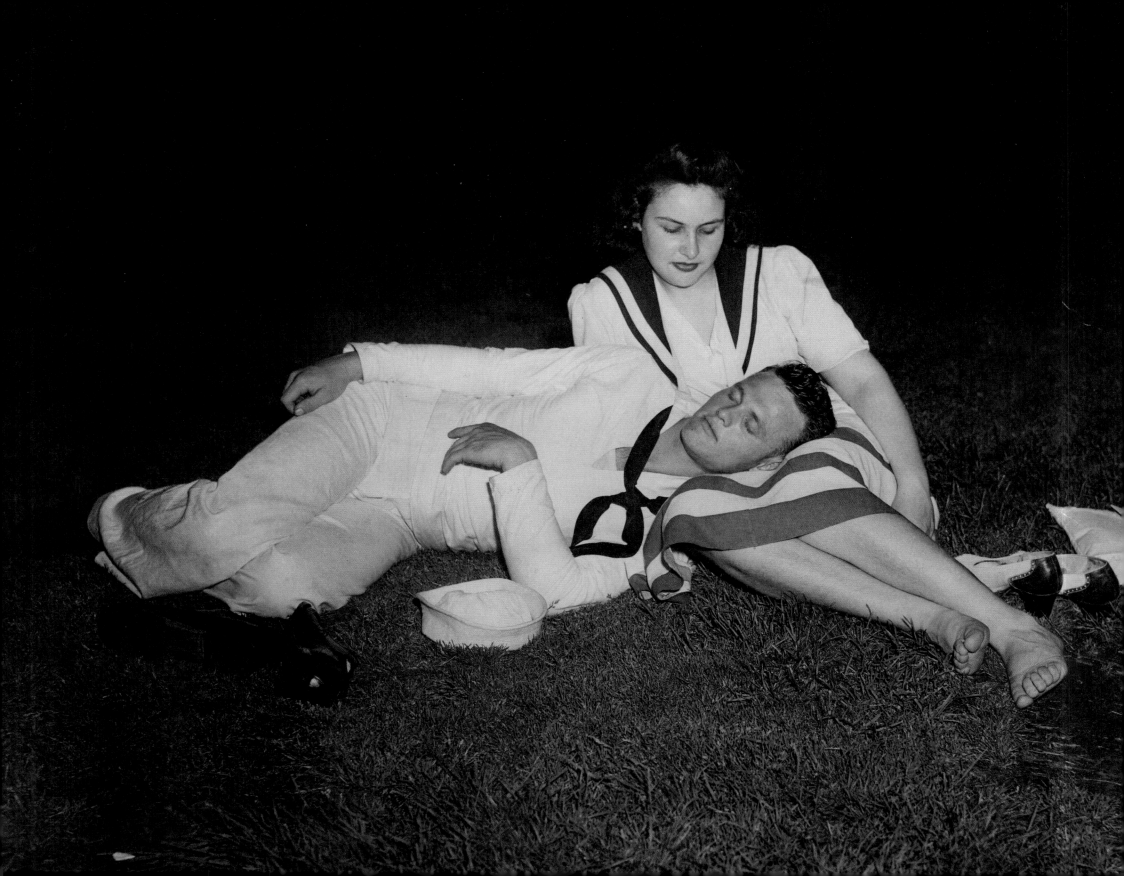

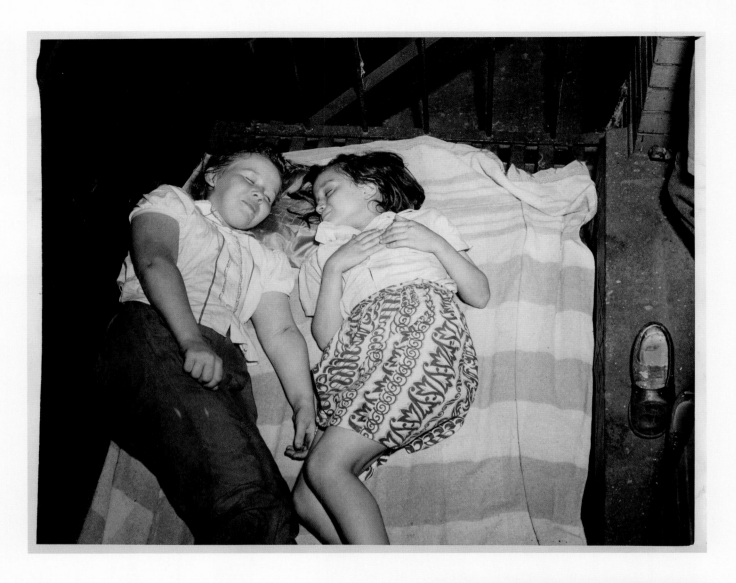

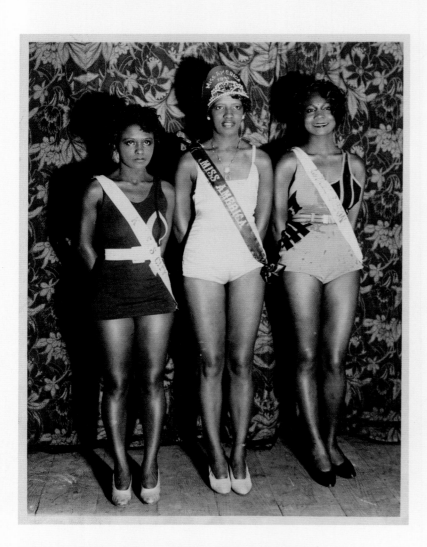

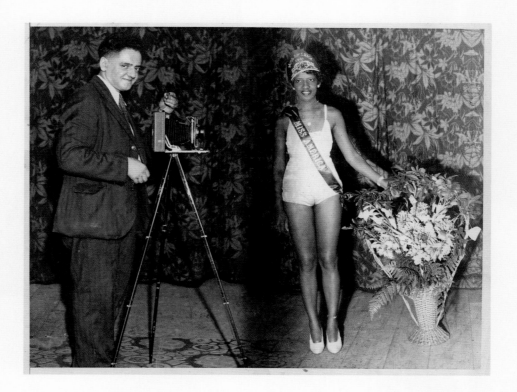

WINNERS IN COLORED BEAUTY CONTEST
THIRTY-ONE SEPIA-TINTED BEAUTIES REPRESENTING THIRTY-ONE
CITIES IN THE UNITED STATES, COMPETED FOR THE TITLE OF
"COLORED MISS AMERICA" IN THE SAVOY BALLROOM, NEW YORK,
ON AUGUST 29TH. LEFT TO RIGHT ABOVE ARE THE THREE WINNERS,
EVA SMITH OF KANSAS CITY WHO PLACED THIRD; BILLY DOW
OF KEY WEST, FLORIDA, THE WINNER; AND DOLORES BLAINE OF
CHARLESTOWN, SECOND.
 CREDIT LINE (ACME) 8/31/31

One for the Book —
Weegee & Miss America
1931 "Colored"

192

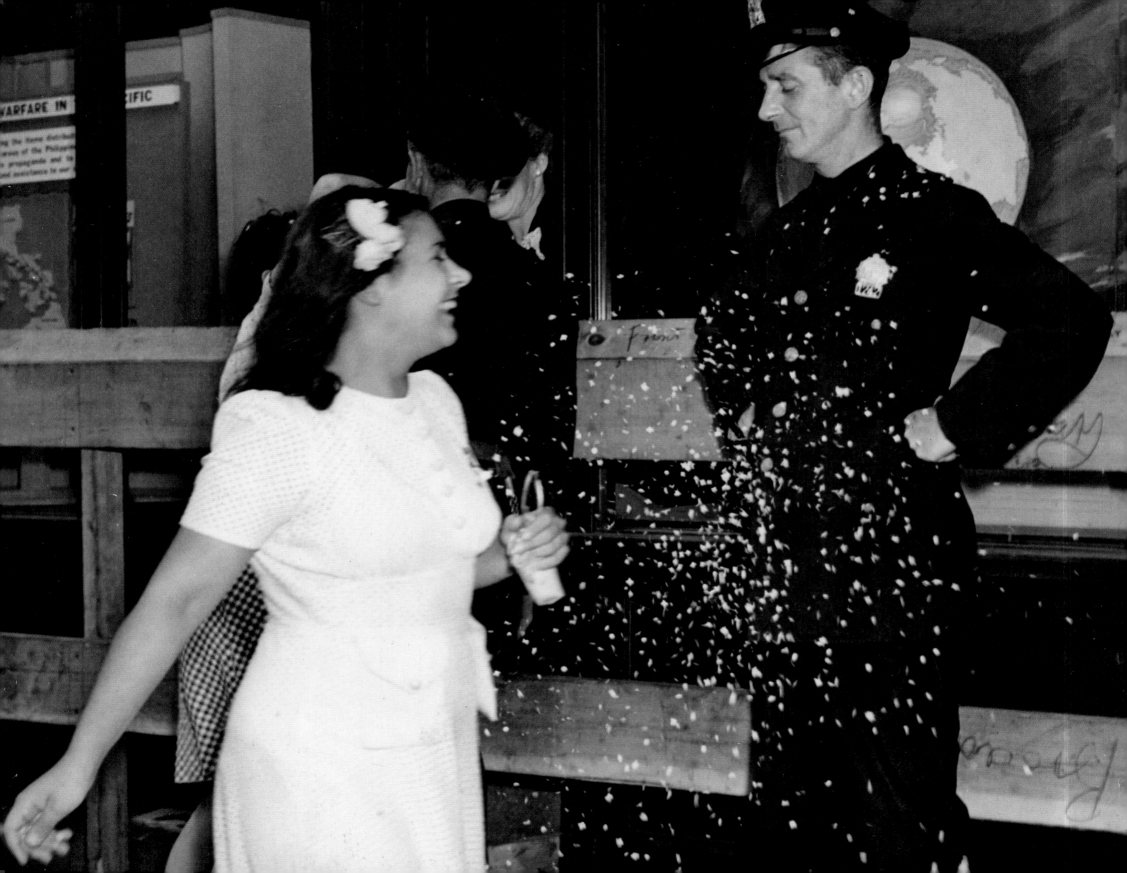

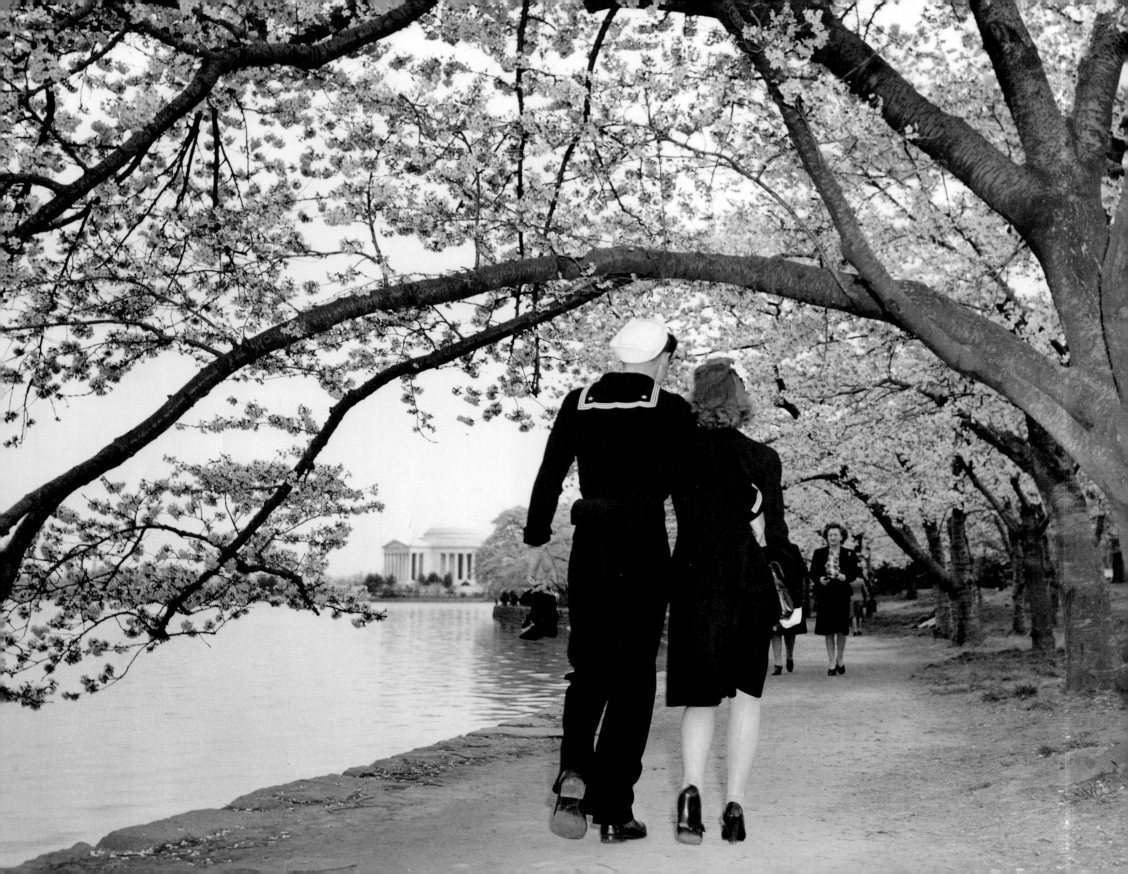

EXTRA!
COOL

← page 196

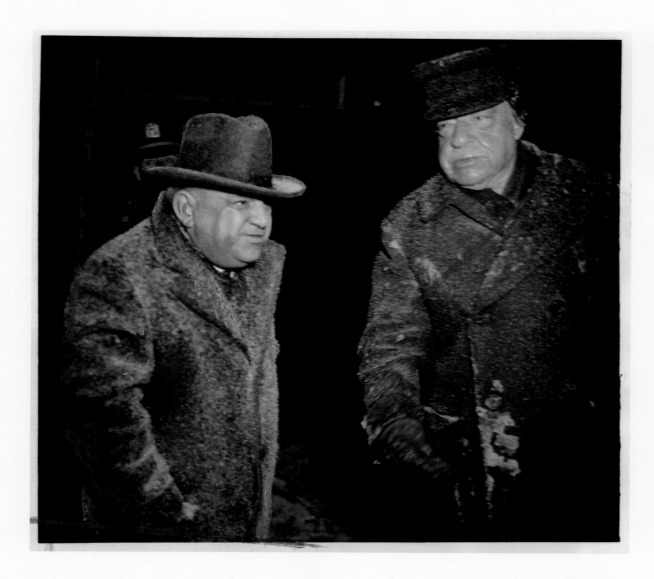

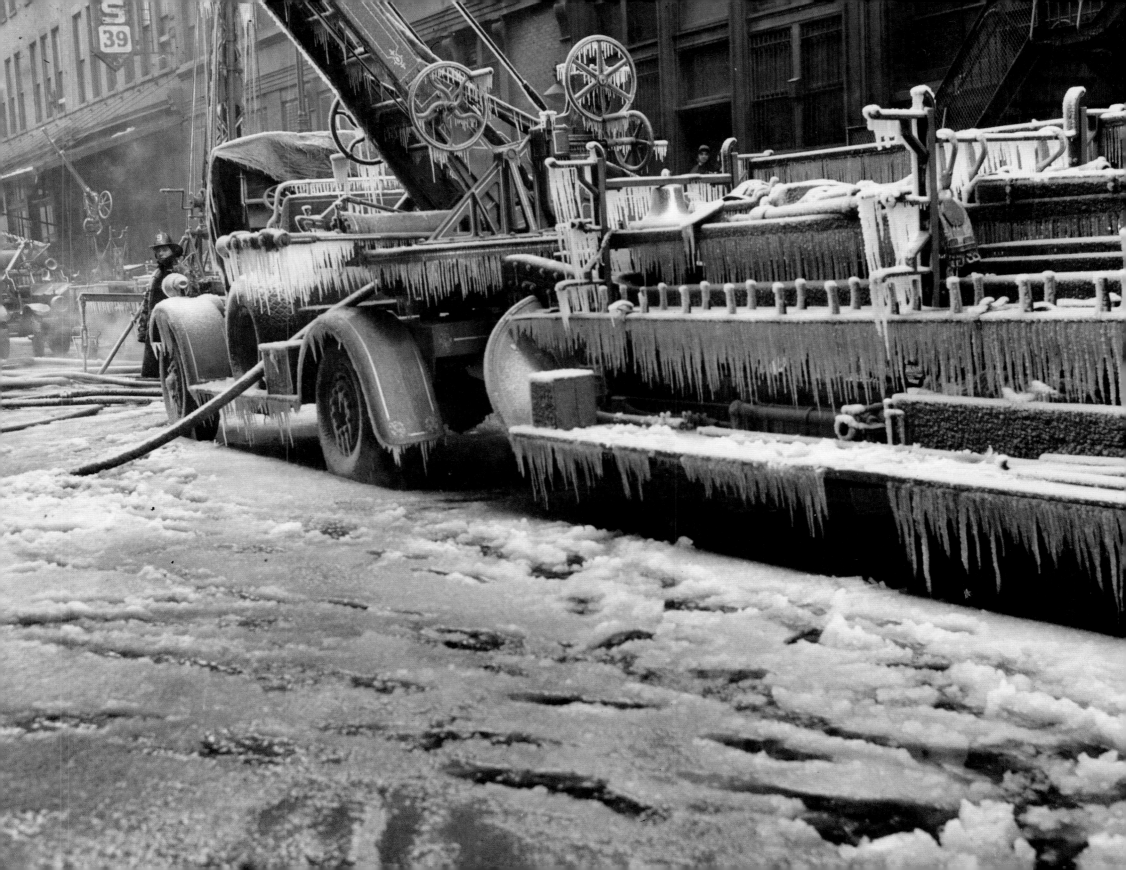

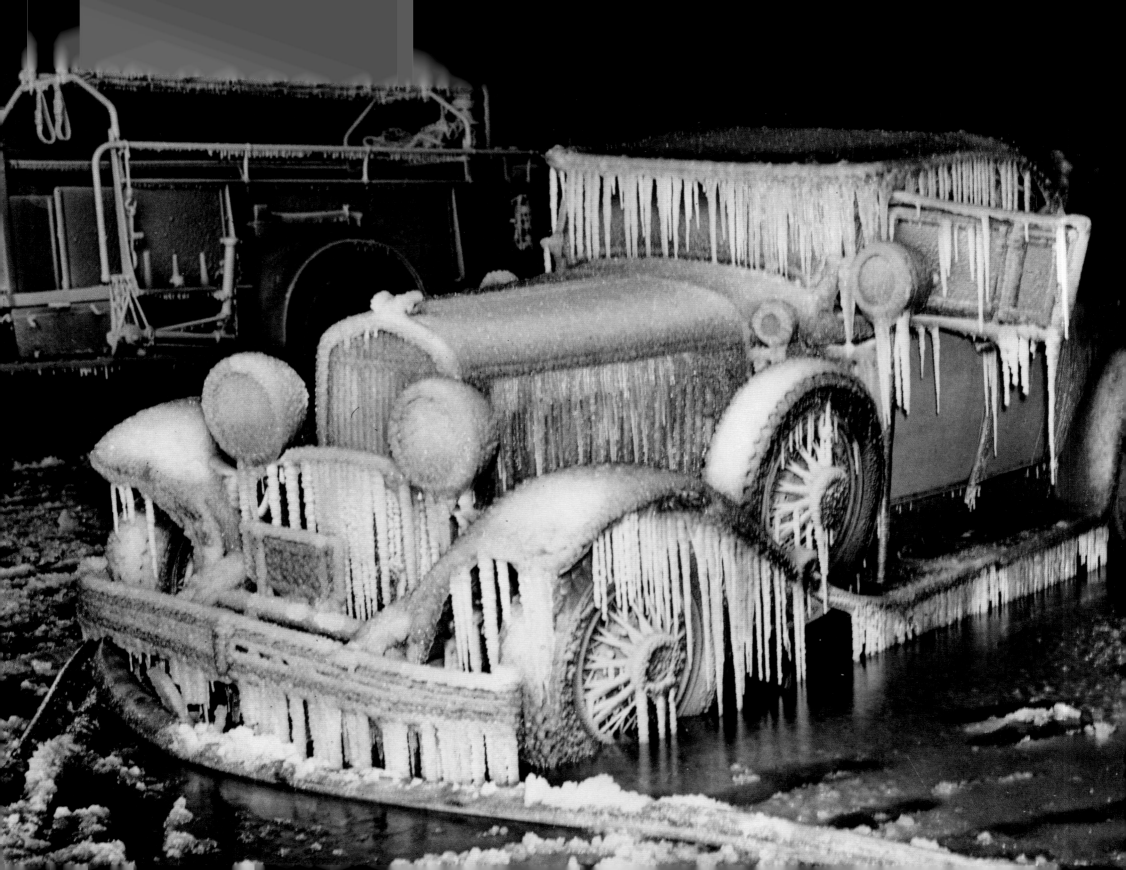

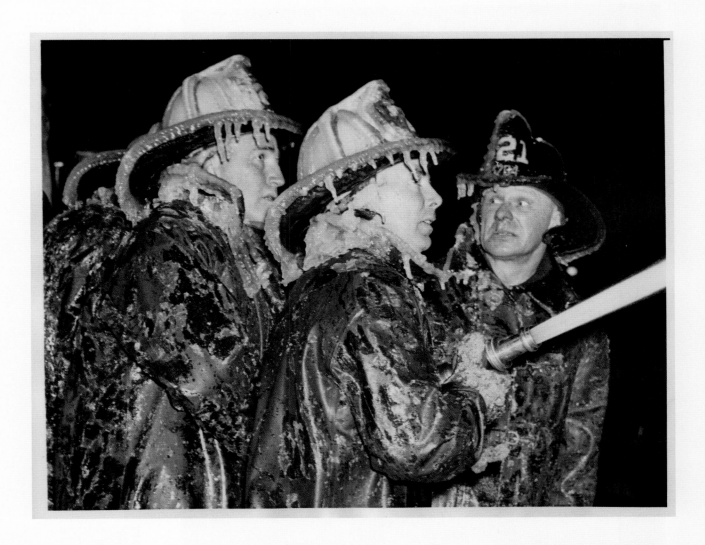

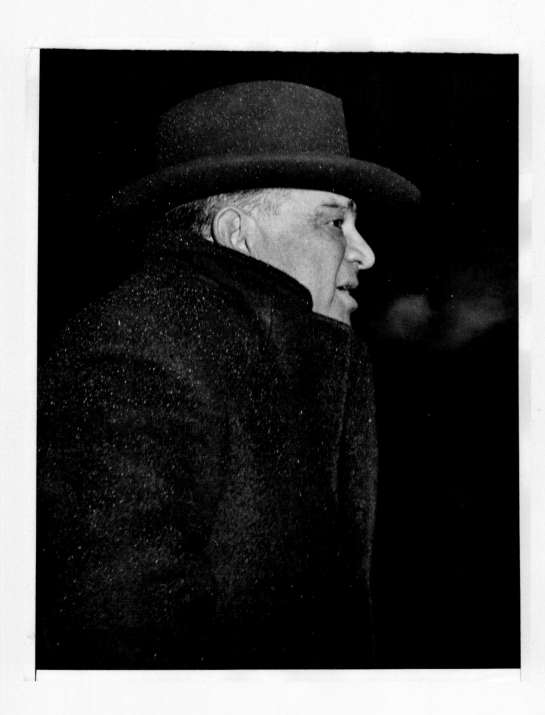

202

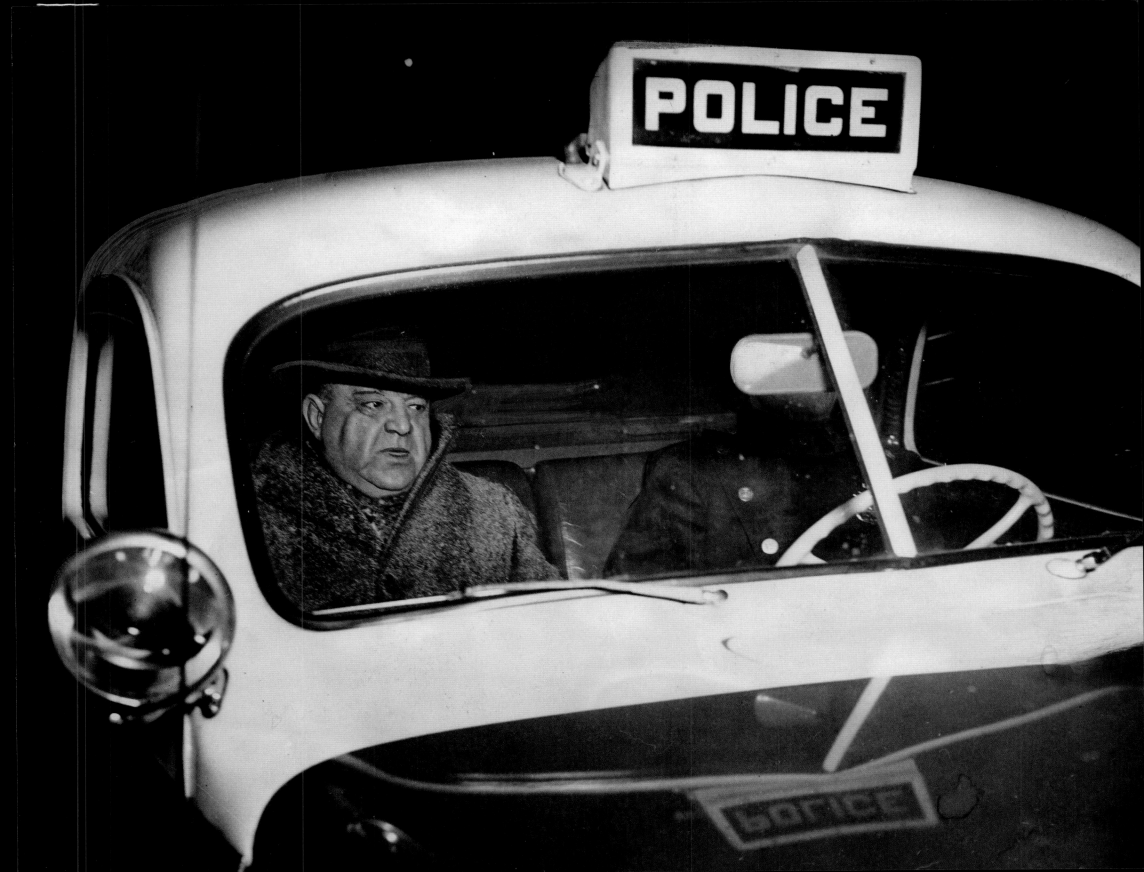

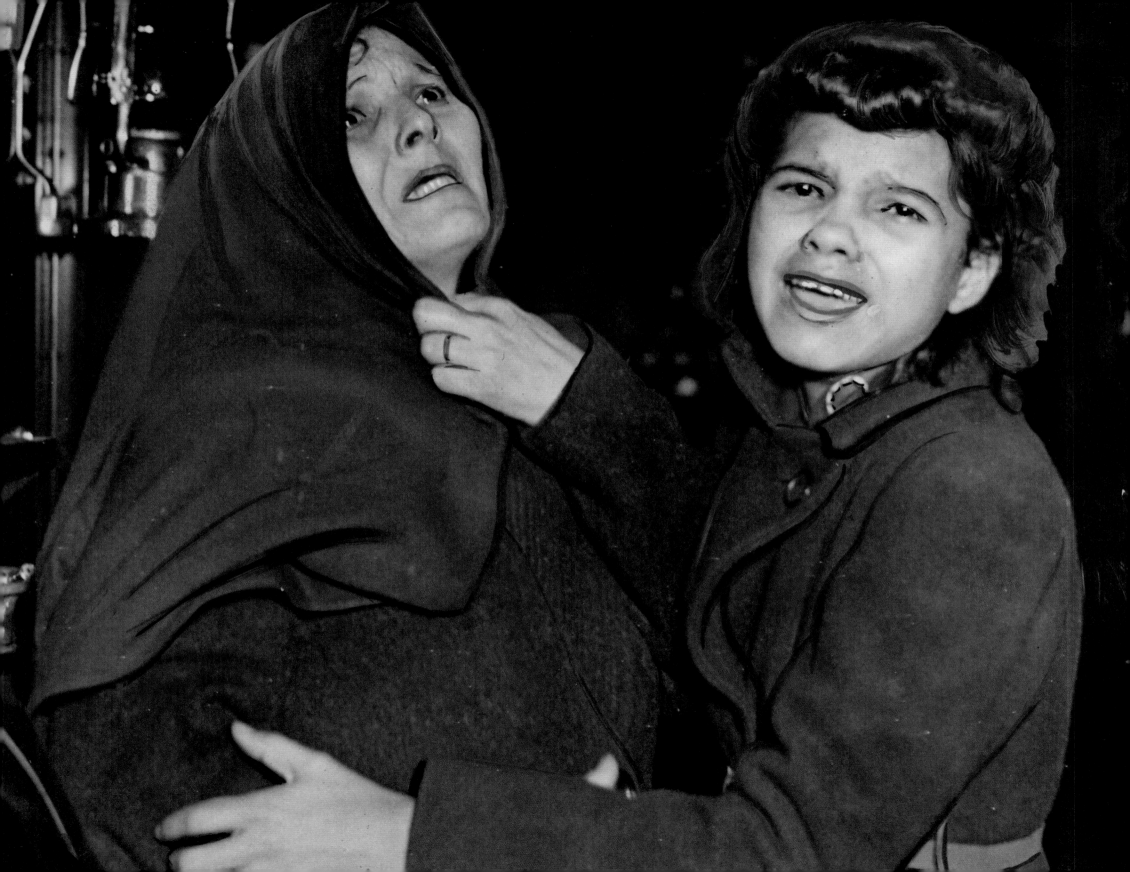

EXTRA!
DEAD

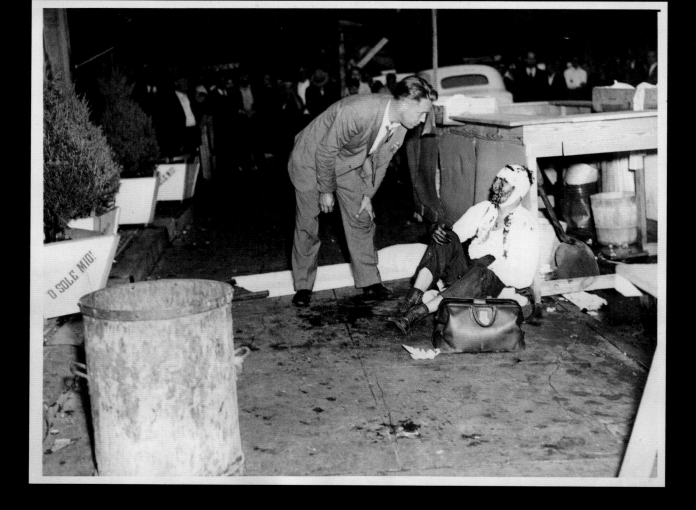

Hi Torres, + daughter ADA,
look up at burning tenement,
not knowing that her sister + boy
persisted? but their faces show their fear

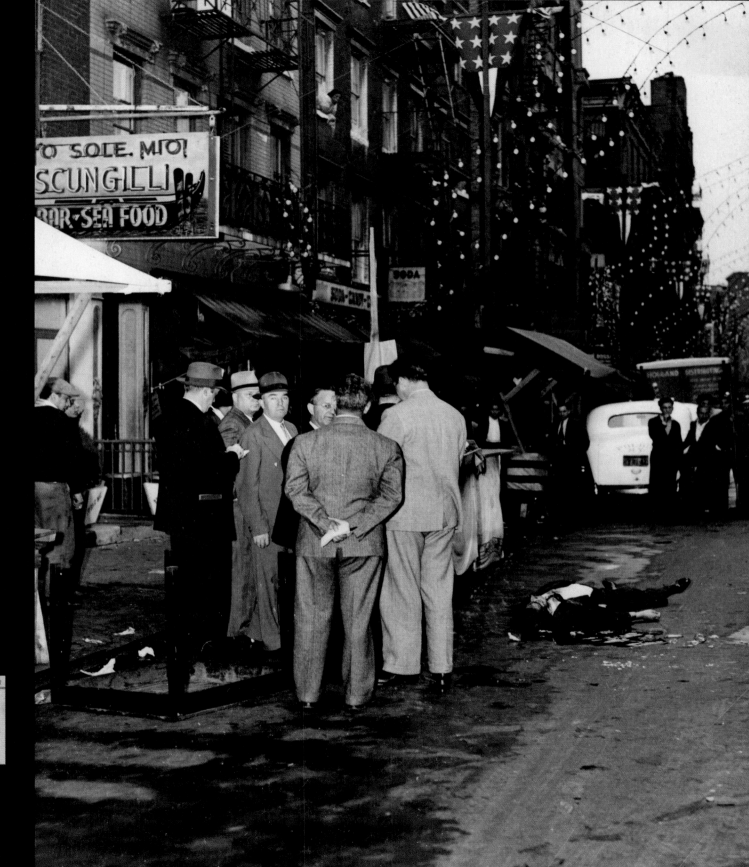

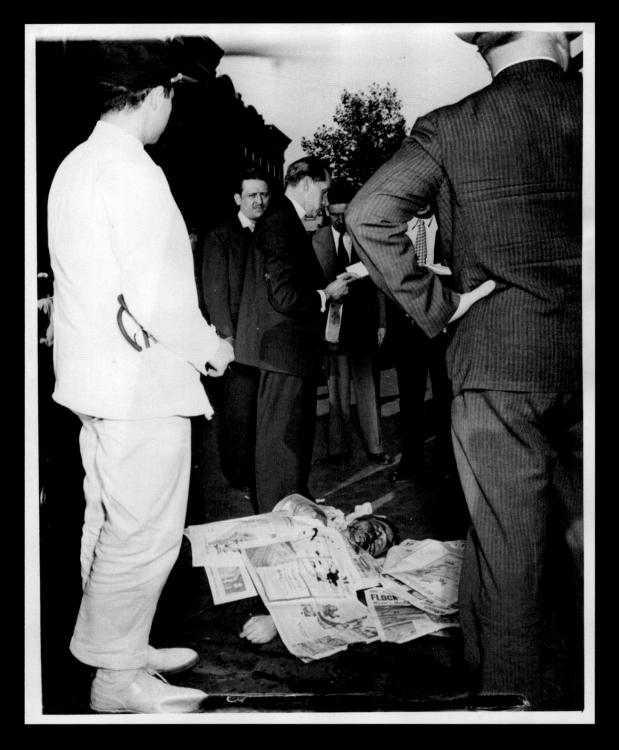

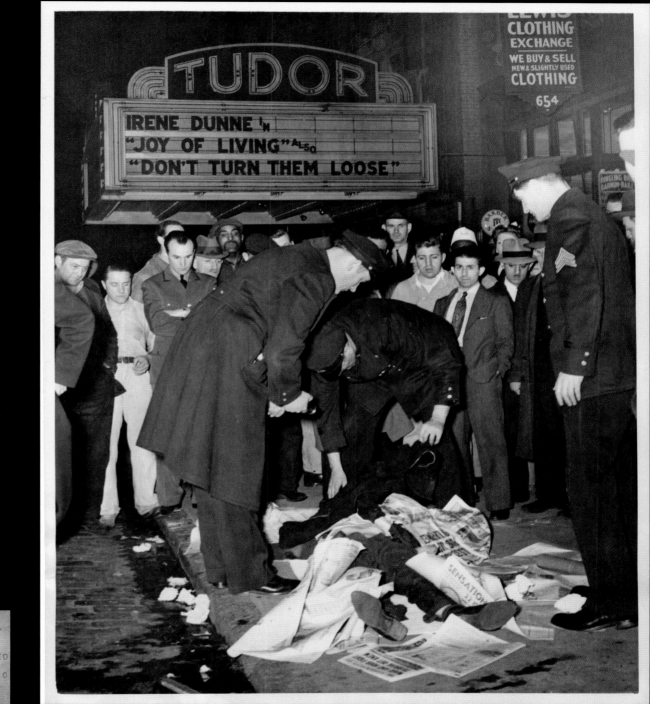

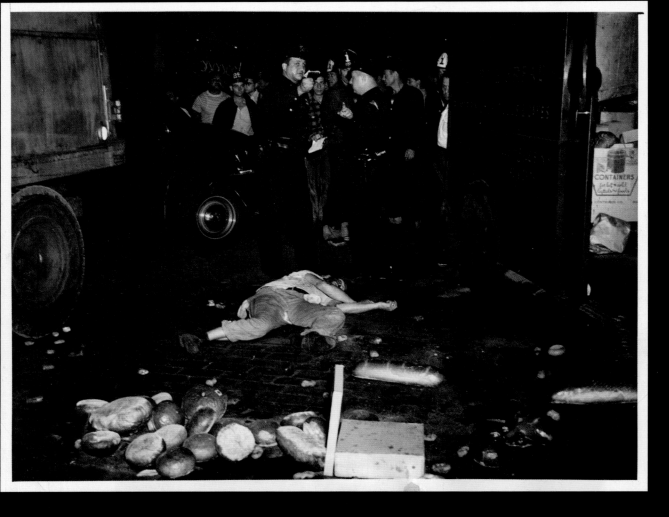

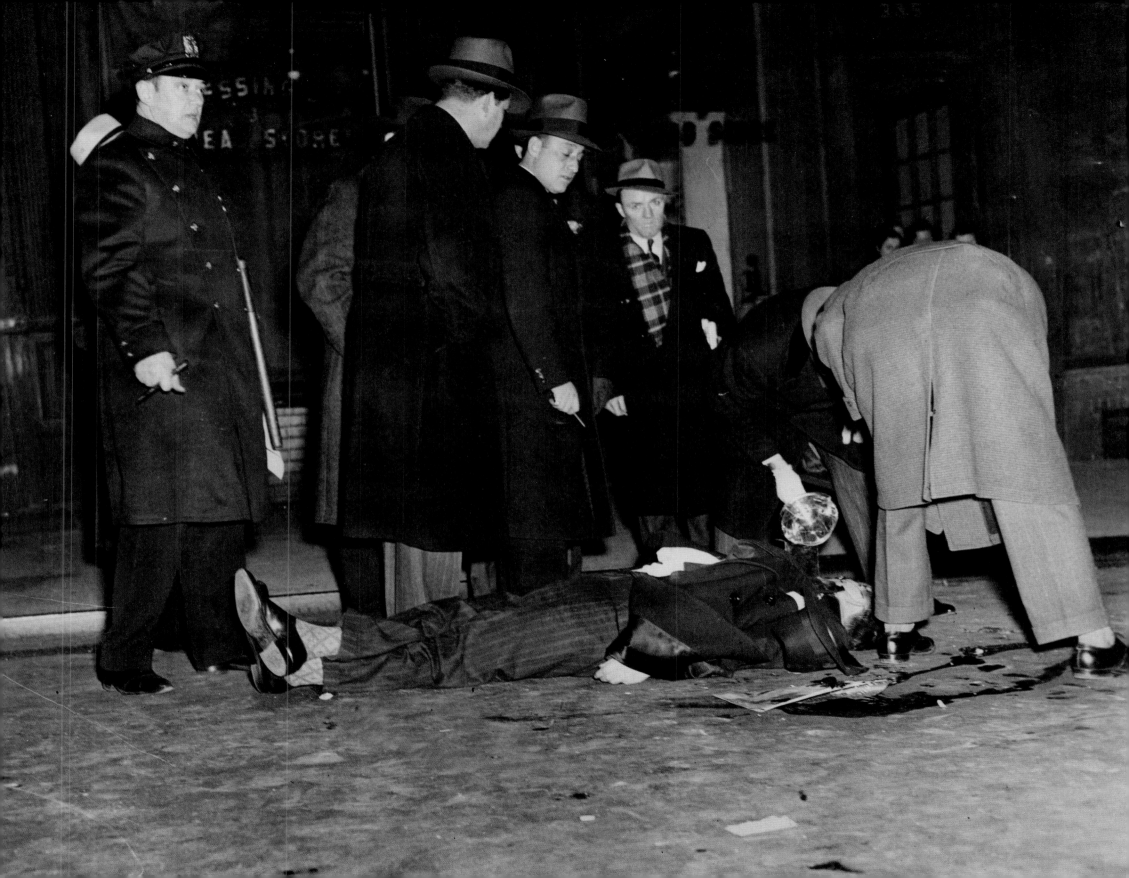

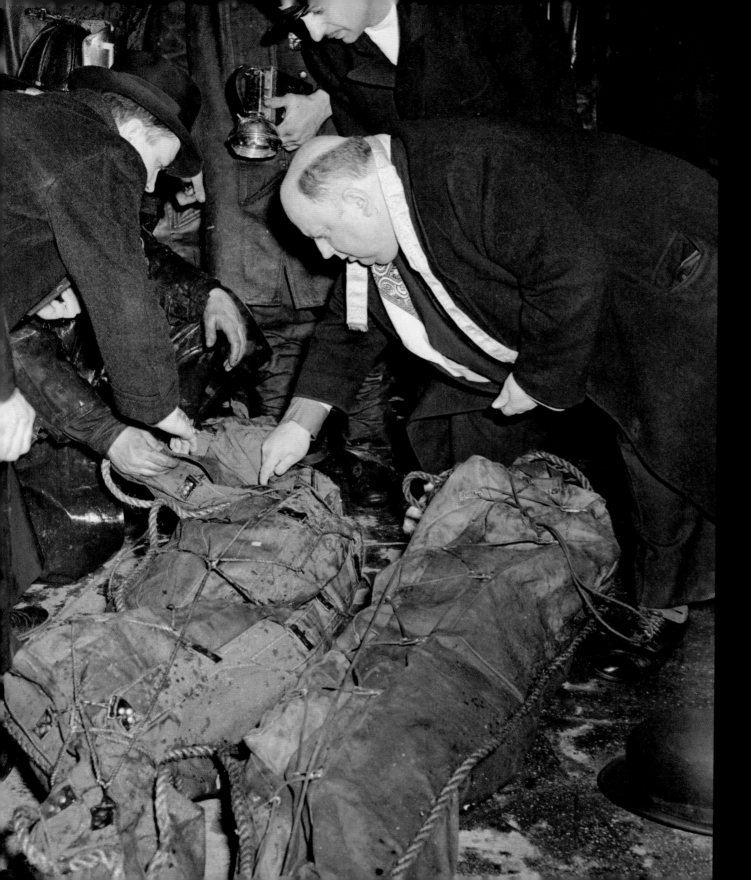

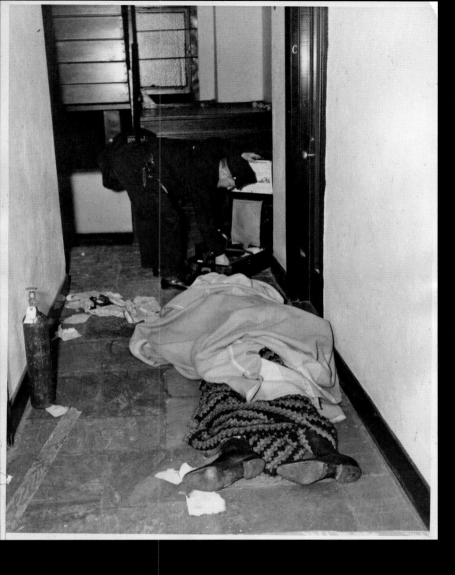

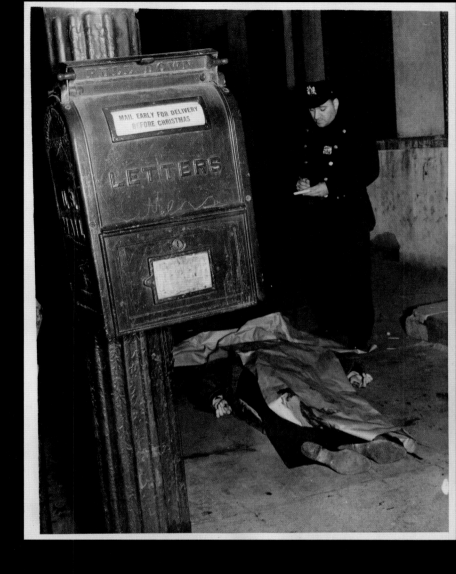

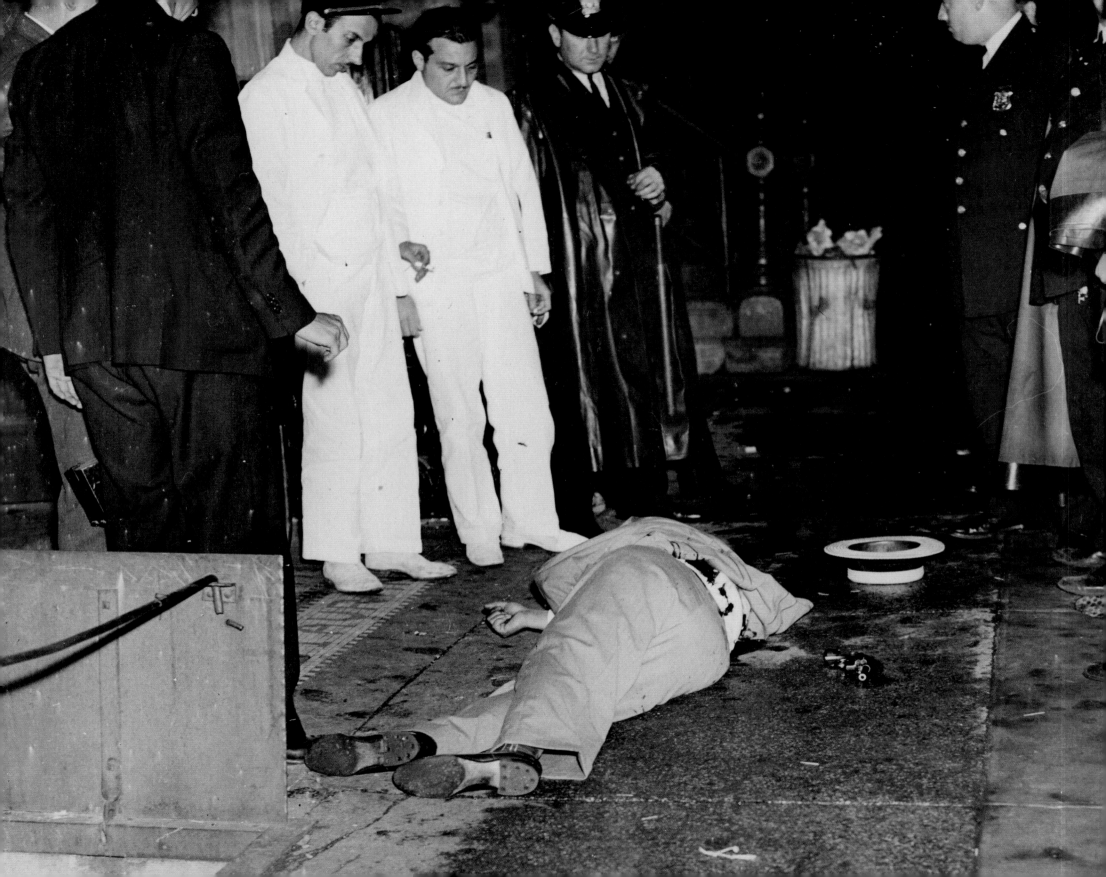

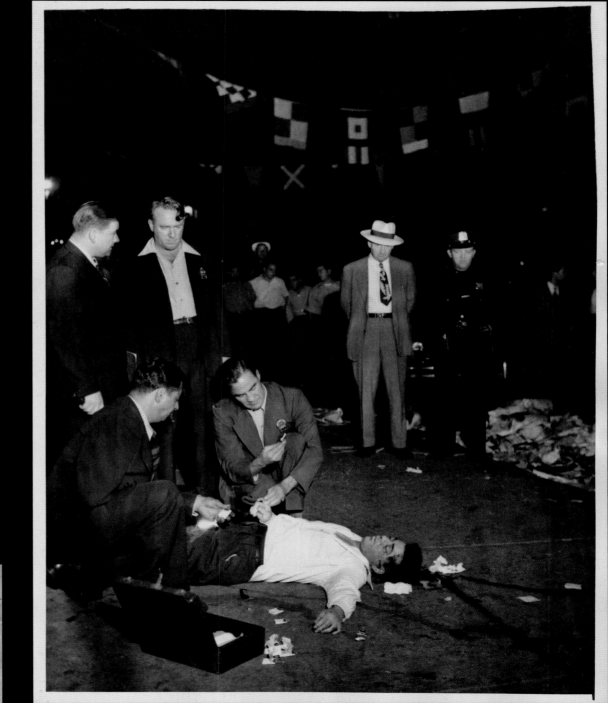

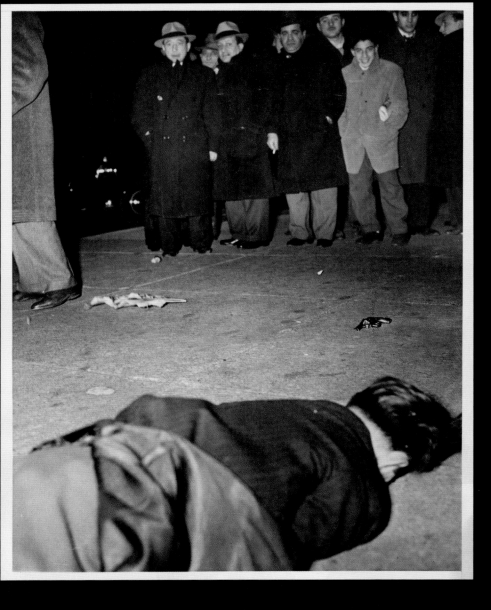

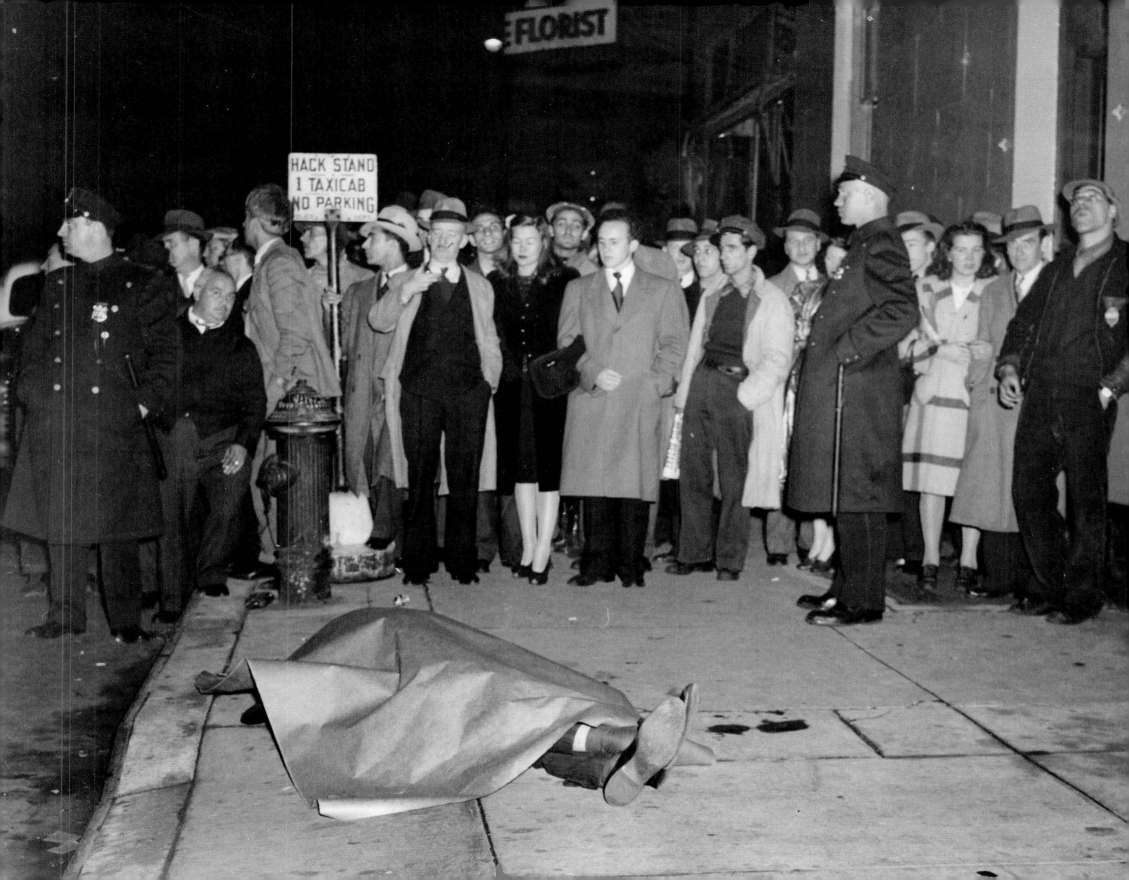

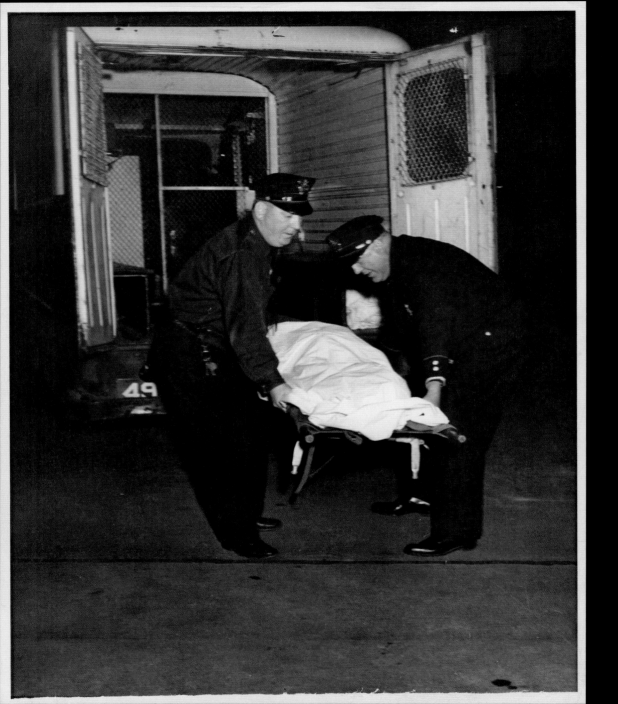

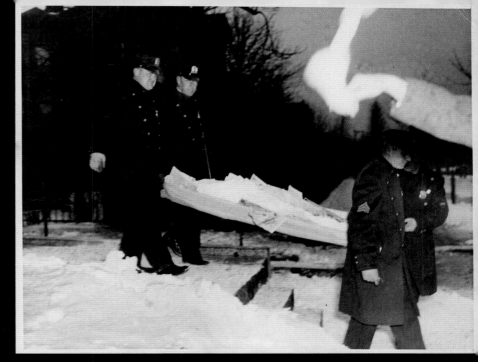

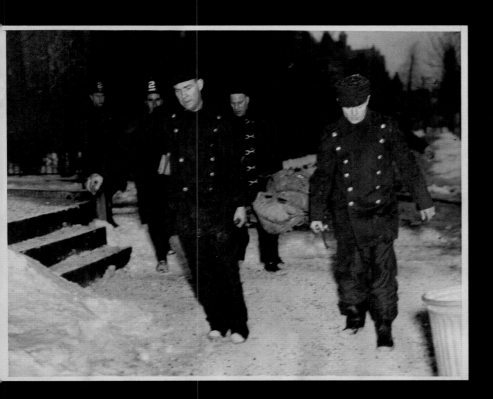

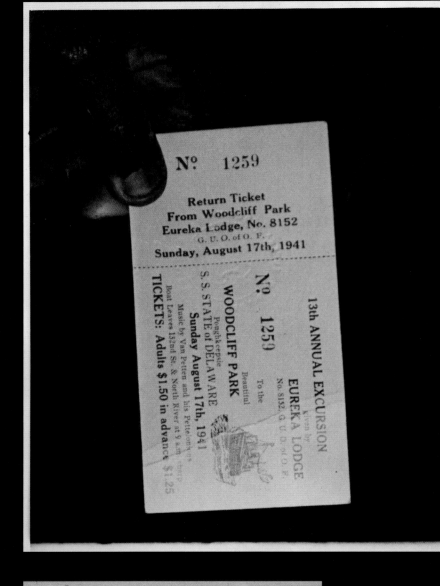

WELCOME TO NE

FIFTH AVENUE COAC
FOUNDED 1885

546695 PDR

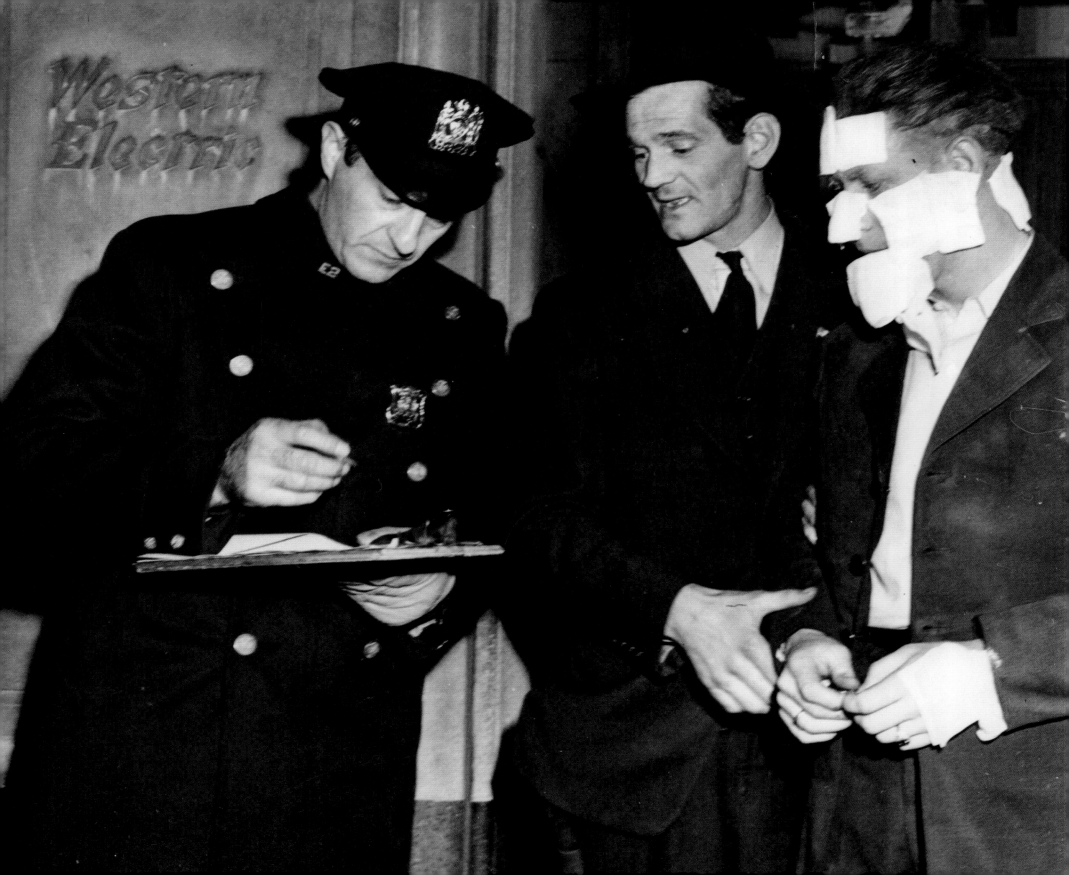

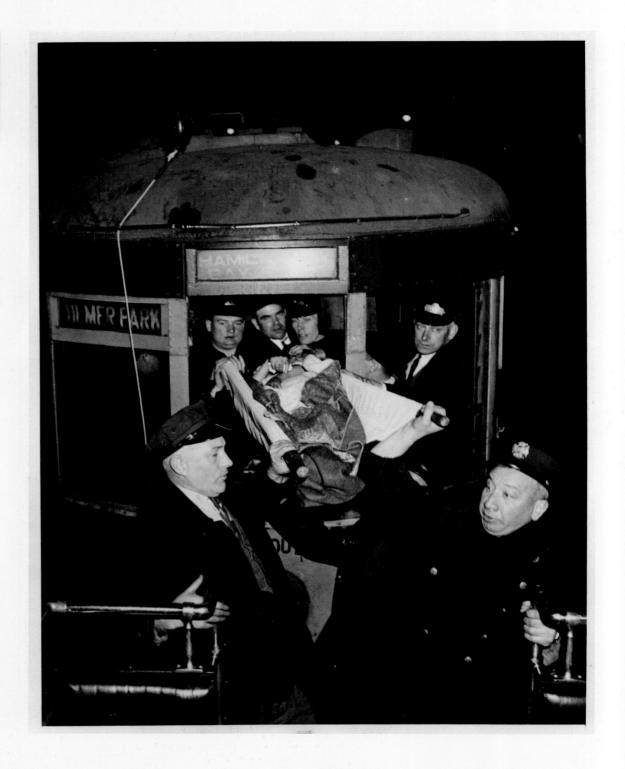

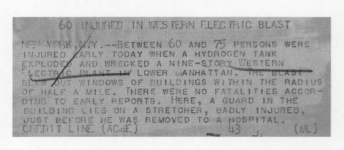

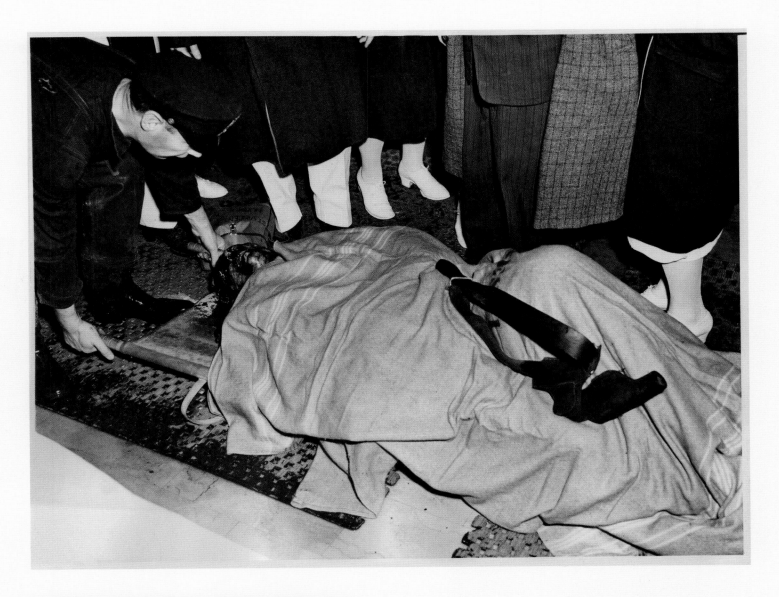

60 INJURED IN WESTERN ELECTRIC BLAST

NEW YORK, N.Y.--BETWEEN 60 AND 75 PERSONS WERE
INJURED EARLY TODAY WHEN A HYDROGEN TANK
EXPLODED AND WRECKED A NINE-STORY WESTERN
ELECTRIC PLANT IN LOWER MANHATTAN. THE BLAST
BLEW OUT WINDOWS OF BUILDINGS WITHIN THE RADIUS
OF HALF A MILE. THERE WERE NO FATALITIES ACCOR-
DING TO EARLY REPORTS. HERE, ONE OF THE GUARDS
OF THE BUILDING, (RIGHT), HIS FACE WRAPPED IN
BANDAGES, GIVES HIS NAME TO A POLICEMAN AT THE
SCENE.
CREDIT LINE (ACME) 43 (ML)

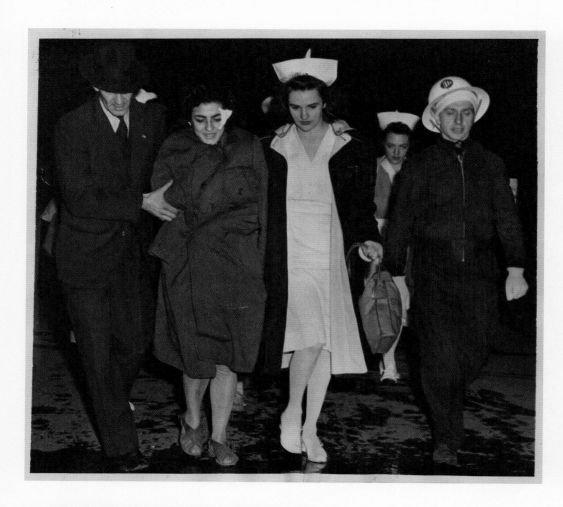

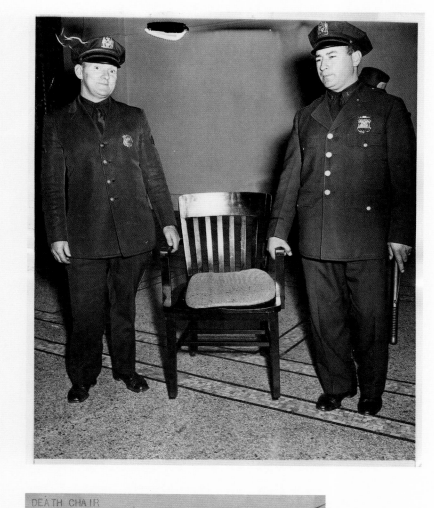

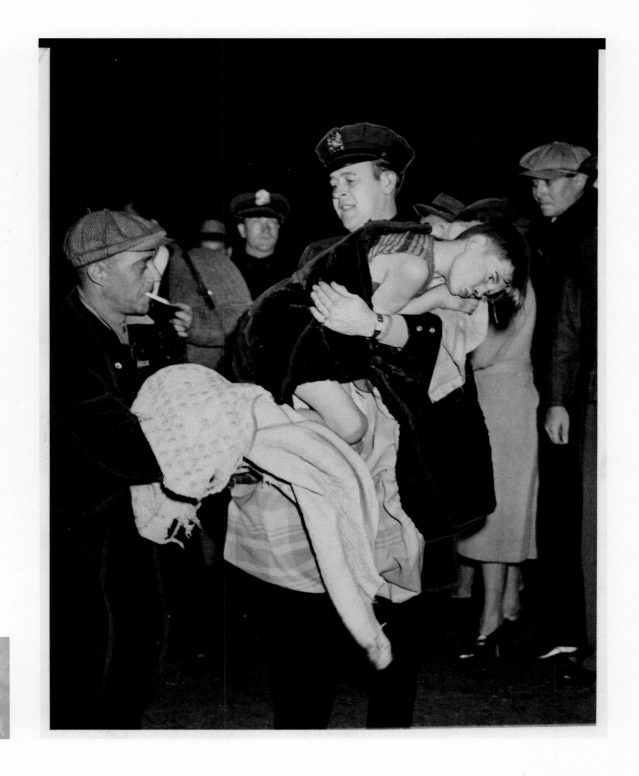

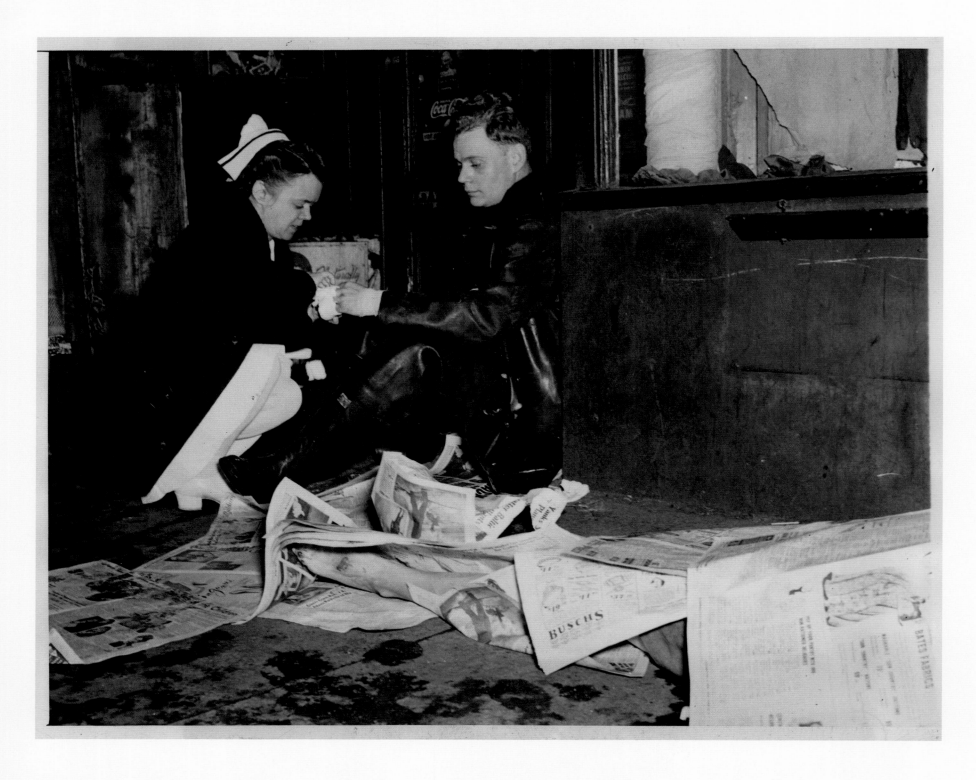

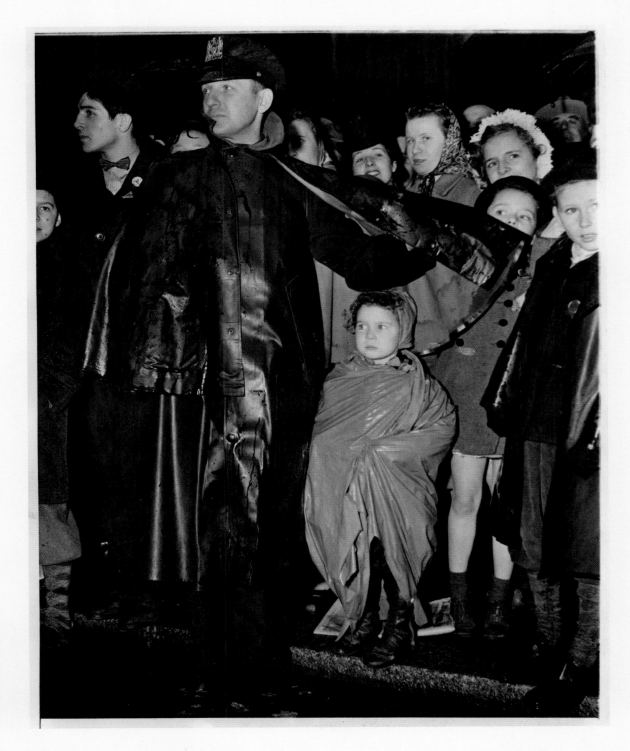

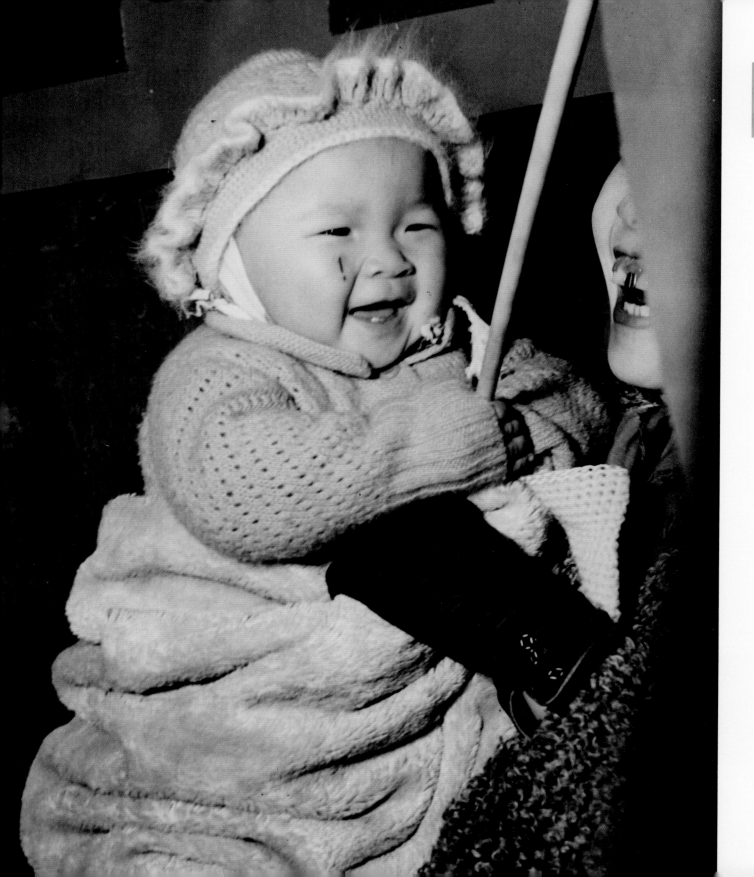

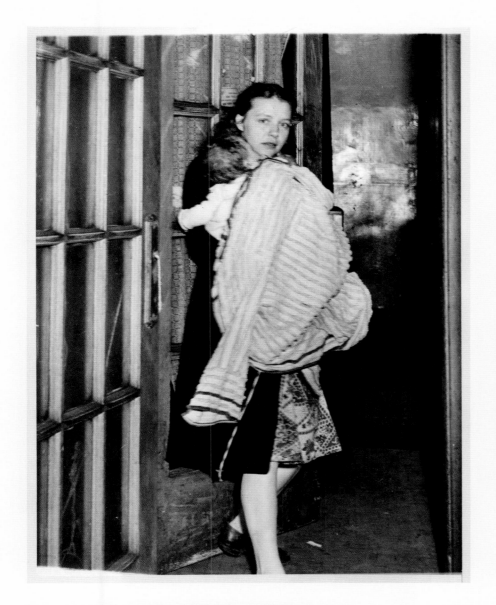

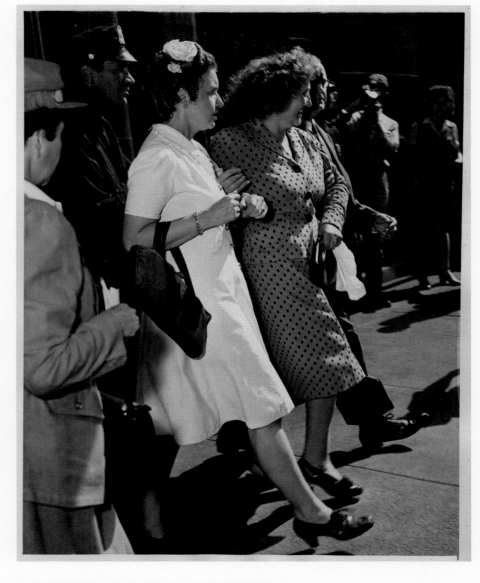

RECOVERS KIDNAPPED DAUGHTER
NEW YORK CITY — HOLDING HER 11-MONTH-OLD
DAUGHTER, MARION, CLOSE TO HER, MRS. MARY
O'BRIEN, 29, LEAVES THE EAST 35TH STREET
POLICE STATION. THE CHILD WAS KIDNAPPED BY
HER JEALOUS SUITOR, JOHN BONAVENTURE, 36, A
TAXICAB DRIVER AND THE FATHER OF SIX CHILDREN.
MRS. O'BRIEN TOLD POLICE THAT HER HUSBAND IS A
SOLDIER AT FORT BLANDING, FLA.
NY CUT INKK
CREDIT LINE (ACME) 43 (BK)

COFFEE WRESTS HER FROM THE HANDS OF DEATH
NEW YORK — MRS. ELIZABETH LASSEN, 1 WEST
30TH ST., IS ESCORTED FROM HER APARTMENT BY
POLICE TO AN AMBULANCE WAITING TO TAKE HER
TO A HOSPITAL AFTER SHE ATTEMPTED TO LEAP
FROM THE ROOF OF HER APARTMENT HOUSE THIS
MORNING (SEPT. 5). SHE CHANGED HER MIND
WHEN ONE OF THE TENANTS INVITED HER IN FOR
A CUP OF COFFEE.
NY
CREDIT (ACME) 9/5/44 (MD)

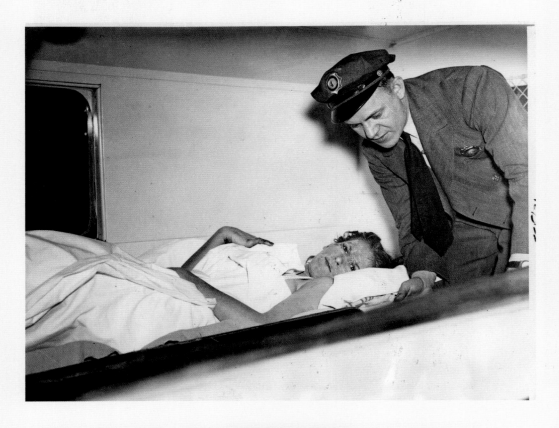

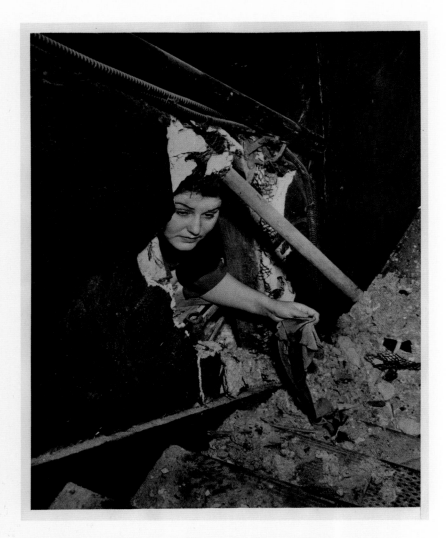

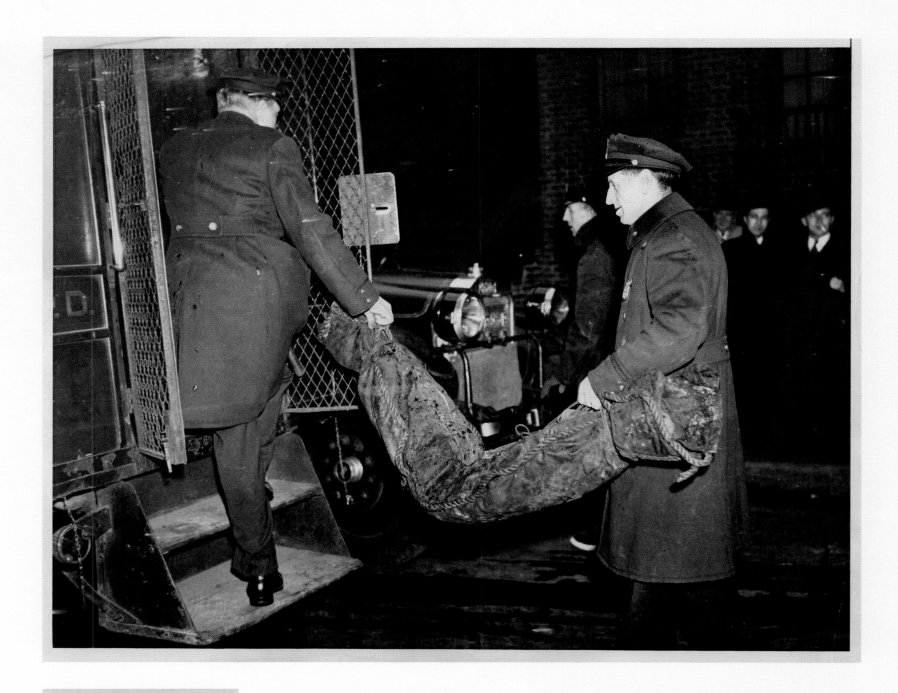

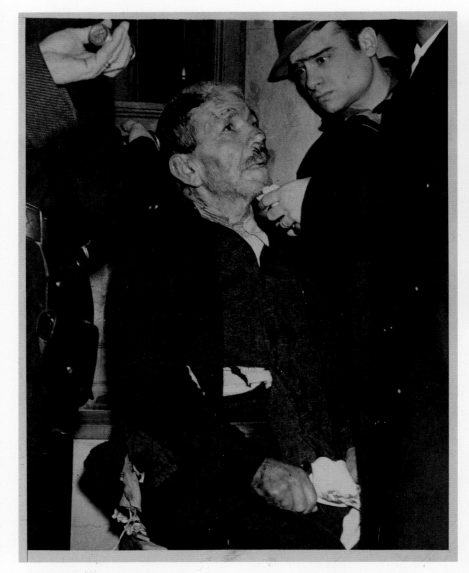

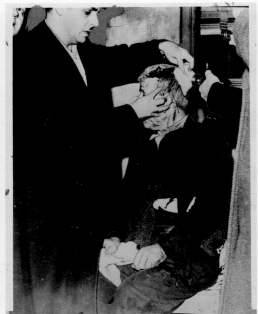

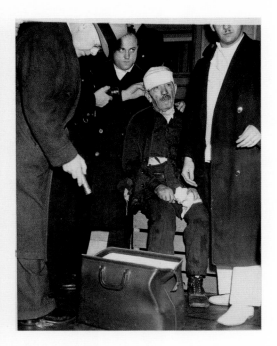

CLOSEUP OF A HIT-AND-RUN VICTIM.
IT WAS JUST A SMALL ITEM IN THE EARLY EDITIONS--A
NAME, AN ADDRESS AND THE STEREOTYPED ENTRY, "HIT-AND
RUN". BUT THE PHOTOGRAPH BRINGS TO LIFE A DRAMA THAT
IS ENACTED TIME AND XXXX AGAIN IN NEW YORK'S STREETS
FRANK TAPEDINO, 70, LEFT HIS HOME FOR WORK. HE HAD
GONE A LITTLE MORE THAN A BLOCK WHEN A SPEEDING BLAC
SEDAN STRUCK HIM DOWN. THE DRIVER SLOWED UP, LOOKED
BACK AND THEN SPED ON. TAPEDINO WAS CARRIED TO HIS
HOME SERIOUSLY INJURED. HE IS SHOWN HERE WAITING
THE ARRIVAL OF A DOCTOR.
#1A
CREDIT LINE (ACME) 1/9/37

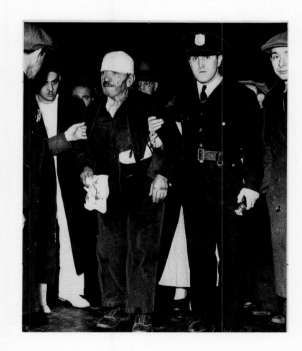

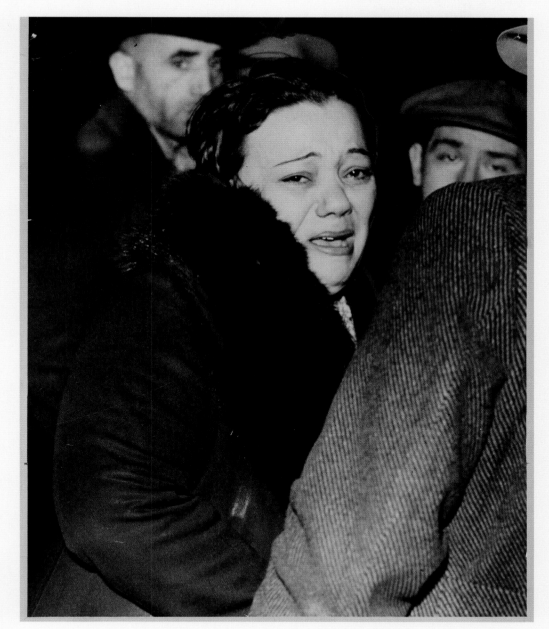

If you know the hit and run driver whose traffic juggernaut felled 70-year-old Frank Tapedino, show him this picture of the mingled grief, terror and despair that distorts the face of Tapedino's daughter after seeing her mangled father.

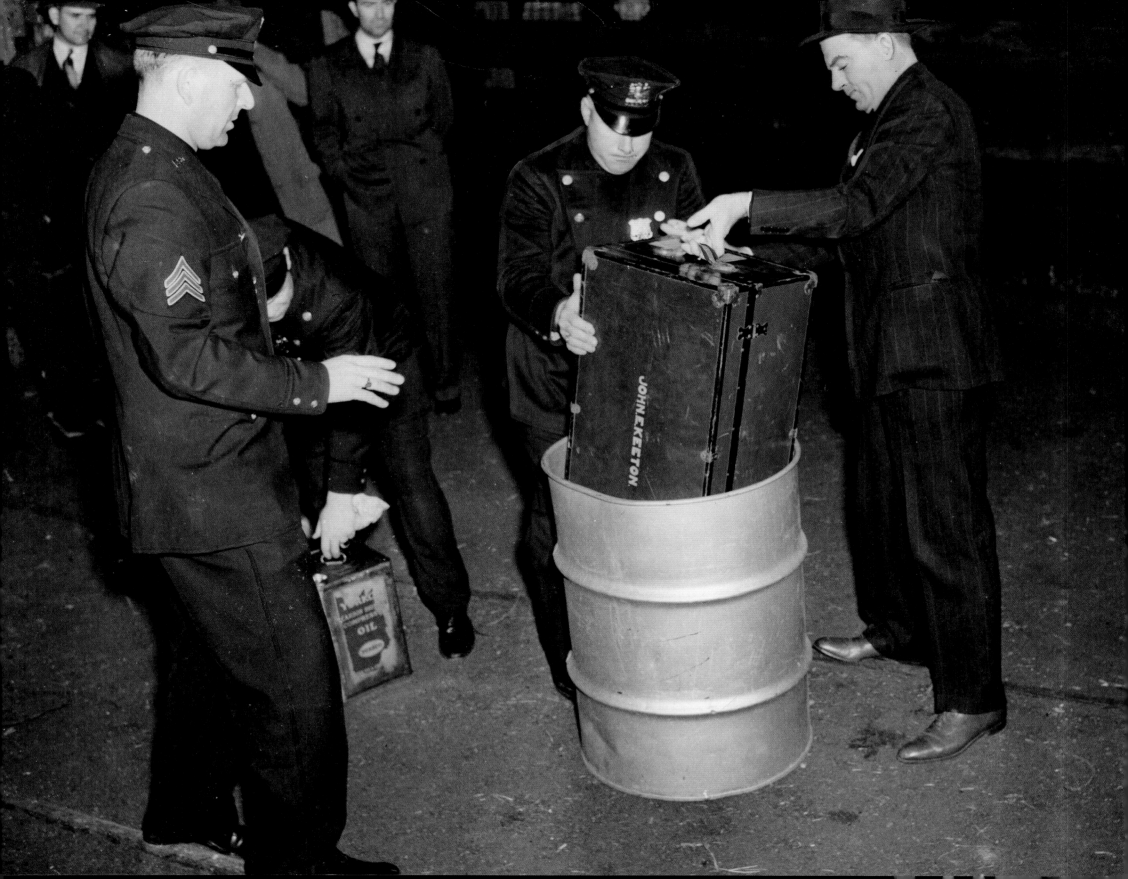

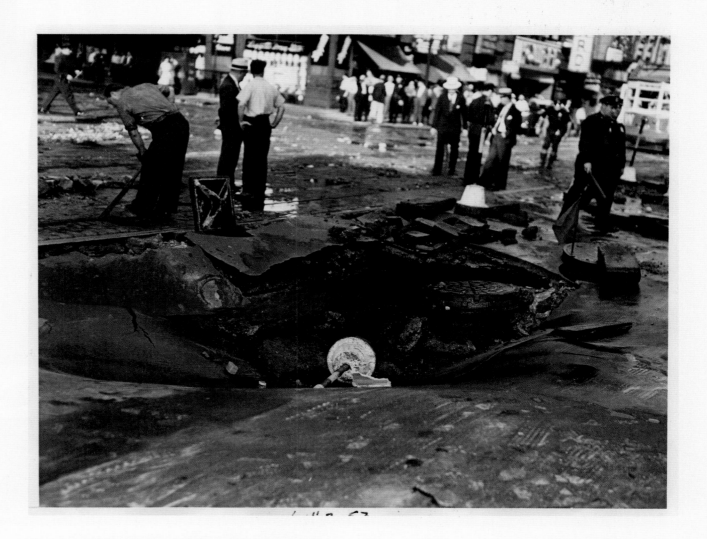

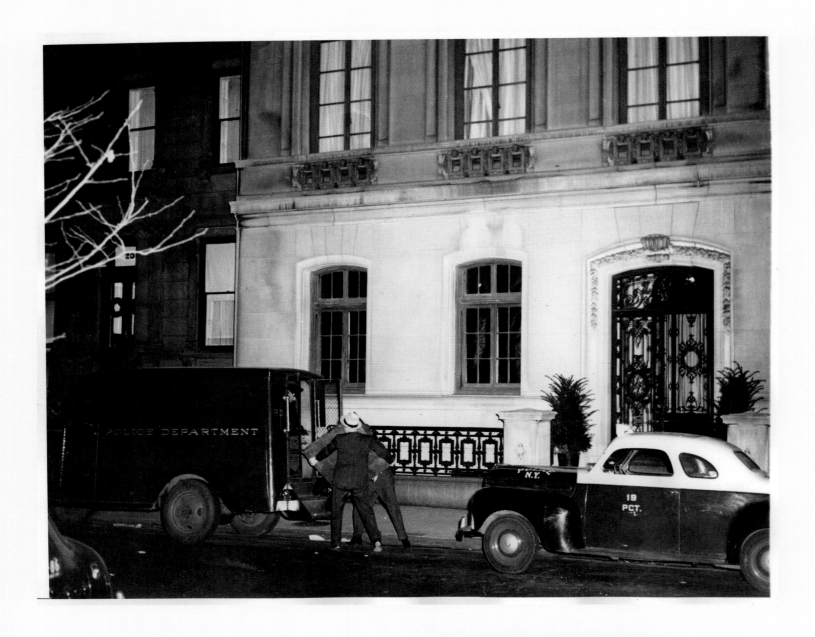

NEW YORK SMART SET GAMBLING HOUSE RAIDED
NEW YORK---POLICE LOADING GAMING EQUIPMENT
INTO A VAN, OUTSIDE THE ELEGANTLY APPOINTED
NEW YORK GAMBLING HOUSE THAT WAS SMASHED BY
POLICE IN AN EARLY SUNDAY MORNING SURPRISE RAID.
MORE THAN 20 PATRONS, INCLUDING ERMINE-COATED
LADIES AND MEN IN EVENING CLOTHES, WERE ALLOWED
TO LEAVE AFTER POLICE HAD TAKEN THEIR NAMES.
CREDIT LINE (ACME) 12-22-40 (OT)

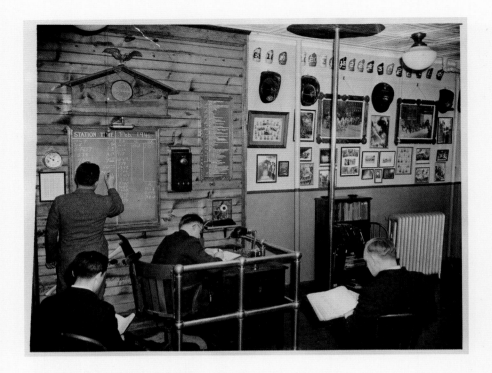

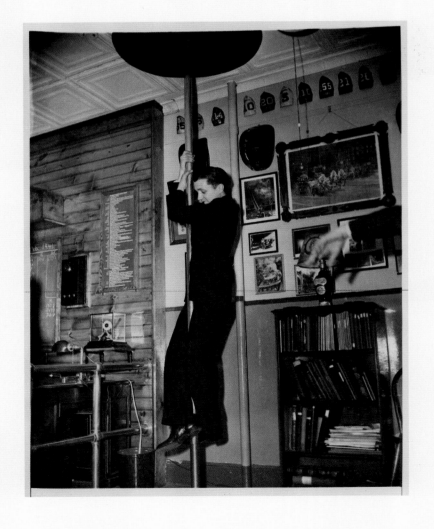

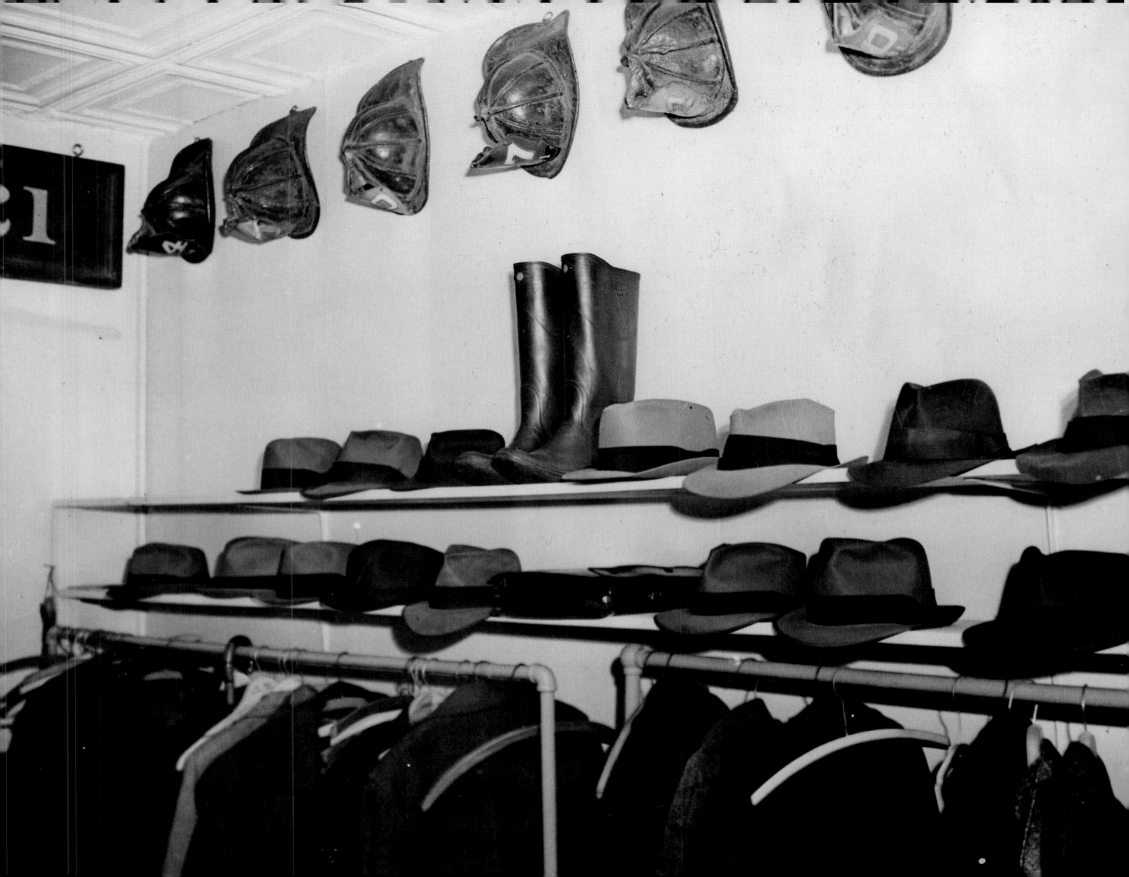

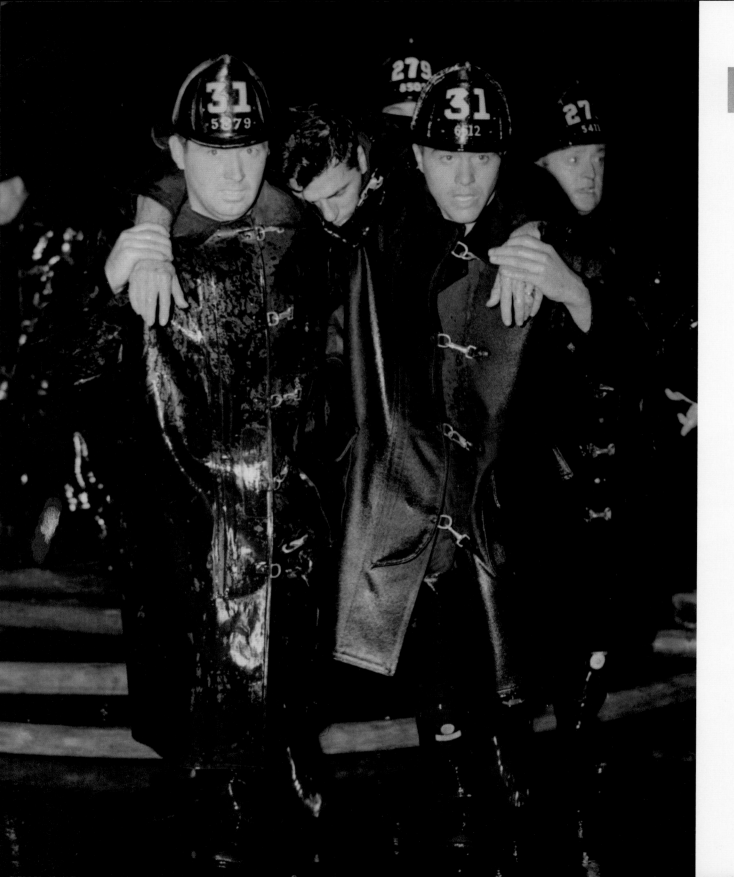

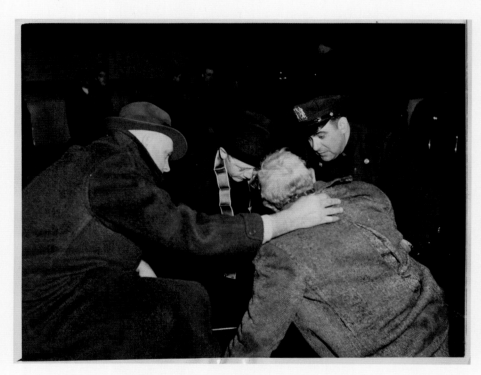 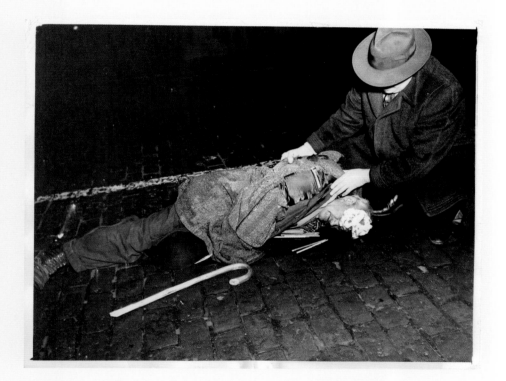

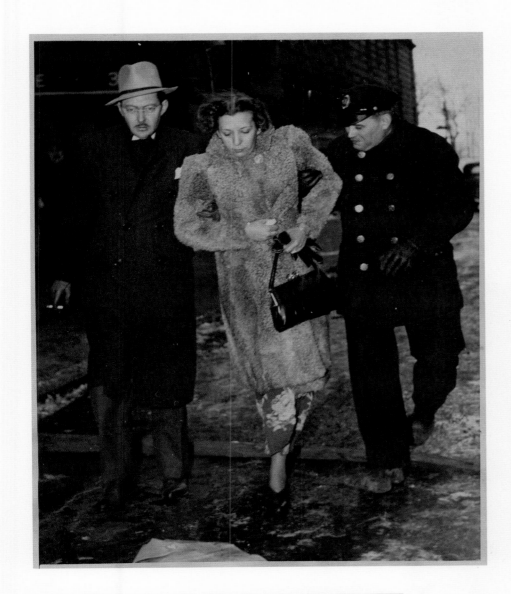

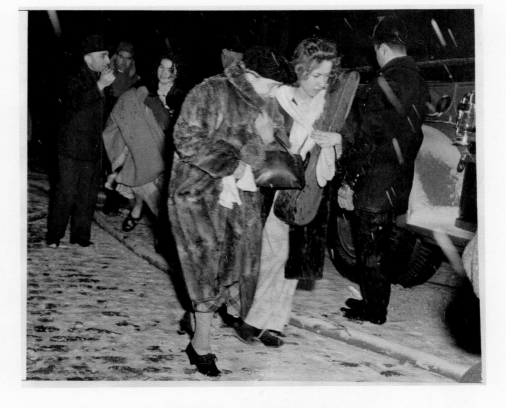

FELLED BY SMOKE IN NEW YORK FIRE
NEW YORK CITY - Constance Regmore IS LEAD TO AN AMBULANCE
AFTER BEING FELLED BY SMOKE IN AN APARTMENT HOUSE FIRE
IN NEW YORK CITY EARLY THIS MORNING. FIVE OTHERS WERE
OVERCOME BY SMOKE AND MANY HAD NARROW ESCAPES FROM DEATH.
CREDIT LINE (ACME) NY 1-21-40 (JO)

TENANTS FLEE FOUR-ALARM FIRE
NEW YORK CITY - CLUTCHING HER VIOLIN, A TENANT
OF THE APARTMENT HOUSE AT 522 RIVERSIDE DRIVE
THAT WAS SWEPT BY FLAMES IN A FOUR-ALARM FIRE
EARLY THIS MORNING (JAN. 27), FLEES FROM THE
BUILDING IN SCANTY NIGHT CLOTHING, HELPING AN-
OTHER TENANT WHO HAD TIME TO DRESS. MANY OF THE
TENANTS WERE STUDENTS OF THE NEARBY JUILLIARD
SCHOOL OF MUSIC. ONE DIED AND 7 WERE INJURED
IN THE FIRE.
BU
CREDIT LINE (ACME) 1/27/43 (RK)

248

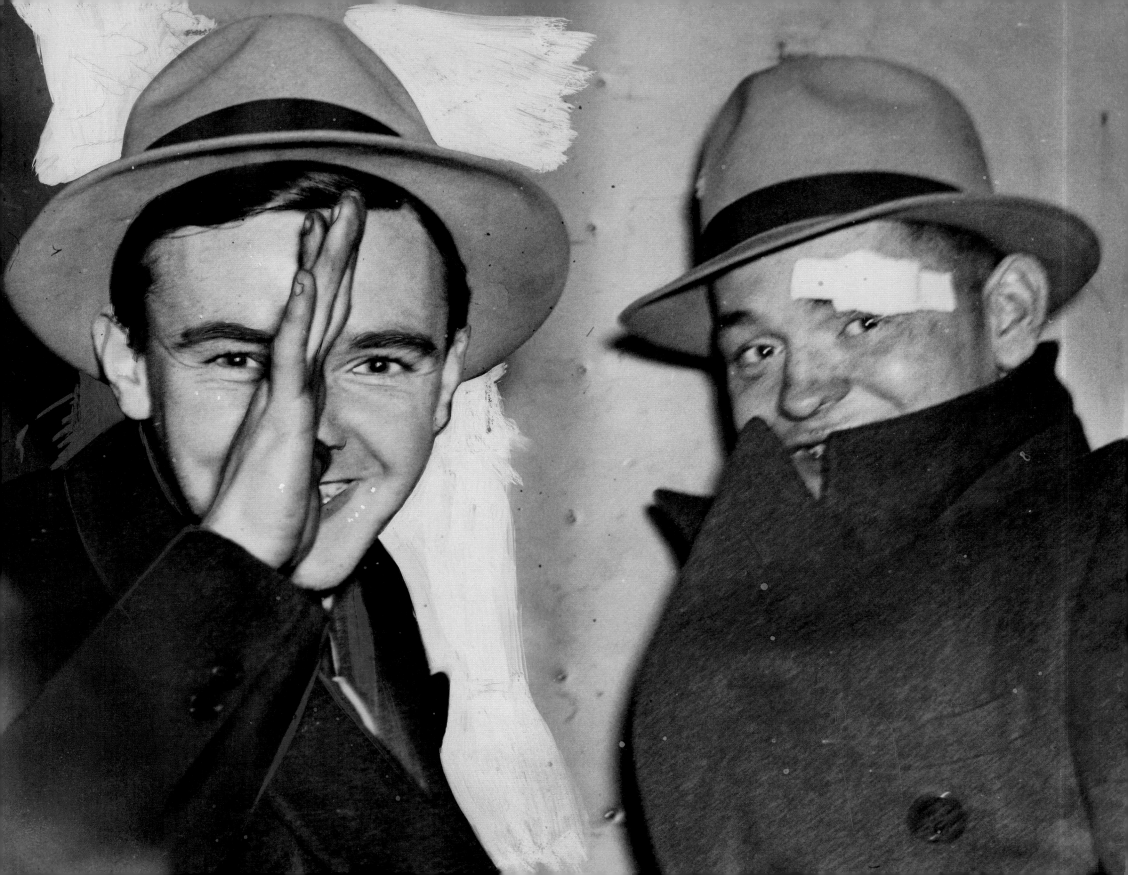

EXTRA!
CRIME

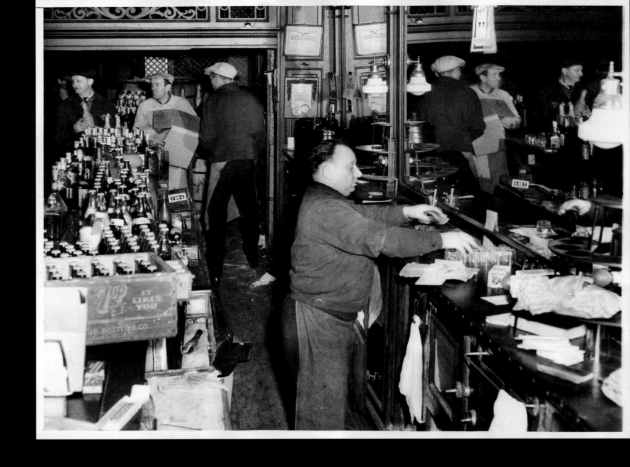

CONFISCATED MOONSHINE
NEW YORK CITY:— FEDERAL AGENTS AND POLICE
SWARMED THROUGH NEW YORK CITY ON A RAIDING
JAMBOREE OF PROHIBITION ERA PROPORTIONS
YESTERDAY, CLOSING DOWN 34 STORES AND TAVERNS
SELLING BOOTLEG LIQUOR, WALSH'S BAR AND GRILL,
AT 213 TENTH AVE., WAS ONE OF THOSE RAIDED.
HERE, MEN REMOVE BOTTLES OF THE "MOONSHINE"
FROM THE BAR.

CREDIT LINE (ACME) 11/24/43 (RK)

NAUGHTY BOYS
NEW YORK:— THOMAS DOHERTY 20 (LEFT) AND FRANCIS DORRY, 17,
SHOW MARKED DISRESPECT FOR THE CAMERAMAN WHO TOOK THEIR
PICTURE AFTER THEY HAD BEEN CAPTURED BY RADIO POLICE,
JANUARY 10. THE TWO YOUTHS ARE ALLEGED TO HAVE HELD UP
TWO GASOLINE STATIONS AND WERE ATTEMPTING A THIRD ROB-
BERY WHEN POLICE SURPRISED THEM. A 90-MILE-AN-HOUR CHASE
THRU THE CITY STREETS, WITH BULLETS FLYING FROM THE GUNS
OF POLICE AND CAPTURED MEN, OCCURRED BEFORE THEY WERE
NABBED TRYING TO ELUDE THE POLICE IN A HIRED TAXI.
#1 DJR LV AC TS
CREDIT LINE (ACME) 1/10/40 (NS)

CLOSE "MOONSHINE" BAR
NEW YORK CITY:— CHARGED WITH SELLING BOOTLEG
LIQUOR, THIS BAR AT 264 WEST 34TH STREET WAS
CLOSED BY FEDERAL AGENTS AND POLICEMEN IN THEIR
RAID YESTERDAY (NOV. 23RD). STORAGE MEN MOVE
THE BAR OUT OF THE TAVERN. ITS OWNER WAS ONE
OF 43 ARRESTED IN THE RAID.
BU DJH HOCH BUF NWK DC
CREDIT LINE (ACME) 11/24/43 (RK)

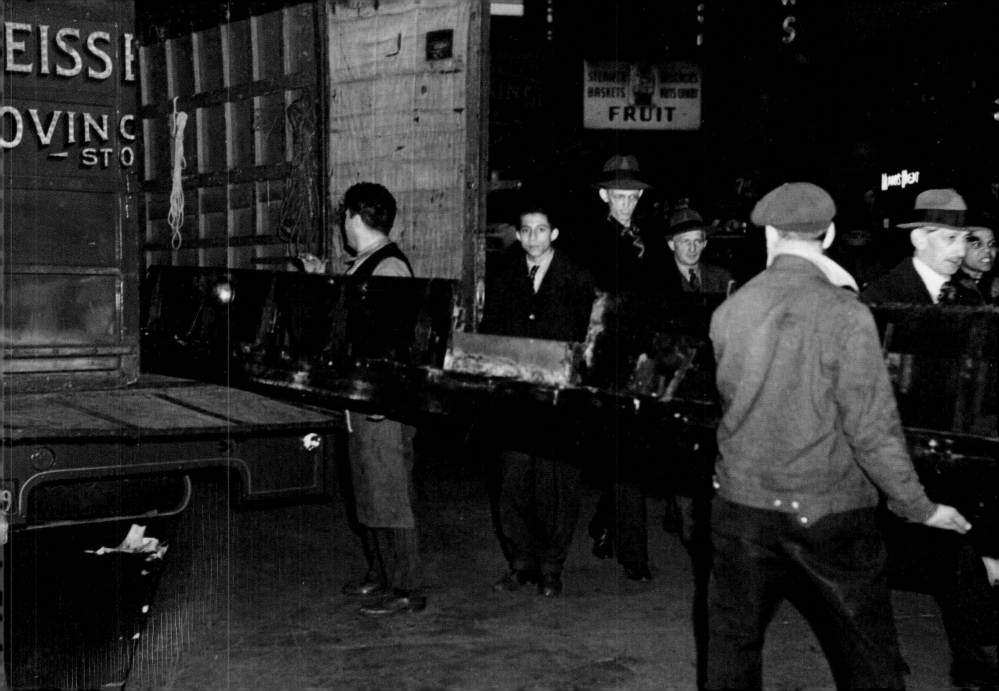

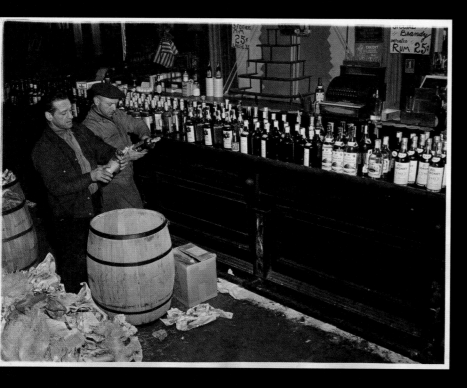

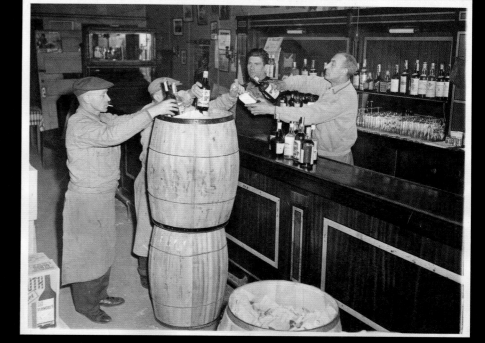

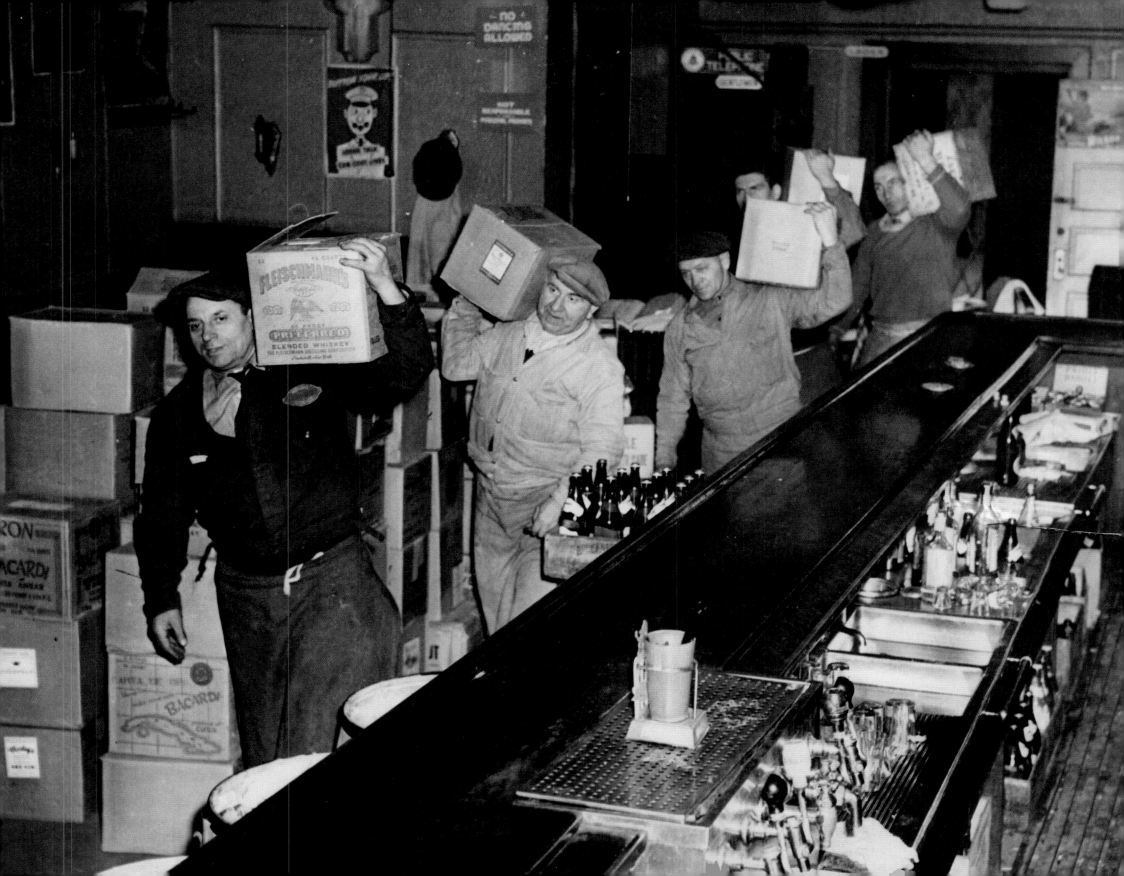

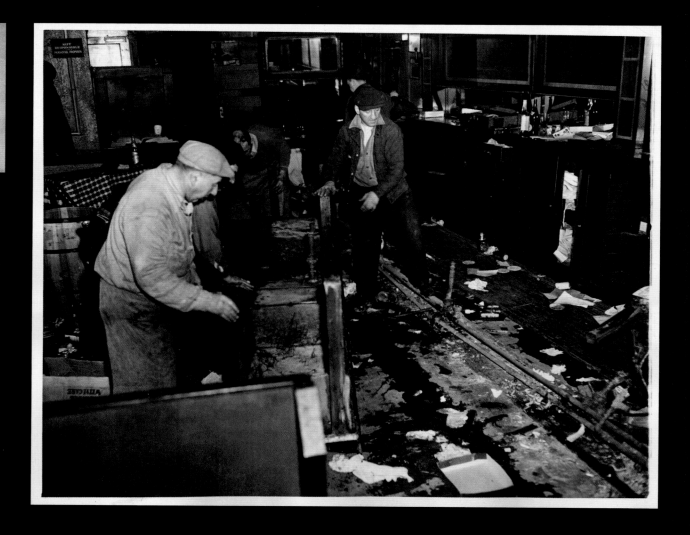

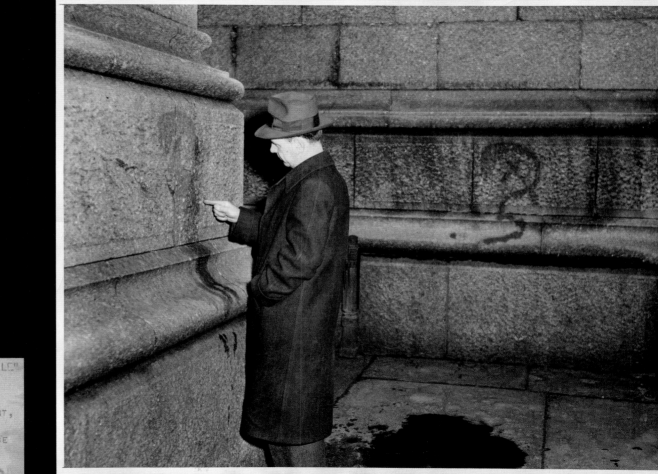

ST. PATRICKS DECKED WITH RED "HAMMER AND SICKLE"
NEW YORK CITY --A PEDESTRIAN PASSING BY
ST. PATRICK'S CATHEDRAL IS AMAZED TO FIND
A RED, SMEARY PAINTED HAMMER AND SICKLE
DECKING A WALL OF THE CHURCH AT 50TH STREET
AND FIFTH AVENUE. ANOTHER BLOTCH OF RED PAINT,
EVIDENTLY MEANT TO REPRESENT ANOTHER SICKLE,
CAN BE SEEN ON THE WALL BEHIND HIM, ON THE
51ST STREET SIDE OF THE SACRED EDIFICE. POLICE
SAY THE PAINT DAUBS ARE THE WORK OF VANDALS.

CREDIT LINE (ACME) 2/18/44 (JR)

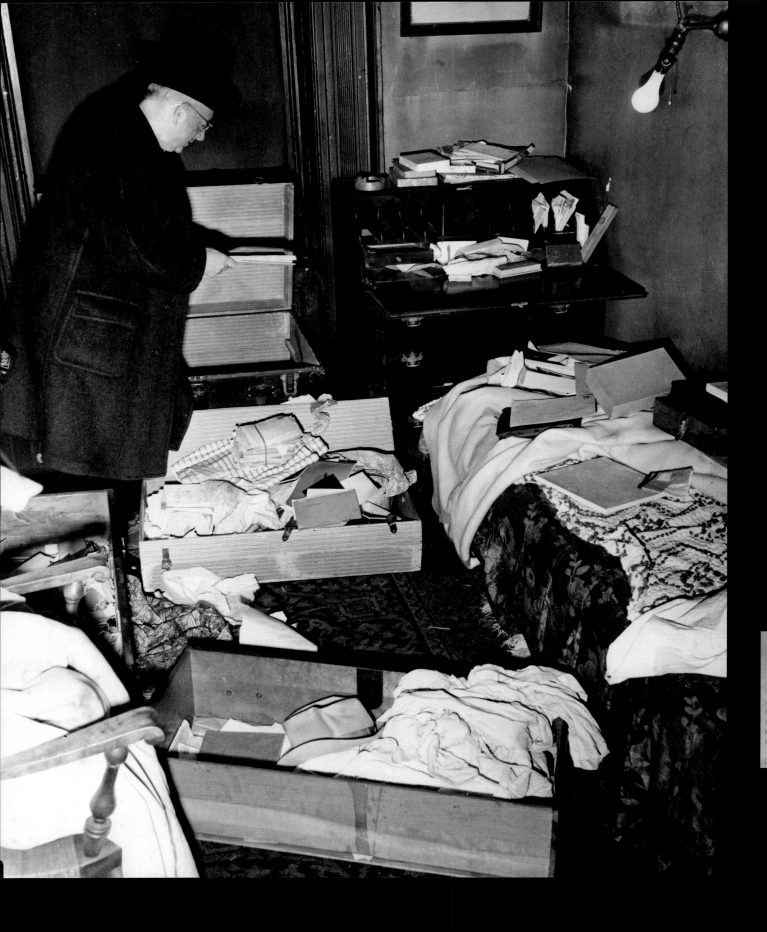

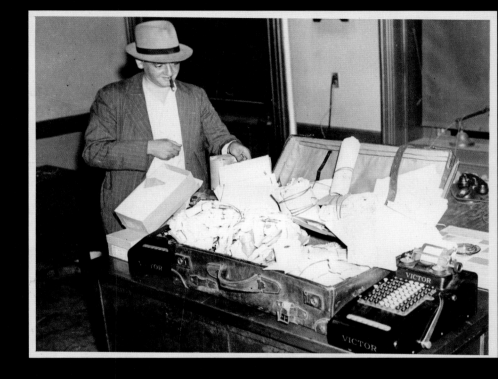

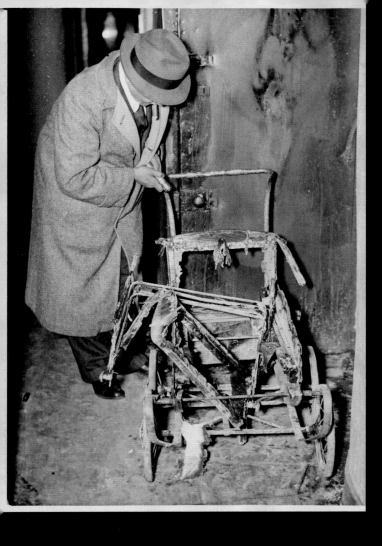

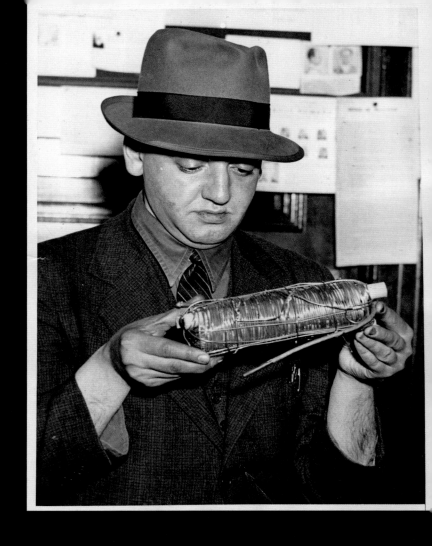

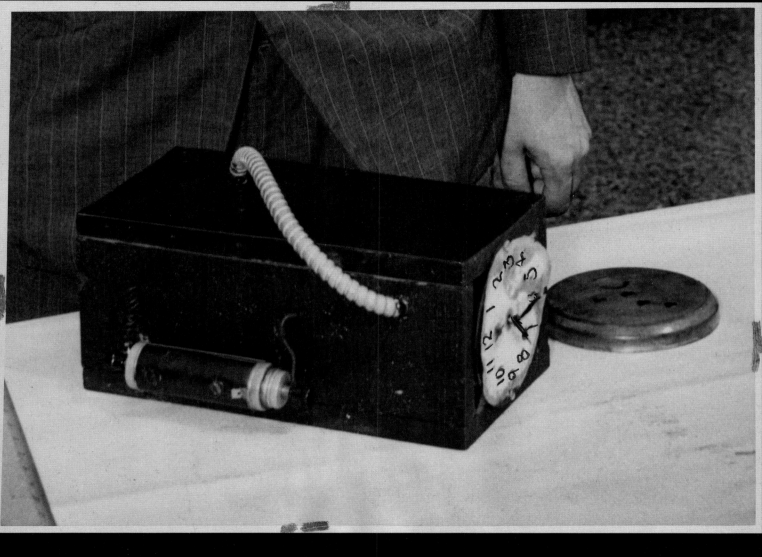

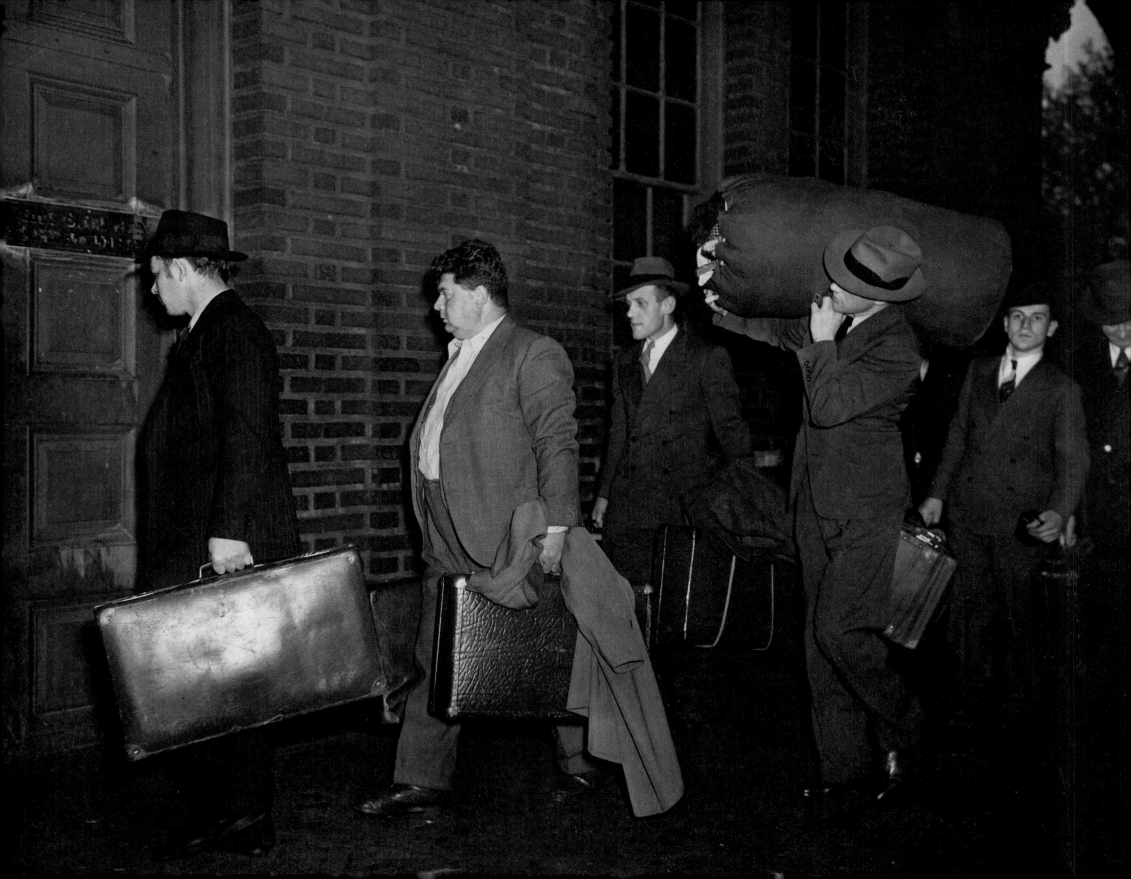

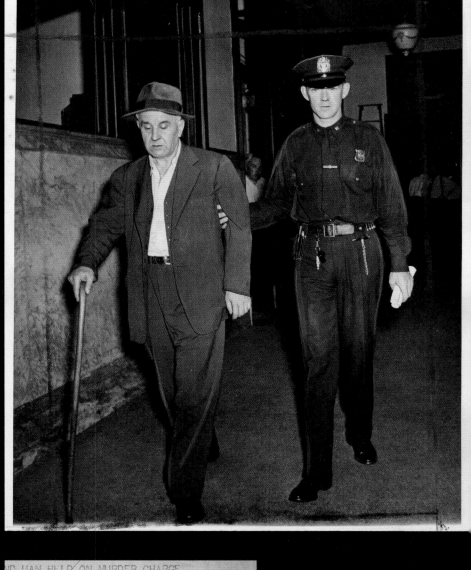

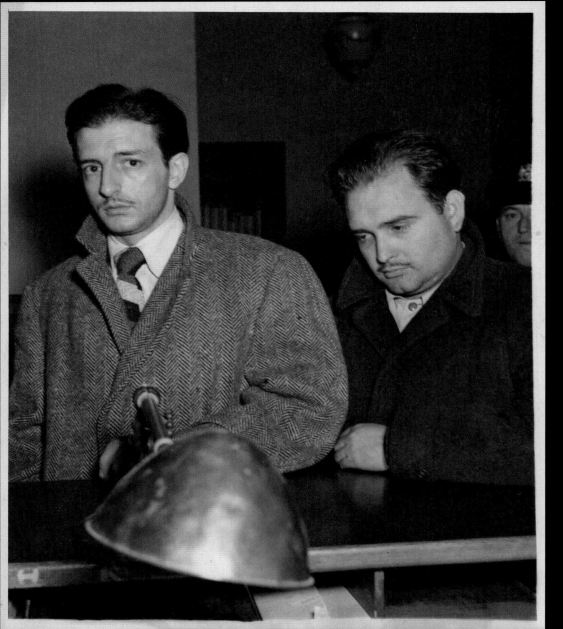

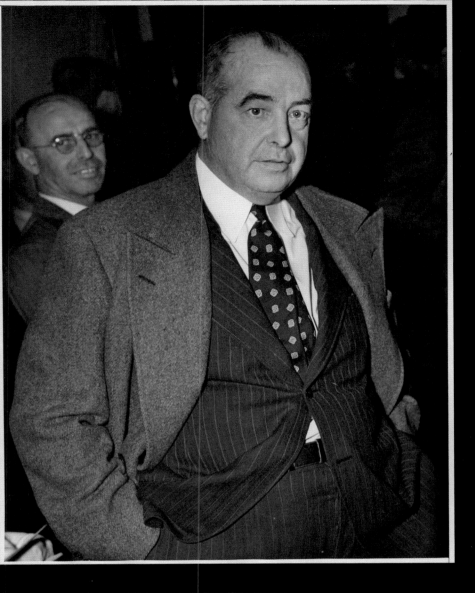

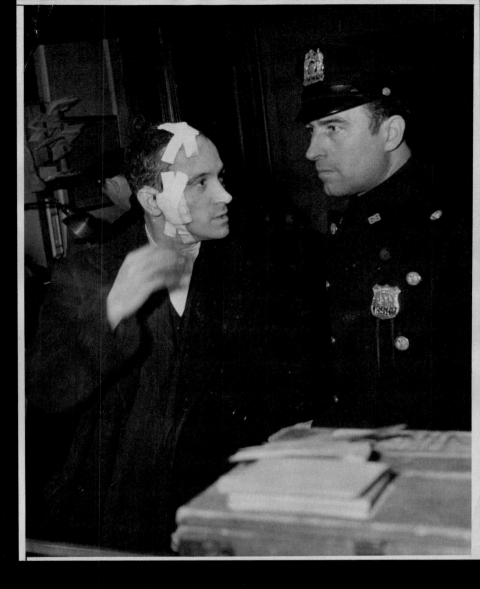

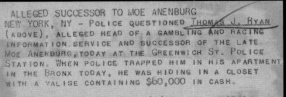
265

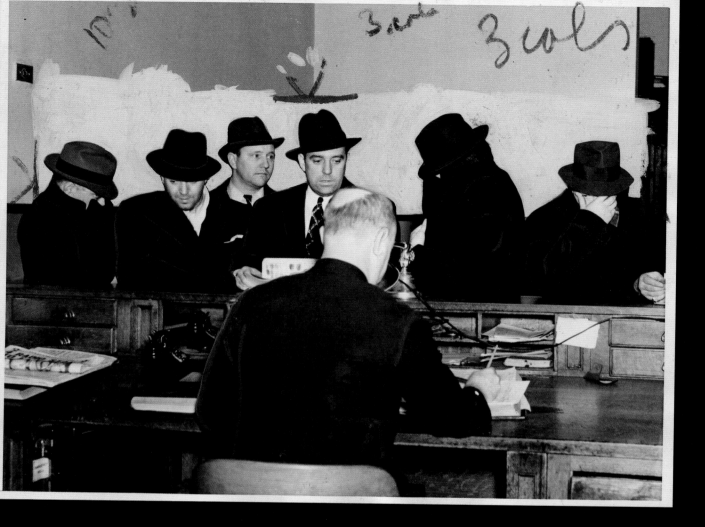

Eight subway employes were arrested and more than a score of others involved in the alleged theft of 25,000,000 nickels during the last three years from New York's city-owned subway. Four of the suspects are shown being booked at Police Headquarters on charges of grand larceny and forgery. The two men in the center are detectives.

FATHER DIVINE BOOKED
FATHER DIVINE, WHOSE BAPTISMAL NAME WAS GEORGE BAKER, AND WHO IS KNOWN TO MANY THOUSANDS OF FOLLOWERS AS GOD, PICTURED, CENTER, WITHOUT HAT, AS HE WAS BOOKED AT POLICE HEADQUARTERS IN NEW YORK, APRIL 22ND, ON CHARGES ARISING OUT OF THE STABBING OF A PROCESS SERVER IN HIS MAIN HARLEM "HEAVEN", APRIL 20TH. DIVINE WAS ARRESTED AT A LESSER "HEAVEN" IN MILFORD, CONN., HIDING BEHIND THE FURNACE IN THE CELLAR.
CREDIT LINE (ACME) 4/22/37 FULL

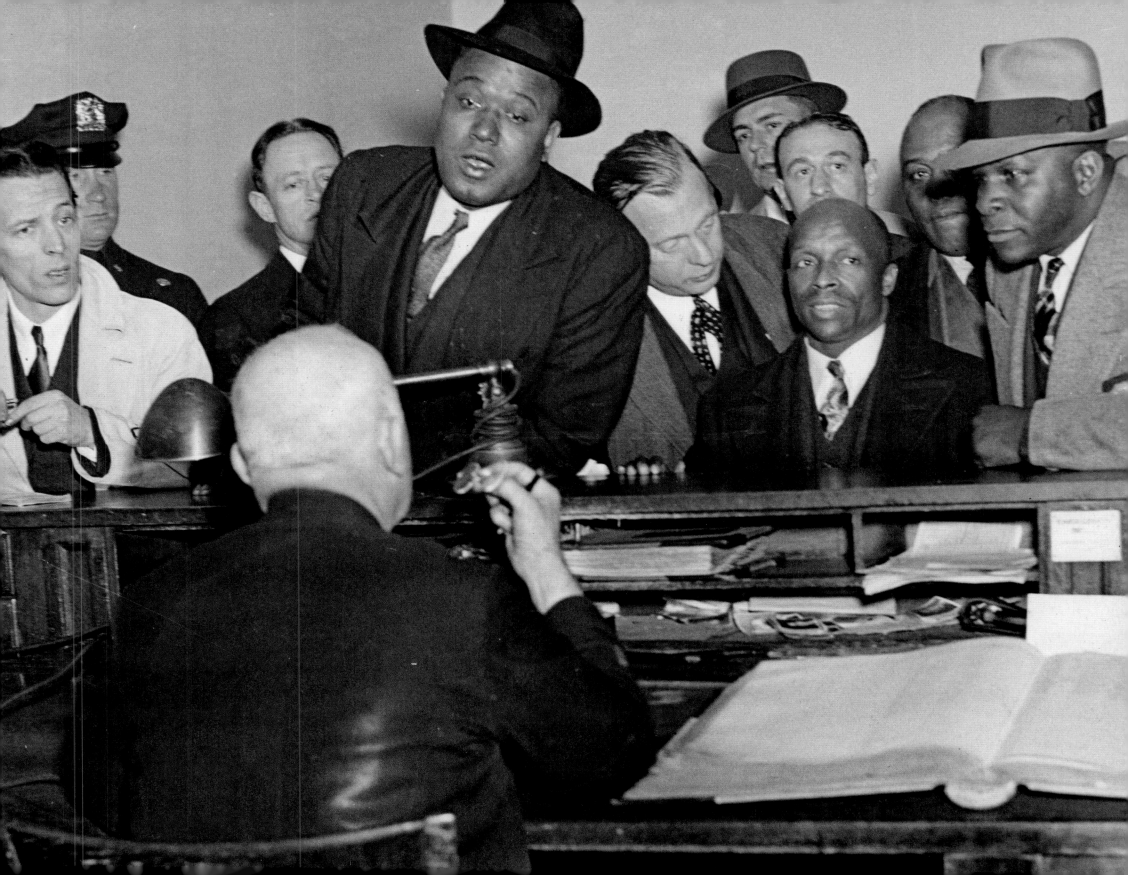

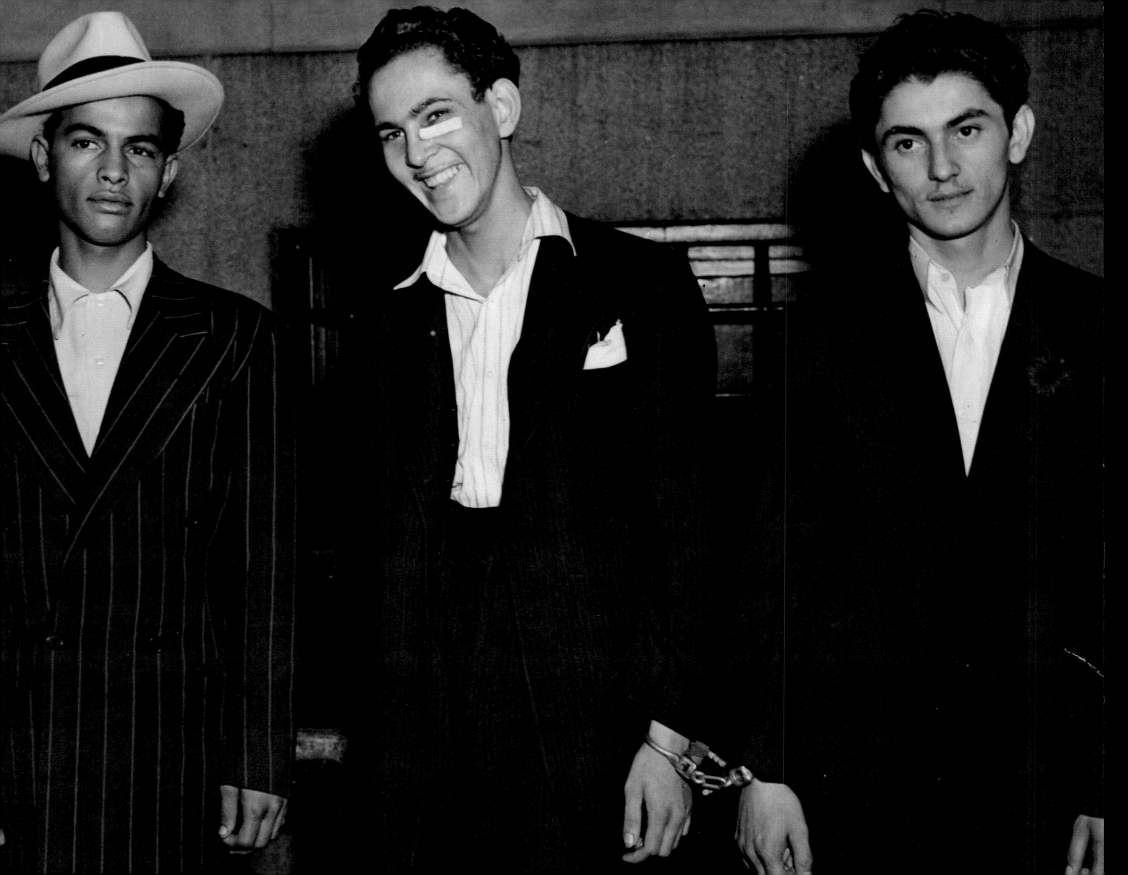

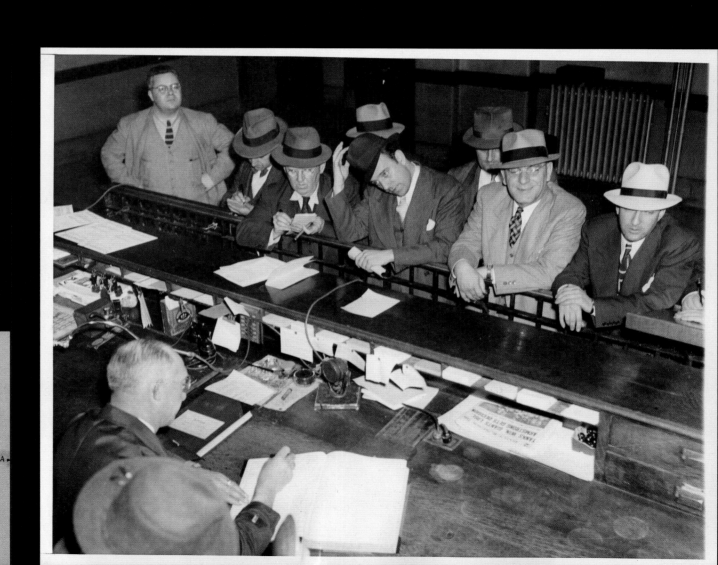

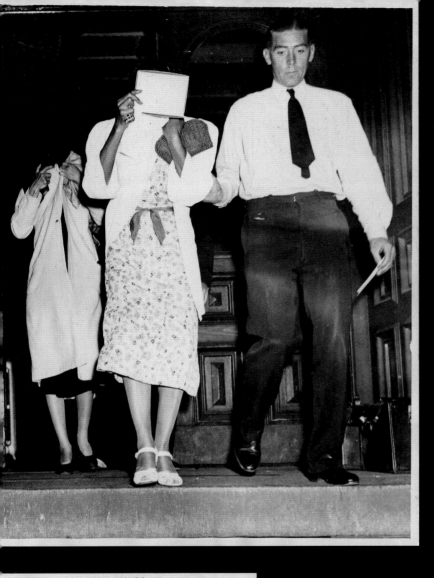

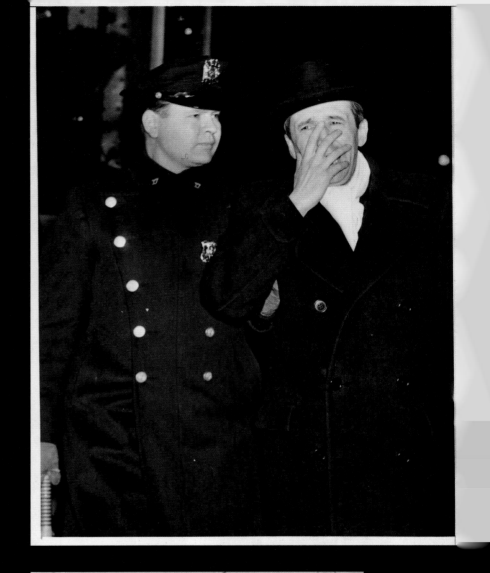

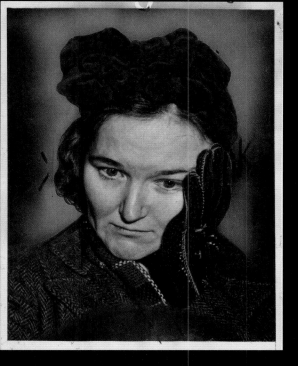

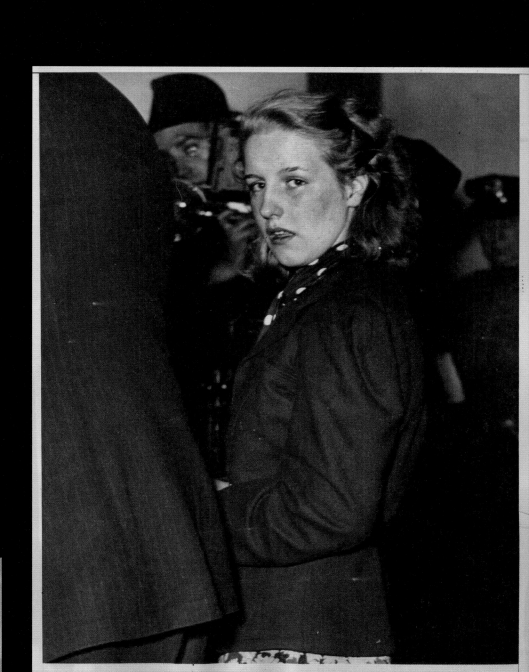

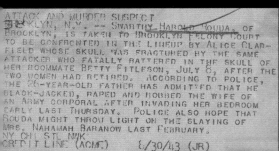

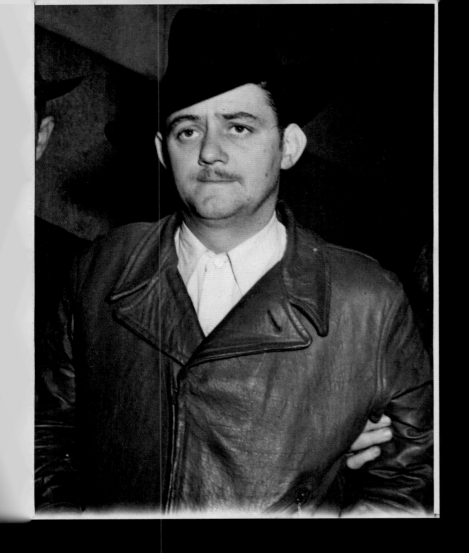

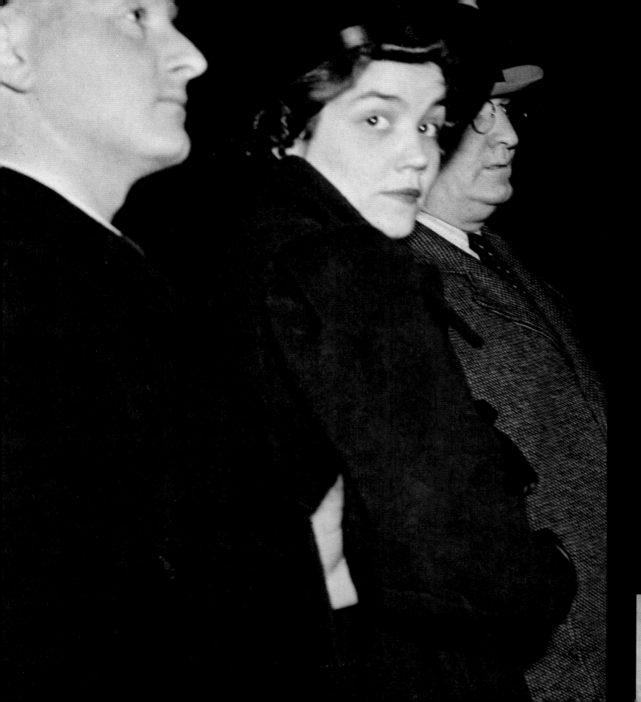

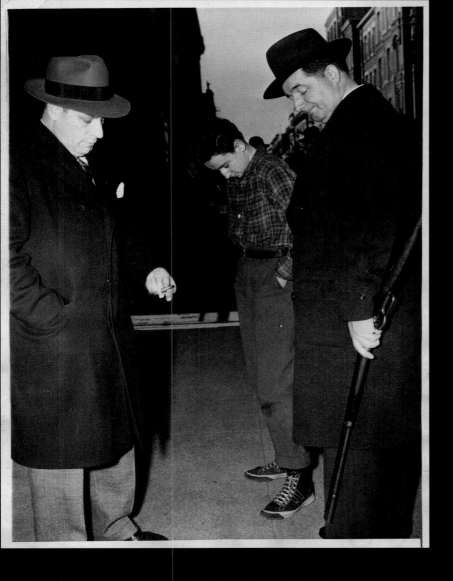

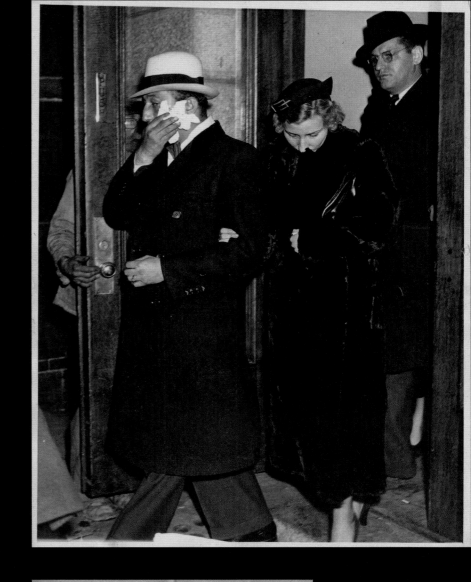

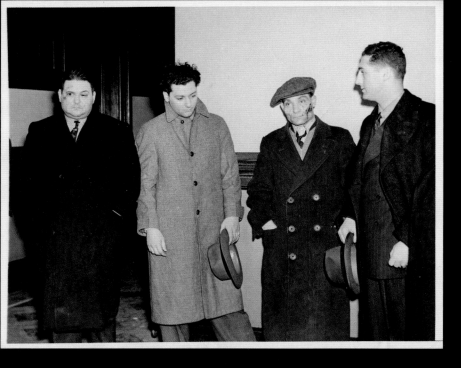

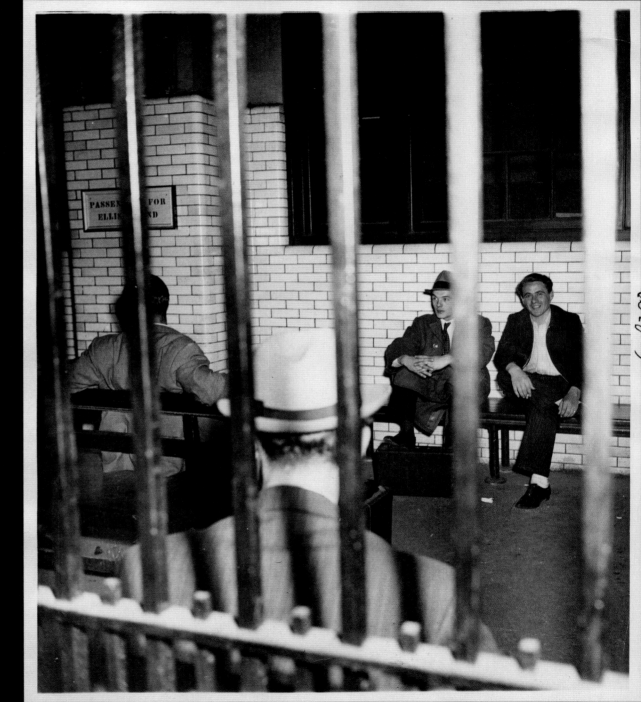

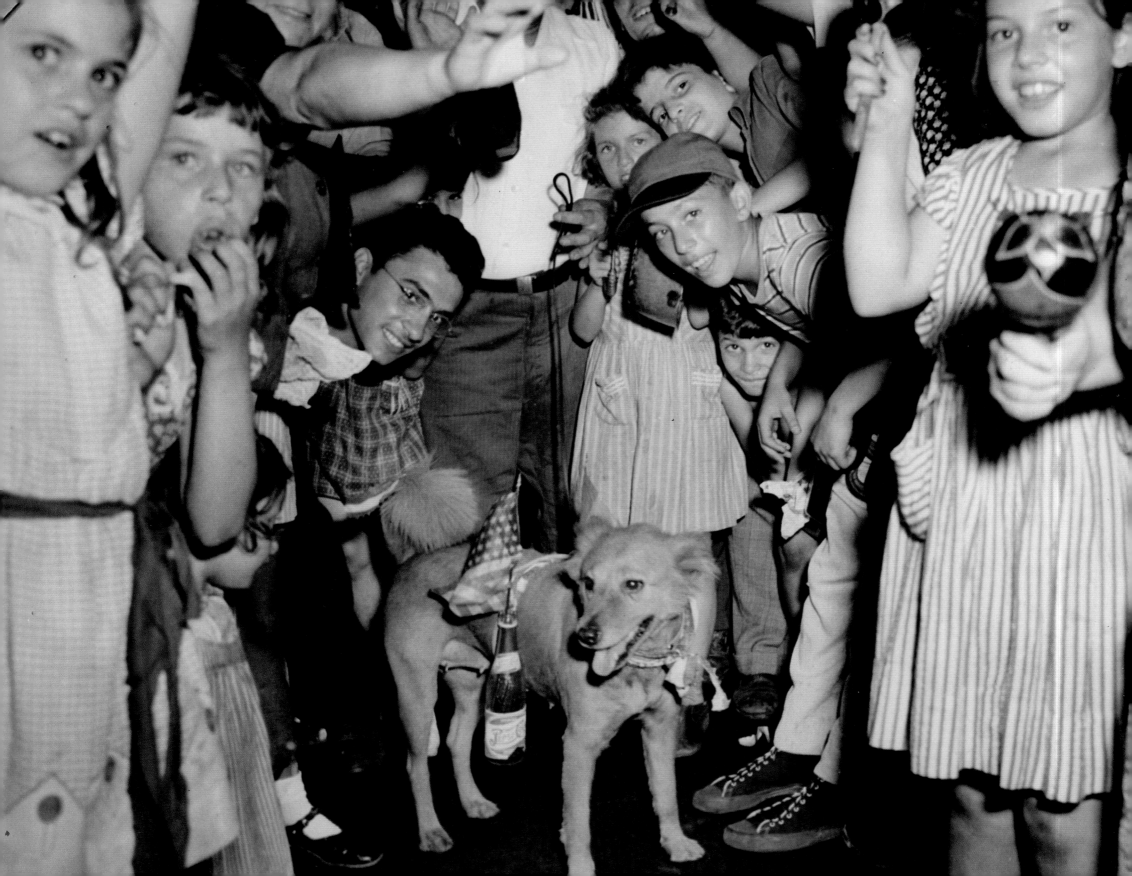

EXTRA!
FRIENDS

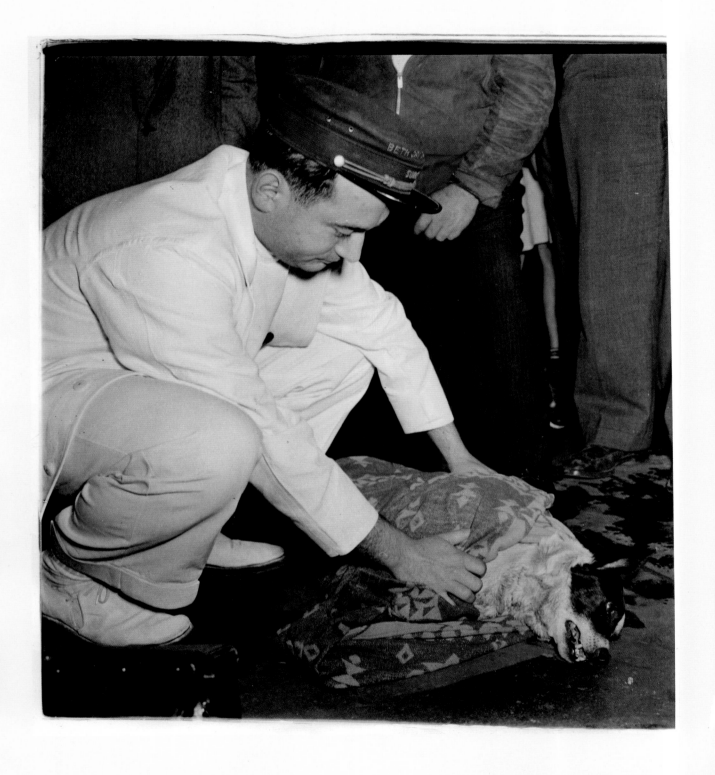

DOG OVERCOME BY SMOKE.
NEW YORK CITY--AMBULANCE SURGEON DR. TREICHNER
OF BETH DAVID HOSPITAL GIVES FIRST AID TO
JERRY AFTER THE DOG WAS OVERCOME BY SMOKE IN
A TENEMENT HOUSE FIRE ON EAST 106TH STREET
THIS MORNING. THE PUP'S OWNER, JOHN LAMANNA,
WAS ABLE TO TAKE HIM HOME NONE THE WORSE FOR
HIS EXPERIENCE.
BURS 80 PRV NJ BUFF
CREDIT LINE (ACME) 11/16/41 (FK)

VICTORY PUP
NEW YORK, N.Y.--MERRYMAKERS ON SECOND AVENUE
NEAR 5TH STREET, ON NEW YORK'S LOWER EAST SIDE,
DECORATED THIS PUP IN THE SPIRIT OF THE
OCCASION, AS NEWS OF THE END OF THE WAR WITH
JAPAN WAS ANNOUNCED.
CREDIT LINE (ACME) 45 (ML)
BURS 80 BUFF NWK TRENTON

← page 278

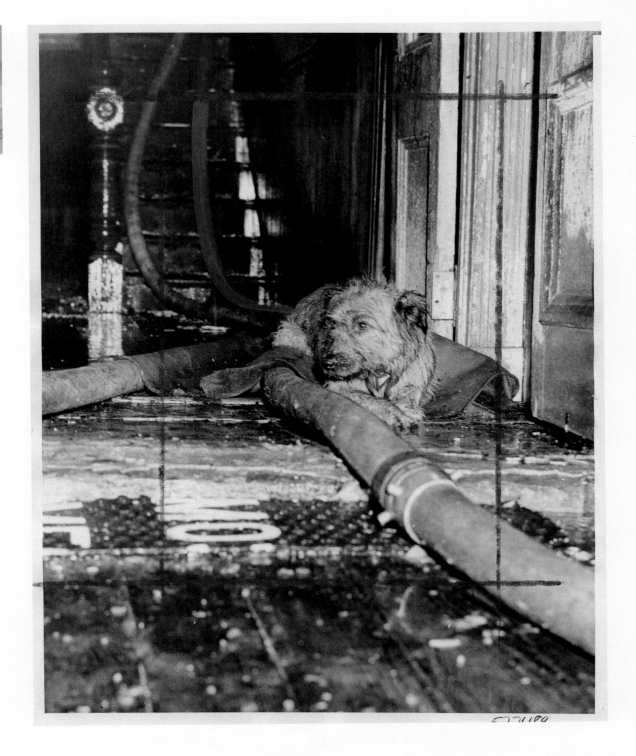

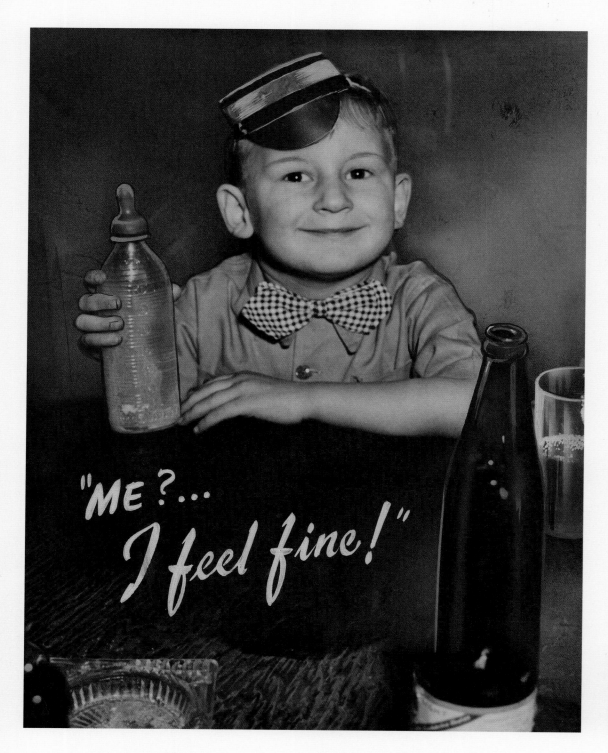

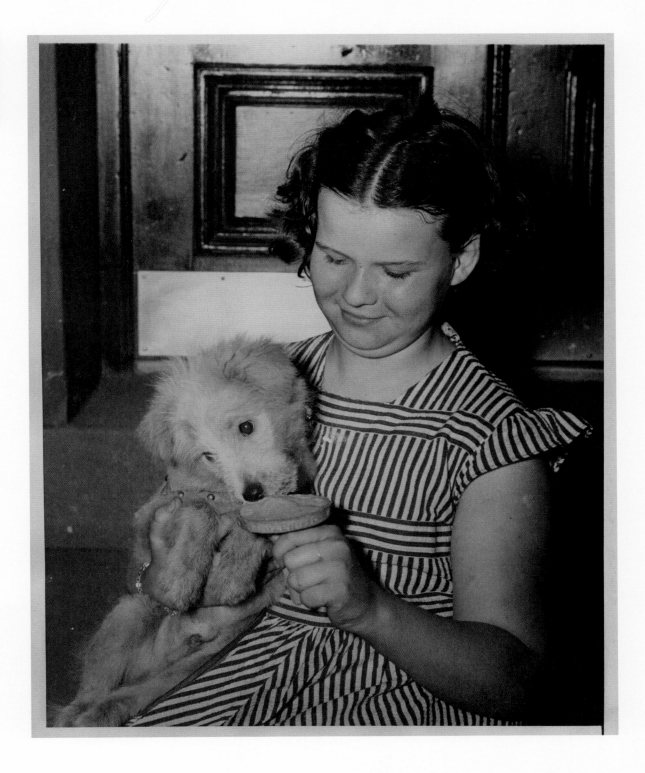

287

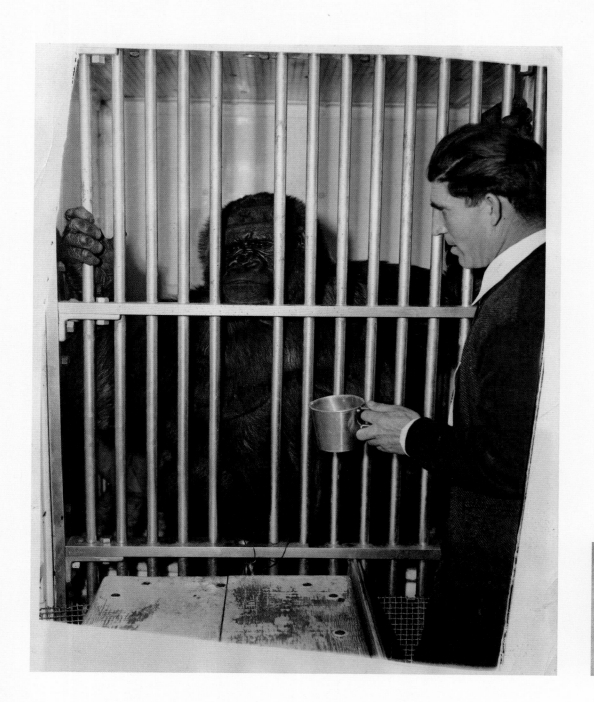

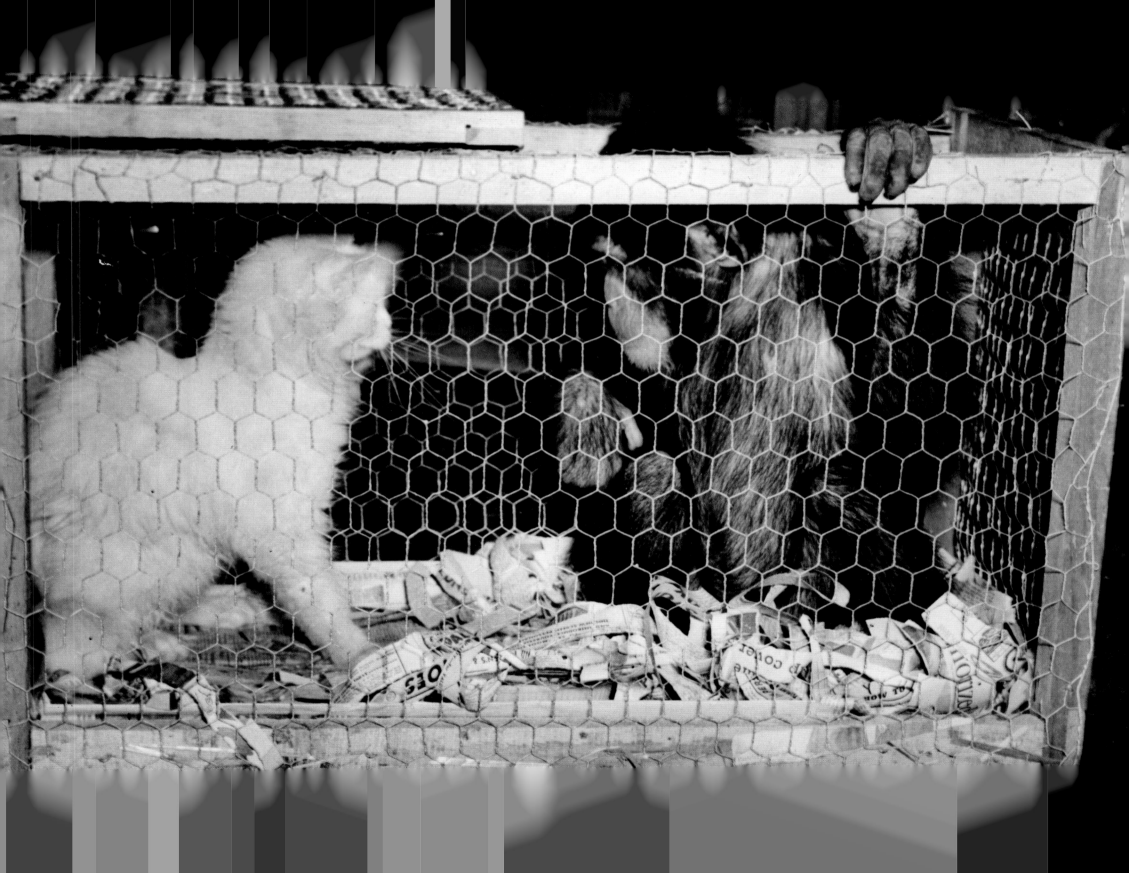

EXTRA!
STRIKES

← page 292

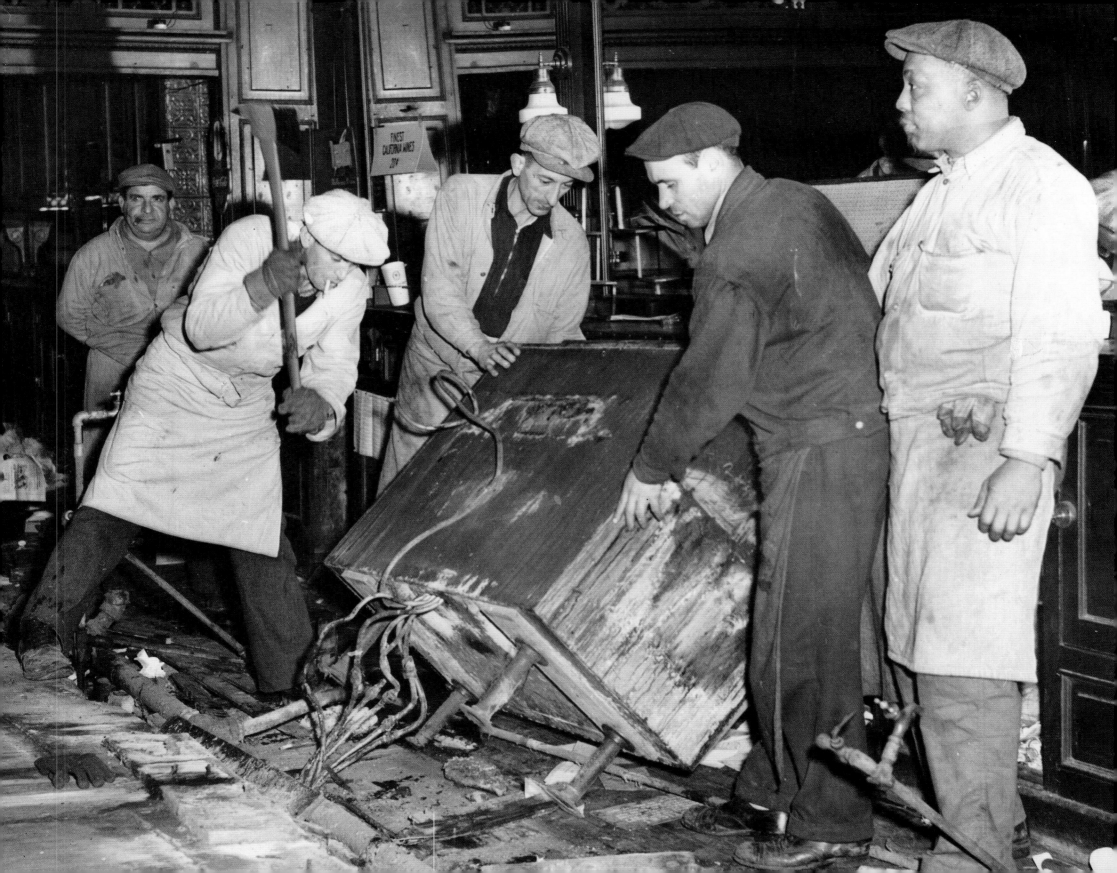

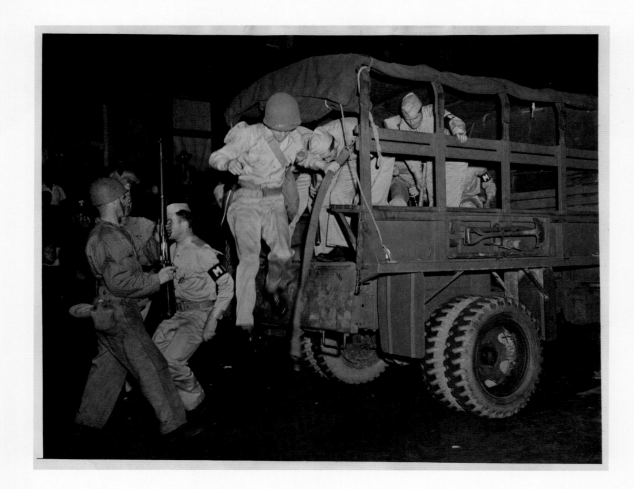

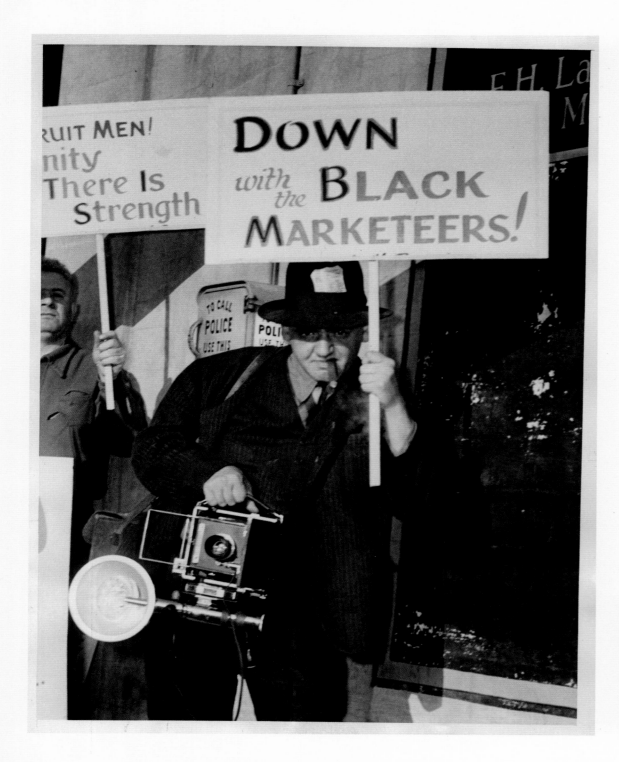

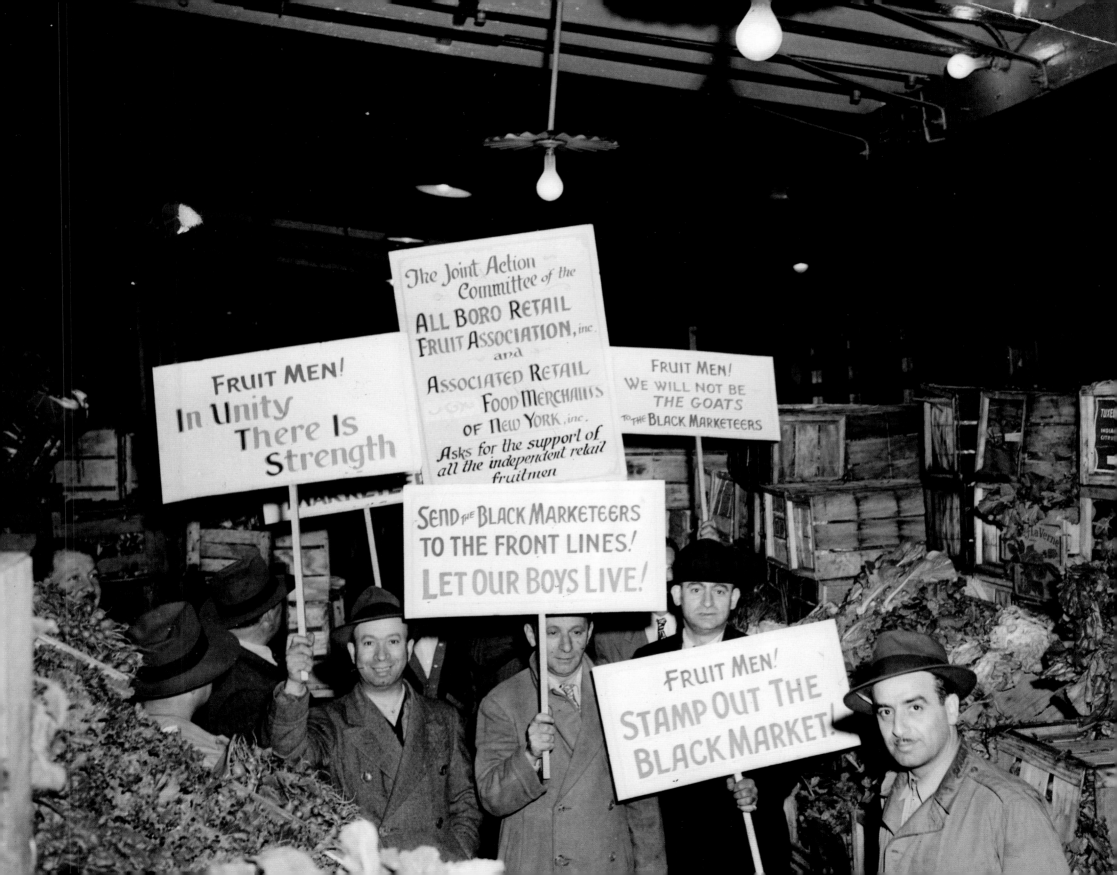

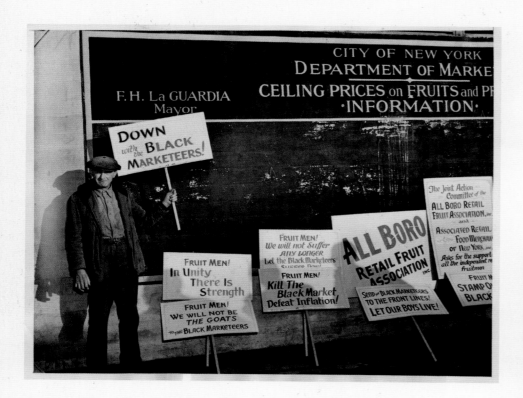

RETAIL DEALERS PROTEST BLACK MARKET
NEW YORK -- JOSEPH SCHOENFELD, A RETAIL FRUIT
DEALER OF 1565 FULTON AVE., CARRIES A PLACARD
DENOUNCING BLACK MARKETEERS, AS HE JOINED
OTHER RETAIL DEALERS PICKETING THE BRONX
TERMINAL MARKET, 151ST AND EXTERIOR STS.,
THIS MORNING (MAY 29). THE DEALERS, PROTESTING
AGAINST BLACK MARKET AND TIE-IN SALES,
THREATEN TO CLOSE THEIR SHOPS IF THE SITUATION
IS NOT REMEDIED. NOTE OTHER PLACARDS OF
INDIGNANT PROTEST LINED UP AGAINST THE WALL.
CREDIT (ACME) 5/29/45 (MD)

Meat Black Market

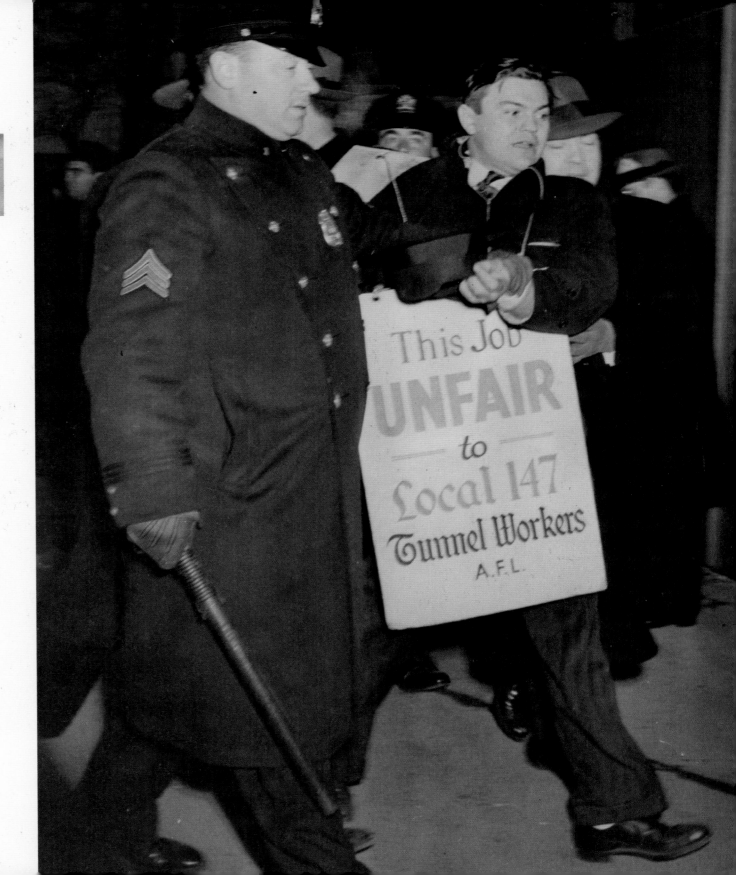

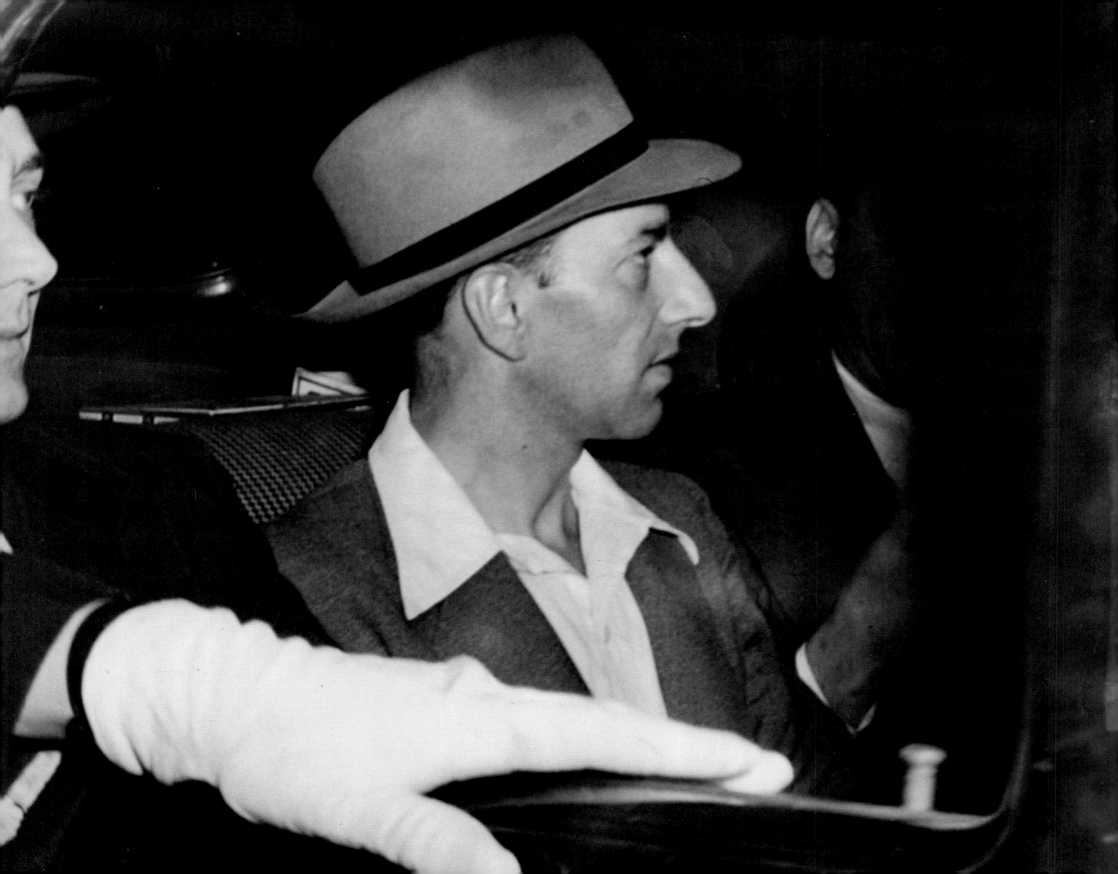

EXTRA!
CHARACTERS

2 ARRESTED IN RADIO CITY LIFT STRIKE

NEW YORK, N.Y.--TWO STRIKERS WERE ARRESTED SHORTLY AFTER NOON TODAY, DURING A STRIKE WHICH TIED UP THOUSANDS OF OFFICES IN THE 14 BUILDINGS OF RADIO CITY. THE STRIKE WAS CALLED AMONG ELEVATOR OPERATORS AND OTHER BUILDING EMPLOYES DURING THE 5 P.M. RUSH YESTERDAY AND CONTINUED TODAY. HERE, ONE OF THE TWO STRIKERS, (CENTER), IS SHOWN IN A POLICE CAR AFTER HIS ARREST ON A CHARGE OF INTERFERING WITH OPERATORS ON THE FEW ELEVATOR KEPT RUNNING.
CREDIT LINE. (ACME.) 43 (ML)

← page 304

3- Charles E. Cox being led to detention cell to await morning lineup after being booked.

BUND LEADER LED TO CELL AFTER RETURN FROM PENNSYLVANIA
NEW YORK CITY—FRITZ KUHN, LEADER OF THE GERMAN-AMERICAN
BUND, IS SHOWN AT THE RIGHT AS HE WAS LED TO A CELL
AT MANHATTAN POLICE HEADQUARTERS, EARLY MAY 26TH, AFTER
BEING BROUGHT BACK TO NEW YORK FROM KRUMSVILLE, PA.,
WHERE HE WAS SEIZED BY DETECTIVES FROM DISTRICT
ATTORNEY DEWEY'S OFFICE ON CHARGES OF EMBEZZLING
$14,548 OF THE BUND'S FUNDS. KUHN DENIED THAT HE WAS
FLEEING, CLAIMING THAT HE HAD LEFT NEW YORK FOR A
VACATION.
CREDIT LINE(ACME) 5/26/39 BURS FOR NWK PHIL DC (GW)

BUND LEADER BOOKED ON THEFT CHARGE
NEW YORK CITY—FRITZ KUHN, THE FUEHRER OF THE GERMAN-
AMERICAN BUND, BEING BOOKED IN THE BEAVER STREET POLICE
STATION, EARLY MAY 26TH, ON CHARGES OF EMBEZZLING
$14,548 OF THE BUND'S FUNDS. AFTER HIS RETURN FROM
KRUMSVILLE, PA., WHERE HE WAS ARRESTED BY DETECTIVES
FROM DISTRICT ATTORNEY DEWEY'S OFFICE WHO HAD TRAILED
HIM TO THE HAMLET FROM NEW YORK CITY. HE WAS ARRESTED
BY THE OFFICERS AS SOON AS THEY LEARNED THAT THE NEW
YORK COUNTY GRAND JURY HAD INDICTED THE BUND LEADER.
KUHN DENIED THAT HE WAS FLEEING.
CREDIT LINE(ACME) 39 BURS FOR SA #1 SEEC. (GW)

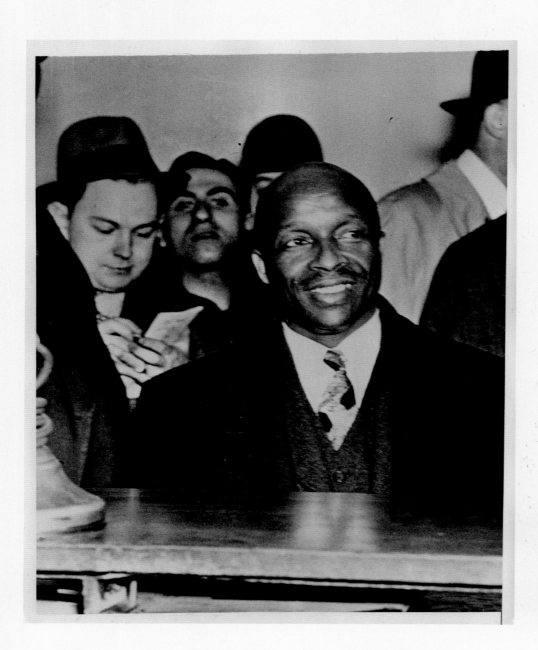

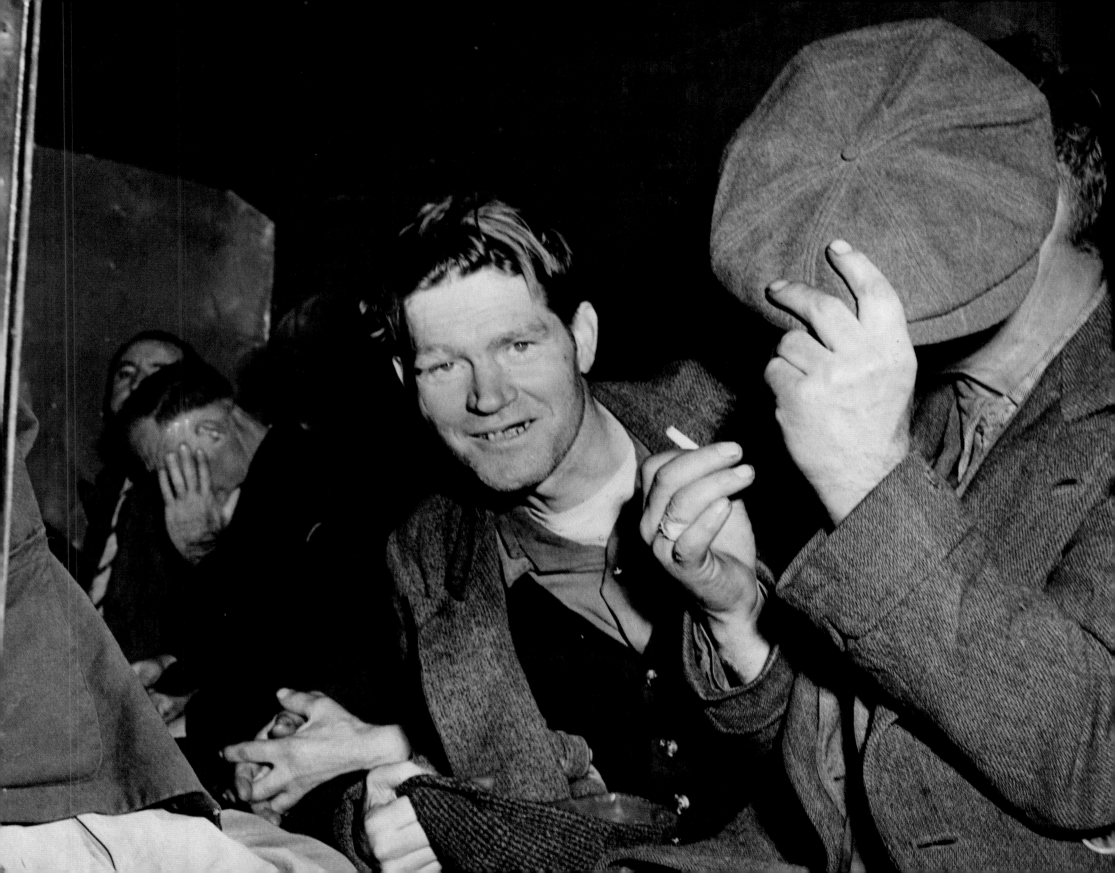

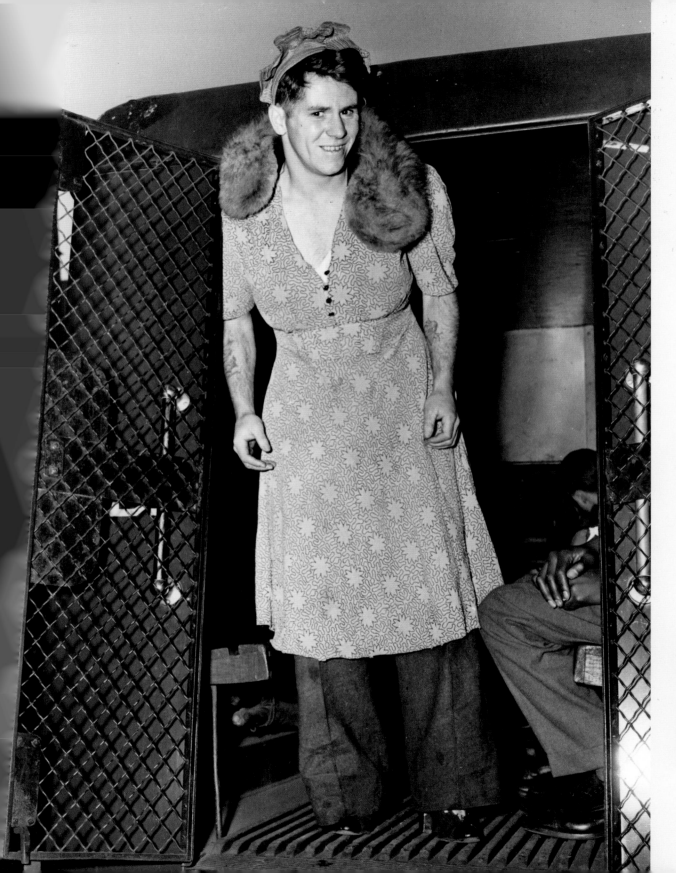

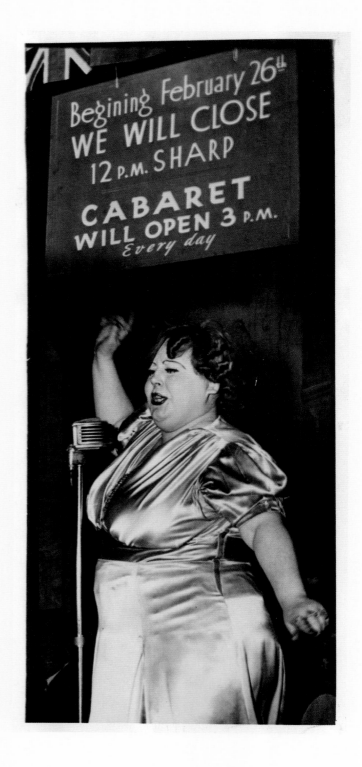

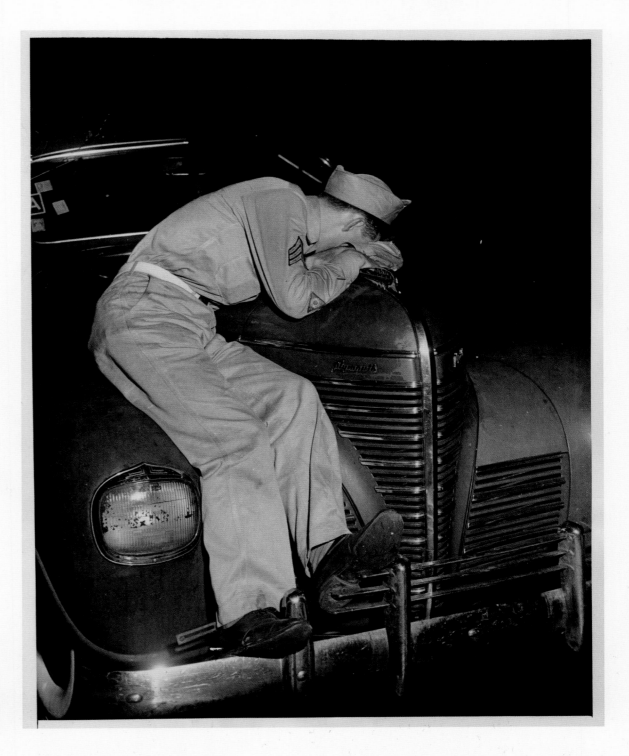

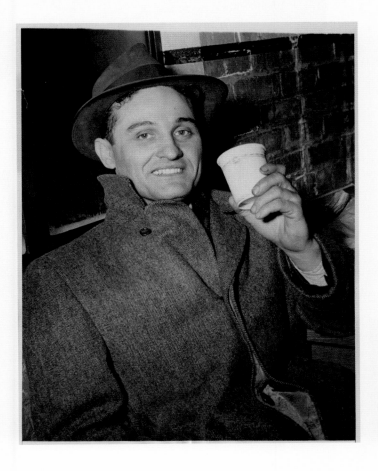

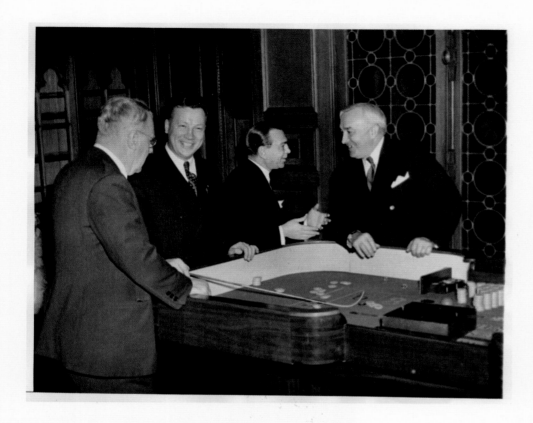

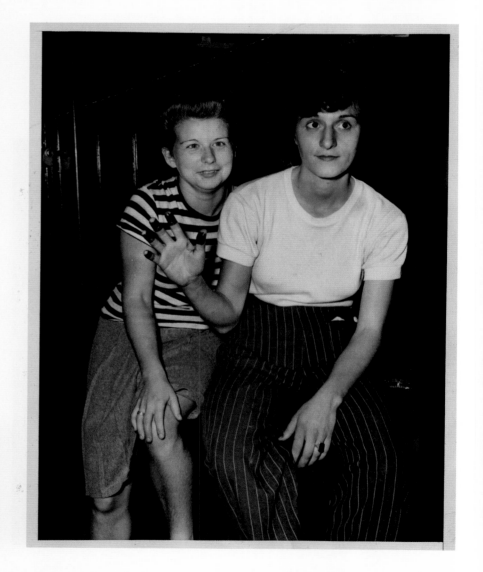

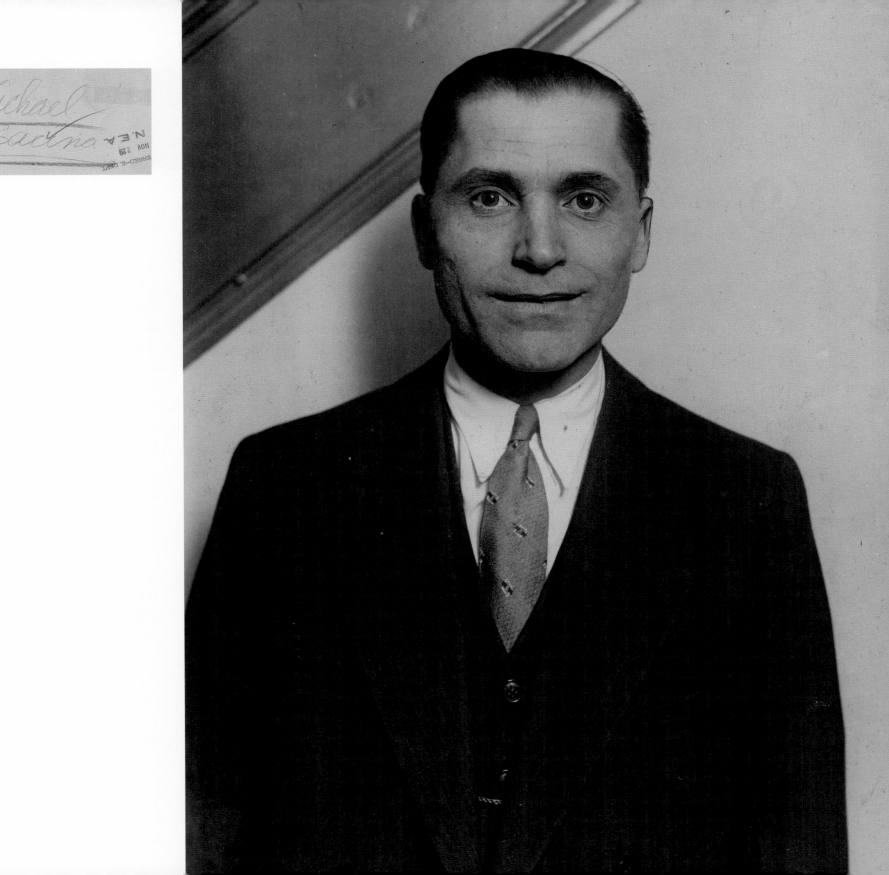

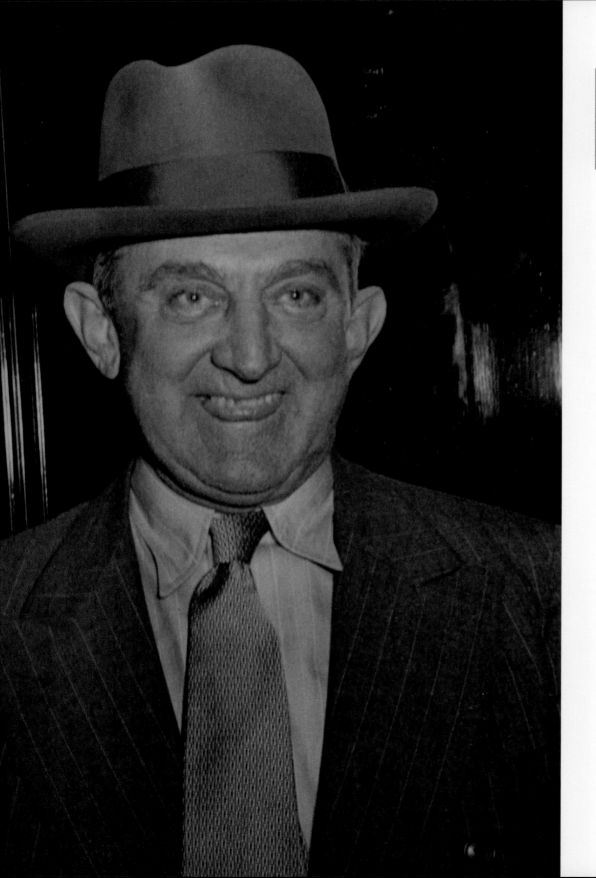

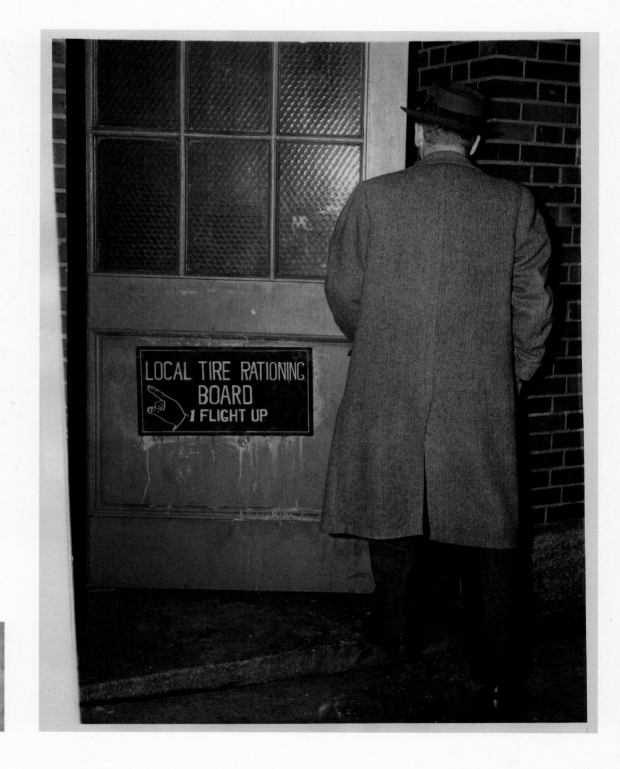

HAPPY TO BE HOME AGAIN
NEW YORK CITY — NESTLED IN THE ARMS OF
HER MOTHER, MRS. MARGARET SARDINIA, ONE-MONTH-
OLD MARIAN SARDINIA FEEDS CONTENTEDLY. THE IN-
FANT WAS KIDNAPPED FROM HER CARRIAGE YESTERDAY
(MARCH 12) AS SHE SLEPT IN THE SUNSHINE OUTSIDE
HER HOME, 65 WEST 104 STREET. SHE WAS FOUND,
UNHARMED, WRAPPED IN THREE NEW BLANKETS, IN A
LARGE PAPER SHOPPING BAG PROPPED IN THE VESTIBULE
OF A HOUSE ON 62ND STREET.
NY CHI NY'K
CREDIT LINE (ACME) 3/13/43 (KK)

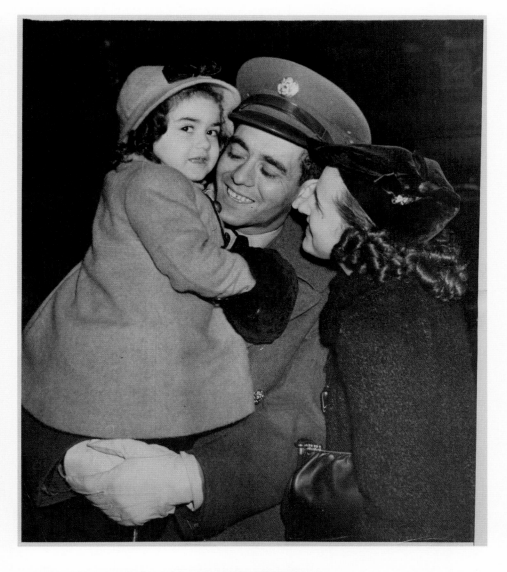

FAMILY REUNION
NEW YORK—LIEUT. LOUIS FRAGALI IN HAPPY REUNION
WITH MRS. FRAGALI AND THEIR YOUNG DAUGHTER,
SADIE, AS HE ARRIVED AT PENNSYLVANIA STATION,
NEW YORK CITY, WITH OTHER FEDERALIZED NEW
YORK NATIONAL GUARDSMEN FROM FORT MCCLELLAN,
ALA., TO SPEND CHRISTMAS AT HOME.
CREDIT LINE (ACME) 12-22-40 (CT) BU #1A 80

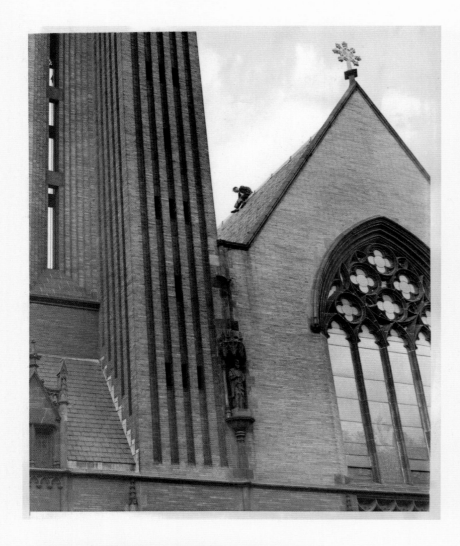

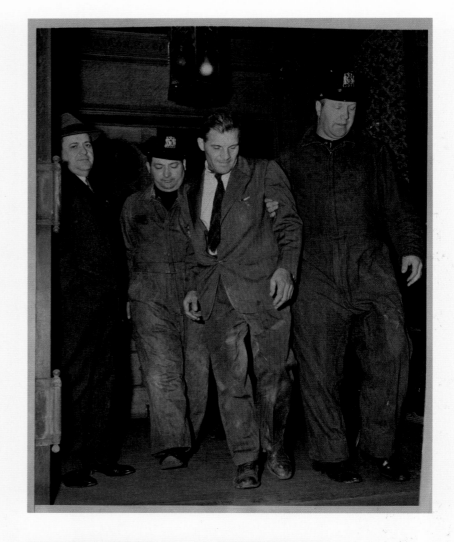

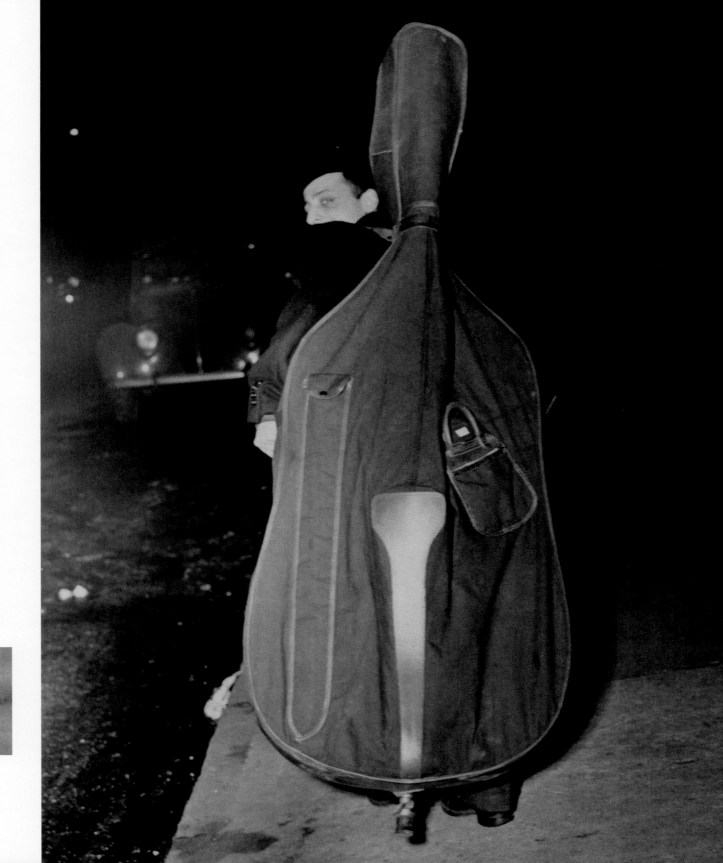

BIOGRAPHY

Usher Fellig was born in **1899** in Zlotshov, Austria, in what is now Ukraine. Seeking a new life in the United States, Usher moved to New York City in **1909** with his mother and his three siblings. Usher's name was changed to Arthur upon arrival. They joined Arthur's father, who had left Europe in **1903**, and settled in the Lower East Side of Manhattan.

Life was difficult in New York City for Arthur's family. He never finished school. Like most immigrant families, he quit so he could help support his family. He held several jobs during the coming years but often found himself struggling. However, during this time he discovered photography. He worked for a commercial photographer as an assistant, at one point as a street photographer selling portraits. However, he still found it difficult to make a living as a photographer. Even though he had to seek other work he never gave up his desire to follow his chosen profession. He took a job in the darkroom as a "squeegee boy" for the New York Times in **1921** and worked there for several years before finding work with a new and upcoming photo agency, Acme Newspictures.

He joined Acme Newspictures in **1924**. During his early years with Acme, Arthur worked in the darkroom as a technician. By **1929**, he had already adopted the name Weegee, and would often cover stories during the early morning hours. He traveled to Los Angeles in **1932** to assist Acme's LA bureau as a printer during the Olympic Games. Weegee continued working for Acme until **1935** before finally deciding to work as a freelance photographer.

Weegee first found fame in **1937** when Life magazine published a story about his work as a crime photographer in New York City. The following year he installed a police radio in his a car which allowed him to be the first on the scene. Gaining wide recognition for his work, Weegee joined PM in the summer of **1940**. Along with PM, Weegee's photographs regularly appeared in New York newspapers.

1941 he had his first exhibition, Murder is My Business. In **1943**, a selection of his photographs was included in the Museum of Modern Art's exhibition Action Photography. Weegee's success as a crime and street photographer was equally mirrored by his **1945** bestseller, Naked City. One year later he released a second bestseller, Weegee's People. The combination of the two publications gained Weegee a national audience and the stardom he always sought.

Weegee decided to take advantage of his new fame. In November **1947**, he moved to Los Angeles to pursue an acting career in Hollywood. Unfortunately for Weegee, Hollywood was not a surrogate for New York City. He found himself struggling to succeed as an actor. Weegee continued to take photographs in Hollywood but they lacked the lurid appeal of his New York work that had made him famous.

Finally in **1952**, Weegee returned to New York City. The city he once knew had changed. The city was vibrant, more organized, and the cops had cleaned up the streets. It was no longer the disorderly landscape he had known in the 1920s, 1930s, and 1940s. Weegee stayed in New York City until his death in the winter of **1968**.

Weegee: "It's exciting. It's dangerous. It's funny. It's tough. It's heartbreaking."
He was a newsman, and this was his story to tell. No one else could capture the unfolding drama better than he.

LIST OF WORKS

All illustrations by Weegee
listed by page

10
"Weegee the Noted Photographer",
c. 1946, silver gelatin print on glossy fibre
paper, printed by November 7, 1946,
22,7 (25,4) x 19,1 (20,6) cm (7802)

16
"Phil Baker's Car in Collision",
September 1, 1942, silver gelatin print on glossy
fibre paper, printed by September 11, 1942,
16,7 (18,0) x 21,1 (22,8) cm (8161)

18
"No Gas Today!",
May 14, 1942, silver gelatin print on glossy
fibre paper, printed by May 22, 1942,
20,9 (22,8) x 16,4 (18) cm (8205)

19
"Shrinking Violet Explains",
May 24, 1942, silver gelatin print on glossy
fibre paper, printed by May 29, 1942,
21,5 (22,8) x 16,8 (18,1) cm (8258)

20
"Auto Hits 'El' Pillar",
May 5, 1939, silver gelatin print on glossy
fibre paper, printed by May 9, 1939,
19,0 (20,2) x 24,8 (25,6) cm (7986)

21
"Car Collides with Ambulance",
June 26, 1941, silver gelatin print on glossy
fibre paper, printed by July 3, 1941,
16,6 (18,1) x 21,0 (22,8) cm (9308)

22
"Women Injured in Triple Auto Collision",
April 2, 1941, silver gelatin print on glossy
fibre paper, printed by April 8, 1941,
16,8 (18,0) x 21,8 (22,8) cm (7999)

22
"New Year's Eve Crash Injures Two",
January 1, 1941, silver gelatin print on glossy
fibre paper, printed by January 7, 1941,
17,2 (17,9) x 20,7 (22,8) cm (8550)

23
"Sudden Stop",
June 19, 1940, silver gelatin print on glossy
fibre paper, printed by June 21, 1940,
17,1 (17,9) x 21,5 (22,8) cm (7993)

24
"Death on the Highway",
c. 1938, silver gelatin print on glossy fibre
paper, printed by April 5, 1938,
16,7 (17,7) x 22,0 (23,2) cm (7903)

25
"Truck - Auto Crash Kills One",
September 6, 1944, silver gelatin print on glossy
fibre paper, printed by September 15, 1944,
14,4 (15,4) x 19,0 (20,2) cm (8250)

26
"Car Burns After Hitting 'L' Pillar",
April 16, 1942, silver gelatin print on glossy
fibre paper, printed by April 24, 1942,
16,6 (18,2) x 21,0 (22,8) cm (8017)

27
"A Curious Bystander Examining Car",
May 5, 1939, silver gelatin print on glossy
fibre paper, printed by May 9, 1939,
24,5 (25,7) x 19,2 (20,3) cm (8271)

28
"Auto Hits Lamp Post",
August 2, 1937, silver gelatin print on glossy
fibre paper, printed by August 7, 1937,
19,1 (20,4) x 24,0 (25,3) cm (8088)

28
"Auto - Truck Crash Two Hurt",
May 4, 1939, silver gelatin print on glossy fibre
paper, printed by May 9, 1939,
19,4 (20,5) x 24,1 (25,2) cm (8512)

29
"Crash Kills One",
January 17, 1944, silver gelatin print on glossy
fibre paper, printed by January 21, 1944,
16,9 (18,0) x 21,7 (22,8) cm (8110)

30
"Smash-Up",
May 15, 1945, silver gelatin print on glossy
fibre paper, printed by May 1945,
16,7 (18,2) x 21,3 (23,0) cm (8984)

30
"Truck Driver Killed in Crash and Blaze",
June 15, 1943, silver gelatin print on glossy
fibre paper, printed by June 18, 1943,
16,8 (18,0) x 21,3 (22,8) cm (9299)

31
"Almost a Nosedive",
March 29, 1942, silver gelatin print on glossy
fibre paper, printed by April 3, 1942,
21,0 (22,8) x 16,7 (18,1) cm (8281)

32
"Hit and Run Driver Uses His Feet",
April 14, 1940, silver gelatin print on glossy
fibre paper, printed by April 19, 1940,
17,2 (18,0) x 21,5 (22,8) cm (8431)

33
"Injuries: One Lacerated Lip",
December 2, 1940, silver gelatin print on glossy
fibre paper, printed by December 6, 1940,
20,2 (23,0) x 16,5 (18,0) cm (8421)

34
"Ambulance Takes Dive into East River",
August 23, 1943, silver gelatin print on glossy
fibre paper, printed by September 3, 1943, 16,5
(18,0) x 21,1 (22,8) cm (7894)

34
"Four Were Hurt In this Crash",
June 18, 1941, silver gelatin print on glossy
fibre paper, printed by June 26, 1941,
17,5 (20,5) x 22,4 (25,4) cm (8262)

35
"Car Plunges into Hudson River",
May 3, 1942, silver gelatin print on glossy
fibre paper, printed by May 8, 1942,
21,5 (22,8) x 17,1 (18,1) cm (8167)

36
"Crash Kills Two on West Side Highway",
October 11, 1941, silver gelatin print on glossy
fibre paper, printed by October 16, 1941,
15,5 (18,1) x 21,3 (22,9) cm (7989)

37
"Youth in Stolen Car Wrecks Milk Wagon",
June 26, 1941, silver gelatin print on glossy
fibre paper, printed by July 3, 1941,
16,3 (17,9) x 18,8 (22,8) cm (8564)

38
**"Rockaway Windows Knocked Out
by Explosion"**,
January 3, 1944, silver gelatin print on glossy
fibre paper, printed by January 14, 1944,
21,4 (22,9) x 16,6 (18,0) cm (8964)

39
"No Injuries - Only Dummies",
December 16, 1944, silver gelatin print on glossy
fibre paper, printed by December 22, 1944,
21,0 (22,8) x 16,9 (18,0) cm (8982)

39
"Taxi Crashes Through Store Window",
November 29, 1941, silver gelatin print
on glossy fibre paper, printed by
December 4, 1941,
16,6 (18,0) x 20,2 (22,8) cm (9309)

40
**"Joseph Fiddleman's Apartement that
was Wrecked by the Explosion"**,
May 27, 1943, silver gelatin print on
glossy fibre paper, printed by June 4, 1943,
17,0 (18,0) x 21,5 (22,7) cm (8956)

40
"Wrecked Apartement where Woman Died",
May 27, 1943, silver gelatin print on glossy
fibre paper, printed by June 4, 1943,
17,0 (18,0) x 21,6 (22,8) cm (8957)

41
"Spinster's Suicide Blasts Apartement",
May 27, 1943, silver gelatin print on glossy
fibre paper, printed by June 4, 1943,
17,2 (18,2) x 20,7 (22,7) cm (8949)

41
"Gas Suicide Blows Out Walls",
May 27, 1943, silver gelatin print on glossy
fibre paper, printed by June 4, 1943,
17,1 (18,1) x 21,3 (22,7) cm (8950)

42
"Dancers Escape Explosion Unhurt",
February 17, 1943, silver gelatin print
on glossy fibre paper, printed by
February 19, 1943,
16,7 (18,1) x 21,4 (22,8) cm (8944)

43
"26 Injured in Crash on Third Avenue Elevated",
June 9, 1942, silver gelatin print on glossy fibre paper, printed by June 19, 1942, 16,4 (18,0) x 21,2 (22,8) cm (8940)

44
"60 Injured in Western Electric Blast",
November 30, 1943, silver gelatin print on glossy fibre paper, printed by December 10, 1943, 21,2 (22,9) x 16,7 (18) cm (8097)

44
"60 Injured in Western Electric Blast",
November 30, 1943, silver gelatin print on glossy fibre paper, printed by December 3, 1943, 17,7 (16,8) x 23,2 (21,7) cm (8170)

46
"An Outsider Amazes New York",
September 6, 1940, silver gelatin print on glossy fibre paper, printed by September 10, 1940, 17,0 (18,0) x 21,5 (22,8) cm (8439)

48
"Times Square Blackout by Infrared Light",
April 30, 1942, silver gelatin print on glossy fibre paper, printed by May 8, 1942, 17,1 (18,1) x 21,6 (22,9) cm (8590)

49
"Whee - It's the Mayor",
October 15, 1942, silver gelatin print on glossy fibre paper, printed by October 23, 1942, 16,9 (18,0) x 21,5 (22,8) cm (8130)

50
"They Can't Get into the Swim",
June 27, 1943, silver gelatin print on glossy fibre paper, printed by July 2, 1943, 17,1 (18,0) x 21,7 (23,0) cm (8318)

51
"Nobody Works on Labor Day!",
c. 1939, silver gelatin print on glossy fibre paper, printed by December 1, 1939, 16,9 (18,0) x 21,4 (22,8) cm (8269)

52
"Business as Usual",
January 30, 1943, silver gelatin print on glossy fibre paper, printed by February 5, 1943, 16,7 (18,1) x 21,1 (22,8) cm (8943)

53
"And They All Got Meat!",
March 27, 1943, silver gelatin print on glossy fibre paper, printed by April 2, 1943, 16,8 (18,1) x 21,7 (22,9) cm (8946)

54
"Flash: 'D-Day' Has Dawned!",
June 06, 1944, silver gelatin print on glossy fibre paper, printed by June 6, 1944, 16,7 (18,0) x 21,2 (22,8) cm (8147)

55
"Passengers For One Car",
September 23, 1943, silver gelatin print on glossy fibre paper, printed by October 1, 1943, 21,8 (22,8) x 17,2 (18,1) cm (8206)

56
"Here's Meat!",
July 9, 1943, silver gelatin print on glossy fibre paper, printed by July 16, 1943, 16,4 (18,0) x 20,7 (22,9) cm (9300)

57
"Elliott and Faye Roosevelt Mobbed in Times Square",
August 14, 1945, silver gelatin print on glossy fibre paper, printed by August 16, 1945, 16,6 (18,1) x 20,6 (22,8) cm (9291)

58
"Fuel Droughts Ends in East Side Temporarily",
January 28, 1945, silver gelatin print on glossy fibre paper, printed by February 2, 1945, 16,5 (17,9) x 21,4 (22,8) cm (7981)

59
"Who Said People are all Alike?",
July 27, 1945, silver gelatin print on glossy fibre paper, printed by August 3, 1945, 16,8 (18,0) x 20,5 (22,8) cm (8246)

60
"Necktie-less Man",
August 3, 1945, silver gelatin print on glossy fibre paper, printed c. 1945, 16,6 (17,7) x 11,7 (12,7) cm (8245)

60
"A Young Girl Squints Slightly",
August 3, 1945, silver gelatin print on glossy fibre paper, printed c. 1945, 16,8 (18,0) x 11,6 (12,6) cm (8673)

60
"This Youngster Sits Piggy-Back-Style",
August 3, 1945, silver gelatin print on glossy fibre paper, printed c. 1945, 16,5 (17,7) x 11,8 (12,8) cm (8674)

61
"Young Man with Glasses",
August 3, 1945, silver gelatin print on glossy fibre paper, printed c. 1945, 16,8 (18,0) x 11,6 (12,6) cm (7893)

61
"A Scholarly-Looking Gentleman",
August 3, 1945, silver gelatin print on glossy fibre paper, printed c. 1945, 16,8 (18,0) x 11,7 (12,7) cm (8071)

61
"A Chinaman Wearing a White Panama",
August 3, 1945, silver gelatin print on glossy fibre paper, printed c. 1945, 16,8 (18,0) x 11,7 (12,7) cm (8428)

62
"20 Seized in Raid on Huge New York Still",
October 11, 1940, silver gelatin print on glossy fibre paper, printed by October 22, 1940, 21,6 (22,8) x 17,0 (18,0) cm (8921)

63
"Tonsorial Spuds",
May 19, 1943, silver gelatin print on glossy fibre paper, printed by May 28, 1943, 16,5 (17,9) x 21,0 (22,8) cm (8948)

64
"Potatoes: 16.100 Pounds of 'Em",
May 19, 1943, silver gelatin print on glossy fibre paper, printed by May 28, 1943, 16,8 (17,9) x 16,8 (18,6) cm (8056)

65
"Anything Goes (If It Goes)",
September 6, 1944, silver gelatin print on glossy fibre paper, printed by September 8, 1944, 16,7 (18,0) x 20,7 (22,9) cm (8226)

66
"Flood Halts Bronx Subway",
October 27, 1941, silver gelatin print on glossy fibre paper, printed by October 29, 1941, 17,1 (18,1) x 21,5 (22,7) cm (7965)

68
"But Not a Drop to Drink",
July 27, 1941, silver gelatin print on glossy fibre paper, printed by July 31, 1941, 21,0 (22,8) x 16,3 (18,0) cm (8569)

69
"Seven Firemen Injured as Spectacular Three-Alarm Fire Sweeps New York Loft Building",
January 17, 1940, silver gelatin print on glossy fibre paper, printed by January 23, 1940, 16,4 (18,1) x 21,2 (23,0) cm (7968)

70
"Shipwreck",
1936, silver gelatin print on glossy fibre paper, printed by September 25, 1936, 20,3 x 25 (25,4) cm (9317)

71
"Saved as Wife and Kin Die in Auto Plunge into Bay",
November 20, 1938, silver gelatin print on glossy fibre paper, printed by November 22, 1938, 22,2 (22,7) x 17,1 (18,0) cm (9313)

72
"Altogether Cool About the Heat",
June 27, 1943, silver gelatin print on glossy fibre paper, printed by July 2, 1943, 21,5 (22,9) x 17,2 (18,1) cm (8151)

73
"Keeping Cool",
June 14, 1945, silver gelatin print on glossy fibre paper, printed by June 22, 1945, 21,2 (22,9) x 16,6 (18,0) cm (7949)

74
"Less Humidity and More *Coolidity*",
July 19, 1942, silver gelatin print on glossy fibre paper, printed by July 23, 1942, 17,1 (18,1) x 21,6 (22,8) cm (7912)

75
"New York Cooling System",
June 3, 1943, silver gelatin print on glossy fibre paper, printed by June 11, 1943, 16,7 (17,9) x 21,4 (22,8) cm (8152)

76
"Coney Island Has New Year's Eve Three Alarm Fire",
January 1, 1940, silver gelatin print on glossy fibre paper, printed by January 3, 1940, 16,5 (18,1) x 21,1 (22,8) cm (8018)

78
"Pier Burned to Water's Edge",
January 8, 1942, silver gelatin print on glossy fibre paper, printed by January 16, 1942, 16,8 (17,9) x 21,3 (22,8) cm (7936)

79
"Garage Fire Destroys 200 Trucks",
April 4, 1942, silver gelatin print on glossy fibre paper, printed by April 10, 1942, 16,2 (18,0) x 21,0 (22,8) cm (7980)

80
"200 Trucks Ruined in Oil-Fed Fire",
April 4, 1942, silver gelatin print on glossy fibre paper, printed by April 10, 1942, 16,7 (18,1) x 21,1 (22,8) cm (8042)

81
"Firebirds",
April 4, 1942, silver gelatin print on glossy fibre paper, printed by April 10, 1942, 16,7 (18,2) x 21,5 (22,8) cm (8043)

82
"St. Martins Church",
c. 1939, silver gelatin print on glossy fibre paper, printed by January 24, 1939, 17,3 (18,0) x 21,9 (22,8) cm (8032)

83
"Fire Sweeps St. Mary's Cathedral",
March 7, 1943, silver gelatin print on glossy
fibre paper, printed by March 12, 1943,
17,2 (18,1) x 21,5 (22,8) cm (7985)

84
"Cathedral in Flame",
March 7, 1943, silver gelatin print on glossy
fibre paper, printed by March 12, 1943,
17,2 (18,1) x 21,6 (22,7) cm (8450)

85
"Church Blazes in Four-Alarm Fire",
March 8, 1943, silver gelatin print on glossy
fibre paper, printed by March 12, 1943,
16,9 (18,0) x 21,6 (22,9) cm (8279)

86
"One Dead, 20 Hurt in Bowery Fire",
July 28, 1937, silver gelatin print on glossy
fibre paper, printed by August 2, 1937,
24,4 (25,6) x 19,2 (20,3) cm (7958)

87
"Two Die in Rectory Fire",
November 4, 1938, silver gelatin print on glossy
fibre paper, printed by November 9, 1938,
21,4 (22,8) x 17,1 (18,1) cm (7942)

87
"Escaped Flames in Fatal Bronx Fire",
February 20, 1938, silver gelatin print on glossy
fibre paper, printed by February 24, 1938,
22,1 (23,1) x 16,8 (17,8) cm (8241)

88
"One Dead, 20 Hurt in Bowery Fire",
July 28, 1937, silver gelatin print on glossy
fibre paper, printed by August 2, 1937,
16,8 (17,7) x 22,0 (23,01) cm (8048)

88
"One Dead, 14 Hurt in Brooklyn Tenement
Fire",
November 17, 1939, silver gelatin print on glossy
fibre paper, printed by November 21, 1939,
21,2 (22,8) x 16,5 (18,1) cm (8192)

89
"Apartment House Fire in which Three Died",
February 20, 1938, silver gelatin print on glossy
fibre paper, printed by February 24, 1938,
16,9 (18,0) x 21,8 (22,7) cm (8173)

90
"Commissioner Watches Men Battle 4-Alarm
Blaze",
July 5, 1941, silver gelatin print on glossy
fibre paper, printed by July 17, 1941,
18,9 (20,3) x 14,3 (15,4) cm (7895)

90
"Directing the Fighting of the Fire",
c. 1940, silver gelatin print on glossy fibre paper,
printed by February 6, 1940,
21,2 (22,8) x 16,4 (17,9) cm (8159)

91
"Firemen Directing Water on Fire",
c. 1940, silver gelatin print on glossy fibre paper,
printed by August 23, 1940,
21,7 (23,0) x 16,4 (18,1) cm (8536)

92
"Two Die in Rectory Fire",
November 4, 1938, silver gelatin print on glossy
fibre paper, printed by November 9, 1938,
21,7 (22,9) x 17,1 (18,0) cm (8118)

93
"Where Three Died in Brooklyn Fire",
January 20, 1939, silver gelatin print on glossy
fibre paper, printed by January 24, 1939,
21,8 (22,8) x 16,9 (18,0) cm (8188)

94
"Where Woman, 90, Died in Brooklyn Fire",
Januar 20, 1939, silver gelatin print on glossy
fibre paper, printed by January 25, 1939,
16,4 (17,9) x 20,0 (22,9) cm (8280)

95
"Where Two Died in Brooklyn Residence
Fire",
January 20, 1939, silver gelatin print on glossy
fibre paper, printed by January 24, 1939,
17,2 (18,0) x 21,9 (22,8) cm (8189)

96
"20 Firemen Injured When Fire Back-Fires",
July 5, 1941, silver gelatin print on glossy fibre
paper, printed by July 10, 1941,
21,6 (22,8) x 17,1 (18,1) cm (8931)

97
"A General View at the Hight of the Fire",
c. 1940, silver gelatin print on glossy fibre
paper, printed by February 6, 1940,
21,7 (22,8) x 16,8 (18,1) cm (7937)

97
"Alarm Fire Destroys Manhattan Block",
March 1, 1944, silver gelatin print on glossy
fibre paper, printed by March 11, 1944,
16,6 (18,0) x 20,5 (22,8) cm (9292)

98
"Bronx Fire Destroys 100 Autos",
October 27, 1941, silver gelatin print on glossy
fibre paper, printed by October 29, 1941,
16,8 (18,2) x 21,5 (22,8) cm (8030)

99
"All That's Left After Lumber Yard Blaze",
October 9, 1940, silver gelatin print on glossy
fibre paper, printed by October 18, 1940,
18,4 (20,3) x 24,3 (25,7) cm (8179)

100
"Childs Cafe Fire Congest Traffic in Herald
Sq.",
February 26, 1942, silver gelatin print on glossy
fibre paper, printed by March 6, 1942,
21,6 (22,8) x 16,9 (18,1) cm (8939)

100
"Three-Alarm Fire in Downtown Manhattan",
September 11, 1942, silver gelatin print on glossy
fibre paper, printed by September 18, 1942,
21,3 (22,8) x 16,8 (18,1) cm (8941)

101
"60 Injured in Western Electric Blast",
November 30, 1943, silver gelatin print on glossy
fibre paper, printed by December 3, 1943,
21,2 (22,8) x 16,7 (17,9) cm (8094)

101
"Prone Fire-Fighters",
September 1, 1941, silver gelatin print on glossy
fibre paper, printed by September 3, 1941,
21,2 (22,8) x 16,7 (18,1) cm (8440)

102
"Where There's Smoke There's Fire",
September 1, 1941, silver gelatin print on glossy
fibre paper, printed by September 4, 1941,
16,6 (18,0) x 21,1 (22,8) cm (8574)

102
"Firemen Fight Three Alarm Blaze",
October 9, 1940, silver gelatin print on glossy
fibre paper, printed by October 18, 1940,
17,0 (18,0) x 21,4 (22,8) cm (8920)

103
"Four-Alarm Blaze in Downtown Brooklyn",
December 18, 1940, silver gelatin print on glossy
fibre paper, printed by December 31, 1940,
24,5 (25,7) x 19,2 (20,3) cm (8112)

104
"Fire Defies Test Blackout",
February 18, 1943, silver gelatin print on glossy
fibre paper, printed by February 26, 1943,
21,0 (22,9) x 17,4 (18,1) cm (8604)

105
"Fighting Tenement Flames",
March 7, 1942, silver gelatin print on glossy fibre
paper, printed by April 9, 1942,
21,3 (22,7) x 16,7 (17,8) cm (7940)

105
"5-Alarm Fire Destroys Manhattan Block",
March 1, 1944, silver gelatin print on glossy fibre
paper, printed by March 3, 1944,
16,8 (18,1) x 20,0 (22,8) cm (8057)

106
"Three Killed in Three-Alarm Brooklyn Fire",
May 26, 1944, silver gelatin print on glossy fibre
paper, printed by June 2, 1944,
21,4 (22,9) x 16,7 (18,0) cm (8970)

107
"60 Injured in Western Electric Blast",
November 30, 1943, silver gelatin print on glossy
fibre paper, printed by December 10, 1943,
21,0 (22,8) x 16,6 (18,0) cm (8095)

107
"Mayor LaGuardia on Hand to Watch",
c. 1939, silver gelatin print on glossy fibre paper,
printed by July 22, 1939,
24,0 (25,3) x 19,2 (20,7) cm (8203)

108
"60 Injured in Western Electric Blast",
November 30, 1943, silver gelatin print on glossy
fibre paper, printed by December 3, 1943,
16,8 (18,0) x 20,9 (22,8) cm (8092)

109
"Chinatown Catastrophe",
July 5, 1944, silver gelatin print on glossy fibre
paper, printed by July 7, 1944,
16,8 (18,0) x 21,0 (22,8) cm (8165)

110
"Victory Fire",
August 14, 1945, silver gelatin print on glossy
fibre paper, printed c. 1945,
16,8 (18,0) x 20,1 (22,8) cm (8297)

112
"Those Three Dummies Land
on the Scrap Heap",
October 19, 1942, silver gelatin print on glossy
fibre paper, printed by October 23, 1942,
16,5 (18,1) x 21,1 (22,9) cm (8942)

113
"Good News - Bad Omen",
June 4, 1944, silver gelatin print on glossy
fibre paper, printed by June 9, 1944,
21,4 (22,7) x 17,0 (18,0) cm (8197)

114
"Happy Days are Here Again!",
August 14, 1945, silver gelatin print on glossy
fibre paper, printed by August 24, 1945,
21,0 (22,8) x 16,4 (18,0) cm (8986)

115
"Hep Cats in a Hurry - Hurry, Hurry, Hurry -
Only 6,000 Seats Left",
April 28, 1943, silver gelatin print on glossy
fibre paper, printed by May 7, 1943,
17,0 (17,8) x 21,4 (22,7) cm (8612)

116
"Hitler Gets It in the Neck",
May 7, 1945, silver gelatin print on glossy
fibre paper, printed by May 11, 1945,
14,4 (15,5) x 18,5 (20,3) cm (8142)

117
"Just Finding It Out?",
May 7, 1945, silver gelatin print on glossy
fibre paper, printed by May 11, 1945,
16,2 (17,9) x 20,5 (22,8) cm (8145)

118
"Banner Day",
September 10, 1943, silver gelatin print on glossy
fibre paper, printed by September 17, 1943,
16,9 (18,1) x 21,5 (22,9) cm (8136)

119
"The Ladies Say a Word",
August 10, 1945, silver gelatin print on glossy
fibre paper, printed by August 17, 1945,
16,0 (18,0) x 21,0 (22,8) cm (8036)

120
"Ring-A-Round for Victory",
May 7, 1945, silver gelatin print on glossy
fibre paper, printed by May 11, 1945,
14,5 (15,6) x 19,0 (20,2) cm (8143)

121
"There Was Dancing in the Streets",
May 7, 1945, silver gelatin print on glossy
fibre paper, printed by May 11, 1945,
16,8 (18,0) x 21,5 (22,9) cm (8291)

122
"No *Long Underwear* Here",
April 28, 1943, silver gelatin print on glossy
fibre paper, printed by May 7, 1943,
21,0 (22,8) x 16,7 (18,0) cm (8164)

123
"Sleeps Through it all",
August 14, 1945, silver gelatin print on glossy
fibre paper, printed c. 1945,
16,7 (18,0) x 21,8 (22,9) cm (7952)

124
"Victory Celebration in the Street",
1945, silver gelatin print on glossy fibre paper,
printed c. 1945,
21,5 (22,8) x 16,8 (18,2) cm (8298)

125
"Victory Celebration in the Street",
1945, silver gelatin print on glossy fibre paper,
printed c. 1945,
20,9 (22,8) x 16,8 (18,1) cm (8299)

126
"Ding Dong the Witch is Dead!",
July 25, 1943, silver gelatin print on glossy
fibre paper, printed by August 6, 1943,
17,0 (18,0) x 21,5 (22,8) cm (8624)

127
"Souvenir Hunters Raid World's Fair Closing",
October 27, 1940, silver gelatin print on glossy
fibre paper, printed by November 1, 1940,
21,4 (22,9) x 16,8 (18,1) cm (8922)

128
"Here's a Toast",
July 25, 1943, silver gelatin print on glossy
fibre paper, printed by August 20, 1943,
17,0 (17,9) x 21,5 (22,8) cm (8626)

129
"Girl Triplets Born to Brooklyn Woman",
November 1, 1944, silver gelatin print on glossy
fibre paper, printed by November 3, 1944,
16,8 (18,0) x 21,7 (22,8) cm (89739)

130
"Anyway, it Feels Cool",
June 27, 1943, silver gelatin print on glossy fibre
paper, printed by July 2, 1943,
17,1 (18,1) x 21,6 (22,8) cm (8289)

131
"Mine's Next!",
April 17, 1941, silver gelatin print on glossy fibre
paper, printed by April 25, 1941,
20,9 (22,9) x 16,7 (18,0) cm (8010)

131
"*The Modern Cinderella*",
April 17, 1941, silver gelatin print on glossy fibre
paper, printed by April 22, 1941,
21,4 (22,9) x 16,8 (18,2) cm (8928)

132
"Italian Flag Waves in New York",
September 8, 1943, silver gelatin print on glossy
fibre paper, printed by September 10, 1943,
21,3 (22,8) x 16,6 (18,0) cm (8150)

133
"New York Celebrates Italy's Defeat",
September 8, 1943, silver gelatin print on glossy
fibre paper, printed by September 10, 1943,
20,5 (22,7) x 16,4 (18,0) cm (8040)

134
"Celebrating Italy's Defeat",
September 8, 1943, silver gelatin print on glossy
fibre paper, printed by September 10, 1943,
16,2 (17,2) x 21,1 (23,1) cm (8637)

135
"Learns Good News",
September 8, 1943, silver gelatin print on glossy
fibre paper, printed by September 10, 1943,
21,2 (22,8) x 16,4 (18,0) cm (8104)

136
"It'll be a Pleasure",
September 8, 1943, silver gelatin print on glossy
fibre paper, printed by September 10, 1943,
21,2 (23,2) x 16,2 (17,8) cm (8234)

137
"They're Dancing in the Streets!",
August 14, 1945, silver gelatin print on glossy
fibre paper, printed by August 17, 1945,
16,6 (18,0) x 20,6 (22,8) cm (8223)

138
"*Frankie! Give Us Frankie!*",
October 12, 1944, silver gelatin print on glossy
fibre paper, printed by October 20, 1944,
16,6 (17,9) x 21,3 (22,7) cm (8022)

139
"*Sinatra Sings Bobbysocks Swoon*",
October 11, 1944, silver gelatin print on glossy
fibre paper, printed by October 13, 1944,
16,8 (17,9) x 21,2 (22,7) cm (8135)

140
"Entertainment World Observes *Curfew*",
February 26, 1945, silver gelatin print on glossy
fibre paper, printed by March 2, 1945,
14,5 (15,5) x 18,2 (20,2) cm (8238)

141
"Getting an Early Start",
February 26, 1945, silver gelatin print on glossy
fibre paper, printed by March 2, 1945,
14,5 (15,5) x 18,8 (20,3) cm (8237)

142
"No Paper Shortage Here",
August 14, 1945, silver gelatin print on glossy
fibre paper, printed by August 14, 1945,
17,0 (18,0) x 21,6 (22,7) cm (8128)

143
"Snow in August",
August 10, 1945, silver gelatin print on glossy
fibre paper, printed by August 24, 1945,
21,1 (22,8) x 16,4 (18,0) cm (8677)

144
"Manhattan Celebrates",
August 14, 1945, silver gelatin print on glossy
fibre ppaper, printed by August 17, 1945,
23,5 (25,3) x 8,4 (10,1) cm (8294)

145
"Just Ready and Waiting",
August 12, 1945, silver gelatin print on glossy
fibre paper, printed by August 14, 1945,
16,5 (18,0) x 20,8 (22,7) cm (8451)

146
"Everybody's Happy",
August 14, 1945, silver gelatin print on glossy
fibre paper, printed by August 17, 1945,
16,3 (17,9) x 20,3 (22,8) cm (8141)

147
"Porthole Peekers",
October 9, 1945, silver gelatin print on glossy
fibre paper, printed by October 12, 1945,
16,4 (18,0) x 21,2 (22,8) cm (8069)

148
"Pajama Party",
August 14, 1945, silver gelatin print on glossy
fibre paper, printed by August 17, 1945,
16,6 (17,9) x 21,2 (22,7) cm (8680)

149
"Brooklyn Comes to New York",
August 14, 1945, silver gelatin print on glossy
fibre paper, printed by August 17, 1945,
16,6 (18,1) x 21,3 (22,8) cm (8313)

149
"Cheer Jap Peace Report",
August 14, 1945, silver gelatin print on glossy
fibre paper, printed by August 17, 1945,
16,3 (17,8) x 20,6 (22,8) cm (8681)

150
"Little Italy Celebrates",
August 14, 1945, silver gelatin print on glossy
fibre paper, printed by August 17, 1945,
16,5 (17,9) x 21,3 (22,8) cm (8682)

151
"China Town Greets Victory",
August 14, 1945, silver gelatin print on glossy
fibre paper, printed by August 17, 1945,
16,6 (18,0) x 21,2 (22,8) cm (8683)

152
"Up in the Air Over Peace Report",
August 14, 1945, silver gelatin print on glossy
fibre paper, printed by August 17, 1945,
16,3 (18,0) x 21,1 (22,8) cm (8222)

153
"The Navy's Night",
August 14, 1945, silver gelatin print on glossy
fibre paper, printed by August 17, 1945,
21,2 (22,8) x 16,8 (18,0) cm (8221)

154
"Navy Brides in *Protective Custody*",
April 20, 1943, silver gelatin print on glossy
fibre paper, printed by April 23, 1943,
14,3 (15,6) x 18,0 (20,4) cm (8947)

155
"He Wants Another Fight",
August 14, 1945, silver gelatin print on glossy
fibre paper, printed by August 17, 1945,
16,8 (18,0) x 21,5 (22,8) cm (8688)

156
"The Victory Flag",
August 14, 1945, silver gelatin print on glossy
fibre paper, printed by August 17, 1945,
22,5 (25,3) x 8,9 (10,3) cm (8065)

156
"Swing Your Partner - The War's Over!",
August 14, 1945, silver gelatin print on glossy
fibre paper, printed by August 17, 1945,
16,5 (17,9) x 21,0 (22,9) cm (9290)

157
"Double Decker Celebrants",
August 14, 1945, silver gelatin print on glossy
fibre paper, printed by August 17, 1945,
21,1 (22,8) x 16,8 (18,0) cm (8302)

158
"Joy Was too Much",
August 14, 1945, silver gelatin print on glossy
fibre paper, printed by August 17, 1945,
21,3 (22,8) x 16,6 (18,1) cm (8303)

159
"Pajama Party",
August 14, 1945, silver gelatin print on glossy
fibre paper, printed by August 17, 1945,
16,8 (17,9) x 19,8 (22,8) cm (8035)

160
"The Waltz They Saved For Victory!",
August 14, 1945, silver gelatin print on glossy
fibre paper, printed by August 17, 1945,
16,7 (17,9) x 21,0 (22,8) cm (8690)

161
"Celebrate War's End",
August 14, 1945, silver gelatin print on glossy
fibre paper, printed by August 17, 1945,
16,7 (18,1) x 20,6 (22,8) cm (8140)

162
"Hubba, Hubba - The War's Over",
August 14, 1945, silver gelatin print on glossy
fibre paper, printed by August 17, 1945,
16,6 (17,9) x 21,3 (22,7) cm (8317)

163
"Whatta Victory!",
August 14, 1945, silver gelatin print on glossy
fibre paper, printed c. 1945,
20,9 (22,8) x 16,4 (18,1) cm (8227)

164
"Has Looked Everywhere",
July 6, 1943, silver gelatin print on glossy
fibre paper, printed by July 16, 1943,
21,3 (22,9) x 16,9 (18,2) cm (8958)

164
"Her Son Adopted?",
July 6, 1943, silver gelatin print on glossy
fibre paper, printed by July 9, 1943,
21,7 (22,9) x 16,8 (18,1) cm (8959)

165
"Happy Trio",
July 11, 1943, silver gelatin print on glossy
fibre paper, printed by August 6, 1943,
16,5 (18,1) x 21,0 (22,8) cm (7913)

166
"Prince Charming to the Rescue",
April 17, 1941, silver gelatin print on glossy
fibre paper, printed by April 22, 1941,
16,7 (18,1) x 21,3 (22,8) cm (8134)

168
"Win Waltz Contest at Cinderella Ball",
April 17, 1941, silver gelatin print on glossy
fibre paper, printed by April 22, 1941,
21,1 (22,9) x 16,7 (18,0) cm (8927)

168
"Palm Beach Visitor",
January 16, 1931, silver gelatin print on glossy
fibre paper, printed by February 5, 1931,
24,2 (25,3) x 19,4 (20,4) cm (9320)

169
"Attend Cinderella Ball",
April 17, 1941, silver gelatin print on glossy
fibre paper, printed by April 22, 1941,
21,0 (22,9) x 16,7 (18,0) cm (8929)

169
"Present at the Metropolitan Opening",
November 27, 1944, silver gelatin print on glossy
fibre paper, printed by December 1, 1944,
21,3 (23,0) x 16,7 (18,1) cm (8978)

170
"Met Opening Attracts Social World",
November 27, 1944, silver gelatin print on glossy
fibre paper, printed by December 1, 1944,
21,5 (22,7) x 17,0 (18,0) cm (8064)

171
"The Human Touch",
November 27, 1944, silver gelatin print on glossy
fibre paper, printed by November 30, 1944,
16,5 (18,0) x 2,1 (22,7) cm (7804)

172
"Eloping Couple Nabbed by Police",
January 21, 1940, silver gelatin print on glossy
fibre paper, printed by January 26, 1940,
13,9 (15,2) x 11,4 (12) cm (8194)

173
"Elopers Return to Philadelphia",
January 21, 1940, silver gelatin print on glossy
fibre paper, printed by January 26, 1940,
17,3 (18,3) x 21,5 (22,8) cm (8277)

174
"New York Smart Set Gambling House
Raided",
December 22, 1940, silver gelatin print on glossy
fibre paper, printed by December 31, 1940,
17,0 (18,1) x 21,4 (22,8) cm (7971)

175
"Crowds Brave Weather for Met Opening",
November 27, 1944, silver gelatin print on glossy
fibre paper, printed by December 1, 1944,
16,9 (18,0) x 21,2 (22,8) cm (8977)

175
"No Dampening the First Nighters' Spirits",
November 27, 1944, silver gelatin print on glossy
fibre paper, printed by December 1, 1944,
16,8 (18,2) x 21,4 (23,0) cm (8980)

176
"Weegee in the Groove",
July 18, 1945, silver gelatin print on glossy fibre
paper, printed by July 27, 1945,
20,5 (22,8) x 16,7 (18,0) cm (8255)

177
"The End of a Successful First Night",
November 27, 1944, silver gelatin print on glossy
fibre paper, printed by December 1, 1944,
17,0 (18,0) x 21,6 (22,8) cm (8979)

178
"At Metropolitan Opening",
1943, silver gelatin print on glossy fibre paper,
printed by December 10, 1943,
18,9 (20,2) x 14,4 (15,4) cm (9301)

179
"The Critic",
July 27, 1945, silver gelatin print on glossy
fibre paper, printed by August 3, 1945,
16,9 (18,1) x 21,5 (22,8) cm (9082)

180
"There Goes Mrs. ...",
November 22, 1943, silver gelatin print on glossy
fibre paper, printed by November 26, 1943,
16,7 (18,0) x 21,4 (22,9) cm (8965)

181
"Oh! and at The Metropolitan",
November 27, 1944, silver gelatin print on glossy
fibre paper, printed by January 4, 1944,
16,8 (18,1) x 21,5 (22,9) cm (8052)

182
"At Metropolitan Opening",
November 22, 1943, silver gelatin print on glossy
fibre paper, printed by December 1, 1943,
16,7 (18,2) x 21,1 (22,9) cm (8962)

183
"Golden Horseshoe Glitters at Met Opening",
November 27, 1944, silver gelatin print on glossy
fibre paper, printed by December 1, 1944,
17,2 (18,2) x 21,7 (23,0) cm (8976)

184
"Times Square During Blackout",
April 30, 1942, silver gelatin print on glossy
fibre paper, printed by May 8, 1942,
16,8 (18,1) x 21,2 (22,8) cm (8129)

185
"Opera Epilogue",
December 6, 1940, silver gelatin print on glossy
fibre paper, printed by December 17, 1940,
16,4 (17,9) x 21,2 (22,8) cm (8548)

186
"Times Square Before Blackout",
April 30, 1942, silver gelatin print on glossy
fibre paper, printed by May 8, 1942,
17,1 (18,1) x 21,7 (22,8) cm (8311)

187
"Liberty's Daughter Needs Help",
November 30, 1944, silver gelatin print on
glossy fibre paper, printed by August 12, 1944,
21,3 (22,8) x 16,8 (18,0) cm (8146)

188
"Blackout Traffic Light Tested",
January 29, 1942, silver gelatin print on
glossy fibre paper, printed by June 2, 1942,
20,8 (22,8) x 11,6 (13,4) cm (8936)

189
"Times Square's Loss",
February 24, 1942, silver gelatin print on
glossy fibre paper, printed by March 6, 1942,
9,6 (11,6) x 21,6 (22,8) cm (8935)

190
"Get Away from Heated City",
June 3, 1943, silver gelatin print on glossy
fibre paper, printed by June 11, 1943,
17,0 (18,0) x 21,2 (22,8) cm (8614)

191
"Sleeping in the Great Outdoors",
June 3, 1943, silver gelatin print on glossy
fibre paper, printed by June 11, 1943,
16,9 (18,0) x 21,1 (22,8) cm (7897)

192
"Winners in Colored Beauty Contest",
August 29, 1931, silver gelatin print on glossy
fibre paper, printed by September 1, 1931,
18,8 (20,3) x 14,3 (15,5) cm (8187)

192
"One for the Book Weegee +
Miss America (Billie Bow)",
c. 1931, silver gelatin print on glossy fibre
paper, printed by February 9, 1932 ,
19,3 (20,3) x 24,8 (25,9) cm (8270)

193
"Gee, Ain't He Grand",
April 28, 1943, silver gelatin print on glossy
fibre paper, printed by May 21, 1943,
17,0 (18,0) x 21,3 (22,8) cm (7973)

194
"Lookout, Lady - That's the Law",
August 14, 1945, silver gelatin print on glossy
fibre paper, printed by August 17, 1945,
20,4 (22,8) x 16,2 (17,9) cm (8307)

195
"Sleeper",
November 1, 1946, silver gelatin print on glossy
fibre paper, printed by December 27, 1946,
21,3 (22,8) x 17,0 (18,2) cm (8139)

196
"It's Cherry Blossom Time",
April 8, 1944, silver gelatin print on glossy
fibre paper, printed by August 4, 1944,
16,6 (18,0) x 21,2 (22,9) cm (8068)

198
"Mayor at Pier Fire in Near-Zero Weather",
January 8, 1942, silver gelatin print on glossy
fibre paper, printed by January 16, 1942,
14,4 (15,4) x 15,8 (17,5) cm (8155)

199
"Fireengine Covered with Ice",
1942, silver gelatin print on glossy fibre paper,
printed by January 16, 1942,
16,4 (18,1) x 21,0 (22,7) cm (7997)

200
**"Seven Firemen Injured as Spectacular
Three-Alarm Fire Sweeps New York Loft
Building"**,
c. 1940, silver gelatin print on glossy fibre
paper, printed by January 23, 1940,
16,5 (18,2) x 21,2 (23,0) cm (8272)

201
**"Ice Sheathed Firemen at Coney Island
New Year's Eve Fire"**,
January 1, 1940, silver gelatin print on glossy
fibre paper, printed by January 9, 1940,
16,8 (18,0) x 21,5 (22,8) cm (8284)

202
"Mayor Nipped by Jack Frost",
January 8, 1942, silver gelatin print on glossy
fibre paper, printed by January 16, 1942,
19,1 (20,3) x 14,5 (15,5) cm (8204)

203
"Bitter Cold too Much for Mayor",
January 8, 1942, silver gelatin print on glossy
fibre paper, printed by January 16, 1942,
17,0 (18,0) x 21,7 (22,8) cm (8260)

204
"But Their Faces Show Their Fear",
December 15, 1939, silver gelatin print on glossy
fibre paper, printed by December 19, 1939,
25,8 x 20,4 cm (7672)

206
**"Slashed During Street Fete in
New York's *Little Italy*"**,
September 21, 1939, silver gelatin print on glossy
fibre paper, printed by September 26, 1939,
16,8 (18,0) x 21,3 (22,9) cm (8209)

207
**"One Slain During Street Fete in
New York's *Little Italy*"**,
September 21, 1939, silver gelatin print on glossy
fibre paper, printed by September 26, 1939,
21,5 (22,8) x 17,3 (18,1) cm (8268)

208
"School Children Witness Shooting",
October 9, 1941, silver gelatin print on glossy
fibre paper, printed by October 16, 1941,
21,5 (22,8) x 16,8 (18,0) cm (8111)

209
"Crash Victim",
April 16, 1942, silver gelatin print on glossy
fibre paper, printed by 1942,
20,6 (22,8) x 17,1 (18,0) cm (8015)

210
"Truck Driver Dies in Collision",
September 6, 1944, silver gelatin print on glossy
fibre paper, printed by September 8, 1944,
16,8 (18,1) x 21,7 (22,8) cm (7959)

211
"Two Slain in Lower East Side",
January 28, 1939, silver gelatin print on glossy
fibre paper, printed by February 3, 1939,
17,0 (18,1) x 21,5 (22,8) cm (8501)

212
"Last Rites for Fire Victims",
March 7, 1942, silver gelatin print on glossy
fibre paper, printed by March 12, 1942,
19,5 (22,8) x 16,6 (18) cm (8276)

213
"No Christmas Deliveries for Him",
December 19, 1940, silver gelatin print on glossy
fibre paper, printed by December 31, 1940,
21,0 (22,8) x 15,9 (18,0) cm (7962)

213
"Killed in Gas Explosion",
December 25, 1940, silver gelatin print on glossy
fibre paper, printed by December 31, 1940,
21,4 (22,9) x 16,6 (18,0) cm (8201)

214
"Spot Murder Near Headquarters",
August 6, 1936, silver gelatin print on glossy
fibre paper, printed by August 11, 1936,
16,8 (17,2) x 22,0 (23,2) cm (8158)

215
"Tragedy Amid Celebration",
August 19, 1945, silver gelatin print on glossy
fibre paper, printed by August 24, 1945,
21,3 (22,8) x 16,6 (17,9) cm (8083)

216
"Dies in Attempted Hold-up",
February 3, 1942, silver gelatin print on glossy
fibre paper, printed by February 6, 1942,
21,2 (22,9) x 16,5 (18,1) cm (8259)

217
"Policeman Off Duty Shot to Death",
December 6, 1941, silver gelatin print on glossy
fibre paper, printed by December 11, 1941,
16,7 (18,1) x 21,0 (22,8) cm (8254)

218
"Two Policemen Carrying a Dead Body",
c. 1950, silver gelatin print on glossy fibre
paper, printed c. 1950,
24,2 (25,3) x 19,4 (20,7) cm (7914)

219
"One of Three Brooklyn Fire Victims",
January 20, 1939, silver gelatin print on glossy
fibre paper, printed by January 24, 1939,
17,2 (18,1) x 21,8 (22,8) cm (8190)

219
"Three Burn to Death in Brooklyn Fire",
January 20, 1939, silver gelatin print on glossy
fibre paper, printed by January 24, 1939,
17,3 (18,2) x 21,9 (22,8) cm (8911)

220
"Three Die in Stampede on Pier",
August 17, 1941, silver gelatin print on glossy
fibre paper, printed by August 21, 1941,
11,8 (12,8) x 15,7 (17,7) cm (8571)

220
"Recluse Dies in Coffin-Like Bed",
March 15, 1942, silver gelatin print on glossy
fibre paper, printed by March 20, 1942,
20,9 (22,8) x 16,5 (18,0) cm (8585)

221
"Two Die in Collision",
December 5, 1942, silver gelatin print on glossy
fibre paper, printed by December 11, 1942,
14,5 (18,2) x 21,2 (22,8) cm (9323)

222
"NY City Bus",
1939, silver gelatin print on glossy fibre paper,
printed by August 25, 1939,
21,7 (22,3) x 17,1 (18,0) cm (9310)

223
"Confesses Hatchet Slaying of Sweetheart",
March 11, 1940, silver gelatin print on glossy
fibre paper, printed by March 15, 1940,
21,5 (22,8) x 13,1 (17,9) cm (8427)

223
"Victim in Hatchet Slaying",
March 11, 1940, silver gelatin print on glossy
fibre paper, printed by March 15, 1940,
21,7 (22,8) x 16,9 (17,9) cm (8429)

224
"60 Injured in Western Electric Blast",
November 30, 1943, silver gelatin print on glossy
fibre paper, printed by December 3, 1943,
16,9 (17,7) x 22,0 (23,2) cm (8093)

226
"Casualty in Brooklyn Tenement Fire",
November 17, 1939, silver gelatin print on glossy
fibre paper, printed by November 21, 1939,
21,3 (22,9) x 16,4 (18,0) cm (8265)

227
"60 Injured in Western Electric Blast",
November 30, 1943, silver gelatin print on glossy
fibre paper, printed by December 3, 1943,
16,6 (17,6) x 21,6 (23,2) cm (8091)

228
"Death Chair",
October 2, 1941, silver gelatin print on glossy
fibre paper, printed by October 9, 1941,
19,9 (22,8) x 16,2 (18,0) cm (8160)

228
"60 Injured in Western Electric Blast",
November 30, 1943, silver gelatin print on
glossy fibre paper, printed by October 12, 1943,
16,6 (17,9) x 18,5 (22,8) cm (8966)

229
"Boy Rescued From Fire (Stanley Hansen)",
November 17, 1939, silver gelatin print on glossy
fibre paper, printed by November 21, 1939,
21,1 (22,7) x 16,5 (18,1) cm (8266)

230
"Fireman Injured in Brooklyn Blaze",
May 14, 1944, silver gelatin print on glossy
fibre paper, printed by May 19, 1944,
16,5 (17,9) x 20,9 (22,8) cm (9326)

231
"Police Protection",
March 17, 1944, silver gelatin print on glossy
fibre paper, printed by March 24, 1944,
20,8 (22,9) x 16,5 (18) cm (8274)

232
"Chinatown Was Happy",
March 1, 1943, silver gelatin print on glossy
fibre paper, printed by March 3, 1943,
19,0 (20,3) x 14,3 (15,5) cm (8454)

233
"Recovers Kidnapped Daughter",
March 17, 1943, silver gelatin print on glossy
fibre paper, printed by March 26, 1943,
19,0 (20,3) x 14,5 (15,5) cm (7960)

233
"Coffee Wrests Her from the Hands of Death",
September 5, 1944, silver gelatin print on glossy
fibre paper, printed by September 8, 1944,
21,5 (22,9) x 16,7 (18,1) cm (9295)

234
**"Model Buried by Shower of Debris in
New York Explosion"**,
May 9, 1940, silver gelatin print on glossy fibre
paper, printed by May 14, 1940,
16,8 (18,0) x 21,5 (22,6) cm (7956)

234
"Gettin Stockings the Hard Way",
April 4, 1943, silver gelatin print on glossy
fibre paper, printed by April 9, 1943,
20,9 (22,8) x 16,5 (18,1) cm (8607)

235
"Policemen Carrying a Body Bag",
1937, silver gelatin print on glossy fibre paper, printed by March 8, 1937,
16,8 (18,0) x 21,5 (22,8) cm (8467)

236
"Closeup of a Hit and Run Victim",
January 9, 1937, silver gelatin print on glossy fibre paper, printed by January 12, 1937,
21,9 (23,3) x 16,8 (17,7) cm (7943)

236
"Frank Tapedio Hit by Auto",
c. 1937, silver gelatin print on glossy fibre paper, printed by January 12, 1937,
22,3 (23,2) x 16,5 (17,8) cm (7945)

236
"Frank Tapedio, NY, Auto Victim",
c. 1937, silver gelatin print on glossy fibre paper, printed by January 12, 1937,
21,7 (23,2) x 16,7 (17,7) cm (7946)

237
"Frank Tapedio New York Auto Victim",
c. 1937, silver gelatin print on glossy fibre paper, printed by January 12, 1937,
24,0 (25,3) x 19,6 (20,4) cm (8080)

237
"Daughter of Frank Tapedino, After He Was Struck by a Hit and Run Driver",
c. 1937, silver gelatin print on glossy fibre paper, printed by January 12, 1937,
24,4 (25,3) x 19,5 (20,5) cm (8081)

238
"Buzzing Trunk Raises Bomb Scare",
October 14, 1940, silver gelatin print on glossy fibre paper, printed by October 18, 1940,
19,1 (20,2) x 23,2 (25,2) cm (8263)

239
"After the Eruption",
July 27, 1941, silver gelatin print on glossy fibre paper, printed by July 31, 1941,
16,3 (18,0) x 21,0 (22,8) cm (8570)

240
"New York Smart Set Gambling House Raided",
December 22, 1940, silver gelatin print on glossy fibre paper, printed by December 31, 1940,
17,0 (18,0) x 21,3 (22,8) cm (7972)

241
"Here They Are - Casting an Expert Eye",
February 13, 1941, silver gelatin print on glossy fibre paper, printed by February 18, 1941,
16,2 (18,0) x 21,2 (22,8) cm (7990)

241
"As Dawn Broke in Harlem",
August 2, 1943, silver gelatin print on glossy fibre paper, printed by August 4, 1943,
21,4 (22,9) x 17,1 (18,1) cm (9297)

242
"This is the *Bell Club*",
February 13, 1941, silver gelatin print on glossy fibre paper, printed by February 18, 1941,
16,8 (18,0) x 21,2 (22,9) cm (8011)

242
"New York's Fire *Buffs* Have Own Club",
February 13, 1941, silver gelatin print on glossy fibre paper, printed by February 18, 1941,
21,2 (22,8) x 16,8 (18,1) cm (8925)

243
"New York Fire *Buffs* Have Own Club",
February 13, 1941, silver gelatin print on glossy fibre paper, printed by February 18, 1941,
16,8 (17,9) x 21,2 (22,7) cm (8075)

244
"Fireman Helping Fallen Comrad",
July 17, 1939, silver gelatin print on glossy fibre paper, printed by July 22, 1939,
24,0 (25,3) x 19,2 (20,6) cm (8420)

245
"Holy Scrolls Saved From Fire",
December 5, 1942, silver gelatin print on glossy fibre paper, printed by December 11, 1942,
18,7 (20,3) x 14,5 (15,5) cm (8257)

246
"Bowery Drama in Three Acts",
December 27, 1942, silver gelatin print on glossy fibre paper, printed by December 31, 1942,
17,2 (18,2) x 21,8 (22,8) cm (7941)

246
"Bowery Drama in Three Acts",
December 27, 1942, silver gelatin print on glossy fibre paper, printed by December 31, 1942,
17,0 (18,0) x 21,7 (22,9) cm (9306)

247
"Tenants Flee Four-Alarm Fire",
January 27, 1943, silver gelatin print on glossy fibre paper, printed by February 21, 1943,
16,0 (17,8) x 19,5 (22,8) cm (8153)

247
"Felled by Smoke in New York Fire",
January 21, 1940, silver gelatin print on glossy fibre paper, printed by January 26, 1940,
20,9 (22,9) x 17,3 (18,2) cm (8918)

248
"They Still Had No. 17 Coupons",
June 14, 1943, silver gelatin print on glossy fibre paper, printed by June 18, 1943,
17,0 (18,0) x 21,5 (22,8) cm (8951)

249
"On the Seventh Day They'll Rest",
September 29, 1945, silver gelatin print on glossy fibre paper, printed by October 5, 1945,
16,3 (17,9) x 21,1 (22,7) cm (8186)

250
"Naughty Boys",
January 10, 1940, silver gelatin print on glossy fibre paper, printed by January 13, 1940,
16,3 (17,9) x 21,4 (22,7) cm (8424)

252
"Confiscated Moonshine",
November 24, 1943, silver gelatin print on glossy fibre paper, printed by December 3, 1943,
16,3 (17,7) x 21,5 (23,0) cm (8211)

253
"Close *Moonshine* Bar",
November 24, 1943, silver gelatin print on glossy fibre paper, printed by December 3, 1943,
17,0 (18,0) x 21,5 (22,8) cm (8213)

254
"Into the Barrel",
November 24, 1943, silver gelatin print on glossy fibre paper, printed by December 3, 1943,
16,4 (17,9) x 21,2 (22,8) cm (8210)

254
"Racking the Hootch",
December 2, 1943, silver gelatin print on glossy fibre paper, printed by December 10, 1943,
16,6 (18,0) x 21,0 (22,8) cm (8218)

255
"Raid Bootleg Liquor Bar",
November 24, 1943, silver gelatin print on glossy fibre paper, printed by December 3, 1943,
16,6 (18,0) x 19,0 (20,5) cm (8215)

256
"Moving Out",
November 24, 1943, silver gelatin print on glossy fibre paper, printed by December 3, 1943,
17,0 (18,0) x 21,5 (22,8) cm (8214)

257
"St. Patricks Decked with Red *Hammer and Sickle*",
February 15, 1944, silver gelatin print on glossy fibre paper, printed by February 25, 1944,
16,7 (18,1) x 21,3 (22,8) cm (7982)

258
"The Law Steps In",
November 24, 1943, silver gelatin print on glossy fibre paper, printed by December 3, 1943,
21,4 (22,8) x 16,9 (18,0) cm (8212)

259
"A Reporter (Weegee) is Shown Looking Over the Evidence Gathered at the Raid",
August 26, 1938, silver gelatin print on glossy fibre paper, printed by August 26, 1938,
16,8 (17,8) x 22,0 (23,02) cm (8067)

259
"Radio Program Service",
October 1, 1942, silver gelatin print on glossy fibre paper, printed by October 9, 1942,
17,0 (18,1) x 21,1 (22,8) cm (9305)

260
"Boy Escapes Unharmed after Bouncing Bomb",
November 29, 1936, silver gelatin print on glossy fibre paper, printed by March 8, 1937 ,
19,0 (20,3) x 14,4 (15,5) cm (7947)

260
"Arrested Arsonist May Have Done This",
April 18, 1937, silver gelatin print on glossy fibre paper, printed by April 23, 1937,
18,9 (20,6) x 13,4 (15,2) cm (8471)

261
"Nip New Jersey Bomb Threat",
July 13, 1940, silver gelatin print on glossy fibre paper, printed by July 19, 1940,
11,8 (12,9) x 16,5 (17,8) cm (8919)

262
"U.S. Seizes Stranded German Sailors",
May 7, 1941, silver gelatin print on glossy fibre paper, printed by September 5, 1941,
16,4 (18,1) x 21,1 (22,8) cm (8930)

263
"Blind Man Held on Murder Charge",
July 1, 1941, silver gelatin print on glossy fibre paper, printed by July 3, 1941,
21,5 (22,8) x 16,9 (17,9) cm (8563)

263
"Hines Case *In The Bags*",
August 31, 1938, silver gelatin print on glossy fibre paper, printed by September 22, 1938,
16,7 (17,8) x 21,9 (23,4) cm (9314)

264
"Accused of Looting $50,000-Worth",
October 24, 1943, silver gelatin print on glossy fibre paper, printed by October 29, 1943,
16,8 (18,1) x 14,0 (15,5) cm (8960)

265
"Bandit Theodore Lutzer Being Booked at Boro Park",
1940, silver gelatin print on glossy fibre paper, printed by March 22, 1940,
24,5 (25,7) x 19,2 (20,4) cm (8913)

265
"Alleged Successor to Moe Anenburg",
October 1, 1942, silver gelatin print on glossy
fibre paper, printed by October 9, 1942,
21,1 (22,9) x 16,4 (18,0) cm (9304)

266
**"Booking Suspects in Theft of
25 Million Nickels"**,
c. 1939, silver gelatin print on glossy fibre paper,
printed by January 26, 1939,
16,4 (18,0) x 21,2 (22,8) cm (8500)

267
"Father Divine Booked",
April 22, 1937, silver gelatin print on glossy
fibre paper, printed by May 3, 1937,
16,0 (16,1) x 21,3 (21,5) cm (8020)

268
"Muggers in Line-Up",
October 5, 1942, silver gelatin print on glossy
fibre paper, printed by October 9, 1942,
16,9 (18,1) x 21,5 (22,8) cm (8593)

269
"Bund Leader Booked",
May 26, 1939, silver gelatin print on glossy fibre
paper, printed by May 29, 1939,
16,8 (18,2) x 21,3 (22,8) cm (8184)

270
"Dewey Witnesses Jailed",
August 26, 1938, silver gelatin print on glossy
fibre paper, printed by August 29, 1938,
21,8 (23,2) x 16,8 (17,7) cm (7924)

270
"Hungarian Screen Actress Dies in Plunge",
December 17, 1939, silver gelatin print on glossy
fibre paper, printed by December 22, 1939,
18,8 (20,2) x 14,3 (15,4) cm (8497)

271
"Booked for Homicide",
February 9, 1942, silver gelatin print on glossy
fibre paper, printed by February 13, 1942,
18,6 (20,3) x 14,4 (15,5) cm (8938)

271
"Girl Who Killed Boy with *Unloaded* Rifle",
May 11, 1938, silver gelatin print on glossy
paper, printed by May 17, 1938,
21,6 (22,8) x 16,8 (17,9) cm (9327)

272
"Accused of Fatally Burning Girl Friend",
December 5, 1940, silver gelatin print on glossy
fibre paper, printed by December 10, 1940,
18,3 (20,6) x 13,5 (15,2) cm (8923)

272
"Off Duty, Officer Shoots Stickup Man",
February 3, 1942, silver gelatin print on glossy
fibre paper, printed by February 6, 1942,
18,9 (20,4) x 14,3 (15,5) cm (8937)

272
"Attack and Murder Suspect",
August 30, 1943, silver gelatin print on glossy
fibre paper, printed by September 3, 1943,
19,0 (20,4) x 12,7 (14,1) cm (8955)

273
"Confesses *Commando* Killing, Police Say",
November 9, 1944, silver gelatin print on glossy
fibre paper, printed by November 17, 1944,
21,7 (22,9) x 16,7 (17,9) cm (8974)

273
"Fatal Beating of Baby Holds AWOL Sailor",
November 15, 1944, silver gelatin print on glossy
fibre paper, printed by November 24, 1944,
19,0 (20,3) x 14,3 (15,5) cm (8975)

274
**"Wife Kills Policeman in Argument
Over Parking Car"**,
October 31, 1937, silver gelatin print on glossy
fibre paper, printed by November 6, 1937,
21,5 (22,8) x 16,7 (17,8) cm (8483)

275
"Sees Wife Sentenced in Secretary-Slaying",
December 20, 1935, silver gelatin print on glossy
fibre paper, printed by December 27, 1935,
22,2 (23,2) x 16,9 (17,8) cm (8912)

275
"Confesses Accidental Shooting",
February 25, 1944, silver gelatin print on
glossy fibre paper, printed by March 3, 1944,
21,7 (22,8) x 16,3 (18,0) cm (8969)

276
**"Held After Gun Fight in $150,000
Drug Smuggling Raid"**,
January 6, 1939, silver gelatin print on glossy
fibre paper, printed by January 9, 1939,
17,2 (18,2) x 21,1 (22,9) cm (8498)

276
"The Woes of a Patriotic Purloiner",
February 23, 1943, silver gelatin print on glossy
fibre paper, printed by Febraury 26, 1943,
14,4 (15,4) x 18,8 (20,3) cm (8605)

277
"German Seamen Rounded Up",
May 7, 1941, silver gelatin print on glossy fibre
paper, printed by May 9, 1941,
22,0 (25,6) x 18,6 (20,2) cm (8275)

278
"Victory Pup",
August 14, 1945, silver gelatin print on glossy
fibre paper, printed by August 17, 1945,
16,8 (18,0) x 19,4 (22,8) cm (7803)

280
"This Dog *Jerry* Overcome by Smoke",
November 16, 1941, silver gelatin print on glossy
fibre paper, printed by November 21, 1941,
21,7 (25,3) x 19,3 (20,7) cm (8261)

281
"Blaze Couldn't Drive this Dog from Home",
October 9, 1940, silver gelatin print on glossy
fibre paper, printed by October 15, 1940,
24,2 (25,6) x 19,0 (20,3) cm (8264)

282
"*Whiskey*, Asleep at the Switch",
December 9, 1943, silver gelatin print on glossy
fibre paper, printed by December 18, 1943,
18,9 (20,3) x 14,4 (15,6) cm (8256)

283
"Buddy is *Watered In*",
May 25, 1945, silver gelatin print on glossy fibre
paper, printed by June 1, 1945,
17,0 (18,0) x 21,7 (22,8) cm (8208)

284
"Blackie's Government Housing Project",
April 28, 1941, silver gelatin print on glossy
fibre paper, printed by May 6, 1941,
21,0 (22,8) x 16,5 (18,0) cm (8182)

285
"Parrot Finds Refuge From Two-Alarm Fire",
March 24, 1939, silver gelatin print on glossy
fibre paper, printed by March 31, 1939,
14,2 (15,2) x 19,6 (20,8) cm (8505)

286
"Seein' the New Year in",
January 1, 1945, silver gelatin print on glossy
fibre paper, printed by January 4, 1946,
19,0 (22,3) x 14,5 (15,4) cm (8694)

287
"Dogs Get Hot Too",
June 3, 1943, silver gelatin print on glossy fibre
paper, printed by June 11, 1943,
21,0 (22,8) x 16,9 (18,0) cm (8615)

288
"It Doesn't Appeal to *Toto*",
April 3, 1942, silver gelatin print on glossy
paper, printed by April 10, 1942,
22,2 (22,7) x 16,8 (18,2) cm (8586)

289
"Story of Bozo",
May 24, 1942, silver gelatin print on glossy
fibre paper, printed by May 29, 1942,
16,4 (18,1) x 20,8 (22,8) cm (8026)

290
**"*Butch*, a Cocker Spaniel,
Became Unwilling Accomplice"**,
c. 1941, silver gelatin print on glossy fibre paper,
printed by September 4, 1941,
22,9 x 18,1 cm (8005)

291
"Hook and Ladder Side Car",
August 13, 1943, silver gelatin print on glossy
fibre paper, printed by August 20, 1943,
21,6 (22,9) x 17,0 (18,0) cm (7807)

292
"Lightning Lashes New York in Heat-Wave",
July 28, 1940, silver gelatin print on glossy fibre
paper, printed by July 30, 1940,
16,8 (18,1) x 21,4 (22,8) cm (8296)

294
"Victim of New York Hurricane",
September 14, 1944, silver gelatin print on glossy
fibre paper, printed by September 22, 1944,
21,1 (22,9) x 16,7 (18,3) cm (8971)

295
"Give It the Axe",
November 24, 1943, silver gelatin print on glossy
fibre paper, printed by December 10, 1943,
17,2 (18,1) x 21,3 (22,8) cm (8216)

296
"Shooting Causes Riot in Harlem",
August 1, 1943, silver gelatin print on glossy fibre
paper, printed by August 6, 1943,
17,0 (18,1) x 21,3 (22,8) cm (8952)

297
"Shooting Causes Harlem Riot",
August 1, 1943, silver gelatin print on glossy
fibre paper, printed by August 6, 1943,
17,1 (18,0) x 21,7 (22,8) cm (8627)

298
"Protest Against Father Divine's Arrest",
April, 1937, silver gelatin print on glossy fibre
paper, printed by April 28, 1937,
24,1 (25,4) x 19,5 (20,6) cm (8472)

299
"Shooting Causes Harlem Riot",
August 1, 1943, silver gelatin print on glossy
fibre paper, printed by August 6, 1943,
16,9 (18,0) x 19,2 (20,8) cm (8628)

300
"*Weegee* Lends a Helping Hand",
May 29, 1945, silver gelatin print on glossy
fibre ppaper, printed by June 1, 1945,
21,3 (22,8) x 16,5 (17,9) cm (7975)

301
"Fruit Men Protest Black Market",
May 24, 1945, silver gelatin print on glossy
fibre paper, printed by June 1, 1945,
16,4 (18,1) x 20,8 (22,8) cm (7979)

302
"Retail Dealers Protest Black Market",
May 29, 1945, silver gelatin print on glossy
fibre paper, printed by June 1, 1945,
16,7 (18,1) x 21,3 (22,9) cm (7976)

302
"Meat Black Market",
1943, silver gelatin print on glossy fibre paper,
printed by July 2, 1943,
16,8 (18,0) x 22,9 (24,4) cm (9296)

303
**"Sandhog Arrested as Violence
Flares Again"**,
February 13, 1941, silver gelatin print on glossy
fibre paper, printed by Febuary 18, 1941,
14,1 (15,2) x 11,2 (12,0) cm (7996)

304
"2 Arrested in Radio City Lift Strike",
September 23, 1943, silver gelatin print on
glossy fibre paper, printed by October 1, 1943,
14,3 (15,4) x 17,0 (18,2) cm (8121)

306
"Suspicious Characters Seated in Wagon",
1935, silver gelatin print on glossy fibre paper,
printed by February 14, 1935,
21,4 (22,8) x 17,0 (17,9) cm (9328)

307
"Admits Killing Sweetheart",
April 14, 1940, silver gelatin print on glossy
fibre paper, printed by April 19, 1940,
24,4 (25,7) x 19,2 (20,3) cm (8544)

308
"Charles E. Cox Being Led to Detention Cell",
February 14, 1939, silver gelatin print on glossy
fibre paper, printed by February 14, 1939,
21,0 (22,7) x 16,2 (17,7) cm (8503)

309
"Bund Leader Booked On Theft Charge",
May 26, 1939, silver gelatin print on glossy
fibre paper, printed by May 31, 1939,
19,0 (20,8) x 14,0 (15,2) cm (8021)

309
**"Bund Leader Led to Cell After Return
from Pennsylvania"**,
May 26, 1939, silver gelatin print on glossy
fibre paper, printed by May 31, 1939,
21,6 (22,9) x 17,0 (18,2) cm (8916)

310
"As Father Divine Was Booked in New York",
April 23, 1937, silver gelatin print on glossy fibre
paper, printed by April 28, 1937,
21,3 (22,8) x 17,1 (18,1) cm (8019)

311
"Pride in the Bowery",
November 18, 1942, silver gelatin print on glossy
fibre paper, printed by November 20, 1942,
16,7 (18,1) x 21,0 (22,9) cm (8597)

312
"Thanksgiving Ragamuffin",
November 26, 1943, silver gelatin print on glossy
fibre paper, printed by December 10, 1943,
21,7 (23,0) x 16,7 (17,7) cm (8251)

313
"Meatless Day on the Bowery",
October 20, 1942, silver gelatin print on glossy
fibre paper, printed by October 30, 1942,
21,7 (22,8) x 17,0 (18,1) cm (8154)

314
"No Celebrating for this G.I.",
May 7, 1945, silver gelatin print on glossy
fibre paper, printed by May 11, 1945,
21,0 (22,9) x 16,4 (18,1) cm (7921)

314
"*Ac-Centuating the Positive*",
February 26, 1945, silver gelatin print on glossy
fibre paper, printed by March 1, 1945,
17,0 (18,0) x 17,5 (11,7) cm (7951)

315
"Just *Wore-Out*",
August 14, 1945, silver gelatin print on glossy
fibre paper, printed by August 17, 1945,
21,0 (22,7) x 16,6 (17,9) cm (8061)

316
"Survivors Tell of Destroyer Explosion",
January 3, 1944, silver gelatin print on glossy
fibre paper, printed by January 7, 1944,
17,0 (18,0) x 21,5 (22,8) cm (7983)

317
"Last Man Off Exploded Destroyer",
January 3, 1944, silver gelatin print on glossy
fibre paper, printed by January 7, 1944,
21,7 (22,8) x 17,0 (18,1) cm (8650)

317
"Aids in Rescue of Bus Crash Victims",
March 20, 1944, silver gelatin print on glossy
fibre paper, printed by March 22, 1944,
18,2 (20,3) x 14,5 (15,4) cm (9293)

318
**"New York Smart Set Gambling House
Raided"**,
December 22, 1940, silver gelatin print on glossy
fibre paper, printed by December 31, 1940,
17,1 (18,1) x 21,2 (22,8) cm (8282)

318
"Caught in the Movie Theatre",
August 27, 1943, silver gelatin print on glossy
fibre paper, printed by September 3, 1943,
21,2 (22,8) x 16,4 (18,0) cm (8953)

319
"Michael Sacina",
1929, silver gelatin print on glossy fibre paper,
printed by November 29, 1929,
24,3 (25,7) x 18,2 (20,3) cm (9319)

320
"Witness to Shooting of Union Official",
October 2, 1941, silver gelatin print on glossy
fibre paper, printed by October 9, 1941,
18,4 (20,4) x 14,2 (15,4) cm (8932)

321
"This May Happen to You!",
January 5, 1942, silver gelatin print on glossy
fibre paper, printed by January 16, 1942,
19,0 (20,4) x 14,3 (15,5) cm (8934)

322
"Says Boys Carved Swastika on Arm",
September 18, 1944, silver gelatin print on glossy
fibre paper, printed by September 22, 1944,
16,7 (18,0) x 21,6 (22,9) cm (8972)

323
"Family Reunion",
December 22, 1940, silver gelatin print on glossy
fibre paper, printed by December 31, 1940,
20,0 (23,0) x 17,1 (18,0) cm (8924)

323
"Happy to be Home Again",
March 3, 1943, silver gelatin print on glossy
fibre paper, printed by March 3, 1943,
19,0 (20,3) x 14,4 (15,5) cm (8945)

324
"Man on the Steeple",
May 22, 1943, silver gelatin print on glossy
fibre paper, printed by May 28, 1943,
21,2 (22,7) x 16,7 (18,1) cm (7955)

324
"Steeple-Squatter Grounded",
May 22, 1943, silver gelatin print on glossy fibre
paper, printed by May 28, 1943,
21,1 (22,8) x 16,6 (18,0) cm (9324)

325
"Twelve O'Clock - and All's Closed",
February 26, 1945, silver gelatin print on glossy
fibre paper, printed by March 2, 1945,
24,3 (25,7) x 16,0 (20,7) cm (8247)

ACKNOWLEDGMENTS

We wish to thank the following people,
who have given generously of their time and
help to make this publication a success:

Ryan Adams
Marion Dietrich
Christopher George
Stefanie Gerstmayr
Patricia Schulze
Cynthia Young
Christiane Wunsch
Thomas Zuhr

Daniel Blau
Maximilianstrasse 26
80539 Munich
Germany
contact@danielblau.com
Tel.: +49 / 89 / 297 342
www.danielblau.com

PUBLISHED BY

Hirmer Verlag GmbH
Nymphenburger Strasse 84
80636 Munich
Germany

Editor:
Daniel Blau

Authors:
Ryan Adams, Daniel Blau,
Herbert Corey, Sydney Picasso

Layout Concept:
Daniel Blau

Hirmer Project Management ,
Layout and Typesetting:
Sabine Frohmader

Printing and Binding:
Printer Trento, Trento

Paper:
Gardapat Kiara 115 g/m^2

Printed in Italy

Bibliographic information published by
the Deutsche Nationalbibliothek
The Deutsche Nationalbibliothek lists
this publication in the Deutsche
Nationalbibliografie; detailed bibliographic
data is available on the Internet at
http://www.dnb.de.

Copyright:
Illustrations: © Weegee/International Center
of Photography, Courtesy Daniel Blau, Munich
Texts: © the authors
Layout: © Daniel Blau

www.hirmerpublishers.com

ISBN 978-3-7774-2813-0

IMAGES ON DUST JACKET:

front cover left:
Detail of "New York Celebrates Italy's Defeat",
September 8, 1943, see p. 133

front cover right:
Detail of "Weegee Lends a Helping Hand",
May 29, 1945, see p. 300

back cover:
"Hep Cats in a Hurry—Hurry, Hurry, Hurry—
Only 6,000 Seats Left",
April 28, 1943, see p. 115

back flap top:
Daniel Blau, 2015 © David Bailey

back flap bottom:
Detail of "'Weegee' Arthur Fellig",
1950, silver gelatin print on glossy fibre paper,
printed by September 27, 1950,
24,5 (25,8) x 19,0 (20,3) cm (8193)

IMAGES ON ENDPAPERS:

front left:
"Keeping Cool",
June 14, 1945, see p. 73

front right:
"One for the Book Weegee +
Miss America (Billie Bow)",
c. 1931, see p. 192

back left:
"Ring-A-Round for Victory",
May 7, 1945, see p. 120

back right:
"Elliott and Faye Roosevelt Mobbed
in Times Square",
August 14, 1945, see p. 57

DANIEL BLAU

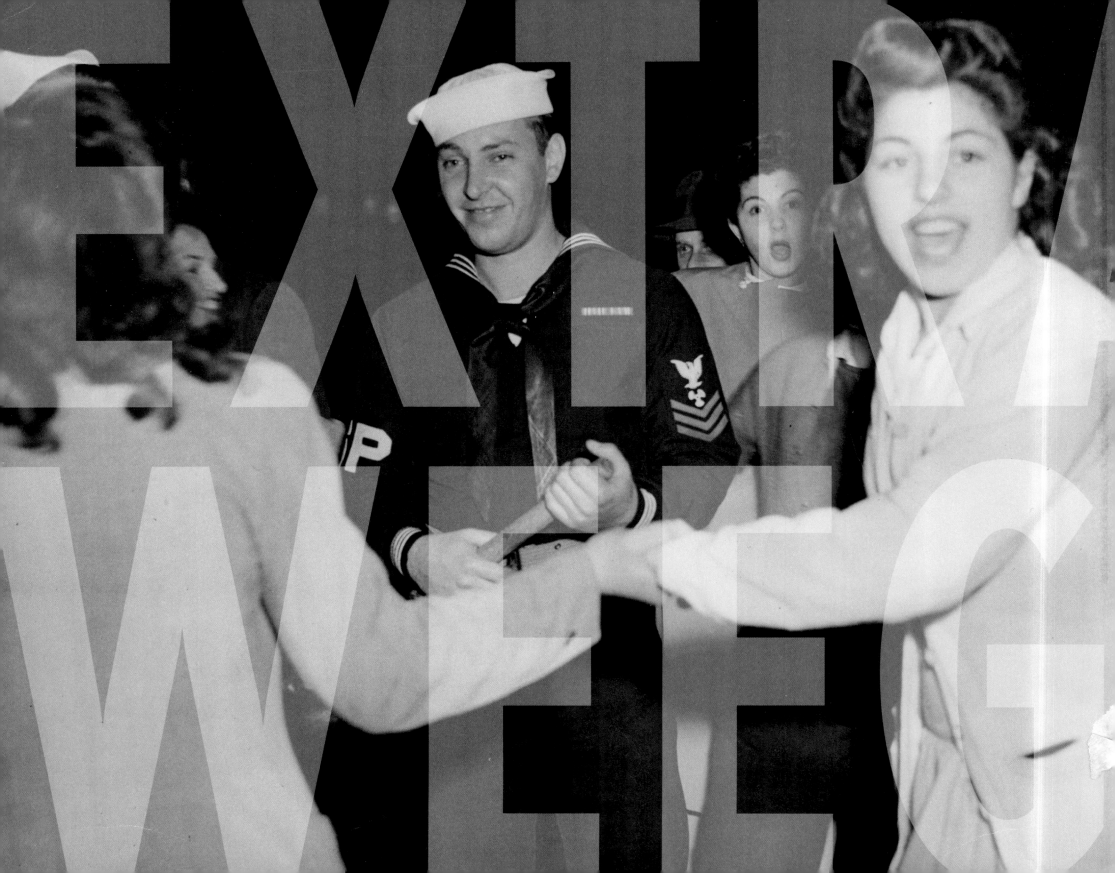